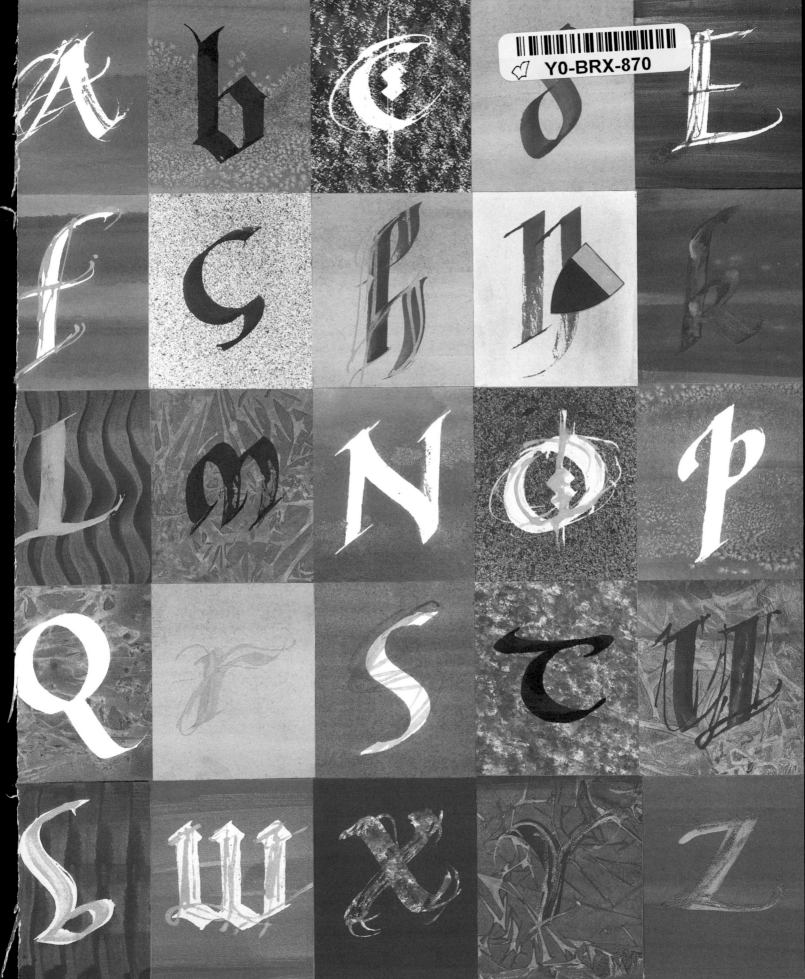

Y0-BRX-870

Calligraphy & Illumination

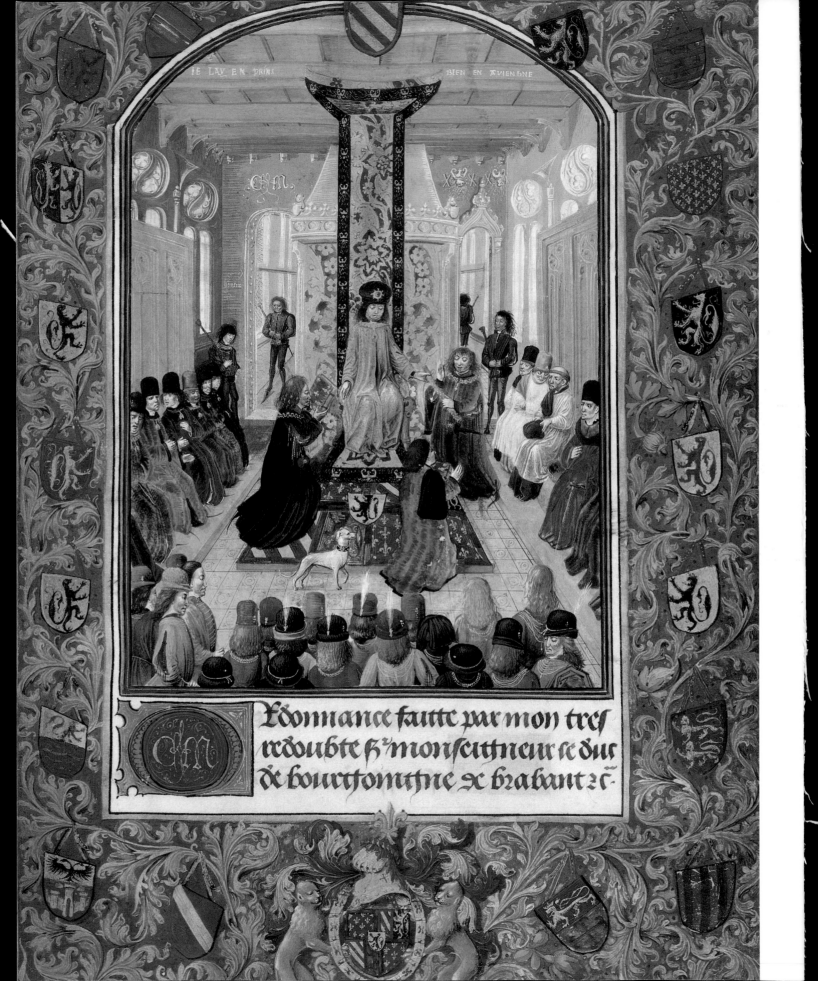

Patricia Lovett

A History and Practical Guide

Harry N. Abrams, Inc.
Publishers

Library of Congress Cataloging-in-Publication Data

Lovett, Patricia.
　　Calligraphy and illumination : a history and practical guide / Patricia Lovett.
　　　　　p.　cm.
　　Includes bibliographical references and index.
　　ISBN 0-8109-4119-8
　　1. Calligraphy.　　2. Illumination of books and manuscripts.　I. Title.

Z43. L86 2000　　　　　　　　　　　　　　　　00-031318
745.6'1—dc21

© 2000, in illustrations, The British Library Board, and other named copyright owners.
© 2000, in text, exemplar letters and artwork, Patricia Lovett.
© 2000, photographs which are not otherwise acknowledged, Patricia Lovett.
© 2000, in text and illustrations, the named authors in their relevant chapters.
© 2000, artwork in the heraldry chapters where acknowledged, Timothy Noad.
© 2000, exemplar letters, page 97, Jim Linwood.
© 2000, artwork, page 85, Fred Marns.

First published in 2000 by The British Library, London

Published in 2000 by Harry N. Abrams, Incorporated, New York
All rights reserved. No part of the contents of this book may be reproduced
without the written permission of the publisher.
Printed and bound in Hong Kong

Harry N. Abrams, Inc.
100 Fifth Avenue
New York, N.Y. 10011
www.abramsbooks.com

Frontispiece.
A glorious page of colour, gold, calligraphy and heraldry. This shows Charles the Bold, Duke of Burgundy, receiving the oath of allegiance from his military captains. Charles is seated on an elaborately decorated throne which is draped with patterned cloth of gold. On the wall to his left is a monogram of his initial and that of his wife, Margaret, and this is repeated within the initial **O** *for 'Ordinance'. Charles's coat of arms is at the foot of the page encircled by the collar of the Order of the Golden Fleece.*

BL Additional MS 36619, f. 5.

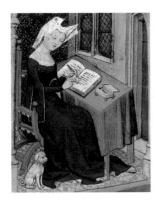

Contents

Acknowledgments:

I would like to thank the contributors of the chapters – Michelle Brown, Hubert Chesshyre, Rosemary Sassoon and Hermann Zapf, who, together with Timothy Noad the artist for many of the illustrations in the *Heraldry* section, Fred Marns for his Copperplate artwork and Jim Linwood for the exemplar letters in Copperplate have helped to make this book different and distinctive. David Way and Kathleen Houghton at the British Library have been both supportive and patient during the production process. Thanks, too, to my teachers and students; I have learnt much from both groups. And, as always, I owe a great debt to my family for their understanding and consideration. *Patricia Lovett*

Endpapers:

There must be twenty-six ways to write your letters…

All letters were written with an automatic pen, the left-hand corner of an automatic pen, and/or a ruling pen. The process for each letter is indicated by the order.

A – automatic and ruling pen with resist, two-colour wash.

B – two-colour wash and salt, automatic pen with Chinese ink.

C – automatic pen and ruling pen with resist, one-colour sponged pattern.

D – one-colour wash, automatic pen with gouache.

E – automatic pen with resist, one-colour wash and gold gouache, ruling pen with silver.

F – automatic pen with resist, two-colour wash, ruling pen with gold gouache.

G – one-colour spatter pattern and silver, automatic pen with gouache.

H – one-colour wash, automatic pen with gouache, ruling pen with gold gouache.

I and **J** – automatic pen with gouache, shield with colour and gold gouache, two-colour scraped pastel background.

K – two-colour wash, automatic pen with gouache, gold gouache dropped in while still wet.

L – two-colour paste with gouache, automatic pen with gold gouache.

M – one-colour wash with clingfilm (saran wrap), automatic pen with Chinese ink.

N – automatic pen with resist, two-colour wash with silver powder dropped in while still wet.

O – automatic pen and ruling pen with resist, two-colour spatter pattern, ruling pen with gold gouache.

P – automatic pen with resist, one-colour wash with salt.

Q – automatic pen with resist, one-colour wash with cling film (saran wrap).

R – one-colour wash, automatic pen and ruling pen with gold gouache.

S – automatic pen with resist, one-colour wash, ruling pen with watery gouache.

T – two-colour sponged background, automatic pen with Chinese ink.

U – two-colour wash with gold gouache dropped in while still wet with cling film (saran warp), automatic pen and ruling pen with gouache.

V – automatic pen with resist, two-colour paste with gouache, narrower automatic pen with gold gouache.

W – automatic pen with resist, one-colour wash with gold gouache, ruling pen with gold gouache.

X – two-colour sponged background with gold gouache, automatic pen and ruling pen with resist, one-colour wash.

Y – two-colour wash with cling film (saran wrap), automatic pen with gouache, ruling pen with gold gouache.

Z – two-colour wash, automatic pen with gold gouache, ruling pen with silver gouache.

Preface

If you wanted to buy a book in Oxford in the thirteenth century, you would make your way to Catte Street. Here in any of the stationers' shops you could look at examples of scripts – noting the variety of styles and sizes, consider whether you would want any illuminations in your book, and decide on how many, of what quality and how much gold and colour would be used, and even be able to choose and feel the quality of skin that would eventually make the pages of your book.

Catte Street at this time consisted of many tenements packed closely together, and would have been very busy. Students were here for the new university at Oxford, and many of their halls and meeting places were in the parallel road of School Street.

Your chosen book might be a Psalter (the Book of Psalms), or perhaps a Book of Hours – which you would use for your private devotions at the eight canonical hours (pausing during your working day to read also one of the Penitential Psalms or even the Office of the Dead, perhaps). Or you may wish to purchase a copy of the four Gospels, or a book to present to a church or other ecclesiastical foundation; this may be a breviary, which would contain all the texts necessary for the celebration of Divine Office. For this presentational book you would probably choose to have a grand painting showing your full coat of arms. You may think it a little vulgar to actually have your name recorded as the benefactor of the volume, but your coat of arms showed exactly who you were in a less obvious way.

A century or so before this, it would be unlikely that you, as a layperson, would consider buying a book, as they were rarely owned by those not connected with the church. But here you are looking at the examples of the scribe, illuminator and miniature painter, all working together in close collaboration in this busy street. The stationer would have gatherings, or sections of pages, folded and in the right page order, which would be given out to the scribes to copy, or may even be hired out to students to write out themselves, making their own, cheaper copies of the text.

Above the shop, perhaps, there may be illuminators working, carefully collecting the tiny pieces of gold not used, and storing it as illuminators' 'perks', to be melted down later and beaten again to tissue-thin leaves. Illuminators in Oxford at this time were successful craftspeople, and were well known. We actually know some of their names – Walter of Eynsham, Radulfo, Roberto and even Job the Illuminator. The painters would have had apprentices, learning which of the pigments could be ground down to the finest of powders, and which ones had to be left a little gritty so that they retained their colour. Scribes would leave the preparation of vellum or parchment to their own apprentices, who would also draw out the guidelines for the lines of text, looking over the shoulder of the writer to follow the construction of the individual letter-forms.

These craftspeople were carrying on a tradition set by the earliest scribes – writing down information so that it could be read and referred to at a later time. The written word may have been represented in a casual, hurried script, such as Roman Cursive, and almost impossible for us to read now. Or the letters may have been carefully and painstakingly constructed, so that the page became a thing of beauty in its own right. This combination of text and colour enhanced the attractiveness of the manuscript. Rich, vibrant colours used perhaps only for the first letter of each paragraph, and then in miniatures to illustrate certain sections of the text, added to, rather than detracted from the message of the words.

William de Brailes, who worked in Oxford in the thirteenth century, records that he painted the page in The de Brailes Hours, *by writing* w. de brail' qui me depeint *in the margin on the left, just above the illuminated letter* C.

BL, Additional MS. 49999, f. 43.

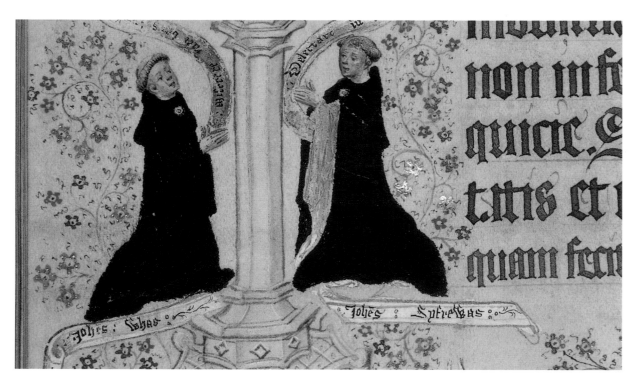

John Whas, the scribe of the Sherborne Missal, complained that he had to get up early every morning to work on the book to complete it and that his body was 'sorely aching' or 'much wasted' as a result of writing the book. It is likely that John Whas was a member of the Benedictine community at Sherborne. The illuminator was John Siferwas, a Dominican friar, who included the coat of arms of the branch of the Siferwas family to which he presumably belonged in one of the delightful illustrations in this book. John Whas is shown on the left and John Siferwas on the right.

BL, Additional MS. 74236, page 27.

And then came gold. Gold retains its shine, colour and brilliance even after hundreds of years; it does not tarnish. Its properties also made it expensive, so it was used only in those volumes which were particularly important – the word of God and ecclesiastical texts. Initially applied only sparingly, gold was increasingly used in books until the High Middle Ages where large sections of the paintings would consist of layers of shiny burnished gold raised up from the surface of the vellum or parchment so that it looked like an enamelled jewel. It was even used for the important letters in the text, and then, later, in Renaissance times as the background to wide borders and as highlights in the paintings themselves.

Associated with the production of written documents at this time was heraldry. The designs on shields which had been allocated to individuals needed to be recorded for posterity, so that there could be no confusion in the future. As well as this those who took part in tournaments or jousts, battles or wars, had to be recorded, and the coat of arms became a shorthand way of noting who was who and indeed, who did what. Realising that the strong, clear colours of heraldry would work well with those used in manuscript painting, coats of arms were combined in books with other decoration, indicating who owned the book or who presented the book to whom. This provides us with valuable history in determining the provenance of a book.

So does this have any relevance to us today? The written word does, of course, as indeed you are reading this now,

and it is by a recognition of letters and then words that you are able to make sense of it. But letters can be so much more. They can be things of beauty in themselves, or combined together to make artworks. Calligraphy is one of the most popular of all the arts and crafts to learn because what is needed is so easily accessible – pen, ink and paper. Developing a range of lettering styles will enhance enjoyment, and combining lettering with colour, gold and perhaps also introducing heraldry reflects back on those mediæval book makers. The mediæval manuscripts themselves are useful as a source of inspiration and study and it is time well spent to copy and learn, but it is also important not to leave your skills there. Develop writing styles which fit your own writing movement or ductus, adapt the letters until they feel comfortable being written by you. Similarly, trace and copy mediæval illuminations, but try to develop also a modern approach to the use of gold with colour. Note as well the many ways in which aspects of heraldry occur in a modern setting, perhaps on street furniture, company logos and for personal use.

This book shows you the historical examples, how they can be analysed and used as exemplars, and also gives you the method and format for reproducing them. But there are also ideas for bringing these three examples of the mediæval book arts – calligraphy, illumination and heraldry – up-to-date. The rest is up to you!

A page from one of the books commissioned by King Edward IV from the workshops in Bruges. This one page combines the three elements of the Mediæval book arts of this book – flowing, rhythmic calligraphy, the use of gold in illumination and bold heraldry. This page shows the author at work, writing on a rather precariously balanced sloping board; note the two lead weights attached to thongs which hold the book open or keep a bouncy piece of vellum flat, thus making the writing easier. The magnificently decorated and illuminated border includes not only two angels each holding aloft a banner of the royal arms but also the white rose of York. In the lower margin Edward's shield is encircled by the Order of the Garter, and his helmet shows a regal crown and the lion crest facing affronty. The two additional shields on either side represent his sons, Edward Prince of Wales and Richard Duke of York (the Princes in the Tower). It is interesting that the first and fourth quarters on the arms – the most important quarters, contain the French royal arms and not the English, indicating the claim to French lands.

BL, Royal MS 18 E. iii, f. 24. (1479).

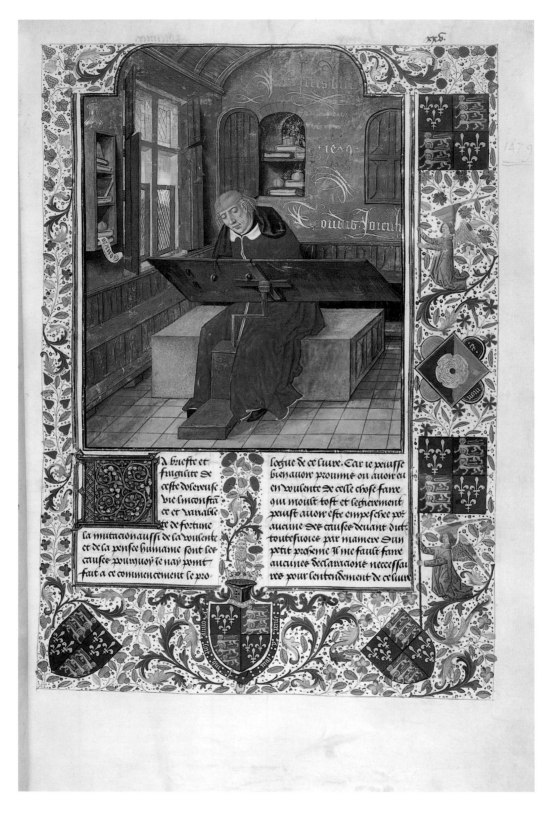

10

Calligraphy

Introduction

You need only a pen, ink and some paper to begin calligraphy and lettering, and start a hobby which may well turn into a career and even an obsession. Many, once the world of letters and lettering has been opened to them, appreciate the intricacies of a well-designed letter in whatever form it may be – a beautifully-written piece in copperplate, an apt choice of a typeface for a book, a fun style font for an advertisement, or even a wonderfully flourished calligraphic Italic letter.

What do you do to begin? Getting the right tools and equipment together is the first step. These can be very cheap and involve hardly any outlay. You can use two pencils held together by elastic bands, and some scrap photocopying paper, using a large tray propped in your lap as your sloping board. Or you may choose to buy a set of calligraphy nibs and a pen holder, an ink stone and ink stick, a pad of layout paper and an adjustable drawing board with a sliding rule, and then gradually build up your stock of paper and the colours of paints you will use as inks.

The first section in this book shows you how – from the very first stages. It gives details of the various ways you can start, what you need, and simple approaches to making letters which mean that you make the quickest progress. It leads you on to design and writing out your own pieces of calligraphy and you can then write out labels, greetings cards, certificates, pieces of poetry and prose and so create your own artworks.

The styles of writing with which we are familiar today – Gothic, Italic, Rustics, Uncials – are all based on various alphabets used in manuscript books from the earliest written codices. Some are even earlier, such as the incised majestic Roman letters carved into stone inscriptions. The writing styles changed and developed subtly over the years, yet are recognisable as distinct and different styles. It is these different historical alphabets that provide exemplars for us to use, and close study of these is rarely time wasted.

In the following pages selected good examples of each style are shown to demonstrate how to analyse and make the best use of these historical writing styles. Yet exact, almost slavish, copying is not the recommended route to take. Every scribe has a different rhythm and flow, and, even with the same teacher or example to copy, a slightly different interpretation. This is the joy of calligraphy. Having learnt the basic strokes and forms, it is your interpretation of the hand which makes a piece distinctly yours. In each example you should go back to the original, note the style and form, and take from it what you need to write, without it becoming a pastiche.

Most early scribes practised a neat and careful hand, writing out long ecclesiastical works which would result in the development of a personal style and rhythm. It is worth writing out longer pieces to develop your own rhythm if you have the time and inclination, although perhaps writing out the whole Bible may be a little ambitious for beginners! The standard of lettering in those manuscript books does vary. Some of them are magnificent, the letters are consistent and well-formed, and you can sense the joy with which they were written. Others are less well executed, and the scribe who wrote at the end of one book how relieved he was to finish and that now what he wanted was a drink and to be well-paid for all his hard work, perhaps did not give of his best throughout the whole book.

The lessons that can be learnt from studying historic manuscripts are many and various. If you are able to look at originals in museums or library exhibitions then take every opportunity to do so. You will be able to see exactly how

the scribe made the letters, where the pen lifts occurred, where the pen ran out of ink and had to be re-charged, and even, sometimes, where the quill became blunt and a new nib was cut. These facets are not always obvious in a reproduction, even of good quality, but they are certainly better than nothing. Care has been taken in this book to select the best examples of manuscripts to aid this sort of study.

The link between handwriting and calligraphy is still somewhat of a blur. These old manuscript books were written by scribes who had 'a good hand', it was their best writing, yet many nowadays regard it as calligraphy. When we receive a well lettered hand-written letter today, set out on a crisp creamy note paper, perhaps in black or brown ink, and maybe in an Italic hand, do we regard this as calligraphy or handwriting? This intriguing question is addressed on pages 133–140 by Rosemary Sassoon, who is not only a trained scribe, a recognised authority and educational consultant, but also the author of many books on handwriting.

The technological developments of the twentieth century have resulted in so much of what we read and see today being not hand written. Books, newspapers and periodicals have been printed for centuries. The invention and use of the typewriter and then the personal computer and desk-top publishing programs has resulted in many people now using these facilities for their own correspondence, for notices, invitations and the like. Yet the typefaces which are used – and there are thousands available – all had to be designed by someone who is an expert in letters and lettering. Hermann Zapf is a calligrapher and letter-designer, one of the best in

the world, and he writes about the links between calligraphy and good type design on pages 141–147.

So will the technology and ease of access for all, even for children in their first school, mean that handwriting and calligraphy will be of no use in the future? This seems unlikely. Anything of any import needs the human touch; it shows that someone felt it was significant enough to hand-write a message. Certificates can be designed, centred, and even printed in a 'calligraphic' hand, in a matter of minutes in a design studio or on a desk-top publishing facility on a personal computer. It is because of this that the designed and hand-written calligraphic certificate has that much more value for the recipient as someone thought it important and significant enough to spend some time writing it out.

Having learnt various styles of writing, different techniques and design from this book, it is likely that your skills as a scribe will soon be in demand. You may produce pieces for your own pleasure, writing out favourite poems or quotations to hang on your wall or to give to friends. You may want to learn how to produce a presentable hand so that you can write in the names for certificates – even the whole certificate – for a local society, or for invitations to parties, for a wedding, or special occasions. Whatever you decide to do with calligraphy you will be carrying on the tradition of those early scribes, feeling the same thrill as the pen bites into the paper, appreciating the smell of the wet ink before it dries, and deriving great enjoyment, pleasure and fun from making letters work for you.

Materials and Equipment

To start calligraphy you will need to write with a pen or tool which has a broad-edge nib for most of the alphabets in this book, ink or paint, paper and a sloping board. What you buy will be entirely up to you, but it is possible to start the craft very cheaply indeed with items that you may already have at home.

Chinese calligraphers refer to the tools that they use as the four treasures of the craft – brush, ink, ink stone and paper. Each is selected carefully and taken care of. The treasures of the craft for western calligraphy are similar; perhaps, though, a sloping board may take the place of an ink stone. This chapter makes suggestions as to the best tools and materials for you at your stage in calligraphy, but all tools will last longer and serve you well if looked after properly.

What to write with

All alphabet styles in calligraphy, apart from Copperplate, use a pen or writing implement which has a broad-edge nib or writing tip. It is this broad edge which automatically produces the thicks and thins on the letters without any additional drawing or pen manipulation.

The broad-edge nib tip should be straight across for right-handers, but left-handers may find it more comfortable to use left-oblique nibs or tips, or cut left-oblique nibs when making pens. Without a left-oblique nib the thicks and thins on the letters will be in the opposite places to where they should be. Apart from alphabet styles where the letters are constructed with a pen held at 0°, left-handers holding a straight cut nib so that the pen angle is correct will have to twist their wrist

and fingers round to such an extent that they may even experience pain after just a short writing session. (See page 16.)

It is your choice what pen or writing implement you will use when you start writing. Some are easier to use than others, and some will last longer.

Pencils

Two ordinary pencils held together with elastic bands or strips of masking tape will give the semblance of a broad edge nib.

Right-handers should line up the points of pencils so that they are at the same height; left-handers should arrange the points so that the upper or left point is about 5 mm (0·25 in) lower than the right point.

Carpenter's pencils have a broad rectangular centre, rather than a thin, narrow, round one. They are also available in a variety of hardnesses. Pencils with harder centres, such as 2H, will keep their point and cause less smudging than those with a softer centre, such as a 2B. This graphite centre can be sharpened and shaped so that it gives a good edge for writing.

Right-handers should sharpen the carpenter's pencil on all four supporting sides and then shave the top so that it is flat. This will give a good edge for letters. Left-handers can sharpen the top of the pencil so that it gives a left-oblique shape.

Pencils create a much freer movement; practising flourishes or large letters is easy with pencils and there is less inhibition or tension. In fact, many professional calligraphers loosen up with pencil work, or use them to make roughs of design ideas. Some use them for finished pieces, too.

Tools for making calligraphic letters.

	WHAT IS IT?	HOW TO USE	LEFT-HANDERS	ADVANTAGES	DISADVANTAGES
Two pencils	Two ordinary graphite pencils held together with masking/magic tape or elastic bands.	Use as ordinary pencils, although the bulk of two pencils can be difficult to control for those with small hands.	Left-handers should adjust the pencils so that the left pencil is about 0·5 mm (0·25 inches) lower than the right.	No ink, no mess and very easily available. It is also possible to see exactly where letters start and finish – useful when learning a new alphabet style.	Gaps at the beginnings and endings of strokes. Letters do not look formal or finished.
Carpenter's pencil	Oblong pencil made of varying hardnesses of graphite with a rectangular core. Choose harder (H) rather than softer (B) cores.	Use as a pen, the thicks and thins of letters are made with the edge of the graphite core. Sharpen the pencil so that the top of the 'lead' is flat.	Left-handers should cut a left-oblique shape at the tip.	No ink or mess. Can be bought from D-I-Y stores. Easy to use and can practise lettering without worries of liquid ink.	Need to be sharpened frequently to maintain square edge to tip. Letters do not look formal.
Balsa wood pens	Sheets of balsa wood available from model shops, use sheets at least 2 mm (0·1 in) thick.	Cut a rectangle about 10 cm by 2 cm (4 by 0·75 inches) and then shave a bevel at the narrower end. Finally make a straight cut down to sharpen the tip.	Left-handers should cut a left-oblique nib shape.	Large letters, can be used for posters. Can cut out notches in tip to make interesting letter-shapes Suitable for using with masking fluid or dilute bleach.	Must be cut. Run out of ink within one or two strokes. Do not last long.
Felt tip pen	Calligraphy or Italic felt tip pens available from most high street stationers.	Use as a pen as normally.	Limited for left-handers as few left-oblique pens are available.	Easy to use, no mess nor worries of liquid ink.	Limited range of colours and nib/tip sizes available. Not really suitable for left-handers. Letter-shapes not particularly fine.
Fountain pen	Calligraphy or Italic fountain pens available from many high street stationers.	Use as a pen as normally.	Left-handers should buy left-oblique or left-handed pen sets.	Easy to use with no worries of bottles of liquid ink.	Limited range of ink colour and nib sizes available. Letters sharper than with a felt tip pen but not always very crisp. Nib not always very responsive.

Tools for making calligraphic letters.

WHAT IS IT?	HOW TO USE	LEFT-HANDERS	ADVANTAGES	DISADVANTAGES	
Pen with a broad-edge tip made from two pieces of metal. Available in different tip widths and with a variety of patterns to create different strokes.	Use as a pen, filling the space between the two pieces of metal with ink or paint using a brush. (Push a small piece of sponge here to act as a reservoir.)	No left-oblique tips for left-handers.	Wide pens available and the variety of patterns to the tips creates interesting letter-forms. Creates large letters. Quite sharp letter-forms. Cheaper than coit pens.	Not available in very small sizes. Cannot write many letters without the pen running out of ink.	**Automatic pen**
Pen with a broad-edge tip made from a piece of folded metal with a central wavy core of metal which acts as a reservoir.	Use as a pen, filling the space between the fold with ink or paint using a brush.	No left-oblique tips for left-handers.	Wide pens available and the variety of patterns to the tips creates interesting letter-forms. Creates large letters. Quite sharp letter-forms.	Not available in very small sizes. Cannot write many letters without the pen running out of ink. More expensive than automatic pens.	**Coit pen**
Pen holder with a range of widths of different size nibs. Reservoir attached to the nib, penholder, or slides or clips on nib.	Assemble the pen by pushing a nib into the pen holder. Attach or adjust the reservoir if necessary.	Left-handers may prefer to choose left-oblique nibs.	Very large range of letter sizes can be written with any ink or paint colour. Nibs can be sharpened to create very crisp letter-forms.	Can only be bought at specialist suppliers. Messy, and liquid ink can be a problem. Can take some time to get used to.	**Calligraphy dip pen**
Length of reed or bamboo (bamboo cane from garden centres) with nib shape cut at one end.	Use as a pen as normally although bamboo/reed pens do take up a lot of ink, and best to use watery ink/paint at first.	Left-handers may prefer to cut left-oblique nibs.	Very cheap and can cut whatever size and shape of nib required. Can make nib tip very flexible for crisp letter-forms and good flourishes.	Must be cut. Soaks up a lot of ink and may take a bit of time to get used to. Liquid ink/paint can be a problem.	**Bamboo/reed pen**
Bird's feather with a nib shape cut at the end of the barrel.	Use as a pen as normally.	Left-handers may prefer to cut left-oblique nibs.	Can be free (from bird sanctuary). Very light and sensitive. Creates beautiful letter-shapes and wonderful flourishes.	Must be cut. Can take some time to get used to how to cure and cut feathers. Can also take some time to get used to writing with them. Liquid ink/paint can be a problem.	**Quill**

If left-handers hold a straight cut nib in a 'mirror image' way to right-handers the thicks and thins on the letters will be in opposite places.

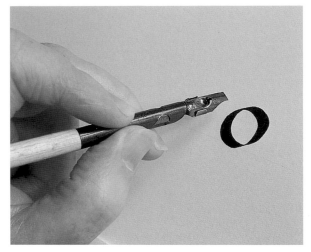

Left-handers may find it more comfortable to use left-oblique nibs. These help to avoid strain on the wrist.

Left-handers can either hold a pen with a left-oblique nib so that it maintains the appropriate nib angle against a horizontal line.
Or they may choose to set up their board with the paper and guard sheet at an angle (see page 31).

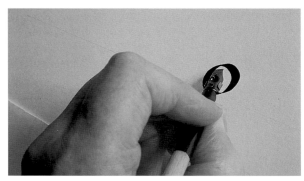

Left-handers may find it better to hold their pens so that the nib is farther away than with a conventional right-hander's grip. This will allow them to see the tip of the nib and also not smudge the letters.

Letters written with two pencils taped together will be large. This is an advantage when starting to write as it is easier to see where the individual strokes start and finish, and learn from any mistakes.

Felt or fibre tip pens

These pens are perhaps the cheapest and most easily obtainable calligraphy pens available from high-street stationers and similar stores. They are also very easy to use, and ideal for sketching out designs. There is no need for bottles of ink and the letters dry almost immediately.

Unfortunately they are usually only available as straight cut pens. Left-handers can use these pens, but will have to twist their wrist to the left, or position the paper at an angle which may not always be the most comfortable.

It may also not be very obvious at the start, but the letters made with calligraphy felt or fibre pens are not particularly sharp and crisp. Sharp letters depend on a thin and flexible nib tip. The thins on the letters with these pens are never very thin, and the edges are not smooth. At some point you may want to progress on to a calligraphy dip pen, but these pens are useful as an introduction or for practice.

Calligraphy fountain pens

Calligraphy fountain pens are a little more expensive than felt or fibre pens. They are often sold in sets with varying nib sizes which are easily changed. Most use ink cartridges which means that there are no problems of spilt ink from ink bottles. You can usually obtain sets for left-handers with left-oblique nibs, too.

Letters made with calligraphy fountain pens are usually sharper and crisper than those with felt pens, and these pens may serve most of your needs for some time. However, there are drawbacks. Again the range of nib sizes is limited, and often the largest nib available is smaller than is best for starting calligraphy. And there is the limited range of colours, usually only red, blue, green and black cartridges being available.

Ink needs to be watery for fountain pens to flow through the pen and not clog it up, but the watery nature means that the resulting letters are not opaque, and so may not always give the look you want. The nature of the pen, where the ink has to be fed through to the nib, means that the nib itself is quite rigid. If it is pliable and springy, it will move away from the feeding arrangement, which means the pen will stop writing. This stiffness of the nib does not always give good letters. However, you can improve the crispness of letters by sharpening the nib. Instructions for this are on page 19.

Calligraphy dip pens

Calligraphy dip pens are usually sold in sets of nibs with a pen holder and a separate reservoir, if not incorporated on the pen holder or on the nib itself. Nibs are available as straight cut, for right-handers, while left-oblique are recommended for left-handers. You will also need some ink or paint and a small cheap brush (see page 27 for ink). The pens have to be assembled before you can write.

If the reservoir is already attached to the pen holder then the nib is simply pushed into position, so that the reservoir is about 2 mm (0·1 in) from the writing tip of the nib.

'Slip on' reservoirs

Some pens have a separate 'slip on' reservoir. Here the nib should be pushed into the pen holder first, and then the reservoir slid on underneath the nib so that it is about 2 mm (0·1 in) from the end of the nib. Problems in writing sometimes occur because of the reservoir.

To do its job properly and feed the ink into the pen it must actually touch the nib and be fitting securely. Hold the pen up to the light and turn it in your hand. Check that the v-shape point of the reservoir is touching the nib. If it is not, take the reservoir off the pen, bend it a little more and slide on again.

If the reservoir is too tight then it may push the two halves of the nib so that they separate, leading to letters with a line down the middle of the stroke; or the two halves may overlap, making writing impossible. Again hold the pen up to the light. Check that the two halves are together and not split, nor that they are overlapping. In either instance take the reservoir off and ease the v-shape point by bending it back if the nib is split, or bend the side hinges outwards a little if the nib overlaps. Replace the reservoir and check again.

All this may seem a great deal of effort at first before you can even start writing, but it is surprising how quickly you will become used to the feel of sliding the reservoir on under the nib. You will then know automatically if it is too tight or too loose.

If it is causing you great problems, then you can always abandon the reservoir altogether and cut a little strip of masking tape, about 2 mm (0·1 in) wide, to wrap around the nib and act as a reservoir. Personally I find this more trouble than getting the reservoir to fit, but do try it if all else fails.

Getting the pen to write

At the start a pen may not write easily because of the layer of shellac which is used to protect the nib by the manufacturers. This can be removed most easily by running the nib under warm water until the shellac has been washed off. Nibs bought recently do not seem to have so much of this problem.

Sometimes the problem with not writing is because the ink has dried on the nib before you even put pen to paper and so blocks the flow. This is especially true with beginners who may take time to start the first stroke.

Some pressure is also needed to make the pen start. We are so used to pens such as ball points or fibre tips which write as soon as they touch the paper that we are now unprepared for pens which need a little help and encouragement to start writing.

Put the nib on the paper and go back and forwards a few times making the narrowest of strokes. When the ink is flowing, then make the thicker strokes.

Some larger nibs will only write one or two strokes when charged with ink. If the pen does not write it may be because there is simply not enough ink in it. You will be able to write more words with narrower nibs, and even a line or two with the narrowest.

For the pen to work well it is important to keep the nib clean from dried or stale ink, so check that there is none blocking the nib. Slide the brush feeding your pen through between the nib and reservoir to clear any blockage. You may need to dilute the ink or paint you are using to make it a little more watery. If it is too thick the ink will not flow properly.

To dip or not to dip

Pictures of scribes in mediæval manuscripts clearly show that quill pens were dipped in to containers of ink. Although they are often called 'dip pens', it is usually best not to dip the nib in the ink. If you do dip there is usually a blob of ink on the top of the nib which either falls straight on to the paper and creates a blot, or flows quickly through the pen and makes the first few letters much heavier and less crisp than the rest.

It is better to use a cheap paint brush to feed the ink into the pen. Dip the brush into a jar of ink, and stroke it gently either underneath the nib or on the sides of the reservoir. The holes in the reservoir will allow the ink to flow through. If you must dip, then have to hand a piece of cloth as a nib wiper, and always remove the ink from the top of the pen by first wiping it on the edge of the bottle of ink and then on the cloth wiper.

It is wise to have the ink pot in another shallow container so that any spills do not ruin good work, paper, or the work top. Polystyrene food trays from a supermarket are ideal for this. Once rinsed clean they will last a long time, and if ink is spilled they are cheap and easy to replace. Cut a couple of notches in the side with a sharp knife to take your brush and other pens you may be using. You could also, for added

Slide the slip-on reservoir under the nib so that the v-shape is about 2 mm (0·1 in) from the tip of the nib. Adjust it so that it slides on easily but is not so tightly that it distorts the nib.

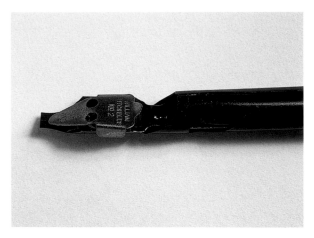

Feed the ink into the underneath or sides of the reservoir with a cheap paintbrush.

Make narrow strokes with the nib until the ink is flowing well, then make the thicker strokes.

Care of equipment

Metal nibs and reservoirs will last you years if looked after properly. At the end of each writing session remove the nib from the penholder and the reservoir from the nib and wash them, but be sure to put the plug in the sink before you start as nibs and reservoirs are both small and will disappear down the drain or waste as easily as can be! Rinse nibs and reservoirs in water, using an old toothbrush to scrub away any dried ink. Wipe dry on an old cloth or paper kitchen towel. When they are completely dry, nibs, reservoirs and pen holders can be reassembled. Do note that the iron content in the nibs and some pen holders will rust if stored when damp, and once one has rusted on to the other you will need a set of stout pliers to separate them. You can, of course, store nibs and reservoirs in a small box and assemble the pen whenever you write.

Sharpening nibs

Most metal nibs, including those on fountain pens but excluding Copperplate nibs, can be sharpened, and you will be surprised what a difference is made to your letter-forms when you write with a sharp nib. Even new nibs are often improved by sharpening, as the nib reacts so much better with paper when it is sharp, and there is a 'tooth' or bite between the pen and paper.

By sharpening the nib you are making the metal of the very tip of the nib slightly thinner. The part which is in contact with the paper is finer and has more spring therefore.

You will need a sharpening stone of some sort. The finer the sharpening surface the sharper the nib will be. An off-white Arkansas stone is the best, and these are available from some jewellery suppliers and can sometimes be ordered from pen and graphic suppliers. They are also used by metal and wood workers to sharpen their tools, so try these shops, too. The smoother side of a knife sharpening stone, such as an India stone, can also be used, but it will not give such sharp nibs. Similarly the finest abrasive paper will also sharpen nibs.

With all these stones and sandpaper no water, and certainly no oil is required for sharpening nibs, simply the stone itself.

Once you have written with a really sharp nib then a sharpening stone will be an item of equipment which you will not be able to do without!

Wide pens and poster pens

For writing big letters, which is the best way to start calligraphy, you may choose to use much wider pens. Automatic, Coit or poster pens all have wide nibs.

security, use a sharp knife to cut out a section of the polystyrene from the base and fit your ink pot into this.

It is a matter of preference whether you have your ink pot to the left or right side of your work board. Probably most scribes, right- and left-handers, have the ink to their left. You want to avoid taking a full pen of ink right over your clean work, and as more pieces start with the lines aligned left, having ink to the left side will avoid splashes.

Automatic pens

These are available from some art shops and specialist suppliers in a wide range of widths from about 2 mm to 2 cm (0·1–0·8 in). Some have part of the nib cut away so that the letters have two, three or even five strokes when writing.

There are two sides to automatic pens. Hold the pen so that the top has the little slits showing when writing – the pen will then work better and more evenly.

Ink or paint is fed into the pen from the side. You can increase the number of letters which can be written, as well as control the flow, by cutting a small triangular section of sponge which fits into the reservoir section of the pen. The sponge will absorb more ink and also check the rate at which it is used.

Coit pens

Similar to automatic pens are coit pens, the difference being that these pens are manufactured with a central curved piece of brass which acts as a reservoir. More letters can be written with one fill of the pen because of this. They, too, have pens with a variety of widths and writing tips, although you do not have to be so careful about which way up to use coit pens.

Both coit and automatic pens are easy to use and produce flowing letters. Use ink or gouache with them, rather than permanent ink which contains shellac and so could clog the pen.

When you have finished, wash these pens in water using an old toothbrush to remove any stubborn ink or paint. Dry the pens on an old cloth or paper kitchen towel before you put them away; although the brass and nickel silver of the pens will not rust, any deposit from tap water may dry on the pen and block the very narrow slits through which the ink flows.

Poster pens

Poster pens have special nibs which are manufactured to flow over textured papers. The nibs are also large and so produce big letters suitable for notices and posters. They are used in a similar way to calligraphy dip pens, and should be washed, using an old toothbrush, and dried carefully after use.

Balsa wood pens

Balsa wood is a lightweight wood often used for making models. Rectangular sheets of it can be cut to make your own pens, in fact, one sheet will make a great many pens!

Cut a rectangle about 10 cm by 2 cm (4 in by 0·8 in) from

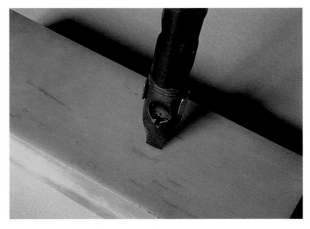

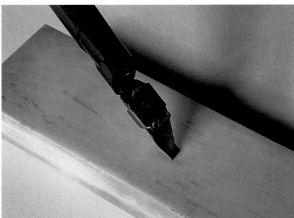

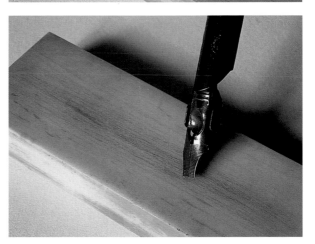

Sharpening nibs. Nibs are sharpened from the top so that the very tip is made a little thinner, resulting in a springier nib and thus sharper and crisper letterforms.

1 Straighten the nib tip first by holding the nib (in the pen holder for ease) vertically and stroke the edge of the nib about 5–6 times along the sharpening stone.

2 Turn the nib so that the top is against the sharpening stone, and, at an angle of about 45° for wide nibs, and 30° for narrower nibs, stroke the nib about 8–9 times.

3 Now remove any metal burs from the sides and back of the nib by stroking these twice against the stone.

Try the nib. If it is too sharp, dull the nib by repeating stage 1.

balsa wood using a metal edge and sharp knife. There is a pronounced grain to the wood, and you will find it easier to cut the length of the pen along this grain. Right-handers should cut a straight edge and left-handers a left-oblique shape. About 1 cm (0·4 in) from one of the shorter ends

19

shave a slight bevel, using the sharp knife. Then cut straight down to sharpen the edge.

Balsa wood pens are used by dipping the pen into ink or a palette of paint. Cut out v-shapes and notches out for interesting letters. The ink does fade towards the end of the stroke but this makes for different letter-forms.

Large felt pens

These pens are easy to make. Cut a piece of balsa wood the width of the letters you wish to make, and about 3 cm (1·2 in) in length. Now cut a piece of felt which is the same width, and about twice the length and wrap this tightly round the balsa wood. It needs to fit snugly particularly at the writing end. Hold the felt in place by pushing this into a bulldog or similar spring clip. You can hold the felt and balsa wood together by paper clips at each end, or even elastic bands, but both tend to get in the way of the writing surface. Also tight elastic bands may snap a wide piece of balsa in half.

The felt around the balsa holds the ink longer and so the distribution of ink in the strokes is more even. In addition, these wide strokes are textured, and beautiful effects can be achieved by dipping each side of the pen in different colours.

Because you will use your whole arm movement to write large letters, the letter-form is often better when using these larger pens. If you feel yourself getting tight or tense when you are writing with a calligraphy dip pen then a session with large pens and big sheets of paper, perhaps writing standing up, too, will help to release some of the tension.

Bamboo and reed pens

In historical times all scribes had to cut their own pens, or had an apprentice cut them. The advantage was that the exact shape of nib and feel of the pen could be devised, rather than having to put up with a manufactured standard. Nowadays cutting your own pen may seem like too much trouble to some, yet bamboo or reed pens and quills are the best pens of all to use. Quills are light – feather weight – and flexible enough for all sorts of letter-forms. A well-cut bamboo pen has a spring to it which even a finely sharpened nib cannot achieve.

Cutting these pens often has an air of hidden mystique about it which is a pity as they are such a delight to use. If you find metal nibs a problem, then make your own pens.

Cutting bamboo and reed pens

Bamboo is probably easier to get hold of than reed, although any hollow or tubular stem which is reasonably firm but flexible can be used. Bamboo canes from a garden or a garden centre are equally suitable. Some stems are too thin, but any

stem which is more than about a centimetre (0·4 in) in diameter could be used when dried.

You need a short length for one pen, about 20 cm (8 in) long. Pick up the reed and bamboo and choose the canes which are the heaviest. These have more moisture and so are easier to cut. Cut or saw the bamboo into 20 cm (8 in) lengths so that the intended writing end is away from the notch in the stem.

Using a heavy-duty craft knife, as bamboo is quite tough to cut, make a long scoop cut to about half way through the stem along one side of the cane at the end. This is the underside of your nib. With the point of the knife scrape out the pith.

Now shape the sides of the nib. Make a cut from the side towards the centre, shallow and upwards. Place the knife where you started that cut and rotate the cane slightly clockwise so that it is on the other side of the first cut. Repeat that shallow and upwards cut so that the shape is symmetrical. You can now see the nib shape forming as you cut.

Place the cane on a cutting mat or similar surface so that the underneath of the nib is showing. The nib must have a central slit so that the ink can flow through the pen on to the paper. Position the knife so that it can make this central slit and press down firmly. The slit needs to be about 1–1·5 cm (0·5–0·7 in).

Now finish the writing end of the pen. Do this by cutting a bevel at the end of the nib you have just cut. Hold the pen firmly and with the knife at an angle of about 30°, and pull the bamboo pen back towards you; this will make a bevel cut. The tip may be a little ragged and uneven at this point. To give a good, sharp writing edge, cut straight down, trimming off about 1 mm (0·05 in), or at the most 2 mm (0·1 in). You do not want to lose the spring of the nib by making it too thick at this point. This is the last 'nib' cut.

Bamboo and reed pens may take a little while to write because they soak up so much ink or paint initially. Use a watery medium to start and make a few letters before you write a best piece. Each time you use the pen it may take more ink than you think to start writing.

Quills

Feathers have been used for writing throughout the centuries. This is not surprising. Writing with a pen which is feather weight, which can be pushed and pulled in all sorts of directions, and which can become almost an extension of your arm and hand is a rare delight. Sadly many have the feeling that cutting and using quills is difficult. This is not the case, it is simply a technique which can be easily learned. However to ensure that all the stages of curing and cutting quills are understood it is explained here in some detail.

The feathers you need are from the first five flight feathers of the bird. Other feathers have too short a barrel for it to

be worth bothering to cut a quill. The first flight feather is called the pinion. You will recognise this because on one side of the feather, the windward side, the barbs are very short having been 'trimmed' by the wind. Pinion feathers have strong but short barrels. The second and third flight feathers are called seconds. Here the barbs along one side are wavy, wider where they have been protected by the pinion feather, but narrower where there has been no protection. Seconds have longer and quite strong barrels. These are the preferred feathers, although I like pinions as well. Fourth and fifth flight feathers are called thirds. The barbs on the flight side are even having been protected by the pinions and firsts. Thirds have long but narrower barrels.

Three main types of birds provide us with feathers for quills. Goose feathers tend to have the smallest and narrowest barrels of the three, although Canada geese can produce feathers with barrels which are almost as long as swans' feathers. Swans' feathers provide long and strong barrels and are the ones usually preferred. Turkey feathers, not available of course to early scribes until the New World was 'discovered', have short but strong barrels. The feathers of all sorts of birds, though, can be used for quills. Crow feathers produce very fine quills, and the name has survived for fine writing and drawing pens. Peacock, magpie, buzzard and many other birds produce feathers which can be cut to a pen shape and used as quills.

Feathers curve round the body of the bird, and this means that feathers from the right and left wings are slightly different. Those from the right wing curve to the left and are suitable for left-handers because they curve away from the body of the writer. Those from the left wing curve to the right and right-handers will find these best to use. If you choose a feather from the wrong side for you it will curve into the body and may get in the way; however some feathers have such a slight curve that it hardly matters, and anyway as you trim the feather until it is of a pen length this curve becomes less important.

Feathers for curing and cutting can be bought from specialist suppliers along with ready-cut quills. They can also be picked up from any lake, bird sanctuary or other stretch of water where water birds live or settle. During the moulting season the feathers are dropped by the birds and can easily be collected at no cost – they do not need to be pulled out of the bird's wing. Some butchers will also arrange to supply the wings of geese and turkeys at appropriate festive occasions if asked, from which the best feathers can be extracted.

Curing quills

Over the years feathers gradually dry out and harden, so that the barrel of the feather changes from being rather soft and able to be pressed easily with the fingers, to a much harder

Chinese goose, Canada goose and swan wing feathers suitable for quills.

Pinions, seconds and thirds.

Feathers for right- and left-handers.

and more robust material. To use feathers for writing more quickly than this then they must be cured, that is, heat applied to them. This can be done in three ways; with hot sand, which is traditional; with a microwave, which is definitely not traditional; or with a Dutching tool.

Preparing feathers for curing
Feathers should be trimmed with a sharp knife or scissors so that they are about as long as a normal pen – 20 cm (8 in). Remove also the longer barbs attached to the feather. Most can be simply pulled off, but use scissors to cut them near to the barrel so as not to weaken it by pulling off some of the membrane.

Now cut off the rounded tip of the barrel and remove the soft pliable membrane from inside. It is easiest to do this

Cutting bamboo or reed pens.
Saw the bamboo into pen lengths of about 20 cm (8 in). Select the end away from the notch.

1 *With a sturdy and sharp craft knife make a long scoop cut which starts about 3 cm (1·2 in) from the end and goes about half way through the bamboo cane. Scoop out the inner pith.*

2 *On the right side of this scoop make another cut about 1·5 cm (0·5 in) from the tip.*
Rest the knife at the point where this cut started, rotate the pen clockwise and make a similar cut on the left hand side. This shapes the shoulders of the nib.

3 *With the top of the pen on a cutting mat, place the blade of the knife in the centre of the pen tip and press down to make a slit about 1–1·5 cm (0·5 in) long.*

4 *Trim the end so it is straight.*

5 *Turn the pen over and hold it at an angle of about 30°, place the knife blade on top and pull the pen upwards so making a bevel cut.*

6 *The last 'nib' cut is made by rocking the knife to take the very tip from the nib.*

**Left-handers may find it best to cut a left-oblique nib.*

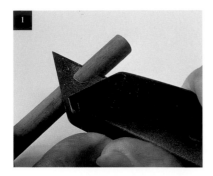
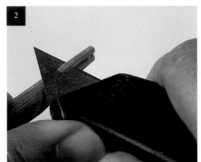
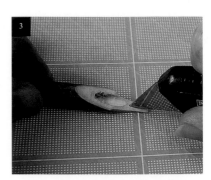
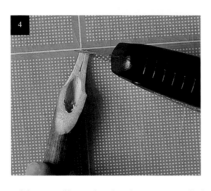
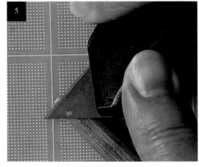
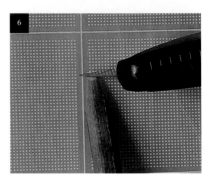

with a small crochet hook or narrow knitting needle. Scrape the waxy material from the barrel with your thumb-nail or the back of a knife.

The feather is almost ready to be cured, but should now be soaked for a few hours, overnight if you can, in a jar of water which easily covers the barrel.

The traditional way of curing feathers is to use hot sand. This is rather a capricious method as sand is such a poor conductor of heat, and you cannot see what you are doing either. However, if you are not able to make a Dutching tool and do not have access to a microwave, then sand may be the only alternative. (Once you have cured feathers with a Dutching tool, though, you will rarely revert to using hot sand or other methods!)

Curing quills with sand

To cure feathers in this way you will need some silver or white sand.

Place the sand in a medium sized heat-proof bowl, a deep pie dish is probably about the right size, as the sand should be about 4–5 cm (2 in) deep. The sand must be thoroughly heated for 20–25 minutes in a hot oven set at Gas Regulo 5, 180°C or 350°F. In an Aga oven or similar oven, heat the sand for about 20 minutes in the hot oven and experiment.

While the sand is heating remove the feathers from the water and shake them well so that there is no water inside. Dry the outside of the barrel on a clean paper kitchen towel.

Press one of the barrels between your finger and thumb

and you will notice how soft and flexible the feather is. This is no use as a quill because every time you write the nib of the pen will bend and splay outwards with any pressure. Heating the feathers will change this soft, opaque barrel into a clear, slightly yellow, hard tube which can be cut into a pen.

It is difficult to prescribe the exact time it takes to cure quills using the hot sand method. It depends on the heat on the sand and the thickness of the individual feathers, so must be essentially a matter of trial and error. It is a good idea to use a test feather to determine the length of time for curing.

Use a teaspoon to scoop some of the sand into the barrel of one feather and immediately plunge it into the hot sand so that all the barrel is covered with sand. Count up to ten. If the sand is too hot the barrel will blister and bubble, and be very brittle; allow the sand to cool a little before you try again with a test feather. If the time is too short the barrel will still be opaque and slightly pliable – squeeze it together with your fingers to check. If conditions are right, the white, opaque barrel will be clear and hard, even slightly yellow, and really quite difficult to squeeze.

When the temperature is right and the time determined you can cure five or six feathers at once. Hold them in one hand with the barrels close together. Spoon in the sand, plunge into the dish and count the required number of seconds. These feathers are now ready to be cut into quills.

Curing feathers with a microwave

Microwaves provide a source of heat which can be used to

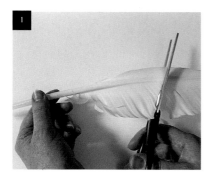

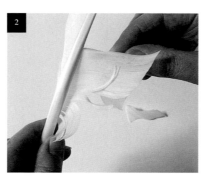

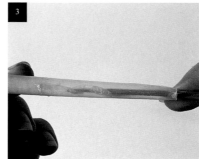

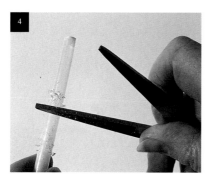

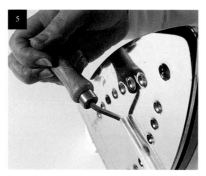

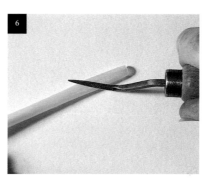

Preparing feathers for quills using a Dutching tool.

1 *Cut the end from the feather so that it is pen length – 20 cm (8 in).*

2 *Remove the barbs from the shaft, but take care near the barrel – these are best cut with scissors so that the barrel wall is not weakened by tearing the membrane.*

3 *Snip off the rounded tip of the feather with scissors and remove the inner membrane with a crochet hook.*

4 *Scrape the outer membrane with your thumbnail or the back of a blade. Let the barrels soak in water for a few hours.*

5 *Heat a Dutching tool on a domestic iron and place it inside the barrel of the quill, using it to keep the barrel – which is rotated – against the iron until it turns from opaque white to almost a translucent yellow.*

6 *Place the feather on a flat surface, check that the feather is the right way up and press the Dutching tool down on the barrel to make it oval so that you can cut wider nibs.*

cure quills. The power of the microwave, and the thickness of the feather are both variables. After the feather has been prepared and soaked, make sure that the rounded tip has been cut off (otherwise the feather may explode in the microwave!). Place the feather in the microwave and turn the microwave on at full power for 10-second blasts until the feather has been cured, changing from milky white opaque to almost clear and slightly yellow.

Curing feathers with a Dutching tool
A Dutching tool leaves the hit and miss element of hot sand and a microwave behind. Each feather is cured separately and it is possible to cut quills with very wide nibs when they have been cured in this way. It is very much the preferred method, but unfortunately no manufacturer has yet produced these tools, and they have to be made from a brass cup hook and a wooden handle.

MAKING A DUTCHING TOOL Use a metal cup hook where the hook itself has a diameter of between 2–3 cm (1 in). Straighten it out gently with a hammer and pliers. File the end to make a dull point.

Screw it into a wooden handle for ease of handling. You will heat the Dutching tool and if there is nothing to protect your hand from the metal it will cause burns and blisters.

USING A DUTCHING TOOL The feathers should be prepared as before and soaked in water. Remove a bunch from the water

and shake out any moisture. Wipe away water on the outside.

Heat a domestic iron for a few minutes on 'one dot' setting – for silk, synthetics and wool. Place the metal of the Dutching tool against the iron's hotplate and allow it to become hot. Keeping it on the iron, pick up a prepared feather in the other hand, and hold this against the hotplate. Place the Dutching tool inside the barrel of the feather and at the same time rotate the feather slowly using the Dutching tool to press the barrel against the iron. Do not keep it in one place for long as the feather may overheat and blister.

Gradually the opaque white of the barrel will change into a transparent pale yellow colour, and you will know that the feather is cured. Check the feather to make sure that it curves in the right direction and that the top is uppermost. While the feather is still warm and pliable, place the barrel on a flat surface, and press it together with the flat part of the Dutching tool. This creates an oval shape which means that you can cut wider nibs on these quills. The feather is now cured and you can cure as many prepared feathers as you wish in turn.

Cutting quills

Quills are cut in a similar way to bamboo pens. There is no separate nib, this is cut from the end of the barrel.

You will need a sharp knife with a curved blade to cut feathers effectively. Some scribes prefer a straight edged knife but I find that this causes problems of its own. Penknives,

Cutting quills.

1 *Make a long scoop cut about 3 cm (1 in) from the tip which goes about half way through the barrel.*

2 *Shape the shoulders by making another scoop cut on the right hand side about 1·5 cm (0·5 in) from the end. Place the knife blade where this cut started, rotate the quill clockwise and make a similar cut on the left-hand side.*

3 *Put the top of the quill on a cutting surface and place the knife blade in the centre of the nib, pressing it down to make a slit about 1 cm (0·3 in) long.*

4 *Trim the end of the quill by cutting about 2 mm (0·1 in) from the tip.*

5 *Hold the quill at an angle of about 30°, place the knife blade on the tip and pull the quill backwards and upwards to make a bevel cut.*

6 *The last 'nib' cut is made by rocking the curved blade on the tip of the nib until it clicks.*

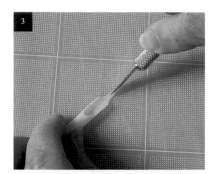
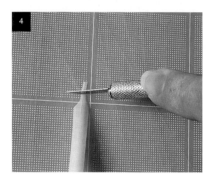
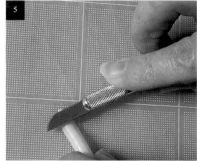
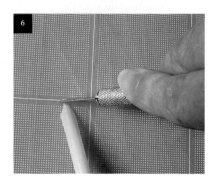

used first to cut pens, usually have a blade with a curved edge for ease of trimming the quills. You can use an 'ordinary' penknife, but do sharpen the blade on a stone first – cured feathers are quite tough. New penknives have blades made of stainless steel, and it is difficult with this metal to get a really sharp edge to the blade suitable for quill cutting. For students and beginners I have found sturdy craft knives with disposable curved blades perfectly satisfactory for cutting quills, and, apart from my favourite quill knife, I often use these myself.

I would also recommend cutting the quill so that the blade of the knife goes away from you. I have seen quills cut with the feather cradled in one hand, and the knife being pulled towards the thumb. This position does seem fraught with dangers, and it would be well to have a first aid box nearby if you are not used to this! The illustrations of cutting quills above show the blade of the knife going away from the fingers and the body. Admittedly there is slightly less control, but you should finish cutting your quill with the full complement of fingers and thumbs!

Hold the quill in one hand and the knife in the other. Make sure that the quill is top side up and that it curves in the best way for your body. Now turn it over and, and about 2–2·5 cm (1 in) from the tip, make a long scoop cut, going through about half the width of the barrel to the end. This is the underneath of the nib.

Turn the feather over to shape the shoulders of the nib. Place the knife about 1–1·5 cm (0·5 in) from the tip, and make a shallow cut on either side. To ensure that it is symmetrical, replace the knife at the point where you made the first cut and gently rotate the feather so that the knife is then the same distance away from the tip for the second cut.

A traditional pen or nib without a split will not write properly, as the ink will not flow down to the tip of the nib. To make a split put the tip of the feather on to a cutting mat or similar surface, and place just the point of the knife at the centre of what will be the nib and where you want the split to end. Press down firmly until the blade goes through the barrel.

If the final nib is to be wide, then you may choose to cut additional slits either side of this central slit to improve the ink flow.

To cut the tip of the nib, replace it on the cutting mat top side uppermost. Place the knife blade at an angle of 30° or less, and pull the feather backwards and upwards towards you. This will shave a slight bevel to the tip of the nib which makes the very tip finer and springier, so producing crisper letterforms. Now cut the end off the nib either as a straight cut, for right-handers, or a left-oblique, for left-handers. Gently rock the blade to cut the end cleanly. You will need to apply some pressure if the feather is thick. You will hear a decided 'click' as the knife trims off the tiny amount of quill in this last 'nib' cut.

Sometimes these thick feathers work best if a little is shaved from the underside of the nib, too. Turn the nib over, and, with some precision so that you do not spoil your carefully cut nib, take off a little from the outer sides of either side of the nib.

Check the end of the nib with a magnifying glass. It should

look smooth and carefully cut. Gently run your fingernail along the edge, it should feel clean with no rough edges.

Now try it! Quills are very light to use, and are very good indeed for flourishes and any letters which need a degree of style in execution. However, they also work particularly well when writing uncials, Roman capitals, and every other lettering style. They are very much the preferred writing tool for many scribes.

There will be some feathers which, even when cured, do not work well as quills. They are too soft and do not hold a sharp writing edge, or the ends splay out with the slightest pressure. If you are short of feathers you may wish to try curing it again to see if it improves. It is probably better, though, not to waste your time on this and concentrate on a feather which will produce good letters.

Reservoir for quills. Bend a thin metal strip 2 mm by 4 cm (0·1 by 1·5 in) cut from a soft drinks can into a 'lazy' s-shape, having trimmed the tip to a rounded v-shape. Slide this into the barrel of the quill, with the v-shape about 2 mm (0·1 in) from the end of the nib. Adjust if necessary.

Sharpening a quill

When writing, the quill will gradually blunt, and will need to be resharpened to produce fine sharp letter-forms. If you have cut your quill, sharpening is easy. Using your knife simply take another very thin slice downwards at the end of the nib. At some point you will need to recut the bevel and, if it is a thick nib trim a little from underneath the nib, then take the slice from the end.

When asked how long a quill will last my answer is 'as long as the barrel'! Quills are so economical because you can recut a quill as many times as you wish, until there is no length of barrel left for cutting a nib.

Reservoirs for quills

You can use a narrow nibbed quill without a reservoir. Wider pens often require some help to get the ink to the end of the nib.

Soft metal strips form the best reservoirs, and the cheapest and easiest source for these is a soft drinks can (not the ring pull which is made of less pliable metal). With care, you can cut a piece of this metal with scissors.

Cut a strip which is about 2–3 mm wide and 3–4 cm long (0·1–0·2 in by 1·25–1·5 in). Trim away the corners of one end, or cut it to make a curved v-shape.

Bend the metal to make a curved letter s-shape (a 'lazy' s), with the tightest curve at the opposite end to the trimmed edge.

Slide the curved end into the quill, and push it until the trimmed end is about 2 mm (0·1 in) from the tip of the nib. You may need to adjust the tightness of the spring or the position of the ends. Feed the ink into the quill in the same way as you would a pen.

Restoring quills

Feathers are a natural material which will gradually lose

moisture no matter how well they are stored. The effect of this is that even the best cut quills will gradually separate along the weakest point which is the split. Do not throw quills away if they do this, simply replace the moisture.

It is better to do this gradually. Wet a cotton wool ball or pad of paper kitchen towel and wrap this around the end of the barrel. Wrap this in cling film or polythene and leave for a few hours or overnight. Gradually the material of the barrel will absorb the moisture.

A quicker method is to leave the quills to soak in a jar of warm water for a few hours. Shake out the water before you use them.

Pointed nibs

Calligraphy is not confined only to nibs which have a broad edge, although these are used for most of the lettering styles used in manuscript books and also in this book.

Copperplate nibs

Copperplate writing is a most attractive style to many. It was taught extensively in schools in the UK during the nineteenth century, and forms the basis to the movement and letter-forms of the Palmer method of handwriting taught in the USA. It is a much admired style of handwriting.

To write Copperplate you should use a springy nib which ends in a point. It is the spring in the nib and the pressure when writing downward strokes which creates the thicks and thins of letters. Copperplate is difficult to perfect, but very satisfying to write.

There are many different types of nibs available, although there is no need for a large range of nibs of different sizes. One or two nibs will make from the very smallest to quite

Types of ruling pen.

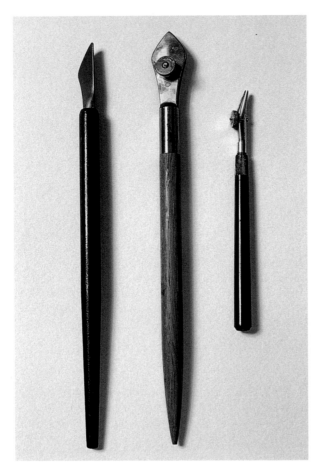

The nib section has a screw device which opens the nib to hold more ink and so creates thicker strokes. Other styles of ruling pens consist of either a piece of folded metal or two wide, diamond shaped pieces of metal, held together with a metal wheel which allows more or less ink/paint to be held in the reservoir and also determines the width of the stroke.

Ruling pens can be held in the conventional position for a pen or so that they are almost vertical so making thin strokes, or held at a much lower angle with the pen section on its side, thus making strokes which are thicker and usually with less precise, rougher edges. You can feed different coloured paints into the pen for an interesting effect.

Brushes

It is likely that the shape of the letters carved in stone on Roman monuments were first made with a broad-edge brush. A brush like this is very responsive to the touch, is easily manipulated, and larger sizes produce wonderful letters for use on posters.

There are more details on the types of brushes and how to select and care for them on page 306.

Other brushes give letters with different textures. An old toothbrush will produce scratchy and rough letters, a stencil brush even rougher letters, and a home decorating brush, because of its stiff bristles, letters which also have rough sides.

Trying out a variety of brushes can be great fun. Use any brush which you have to hand, and experiment with letter-forms. Use watery paint or ink, or a slightly thicker medium. Wipe the brush on a rag or kitchen towel to remove almost all the moisture and write with that. You can achieve many different effects with brushes – some more successful than others!

large letters. It is by simply increasing the pressure in the down strokes that the width of that stroke increases. Writing a large letter requires more pressure to avoid a spindly, weak letter.

Some Copperplate nibs are manufactured with an elbow shape. This is intended to make writing this style easier; some Copperplate writers use them all the time and others find them a hindrance.

For more information on Copperplate, see page 84.

Ruling pens

You will not be able to achieve the exact letter-shapes of a springy Copperplate nib using a ruling pen, but you will enjoy the different letter-forms created.

A ruling pen is used in technical drawing. It can be attached to a set of compasses, replacing the pencil attachment with an ink pen and is usually used to run along a ruler to create straight lines in ink. It consists of a nib section and a holder.

Writing surfaces

Selecting the appropriate papers for calligraphy is not always easy. Sometimes the best looking papers prove to be too greasy or slippery and do not give enough 'tooth' to the pen. On the other hand a most unlikely paper may be the dream writing surface.

To make clean and crisp letters you need a smooth paper. This does not need to have a completely flat surface. There should be a little resistance between the pen and paper; if there is no tooth then the pen skids around with little control.

You may also choose to use animal skin – parchment or vellum – or even papyrus. For more information on all these surfaces, how to choose the most appropriate one and whether they are suitable for calligraphy, see page 291.

Ink and paint

Different inks suit different pens and different purposes. Some inks are too thin and some too thick for easy use in a calligraphy dip pen. Although calligraphers usually refer to ink, a variety of colours and effects can be obtained by using paints. This section looks at the inks and paints which can be used for calligraphy.

Fountain pen ink

Many people choose to use a calligraphy fountain pen in the early stages of learning the craft. It is easier to practise with a pen already assembled, and as the pens normally use cartridges, this saves having to worry about pots of ink and spillage.

The ink for fountain pens is carefully manufactured to flow easily through the pen. It is quite watery so that it does not clog the nib. With the small nibs usually supplied with calligraphy pen sets, this thin nature of the ink does not show; however, when used with thicker nibs, it is quite clear where each stroke of the letters start and end. This may be an advantage to you when learning. It will mean that you will see where to put your pen for the various strokes, and this may be the effect you want for a finished piece. However, many would prefer a more opaque ink which is not darker, and sometimes a little blobby where the strokes join, and lighter elsewhere.

Fountain pen ink is available only in a limited range of colours, too, especially if the pen you have uses only cartridges, and the colours may not be exactly the ones you want.

Liquid calligraphy ink

Ink suitable for calligraphy is runny enough to flow through a pen, but thick enough to give a good coverage. The best way to choose a calligraphy ink is by trying it, but this is rarely possible in a shop. So how do you choose a good ink?

These pointers may help:

1 *Avoid any ink which is waterproof*
Waterproof ink contains shellac which clogs the nib and makes writing difficult as it interrupts the flow. Even though the bottle may have 'calligraphy ink' on it, or be recommended by the shop, do not buy it if it is waterproof.

2 *Hold it up to the light*
You want the ink to have a good dense colour and be opaque on the paper. Ink which you can see through easily will be too watery for a calligraphy dip pen.

3 *Shake the bottle*
This will show you how fluid the ink is. If it moves very

easily around the bottle, it may still be too runny. If it looks thick it may be sticky and again cause problems with the flow. However, if this particular ink has been recommended then it may be worth buying. Ink like this can be diluted with water to a good consistency.

If you have a bottle of ink where the lid has been left off while you are working, or which has been around for a long time, the ink particles may be perfectly all right, but it may simply be too viscous for writing. Again add water to it to dilute it to a suitable consistency. Ink or paint for dip pens should be the consistency of thin, runny cream.

It is always better to decant ink from a larger bottle into a smaller wider-neck jar. First, it will prevent the moisture from evaporating from the main bottle, and so the ink will not become thick so quickly, and secondly, if you do spill the ink or knock over the bottle, less ink will be lost with a smaller jar than if the whole bottle is being used. In addition to this, it is easier to dip a brush into a small wider-necked jar than the larger narrower-necked bottles in which calligraphy ink is usually sold. Suitable wider-necked glass jars are tiny jam or preserve jars.

Japanese and Chinese stick ink

The consistency of ground Chinese or Japanese stick ink is usually ideal for calligraphy, although these are designed to be used with a brush rather than a pen. There are differences between Japanese and Chinese inks, and between inks made from other countries such as Korea. Chinese stick ink is best when it has been allowed to mature over a number of years, whereas Japanese stick ink is best used within ten years of its manufacture.

Black rectangular blocks of ink are available from specialist suppliers, and you will usually need also to buy an ink stone for grinding the ink. An ink stone is most often made from slate or similar fine grained stone, with a central well or slight depression for grinding. Here the stone is not so smooth and has a tooth to it which aids the grinding to make a solution. It is possible to grind stick ink on a ground glass slab, but this not so convenient for using the ink.

Pour a little water into the well or depression, put the ink stick into this water, and push it backwards and forwards steadily over the whole area of well of the ink stone. Gradually the clear water will change to, first, light grey and then to black ink. It may help to count the number of drops of water you added, and time how long you need to grind to produce batches of ink which have the same qualities.

The ink can be used straight from the ink stone, by dipping in a brush to feed it to the nib or the ink can be decanted into a small jar with a wide mouth.

An ink stick will keep in good condition for a long time,

Chinese stick inks.

1 *Vegetable oil ink.*

2 *Pine oil ink.*

3 *Synthetic oil ink.*

not so ground ink in a solution. It will last for a week or so, but will need some sort of preservative added if you want to keep it for longer.

When you have ground the ink, rest the ink stick on a surface so that it can dry and then be put away. If it is allowed to soak in water or ink the stick becomes brittle and crumbly. After use, the ink stone must be scrubbed clean of ink using a stiff brush, such as an old toothbrush. Flakes of ink remaining on the stone will dry and then mix with the new batch of ink, which will then not be as smooth as it should be.

Ink sticks are available in a variety of colours and qualities. I asked a Chinese calligrapher in Beijing what the best ink to use was, and what he would recommend. It seemed that most of the best scribes mix inks to their own preference. Essentially in China it is likely that you get what you pay for; not so in the rest of the world. Here ink sticks vary in quality, and you may be charged a high price for not very special ink.

Chinese inks are made from a variety of smokes which are collected and mixed with gum. The quality of the material from which the smoke is collected determines that of the ink.

The smoke for inks is collected from three different sources. The finest quality is the smoke from vegetable oil – rapeseed, sesame and paulownia oil. The size of the wick affects the quality of the smoke, as a thinner wick will produce smaller soot particles which in turn produces a finer ink, often blue-black in colour. The soot particles are collected on a concave dish or funnel and the ink does not change much with age as it contains so few impurities.

Ink made from pine smoke is the next-finest ink, and the

smoke is usually collected on paper. The soot particles are larger and there are more impurities with this ink.

Lastly, ink can be made from a variety of synthetic sources such as gas and creosote. Here the quality differs according to the source material. Most of the stick inks available in European and US shops are from this source.

The sets of coloured stick inks, which are available from some specialist suppliers, can be a little watery, even when mixed to a thick consistency, and, in my experience, the red is a little too pink to be used as a contrast with black. It is better to use red stick inks which are sold on their own. These are expensive as they are mercuric sulphide – pure vermilion, but the colour is that vibrant orangey-red which is so characteristic of many mediæval paintings and manuscripts. It is also very smooth and good to use for writing and painting.

Chinese and Japanese ink can also be bought as liquid inks, and these are usually good value.

Making your own ink

Scribes always used to make their own ink, and mixed the ingredients to their own particular recipe. Making your own ink is no more tedious than some other processes in calligraphy.

In mediæval times there were two ways of making ink – from carbon black and from oak galls. Crushed charcoal or lamp black is mixed with gum, such as gum arabic, and then diluted with water. The proportions are not set and you will need to experiment to ensure that the liquid flows through the pen, yet adheres to the paper.

Oak galls are the hard spherical remains produced on an oak tree as a result of the gall wasp laying its egg in the growing bud or soft part of a twig. They look like brown marbles, and are most obvious in winter. There are different kinds of oak gall, some soft – oak apples – and some suspended from the leaves like cherries, but it is the hard brown type which are used for ink. (See illustration opposite.)

Collect enough to weigh about 80 gm (3 ounces). Wrap the oak galls in newspaper and smash them into chunks with a hammer. This is best done outside. Cover them with about 500 ml (1 imperial pint) of rain water, and leave the jar on the kitchen window sill, or somewhere in the sun for one to two days.

The pale brown solution is turned to black ink by the addition of copperas or ferrous sulphate (green vitriol). Add 50 gm (2 ounces) of copperas which has been finely crushed. Some old recipes say that the solution should be stirred frequently with a fig stick. This is reputed to have preservative properties and any of the sticky gum which seeps out from the twig will help the ink adhere to paper or vellum. However in practice the use of a fig stick or other specific stirrer does not seem to make much difference. Leave this solution for one or two days again.

Copperas is obtained from specialist suppliers, or from a pharmacy or chemist. It is also used by furniture makers to produce dyes for wood. It will probably have to be specially ordered. The alternative is to make your own. Some iron nails in a jar covered with rain water from an area where there is a lot of air pollution, so the rain water is dilute sulphuric acid, should then produce ferrous sulphate, but the degree of pollution and conditions do vary.

Grind up 25 gm (1 ounce) of gum arabic crystals to make a powder, and add this to the black liquid. This will not only thicken it, but also make it stick to the paper. Again leave the solution for a day in the sun.

Strain the resulting mix through a piece of fine muslin, or a fine mesh nylon tea strainer, into a clean jar with a secure screw top. It will form a sediment after a while, and should be strained again.

The ink increases its depth of colour when exposed to the air. Its permanence is proved by the vibrancy of letters in many mediæval manuscripts.

A preservative such as phenol can be added to prevent the growth of mould.

In the Public Record Office in London is a fifteenth century hand-written recipe for ink made from galls and copperas:

To make hynke take galles
*and coporas or vitrial (*quod idem est*)*
and gumme, of everyche a quartryn
other helf quatryn and a halfe
quatryn of galles more and
breke the galles a ij other a iij
and put hani togedere every-
che on in a pot and stere hyt
often and wythinne
ij wykys after ze mow
wryte therwyth
Yf ze have a quatryn of
everyeche take a quarte of
watyr yf halfe a quatryn of
everyeche than take half
a quarte of watyr

Paint

Paint, the colour straight from the tube with water or two or three colours mixed, will give you a variety of hues, shades and tones which will cover almost every possibility you will need. Paint extends the colour range of inks considerably, and is no more difficult to use than ink.

Most scribes use gouache. It is similar to watercolour but with a chalk or artificial *blanc fixe* base making it opaque rather than translucent. It is available from all good art

Oak galls for making oak gall ink.

shops in tubes which are about 7 cm (2·5 in) long, larger than tubes of watercolour. The range of colours is extensive, and tubes are marked, usually by letter, number or a range of stars according to their degrees of permanence.

Not all tubes of gouache are suitable. Those where the pigment has been ground until it is very fine are the best. Some paints are very grainy, the pigment is almost in granules when it is mixed with water, and this gives an uneven flow through the pen. It is difficult to be specific about recommending paints as they vary with different brands, and you should ask colleagues what range of paints have been successful for them before you buy a new colour.

See pages 308–311 for a list of most of the colours available as paints and how well they work with a pen.

A sloping board

It is so much more comfortable to write at a slope than on a flat surface. The change in almost all our schools from desks made of wood which had a writing slope, to flat tables with a hard unsympathetic surface, has not helped the handwriting nor the posture of our children. Pictures of monks and nuns writing the many pages of mediæval books show them at a sloping board, sometimes supported at a very steep angle.

This slope also controls the flow of ink from the pen. When writing with a dip pen on a flat surface the ink falls out of the pen easily, and very often the letters will flood. At a slope of about 45° the ink is only released from the pen when there is pressure on the nib, as the scribe starts to write.

Because we are not used to it writing at a slope may seem strange at first, but it is worth persevering to overcome any initial difficulties. The lack of aches and pains in your back

Ensure that your board is at a slope. Most scribes find an angle of 45° means that the ink is controlled in the pen and it is comfortable to write. If the ink is flowing too quickly through the pen, raising your board to a steeper angle will aid control. Conversely, if the ink is not flowing well, lowering the board to a flatter slope may help.

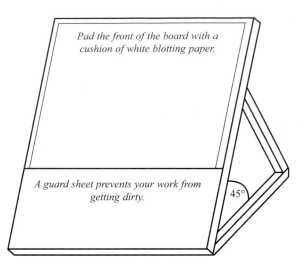

Pad the front of the board with a cushion of white blotting paper.

A guard sheet prevents your work from getting dirty.

45°

and shoulders, and the control of ink will be your rewards.

A sloping board may be an expensive drawing board with an adjustable slope and a sliding parallel motion for drawing lines. Or it may be a piece of wood or manufactured board placed in your lap and leant against the edge of the table, or it could be a similar board placed on the table and supported by large books or even a couple of bricks! All will give you a suitable slope for writing. Choose a larger board than you think you will need. A board which is about 40 cm wide and 30 high (15 by 12 in) in size may seem at first to be perfectly adequate, but if you invest in one this size, when you want to write on anything larger, the board will be inadequate.

Setting up a board

Your board should be covered to produce a sympathetic writing surface as it is not a pleasure writing on a completely smooth hard surface. Cover your board with two or three large sheets of white blotting paper. The blotting paper gives just enough softness to the board, and being white, shows up the lettering well on the paper. If white blotting paper is difficult to obtain, use sheets of white paper instead, sufficient to give a cushion on which to write.

A guard sheet – usually a long piece of folded paper – protects your work from any dirt or grease on your hand and from ink blots which may fall from your pen or brush. If attached properly, it will also prevent your writing paper from sliding down underneath it and possibly smudging your work.

To determine the height of the guard sheet sit on a chair, which is at the most appropriate height for the desk or table from the floor. Your feet should be flat on the floor, and knees

gently bent. Add a cushion if you feel too low, or use a lower chair if you are too high. With a pencil held as if you were about to write move your hand around on the board, which has already been covered with its blotting paper, until you feel at a comfortable writing height. Experiment with different positions to make sure. It is likely to be at a different height for different people, although it will usually be at about a similar level to your shoulder, or just below. Make a tiny mark on the blotting paper at this point. Now make a darker pencil line about 2·5 cm (1 in) below the first mark. This gives you the guideline for the top edge of the guard sheet.

Right-handers
Setting up a board can be different for right- and left-handers from this point.

People who are right-handed should have their guard sheet going straight across the board horizontally.

Attach one end of the folded guard sheet to your board with masking or similar tape, and, before you attach the other end, very gently pull the paper so that there is a degree of tension. The paper you are to write on slides behind the guard sheet until it is at the level which you found most comfortable for writing. The tautness in the guard sheet keeps the writing paper in position so that it should not slide underneath when the ink is wet.

Instead of your hand moving from the top to bottom and right to left of your writing paper, your hand remains in the same comfortable writing position, and it is the paper which moves.

Check that your writing hand rests on the guard sheet, so protecting your work from grease and dirt.

If you are new to calligraphy, you may need to make adjustments to the height of the guard sheet, as you get used to the level which is most comfortable for you when writing at a slope.

Left-handers
Left-handers may find it comfortable to use a sloping board set up in a similar way to right-handers, with the guard sheet going straight across. Using left-oblique nibs, specially designed for left-handers, and which are explained on page 16, you may be able to adjust the position of your hand, wrist and arm so that you can hold the nib at the correct angles for the various hands without pain.

If this is not very comfortable for you, then set your board up differently.

You will already have the mark on the blotting paper indicating a level 2·5 cm (1 in) below the comfortable writing position for you. Fold a piece of paper in half lengthwise as before. Now position the paper so that it is at a slant to the horizontal of about 30°–35°, the left edge being higher than the right edge. This is shown in the illustration opposite.

Use masking or similar tape to attach one edge to the drawing board. Pull the paper very slightly so that there is a degree

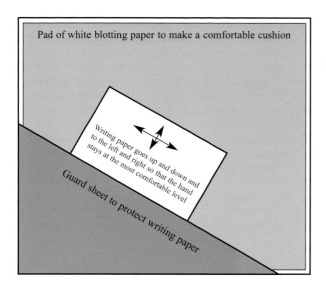

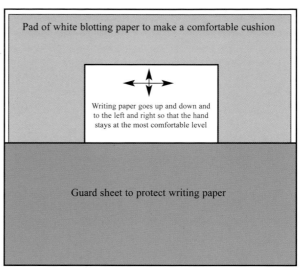

Setting up a board. Right-handers should set their boards up as shown on the right.

Left-handers may find they can write well if they set their boards up in a similar way and by twisting their wrist to the left. If this is not comfortable, then try setting your board up as shown on the far left.

of tension in the guard sheet and attach the other side to the drawing board.

The writing paper is then moved up and down and to the right and left behind the guard sheet.

Many left-handers start to write too high when setting up a board like this, so prepare for adjusting the level downwards.

Calligraphy is not a problem for left-handers if the equipment is good and if you hold your pen from under the writing line. If you usually write with your pen held over the top of the writing line then you will have to adopt a new pen position for calligraphy, which may take a little time for you to get used to. The good thing about this is that it may mean that you change your writing position for your handwriting, which will then cause you less pain and tension.

Some left-handed calligraphers position their paper so that it is almost vertical – not a set-up which is really recommended as it is often difficult to see what you are writing as well as not being easy to assess the angle of slope of the letter-forms. Experienced left-handed scribes usually set up a board with the guard sheet straight and horizontal if this is at all possible, as it then means that they are better able to judge the angle of slope of the individual letters.

Do not be disheartened if you are left-handed and feel that you are making insufficient progress. Left-oblique nibs, setting your board up in this way and perseverance will all help. If you are having some problems initially then remember that just as many right-handers may be, too!

Other equipment

Pen, ink paper and sloping board are the four main requirements for beginning calligraphy, but other tools and equipment will make your life as a scribe a little easier.

Technical equipment

Much of the preparatory work as a scribe will be to do with measuring and drawing lines. For this, the best quality that you can afford will give you tools that will be accurate and last a long time.

Measuring lines

When you begin calligraphy it is important to draw lines for your letters accurately. This will then mean that your eye will become used to the height of the letters in the various styles. After a while you may need to draw the bottom line only, and there may be some pieces which are freer in nature, and where you will have no lines at all.

Measuring lines can be done in one of three ways. First secure the paper to your writing board with a couple of pieces of masking or magic tape at the top edge.

1 Pencil and ruler or straight edge
Most people's natural reaction when asked to measure distances will be to use a ruler, and this is where many start when lettering. Try to buy as long a ruler as you can cope with as it is then easier to draw lines right across a sheet of wide paper. Plastic rulers are available in most high street stationers, and are very cheap. Take care with your plastic ruler to ensure that the edges do not get damaged; any nicks or notches will result in lines which are not straight.

Metal rulers are more robust, will last longer and are less susceptible to damaged edges. It is possible, too, to

31

Measuring lines with a scrap of paper and with dividers.

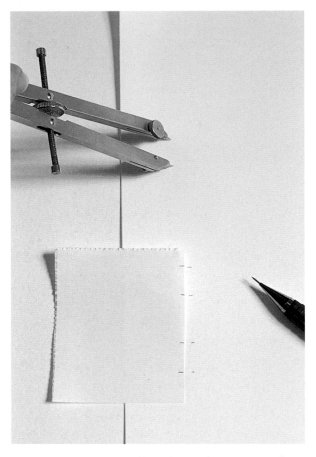

etch the measurement markings finer and more accurately on a metal ruler, and so your measurements will be better – this is important when using a small nib where the lines may be only a very small distance apart.

2 *Using a piece of scrap paper*
Marking out a set of the same measurements down a sheet of paper is tedious, and a slight mishap in counting numbers will throw the whole thing out.

It is easier and quicker to mark your measurements for a few lines down the edge of a scrap of paper. Place this scrap where you are to start measuring lines, and take the measurements from this. Move the paper downwards and line it up again whenever necessary.

3 *Using a set of dividers*
Even quicker and easier to use are sets of dividers. Dividers are similar to sets of compasses with two arms, but rather than one arm ending in a pencil lead and the other a point, both arms end in points.

Dividers are quite easy to obtain. Many stationers sell sets of compasses with spare pencil leads and a spare point. Simply

remove the pencil lead and replace it with the spare point and there is your set of dividers. If possible buy compasses where the distance between the two arms is controlled by a central knurled wheel. The fine measurement you have taken is retained even when you put the dividers down or to one side, as the arms will not move until the wheel itself is turned.

Two sets of dividers will save you a great deal of measuring. Work out how wide apart the lines should be for the body of the letters (the x-height, see page 38) and set one set of dividers to this measurement. Set the distance between the points on the other set of dividers to the interlinear height (distance between the lines).

The tiny holes of the points of dividers will show on the front of paper or vellum, so draw a vertical line at the very edge and take your markings from this. Then place the point of the set of dividers marking the height of the lines where your writing is to begin and mark two points with the dividers. Place one point of the second set of dividers, which will register the distance between the lines in the lower hole, and mark the point where the next set of lines will be with the other arm of the dividers. The two sets of dividers can be 'walked' alternately down the paper so that the series of pin pricks along the edge show the height of the lines and the distance between them.

For pieces which are framed, the holes will be covered by the edge of the frame. For other pieces you may wish to slice off the very edge of the paper where the holes are. It is possible to push most of the holes in the paper back up by rubbing with a burnisher or book-binder's bone folder on the reverse of the paper.

The measurements given by using dividers are very accurate as pin pricks are used rather than pencil markings. They also avoid the need for measuring distances or counting out spaces.

Drawing lines

It is important to have accurately drawn straight and parallel lines when writing. Small differences in measurements, either registering the lines or in the slope will show when the work is completed, and this may spoil your hard work and efforts.

Use a few pieces of masking tape to attach your paper to the board, first making sure that the paper is straight. Whatever tool you use for drawing lines can then be simply run down the paper or the side of the board.

Good-quality hard pencils are worth the extra cost. They are better value in the end because the lead will not break so often, saving you time in sharpening. Use a pencil with a lead which is about 4H; this will be dark enough to show the lines, but faint enough not to be too dominant if the lines are not erased. The harder the lead the longer it will maintain a

good point. Softer pencils will smudge as your hand moves over the surface, creating a messy piece of paper.

If you have a sophisticated drawing board with a parallel rule then drawing straight lines will not be a problem to you. Take some time to adjust the ruling mechanism to ensure that the lines are straight and the motion is running smoothly.

Most people's first choice for drawing straight lines will be a ruler. Plastic rulers about 30 cm (12 inches) long are easily available in many stores. As mentioned before, however, the plastic straight edge can be easily damaged, and in addition to this, the ruler will be too short for almost every piece of paper you use. Try to obtain a longer ruler, at least 50cm (18 inches) and even longer if possible. A metal ruler will also keep its straight edge for longer and will also allow you to cut along its edge without damage.

Although a ruler will draw straight lines, it will not automatically draw lines which are parallel. You can make a number of measurements along a line to ensure that lines are parallel but this will take a long time. Cheap rolling rulers are available, which have an internal roller so that you can draw parallel lines. Some of them are very cheap indeed, and are acceptable if you check the rolling mechanism. Better-quality rulers of this type are usually very accurate.

Sets of architect's parallel lines will also ensure that your lines are parallel, but these are increasingly difficult to track down, and are not that easy to use quickly. To use you draw a line along the top straight edge of the parallel lines, move the lower part downwards, and then slide the upper section down to meet it.

A T-square may be an old-fashioned tool, but is accurate and simple to use for drawing parallel lines. Presuming that the sloping board has a straight edge, a T-square can be pushed on to the side of the board so that it makes a snug fit, then slid up and down to where the lines should be drawn on the paper.

Drawing lines which are straight and square is easy with a set square. One edge is placed at the edge of the paper, or along a drawn vertical straight line, and then the edge at right angles to this will enable straight lines to be drawn accurately. It is possible now to buy good-quality set squares which have a metal strip along one edge, or even the whole set square is made of metal. The set square then has a dual purpose as it can be used as an edge for cutting straight lines with a knife as well.

The nib is held at different angles for the various styles of writing, and some styles, such as Italic, have a natural slope. It is useful to draw out these angles on the paper when starting a new hand because you will then have a guide for matching your nib and this is done with a protractor. Make a small pencil dot where the vertical and horizontal lines cross on a horizontal line on your paper and place the cross lines of the protractor on this. Mark off the angle you

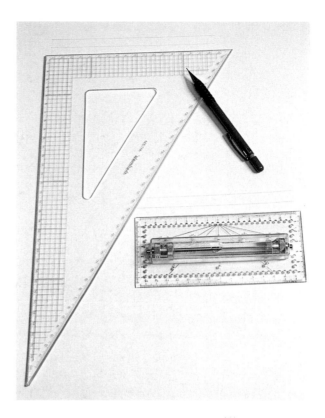

Equipment and tools for helping you to draw straight lines.

require with another dot, and then simply join together the two dots. Use another tool to make a series of parallel lines at this angle if required.

If you find it difficult to maintain a consistent angle of slope when writing letters, then do consider drawing parallel guidelines to help you do this. If your normal handwriting is slanting then writing upright letters consistently perpendicular may cause you problems. Similarly a naturally upright hand may find the 6°–7° slope for Italic or Caroline Minuscule lettering a problem. It may be best to draw lines to help here, which can be erased with other guidelines when you have finished your piece. Calligraphy is not a test – use whatever aids you wish to help you make quickest progress.

Other items

As you work, there will be other pieces of equipment which you will acquire which will become essential to you. For most scribes this will include scissors, a good-quality soft eraser, a sharp knife and glue, all of which are self-explanatory.

Other items may include a pen rest and ink stand, which need not be expensive and sophisticated. Wash out a polystyrene meat or vegetable tray obtained from a supermarket.

33

When it is dry, cut a couple of v-shapes out of one side. Your ink pot or palette can stand inside the tray and the notches will support your pen and brush.

Collect white saucers from china and crockery sales to use as palettes. White shows the paint colour at its truest hue. Small white egg cups and butter pat dishes are also useful as paint containers – so, too, are the clear or white plastic film containers, which have an additional advantage in that the clip-on tops are very secure.

What is not always emphasised is a good light source. It is important not only to avoid eye strain, but also to be able to see those faint parallel lines drawn with a 4H pencil. A desk lamp, raised on a pile of books so that it is above where you are writing will be ideal. One which has arms which adjust is even better because you can change the angle according to whether you are writing or painting. Right-handers should place the lamp so that the light is coming from the left-hand side, and left-handers so that the light comes from the right-hand side.

Daylight bulbs are quite easy to obtain from electrical suppliers and help to ensure that colours, when you are working at night, are true.

You may prefer to use a fluorescent bulb if the heat generated by a normal bulb is uncomfortable. This heat also increases the rate at which paint and ink dries – not always an advantage. Unfortunately, a flickering fluorescent bulb is not to everyone's liking.

And you may need a box or container to store all this equipment in. Many scribes find the cheap plastic tool containers available at do-it-yourself stores ideal for this as they have separate compartments suitable for pens, nibs, brushes, tubes of paint and other equipment.

Starting to Write

Sitting down to write is a pleasurable experience for some. Picking up a pen and thinking about what is to be committed to paper has an air of expectation and excitement. For others it does not have that allure. It may be that time spent sitting at school, chewing the end of a pencil and desperately thinking about what to write has created a tension associated with any writing instrument. People come to calligraphy with all sorts of previous experience; after all, writing is what we all do, it is not like learning some other crafts where tools and equipment may be strange and new.

Before you start to write

Whatever your previous experiences it is worthwhile starting each session by loosening up your muscles and arm movement. Many experienced scribes complain of pain and tension when they have been writing for a number of hours. This should not happen if you are conscious of this from the very beginning. A tense and tight hand, arm and shoulder will produce tense and tight letters, and it is almost impossible to flourish freely if your fingers are rigidly gripping the pen.

Writing with pencils or a felt tip pen, where there are few problems of ink flow or the pen nib catching in the paper surface will help you to relax. Writing with a large pen, too, perhaps standing as you do so, results in your using the whole of your arm to make the movement, not just your fingers; this also will loosen the muscles.

Whenever you feel yourself getting tight and tense, try very hard to relax. It helps to shrug your shoulders and stretch out your arms even while sitting at your board. Stretch and relax your fingers, too. You will be courting problems if you sit for any length of time lettering without getting up to stretch your legs and arms. Although the flow of writing will be broken and it may take a couple of letters to get back into the hand position and feel the letter-shapes when you sit down to write again, the letters will be much better as a result because you will now be less tense.

Preventing tension

It is difficult when you are enjoying your writing to appreciate that sitting for hours at a time at a sloping board is not good for many reasons. Muscles will become tense, and tension can result in pain, occasionally quite severe pain. Right at the beginning of your calligraphic career you should be aware of this and takes steps to avoid it.

Stopping every hour or so (preferably more frequently) to use these same muscles in a different way will go a long way to alleviating future problems. Trying the five easy exercises on the next page may also help to relieve aching fingers and joints.

Holding the pen

People hold pens in a variety of different ways, some of which are more comfortable than others. There is no set grip for holding a calligraphy pen, but you want to aim for a comfortable hold where the very tip of the pen nib only touches the writing surface.

Right:
Hold your calligraphy pen in a comfortable position, between the thumb and second finger. The index or first finger should sit on top to control the pen, and the first joint of this finger should be straight and relaxed. This is a conventional pen hold. However, rather than the pen sitting in the v-shape between the thumb and first finger, try to hold the pen so that it sits on the knuckle of your first finger. This means that only the very tip of the nib touches the writing surface, and the flow of ink is more controlled.

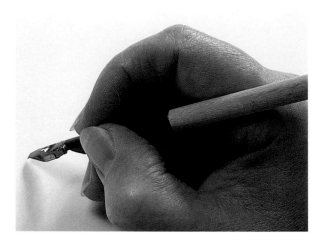

You will find calligraphy more difficult if you usually hold your pen in a grip where your hand is above the writing line. This position will result in letters which are not the same as exemplar letters because the pen nib will not be at the correct angle compared with the horizontal line for writing. As well as this, smudging will be a great problem as the ink used with a nib as broad as 4–5 mm (0·25 in) will take some time to dry.

Beginning lettering

Having loosened up, it is now time to start lettering. Remember that the paper slides behind the guard sheet on your sloping board, so adjust it until it is in the best position for you.

You will not have any problems if you are using a calligraphy felt or fountain pen, but if you are using a dip pen, it may take a second or two to get your pen working. Have a scrap of paper to hand on your board where you can move the pen back and forwards, making only narrow strokes. When the pen is working well then transfer your hand quickly to the position for writing, and your pen should write straightaway. When the nib of a dip pen has been sharpened, there is very little contact between pen and paper, and the thicker ink used in these pens will dry in only a short space of time on the end of the nib. This dried ink will prevent any ink flow, and must be resolved before the liquid will flow freely. The problem that many beginners have is that they charge their pen, check on the letter, and then try to write it. In that short time the ink has often dried on the tip of the nib. On a hot dry day the ink will dry even more quickly and the pen

Five Easy Exercises

Try these simple stretching exercises to help you avoid problems of aches and pains when writing. They are useful for other situations too, not just for writing. If you use a computer a lot, or work sitting in one position for a long time, these exercises will help to free tension.

Do check with your doctor first if you have any health problems or injuries.

1 First shrug your shoulders ten times.

2 Now hold out your arms so that they are horizontal from the shoulders. Spread and stretch your fingers out as far as they will go and then relax them ten times.

3 With your arms outstretched turn your hands so that the palms are facing upwards. Bend your arm from the elbow so that your hands touch the tops of your shoulders. Bend and stretch out each arm in turn ten times.

4 With your hands still touching the tops of your shoulders and your elbows bent, rotate your elbows around like windmills, each arm in turn ten times.

5 Lastly clasp your hands together behind your back and with your arms as straight as they will go pull your clasped hands upwards.

may need encouragement to write when making even the next stroke of the letter. A couple of drops of water to dilute the ink is recommended on hot days.

All this does sound like a problem which may suggest that you should not write with dip pens early on, but it is surprising how quickly you will get used to making each stroke by a few movements back and forth before you make the thicker strokes. It will be so automatic that it will become part of your writing.

Key features in writing letters

In ordinary handwriting, the letter strokes have developed and changed over the years such that we are taught in school to write in a speedy and efficient way. The pens that we use now have been manufactured to write instantly and with no fuss, no matter in what direction they are pushed to write.

Calligraphy broad-edge pens are different. The fact that ink is spread along a broader edge on the paper, unlike the much finer nibs on handwriting pens, means that the pen cannot be pushed around so easily, or it will spray ink.

Nib angle

The angle at which the pen's broad-edge nib is held compared to the horizontal line for writing makes a difference to the letter-shapes.

For most of the alphabets the pen is held comfortably at angles between 30° and 45°, but for some the nib is much flatter and for others much steeper. For Flat Pen Uncials, for example, the nib is held at 0°, but for Rustics it is between 45° and 85° – very much steeper.

It may take a little time to adjust to the way in which your hand holds the pen at these various angles, which may be different from how you would hold your hand when writing informally. For Uncials, you will need to keep your elbow tucked tightly into your waist to achieve a consistently flat angle, or you could cut a quill with a right-oblique nib.

Separate strokes for letters

Letters in calligraphy are written with separate strokes which are usually downwards or pulled to the right. When a broad-edged nib is pushed against its width it resists and may spray ink. Usually the pen is lifted between each stroke and placed into position for the next one.

Each letter consists of one, two, three or more strokes, and the stroke sequence is important in the formation of the letter, as it usually controls spacing between that letter and the previous one. The whole process of letter writing is much slower in calligraphy than with any handwriting because of this.

In the exemplar alphabets in the following chapter the direction strokes for each letter are clearly marked, and numbered to show the sequence. It may take a little time to get used to this, but essentially the order and sequence are logical.

The letter starts with the stroke on the left and continues through the lettershape. The complications arise with Gothic, where there are many pen lifts as there are so few curves for minuscules or small letters.

Letter families

When starting a new alphabet style it would seem natural to start at the first letter – letter **a** – and work your way through the alphabet until you come to the last letter – **z**. This is in fact what many beginners do. The strokes used for the letters in such a sequence are different, and you will not make the quickest progress by tackling each hand in this way.

It is better, and you will learn the shapes much more quickly, if you group the letters into families which use similar strokes. This is not difficult to do and is really a matter of common sense. For example, the letters **r, n** and **m** all start with a short downwards stroke and then arch. It is a natural progression then to add the letters **h** – a longer stroke with an arch, **b** – a longer stroke with an arch taken round to the left, and then **p** – similar to the **b,** but with a downstroke going below the line.

In the exemplars in the following chapter, the minuscules (small letters) have been grouped into letter families according to the strokes used to make them. We use minuscules in our writing ten times more frequently than majuscules, large or capital letters, and so more attention has been given to them.

Letter height

The letter styles which we write in calligraphy today are taken from those used in historical times. These give us our

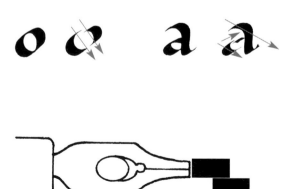

Far Left.
Letters in calligraphy are written with one, two, three or more strokes so that the pen is pulled to the right or downwards. This avoids pushing the pen, which may then spray ink.

Left.
Measure the height of guidelines by relating it to the width of the nib you are using. Turn your pen so that it is horizontal and make a series of little steps which just touch one another – no gaps and no overlaps.

37

pattern of style, rhythm and movement of the letters. They also give us a guide to the size of the letter compared with the width of the pen nib being used. Eventually, you may choose to write the letters much taller or smaller than those in the exemplars and historical examples but, initially, it is better to measure out guidelines which are the accepted distances apart. This helps train your eye so that you become used to the proportions.

The height of the letters is always given in nib widths. Turn your pen so that the nib is parallel to the horizontal guideline. Make a series of little steps, which just touch one another, with no gaps, and which do not overlap.

Now count out the appropriate number of steps for the alphabet you are to write. Two middle lines give the height of the main body of the letters, which is called the *x-height,* because it is the height of a small letter *x.* The parts of the letters which go up, such as on letters **b, d, h** and **k** are called *ascenders,* and go beyond the top line of the x-height, as they do in the letters used for this typeface. Similarly the parts of the letter which go down, as on letters **j, p, q** and **y,** called *descenders,* extend beyond the bottom line of the x-height.

Majuscules, or capital letters, are in every style but one a little shorter than the height of the ascenders. This has always been the pattern with lettering and type, although we are rarely taught this with handwriting. Compare the heights of the ascenders and majuscules in the enlarged lettering style

– Palatino – designed by Hermann Zapf:

Though

The letter **T** is clearly shorter than the ascender for the letter **h.**

Gothic is the only style where this is not the case and the majuscules are taller than the ascenders of the minuscules. This applies even in fonts for the computer such as Old English, shown here.

𝕿𝖍𝖔𝖚𝖌𝖍

You may prefer to draw out sets of lines showing not only the x-height, but also the extent to which the ascenders and descenders go for each hand. This will mean drawing sets of four lines for each line of practice, however. Once you are familiar with the respective heights, then you should only have to draw lines for the x-height and eventually you may need only one base guideline for your letters.

To save time, draw accurate sets of lines for the different writing styles for specific nib widths, and photocopy them. Either use these as your practice sheets, or place them underneath a sheet of layout paper, and these guidelines will show through this lightweight paper.

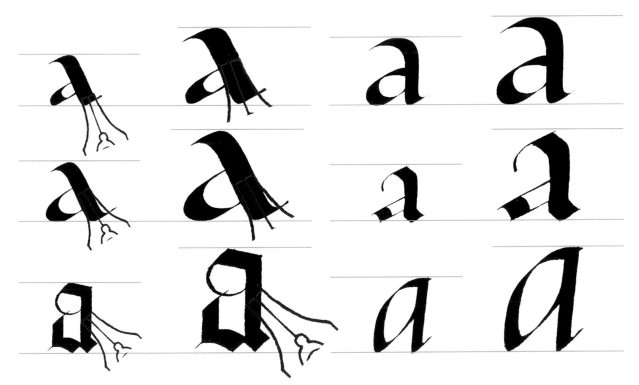

Letters in the different alphabet styles can be written at varying heights, but they are all measured according to the width of the pen nib being used to write them.

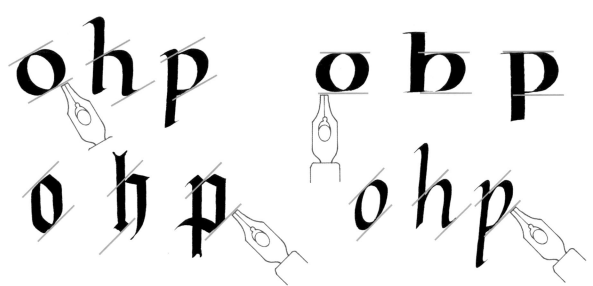

Different hands are written with the nib at different angles. Here, clockwise from top left, English Caroline Minuscule, Flat Pen Uncial, Italic and Gothic are written with the pen nib at angles of 30°, 0°, 45° and 45° respectively, which give the letter-forms their characteristic shapes.

Practising the letters

All calligraphers, no matter how good they are, start by practising the individual letters of the particular hand on which they are working. Writing those letters again and again imprints the shape, stroke sequence and form on the writer. Be prepared, when starting, to have to spend some time filling sheets of paper with letters. This is not wasted if your letters improve the more you write.

The frustrating part is that your brain will know what you have to do to make that letter-shape, but your hand may not comply! It is quite clear that the verticals for Uncials should be straight and upright, but for a whole variety of reasons your hand will decide to make the stroke wobbly and at a slant. Gradually, though, the one good letter on each line will become two, and you will then find that you increasingly write letters which you like.

Try not to become too frustrated at what you may see as your apparent lack of progress. Keep your very first efforts and compare these with your latest letters. The latter will not be so wobbly or patchy.

It does take many years to become as competent as those whose work you will see in exhibitions or published in books, but that does not mean to say that you cannot enjoy what you are doing at the level you are doing it. Most of your friends will be delighted at the time and effort you have spent in writing something especially for them; they will not be bothered about the odd uneven letter, or a slight lack of inconsistency in the vertical lines.

Place the letter you are trying to copy, whether historical example or modern exemplar, as near to your line of sight as possible and certainly on your sloping board, not beside it. This avoids errors and mistakes.

Tracing over letters, perhaps through layout paper, is a good idea if you are finding some letters particular problems. Once you have felt the shape of that letter, then write some of your own. Remember that writing is part of you. No matter how hard you try to emulate another scribe's lettering, there will always be idiosyncrasies which are part of your own hand. The essence is to feel the spirit of the hand, the nib angle, x-height, slant, rhythm, letter-shape but not to copy slavishly.

It is ideal if you can leave your sloping board and writing equipment ready for you to practise at convenient times. Many will not have this luxury and have to share space with the family. Try to reserve a set amount of time each week (at least) to practise your lettering, turn the telephone off, tell

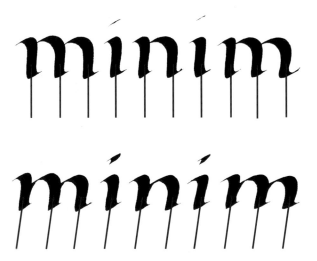

White space within the letter should look about the same as white space between letters. Perpendicular lines from the centre of each stroke should be regular and even.

39

Round letters should also look regular and even.

*Diagonal letters, based on that round letter **o** can be treated in a similar way, and will again be slightly closer together than the straight sided letters.*

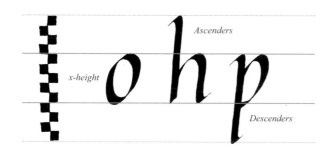

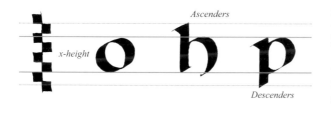

The x-heights, heights of descenders and ascenders and majuscules of Italic, Uncials written with an Angled Pen and Italian Rotunda.

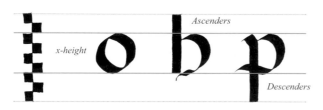

the family what you are doing so that they avoid disturbing you and allow yourself to become absorbed in letters. A positive frame of mind will be reflected in your letter shapes. Hasty and hurried snatches of time may well result in unhappy letters.

Chinese calligraphers will spend some considerable time, as much as twenty minutes or more, staring at the piece of paper where they are to write, thinking the letter-shape through in their head, the form, stroke sequence and where it will be placed on the paper. In our busy lives, twenty minutes may be all the time you have to practise lettering, and you may well feel that it has not been particularly profitable if all you have done is to stare at a blank sheet of paper imagining letters. But there is something to be said for composing yourself, getting yourself into a lettering frame of mind, and cutting out as many other distractions as you can so that you can devote quality time to the craft.

Spacing

As soon as you feel able, put the letters together to make words. You will then get into the rhythm of writing more quickly than practising individual letters endlessly. Rhythm and spacing are important in lettering, and some believe that a bad space is worse than a bad letter.

Spacing between letters

Start writing straight-sided letters, such as the letters **i, l, t, n, m, u** and write out as many words as you can think of with these letter combinations – **tin, nit, nut, mint, tint, lint, nun,** and so on.

You are aiming for the spaces *within* the letters to be visually similar to the spaces *between* the letters. So in the following examples the white space – or counter – within each letter should be similar to that between the letters.

Curved and diagonal letters should also comply with this rule – spaces should look the same.

For other alphabets, minuscules and majuscules, the same rules apply. Note that spacing between a straight-sided letter and a round or diagonal letter is slightly closer than that between two straight-sided letters, so that the inter-letter spacing looks about the same.

Spacing for Gothic is much easier to judge because most of the minuscule letters have straight sides. The letters can be written closer together or wider apart as you will, and this will affect the width of the letters as well.

Thespacebetweenwords

Thespacebetweenwords

Thespacebetweenwords

*Leave the width of the letter **o** of that particular alphabet style between words.*

Spacing between words

Spacing between *words* relates to the width of the letters of that particular alphabet style. As a guide, leave the space which is about the width of a minuscule **o** of that alphabet between words when writing mainly minuscules. If writing in majuscules leave the width of a majuscule **O** between words. Because you are using the space of the key letter in each alphabet, the spaces between the words relate to the whole style. In this way, narrower lettered alphabets, such

Leaving a small space between the lines can lead to ugly clashes between ascenders and descenders.

More space between the lines avoids clashes and looks elegant.

Interlinear space should avoid clashes between ascenders and descenders.
More space between lines gives an air of formality and elegance.
Majuscules can be written much closer together because there are no ascenders and descenders to take into account.

CAPITAL LETTERS OR MAJUSCULES CAN BE WRITTEN WITH LINES VERY CLOSE TOGETHER WITHOUT PROBLEMS OF CLASHING.

41

as Italic and Gothic will have narrower spaces between words that wider spaced alphabets such as English Caroline Minuscule and Caroline Minuscule.

Spacing between lines

Spaces between lines can be varied according to your preference and the piece you are writing. For a formal piece it is better to leave more space between the lines as this adds to the feeling of graciousness and elegance.

Some pieces may have much less space between the lines. Pushing the lines together does not always make reading more difficult, and the end result may be the one you want. Other pieces may have variable spaces between the lines, such as your own interpretation of some lines of poetry.

The main point to bear in mind is that the descenders of one line should not clash in an interfering way with the ascenders of that following. Allow an interlinear space for this. In Italic, with ascenders and descenders of nine nib widths in all, the minimum interlinear space would be nine nib widths, preferably ten.

When writing majuscules only, this point does not apply, because, apart from Uncials and Gothic, there are no ascenders and descenders to take into account.

Occasionally you will have to reduce the interlinear space because a piece has to fit to specific measurements, or because you feel that less interlinear space suits the effect you want to achieve. In this instance, write out the piece in rough, and see where possible clashes may be. Adjust the lines very slightly if possible, and also use a few tricks. For example, the letter **f** can be short, stopping at the line, rather than long, the letter **y** can have quite a short descender, with a diagonal hairline flick to finish the stroke. Generally speaking,

it is easier to reduce the length of descenders than it is to shorten the height of ascenders, although a tiny amount of reduction, which may be all you need, will not show.

Spacing for pieces of work

One of the traps many beginners to calligraphy fall into is that they do not allow enough space around a piece of work. The temptation, if you have a sheet of good quality paper, is to fill it with your lettering, with only small amounts of white space at the edges. Another difficulty is when someone wants you to write out their favourite piece which has to fit a particular picture frame they already have – which is rarely bigger than about the size of a large envelope!

When starting out, too, there are additional difficulties about writing small. You may be more confident with a larger pen nib and so writing out the piece you had planned simply takes a larger area of paper. *Calligraphy needs space around it to breathe.* Lettering which goes from right to left margin and from top to bottom – unless it is a background pattern – loses a great deal, and is not easy to read. It is better to choose a shorter piece to write, buy a bigger frame or try a smaller nib.

As a guide, it is better to have more space around a piece than less. There are traditional margins, but you do not have to keep to these. A small amount of quality lettering surrounded by the white or cream of a textured paper can look really stunning. A block of text towards the bottom of a piece, with a large amount of white space at the top, can be equally arresting. Experiment and see what suits your own style and that of the piece. Ideas for different layouts are shown on page 121, where you can also see some which do not work well because of a lack of balance.

Historical Alphabets

When French speliologists squeezed through a gap no bigger than about 30 cm (1 foot) at the foot of a cliff near Vallon-Pont-d'Arc in the Ardèche, France, in the mid 1990s they probably did not expect to see a series of cave paintings which had been untouched for 18,000 years. The original artists abandoned the site due to a landslide. The cave paintings there are lively and fresh and by an accomplished artist. They may give a clue to whether the figures are simply what the artist saw, whether they are part of some religious invocation to a god or whether perhaps they are some form of communication or even early writing.

The earliest-known naturalistic art was in Germany 33,000 years ago, but it is much later than this, some 5,000–6,000 years ago, that a form of writing is first recognised. The inhabitants of the area between the rivers Tigris and Euphrates (in what is now Iraq) pressed wedge-shaped sticks into flattened lumps of wet clay to make shapes representing 'letters'. The system of writing is called cuneiform, derived from the Latin word *cuneus,* which means wedge.

It is fascinating to trace the history of letters we use now through various stages back to their beginnings in cuneiform. But these early letters, changing subtly and written in a variety of forms in Phoenicia and then Greece, with a sideways diversion to the hieroglyphics of Egypt, are of only passing interest to us as calligraphers.

It is with the great incised inscriptions of Roman letters, which can be still seen throughout Europe in much of what was once the Roman Empire, that the shape and form of letters we recognise and use today take on real significance for our studies, and this section concentrates on that alphabet and ones based on Roman letters which followed.

About the alphabets

The alphabets on the following pages are in historical sequence but do not give a comprehensive historical overview of the development of writing. For example at the same time as lettercutters were incising grand Roman Capitals in marble on the monuments in Rome, a more cursive, everyday hand was used for business records, letters and communications, but this style has not been included. The major hands or alphabet styles, those which calligraphers use and write today, are shown here. But, even all these styles are not exclusive, and there are others which are variations on or a transition between these major hands studied here.

Using the alphabets

An historical example is given for each of the different writing styles. It is, after all, from these historical manuscripts that we know about the style. Edward Johnston (1872–1944) who did so much to revive calligraphy in the twentieth century recommended studying each historical hand for seven essential characteristics – *letter height, nib angle, the shape and form of the letter o, slant, the order and direction of the strokes from which each letter is formed, serifs (the small lines at the beginnings and ends of the strokes in some letters), and finally the speed at which the letters were written which then gives the rhythm of the hand.*

Not all the letters we use now appear at all or in a familiar form in the historic examples. For hundreds of years the letter **s** for example, was written as a long **s**, similar to an **f** without the crossbar, which we do not use now. In addition

the letters **u** and **v** and also **i** and **j** were not distinguished. In the Middle Ages **u** and **v** were identified as separate letters, but **i** and **j** were not separately identified until the seventeenth century. The letter **w,** not used in Roman times, was introduced in the eleventh century by the Normans. These letters, therefore, have been invented using the existing patterns from the hand. There is no hard and fast rule as to whether the letter **y,** for example, should take its form from the **v** shape or the **u,** although usually I have taken the letter **v.** Decide for yourself whether you want to follow this, or develop your own style for the absent letters which is in keeping with the hand.

A small red arrow and a number show the direction and the order for writing the exemplar letters in each chosen alphabet style. Although they have been written carefully, they do contain characteristics peculiar to the writer, in the same way that your letters will be peculiar to you. Note where the strokes begin and end, the shape of the arches on letters such as **n** and **h,** the shape of the letter **o,** and then write your own version of the letters, referring all the time back to those original historical letters. They are unlikely to be exact copies unless you are a very good forger! This is the delight of calligraphy, and is why it is usually not too difficult to recognise the work of eminent calligraphers – they each have their own style. As well as this the actual order of strokes is often a matter of personal choice. Should you write the serif first, followed by the main stroke, or the main stroke first and put on the serif afterwards? If the stroke order suggested here does not seem to work for you, then change it to one that does. However, do bear in mind that writing the first main stroke is crucial in getting the letters spaced evenly, so do not make changes which will adversely affect the ease with which you space the letters.

The exemplar letters are written in stroke-related families. This means that letters which relate to the letter **r,** such as **n, m, h** and so on are grouped together. You will find that you make quickest progress by practising letters in these groups. The letters are written out alphabetically as well for reference.

Following after the letters is a phrase or sentence written in that alphabetic style. The lines were written by poet Ted Walter and were specially commissioned for this book. This gives you an idea of what the hand looks like when written out, using the modernised forms of some letters, such as **s, j** and **y.** It should be pointed out that this lettering will probably not be perfect! When letters are so identical such that it is difficult to decide whether they have been written by hand or set in a type-face on a computer, then the letters become soulless. Hermann Zapf says in his chapter on 'Calligraphy and Type Design' (See page 141.)

This irregularity creates this specific expression, the expression of the scribe's heart, which is also the strength of calligraphy.

The order of learning alphabets

The historical sequence of alphabets is certainly not the recommended order of learning the various hands. Some early styles such as Rustics are very complicated even for those with some experience, as the nib has to be turned and manipulated to make the various strokes.

Edward Johnston was instrumental in the revival of broad-edge nib calligraphy in the twentieth century, following on from studies made by William Morris, as part of the Arts and Crafts Movement. Some of Johnston's students carried his ideas of calligraphy based on historic hands to the Continent and beyond. Anna Simons, for example, took up a teaching post in lettering at Dusseldorf in 1905, after Johnston turned it down. Ernst Frederick Detterer took lessons with Johnston in 1913 and returned to America to promote calligraphy.

Others, for example Rudolf von Larisch in Austria in the early twentieth century and Hans Joachim Burgert in the late twentieth century, disagreed with the strong historical influence and felt that lettering should respond to the piece being written and was a form of self-expression.

However, beginners do need to start somewhere, and a study of the character and form of historic hands is probably the best. This may then lead on to a much more personal style of lettering.

Johnston felt that the writing style in the Ramsey Psalter, now in the British Library (Harley MS 2904, see page 68), was that which would form a good foundation for learning other hands, and he called his interpretation of this – Foundational Hand. Historically this style is called **English Caroline Minuscule** (shown on pages 66–67) and as a minuscule hand with the letters most commonly used (as opposed to a majuscule, or capital hand where letters are used less frequently – at the beginnings of sentences and for proper nouns), is one place to start. Together with Roman Capitals, it will produce a set of minuscules and majuscules which will serve you in good stead until you feel confident in tackling more difficult hands. Others may prefer to start with Italic or Black Letter. The key is to write the style in which you are interested.

There are styles which are better studied earlier and others which should be left until you feel more confident. Those requiring less pen manipulation are **Uncials with an Angled Pen, Caroline Minuscule, English Caroline Minuscule, Gothic** and **Italic.**

Roman inscriptional letters – Roman Capitals

Although some letters on Greek inscriptions are familiar, it is carved Roman letters which are best known to us. Using the Greek alphabet as a base, the Romans adapted some letters and created others for their own use. They developed a hand-

some lettering style, which well matched the grand arches and memorial architecture erected to mark various victories or to commemorate the lives of famous leaders. Interestingly enough, this is often the style which is still selected when a grand or formal piece of lettering is required today. The proportions, shape and formation of these Roman letters are so well designed that they have survived virtually unaltered to be used now by type designers, letter cutters and calligraphers.

Those Roman Capitals which are thought to be nearest perfection are the letters on Trajan's Column, at one end of Trajan's Forum in Rome. The tall column, 38 meters (125 feet) high, was erected in 114 AD and has a spiral band of carvings showing scenes from Trajan's Dacian Wars. Originally the column contained the Emperor's ashes and was topped by his statue; this has since been replaced by a statue of St Peter.

For calligraphers is it the carved inscription which is of greatest interest. About 6 meters or 18 feet high, there is a panel 3·5 m long and 1·2 m high (9 feet 1 inch high by 3 feet 9 inches long). It is particularly interesting to us because the letters are not only beautifully proportioned but they look so well spaced and even. This is deceptive because the height of the rows of letters and spacing between these rows gradually decreases over the six lines from top to bottom so that when viewed from ground level the letters look the same height.

Close inspection of the lettering shows that the original scribe had the same problem that many of us have. He started on the left-hand side with generous spacing, but as he worked along each line it was realised that the letters should be slightly closer together if they were to fit, and they bunch up very slightly.

Letter shapes

The studies that have been made of these letters, particularly the direction and movement of the serifs – the small lines at the beginning and end of strokes – suggest that the letters

Construct these beak serifs by making a small curved stroke to the right first followed by the downstroke, as shown.

were originally written with a brush. This would have been a chisel ended, or one-stroke, brush, which was held at a variety of angles to form the very fluid letters. Pens cannot be manipulated as easily as a brush and so for these letters the nib is usually held at an angle of 30°.

Although the Romans adapted Greek letters to create their own alphabet, not all the twenty-six letters with which we are familiar are to be found on Roman inscriptions. The letter **W**, for example, was later in coming. The letter **Z**, although part of the Roman alphabet, was very rarely used. So there are no models for some of our letters and we have to choose what parts of the existing lettershapes to adopt to create these 'new' letters.

Writing Roman Capitals

This may be the first style of lettering historically in this section, but Roman Capitals are not necessarily the best hand to start writing if you are a beginner. For one thing this hand is wide and contains only majuscules, which will prove to be limited if you want to write out anything of any length. It is better to start with a hand such as English Caroline Minuscule, see pages 66–67 with which these majuscules are used, or Italic, see pages 94–95.

Serifs.
Choose the serifs which fit the style of the text, or which you prefer.
Simple hook serifs look modern, but try out others as well.

The proportions of Roman Capitals. These letters are based on a round letter **O**, *which can be encased within a square.*
Letters which relate to the letter **O** *are* **C, D, G, Q**.
Symmetrical letters are as wide as three-quarters of the square encasing the letter **O**. *Asymmetrical letters are* **A, H, N, T, U, V, X, Y, Z**.
The centre of the letter **M** *is a* **V**, *and it is supported by two slightly splaying straight strokes.*
Asymmetrical letters are half the width of the square encasing the letter **O**.
Symmetrical letters are **B, E, F, J, K, L, P, R, S**.
The letter **W** *is formed by two very slightly narrower* **V**s.
The letter **I** *is a simple downstroke.*

Analysing a manuscript.
Horizontal lines indicate the x-height, and the heights of ascenders and descenders. Dotted vertical lines on the first two lines show the slant of the letters and lines on the lower two lines indicate the angle at which the nib was held. The shape of the letter **o** – a narrow, slanting oval – is shown by the outline red shape overlying two letters **o**. The width of the pen used, shown by the outline of a nib and the red blocks on the left-hand side show that the x-height is about five nib widths and the ascenders and descenders vary from about eight nib widths to just over ten. Interlinear space can also be calculated in this way at about ten nib widths. Although historical manuscripts are invaluable in allowing us to work out how the manuscript was written, the number of variables in such a regular looking script as here strongly emphasises that a number of measurements need to be taken and an average calculated.

Plaster cast of the lettering on Trajan's Column.

Victoria & Albert Museum.

46

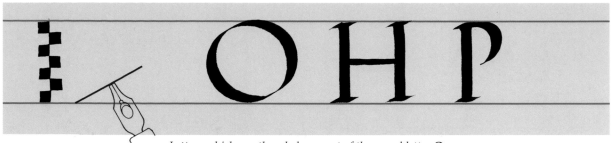

Roman Capital
letter-forms.

KEY FEATURES
(with some variations)

Pen nib angle – *30°*

X-height – *7 nib widths*

Letter **O** form –
round

Slant – *upright*

Speed – *slow*

Serifs – *as chosen*

Letters which use the whole or part of the round letter **O**

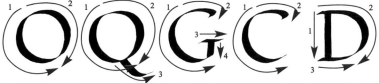

Asymmetrical letters are half the widths of a square encasing the round letter **O**

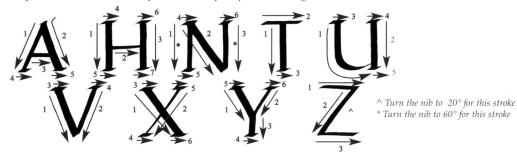

^ *Turn the nib to 20° for this stroke*
* *Turn the nib to 60° for this stroke*

Symmetrical letters which are as wide as three-quarters of a square encasing the round letter **O**

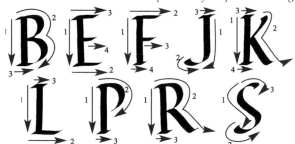

*You may prefer to write the serif
first, followed by the letter-stroke*

Letters which are exceptions

Ampersand

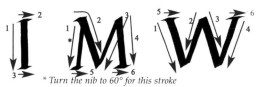

* *Turn the nib to 60° for this stroke*

&

Numerals

0123456789

Punctuation

PQRSTUVWXYZ

47

Roman Capitals look grand and gracious. Use these letters for headings or for pieces which have few words.

RAIN MAY WEATHER HEWN WORDS.

TRUTHS REMAIN

It is a good idea with this hand to start writing the letters with a pencil. It may take a little time to become used to these round letters. If you are finding it very difficult then draw round a coin a few times as a guide, then go over the circles freehand with your pencil, trying to make the same circular shapes, noting that the letters are usually formed with more than one stroke. Once you feel that you have the proportions of the hand then change to a pen which can be a smaller or larger nib. Roman Capitals work well when written almost in skeleton form with a narrow nib, even for formal pieces.

Rustics

Rustics are a narrow upright majuscule hand which is not

STARS ONCE WROTE HUSIC IN THESE STONES

Rustics, capital letters, or majuscules, have a strong diagonal feel to them and can be interestingly compared to the Roman Capitals above.

Uncials with an Angled Pen.

THE LEADING EDGE

IS THE BEGINNING

OF MEANING

recommended as a place to begin lettering because of the different nib angles and pen manipulation needed to write the letters. They are also a hand of majuscules only, which has its own limitations when writing out pieces.

Rustics are a lively style when written well, and were the style used in the first codices, or books. At first the whole book would be written in Rustics but later they were used for headings or endings to chapters, introductions and colophons. Their use was varied – they were even used for advertisements written on the walls of Pompeii in Italy, which have been preserved in the volcanic ash of the volcano Vesuvius.

The Rustic letters used in the Vespasian Psalter are later than those of the first codices, or books, such as the Vergilius Romanus or the Codex Palatinus, written in the fourth or fifth century (although it is now suggested that this is a later copy, perhaps sixth century). No matter which century in which they were written the impression of Rustics on the page is of a flowing style, with a distinctive diagonal feel. Combining Rustics with a more familiar hand as a gloss would be a good solution when you come to write out a piece in this style. Many early Rustics manuscripts were written without any gaps between the words, and this adds to the regularity of texture.

The spacing between lines is narrow, which is possible when there are no ascenders or descenders to clash, which enahnces the richness of the appearance.

Rustics are written with a changing nib angle and a great deal of pen manipulation. Downstrokes are at an angle of between 75° and 85°, with curved and diagonal strokes, the bold serifs at the foot of letters, together with horizontals at

45°. It will take you some time for your hand to become used to this manœuvring; keep your writing arm loose, and use your elbow to help you achieve the various angles. If this arm is tight, and your elbow clenched to your side, it will be challenging for you to write this alphabet.

Uncials with an Angled Pen

The tiny letters in the St Cuthbert's Gospel of St John and the selected Ceolfrith leaf are small, both only 2–3 mm (0·1 in) high. It is difficult, therefore, to link the size of the letters with the usual association of the word *uncial.* The definition of the word in dictionaries is usually as *an inch high* (2·54 cm), or large letters. However, this style works very well and perhaps better in this much smaller form.

St Cuthbert's Gospel is not a large book, the page sizes are only 137 mm by 92 mm (just over 5 inches by 3·5 inches) – and was probably written for personal use. The original scribe maintained a consistent rhythm and style, with almost no changes in pen angle, which means that these letters are less challenging to write than Uncials with a Flat Pen Angle. The book was written in the monasteries of Monkwearmouth/Jarrow, in the north-east of England, about 698 and was found in the tomb of St Cuthbert in 1105.

There are gaps between the words, and the interlinear space is just a little wider than the x-height.

Because these letters are usually written with a low x-height it is possible to use much larger nibs for writing out

Rustics from the Vespasian Psalter. Most of the letters in the Vespasian Psalter are tiny Uncials, made with the pen held at a flat angle, and much nib manipulation. At the beginning of the book, there are a few pages of these Rustic letters, probably added at a later date.

BL, Cotton MS Vespasian A. i. f. 3.

ABCDEFGGHIJKL

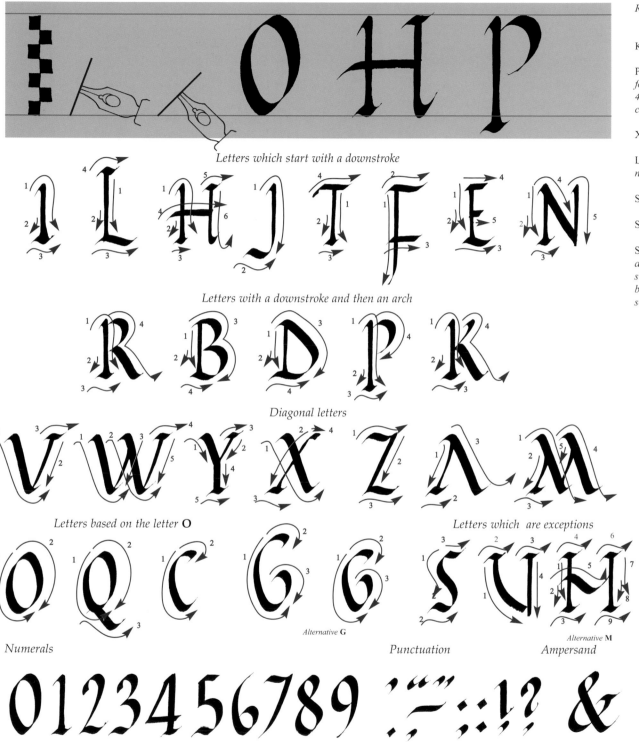

Rustic letter-forms.

KEY FEATURES

Pen nib angle – *70°
for upright strokes,
45° for diagonals,
curves and serifs*

X-height – *7 nib widths*

Letter **O** form –
narrow

Speed – *slow*

Slant – *upright*

Serifs – *hook serifs
and slightly curved
slab serifs to the
base and head of
some letters*

Letters which start with a downstroke

Letters with a downstroke and then an arch

Diagonal letters

Letters based on the letter **O**

Letters which are exceptions

Alternative **G**

Alternative **M**

Numerals

Punctuation

Ampersand

0 1 2 3 4 5 6 7 8 9 &

INOPQRSTUVWXYZ

51

The St Cuthbert Gospel of St John or Stonyhurst Gospel. These tiny letters are remarkably regular and even, and the page has a crispness and freshness to it which belies its age. Monkwearmouth/ Jarrow, c. 698.

BL, Loan MS 74, f. 27.

Dixit autem eis ihs
ego sum panis uitae
qui ueniet ad me non esuriet
et qui credit inme
non sitiet umquam
sed dixi uobis quia et uidistisme
et non credidistis
Omne quod dat mihi pater
ad me ueniet
et eum qui uenit ad me
non eiciam foras
Quia descendi decaelo non
ut faciam uoluntatem meam
sed uoluntatem eius
qui misit me
Haec est autem uoluntas eius
qui misit me patris
ut omne quod dedit mihi
non perdam ex eo

abcdefghijklm

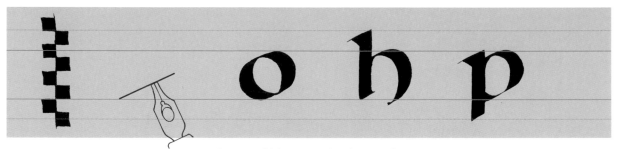

Uncials with an Angled Pen letter-forms.

KEY FEATURES

Pen nib angle – *25°*

x-height – *3·5 nib widths, ascenders and descenders 5·5 nib widths*

Letter **O** form – *round*

Slant – *upright*

Speed – *moderately slow*

Serifs – *hook serifs*

Letters which start with a downstroke

Letters which start with a downstroke and then arch

Letters based on the letter **O**

Letters based on the letter **U** *Letters which are exceptions*

Diagonal letters *E/t ligature*

Numerals *Punctuation*

0 1 2 3 4 5 6 7 8 9 ·' " : : ! ?

p q R s t u v w x y y z

53

Uncial letters on a page from one of the great bibles commissioned by Ceolfrith, bishop of Monkwearmouth-Jarrow. The uncials show the strong Roman influence.

The discoloration of this leaf occured when it was used as binding waste. Before 716.

BL, Loan MS 61, recto.

Uncials with a Flat Pen letter-forms.

KEY FEATURES

Pen nib angle – *0°*

x-height – *3 nib widths, ascenders 4·5 nib widths and descenders 5 nib widths*

Letter **O** form – *round*

Slant – *upright*

Speed – *slow*

Serifs – *flat with some pen manipulation for constructed shapes.*

Letters which start with a downstroke

Letters which start with a downstroke and then arch

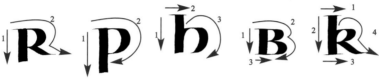

Dotted lines indicate strokes made with the left-hand corner of the nib.

Letters based on the letter O

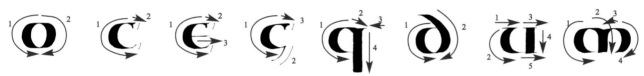

Diagonal letters

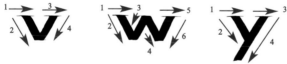

Letters which are exceptions

E/t ligature

** Nib at 45° for this stroke ^ Nib at 90° for this stroke, also gradually twist the nib to 90° for the base of the diagonal*

Numerals

Punctuation

0123456789

.,;'":=!?

opqRSTUVWXYZ

55

Writing Uncials with an Flat Pen.

SCRIBE ON THIS PARCHMENT

THE WORD

FOR HUNTER

pieces. This is useful if you are unsure of your skill in writing with a small nib. However, Uncials do need a some interlinear space to breathe so do not be tempted to cram a lengthy passage into too small a space. Uncials are a grand and impressive style; choose carefully where they will be used.

Uncials written with a Flat Pen

Roman Uncials such as those on the Ceolfrith leaf are carefully written with pen lifts between almost all the strokes.. There is also much pen manipulation using the left-hand corner of the nib to make the shaped serifs and the fine hairlines, and as a result of all this the letters are written slowly and carefully. The change in the nib angle to 0° makes a significant difference to the letter-shapes and the

It only takes a minute or two to grind a square cut nib on a sharpening stone to make a right-oblique nib as has been done here. For Uncials written with a Flat Pen or Half-Uncials you may find it easier if you use a nib with a right oblique tip.

overall appearance of the hand from previous styles.

There are gaps between words, and also a large interlinear space of almost twice the x-height, which makes the page look particularly spacious and grand.

For writing the endings of the strokes made with the corner of the nib press the nib on the paper or vellum within the previously written stroke to release the ink and then pull it into the shape you want with the left-hand corner of the pen nib.

Half-Uncials

The Lindisfarne Gospels is a complete contrast to St Cuthbert's Gospel in size, feel and page design. The Lindisfarne Gospels is a magnificent book, richly and elaborately decorated with intricate knotwork and interwoven designs, which are themselves surprisingly small and delicate. It was used at ecclesiastical ceremonies and was thought to have been written on Lindisfarne Island (Holy Island) off the north-east coast of England in about 698. Recent research suggests that this date may be rather early, and a later date of around 720 is more likely. The size of the book may be large, but the letters are again only a few millimetres tall.

Here the ascenders and descenders of minuscules in most of the letters are where we would expect to find them, although not all the letters are in a form totally familiar to us today. The letter **r** is still in what we would regard as a majuscule form, as are the letters **t** and **n**. The letter **a** is like a

56

dust-motes
illuminate
air about
this quill

Writing Half-Uncials.

double letter **c**, and **g** is of very unusual design. It is a matter of choice whether you write this letter in the Half-Uncial form, or whether you use a more modern form, similarly for the long form of the letter **s.**

Although this hand is a minuscule hand, there are no separate majuscules. When these letters were needed to start a section a minuscule was simply written larger.

Insular Minuscule

The gloss which can be seen on the Lindisfarne Gospels was the handwriting of the period, which was used, amongst other things, to annotate the manuscripts. It is refreshing to meet this flowing, cursive hand in contrast to the formal and carefully written Uncials. Slightly less cursive, or joined,

hold this moment,
thoughts fade, ink dries,
flourish of sunlight
carp feeding.

Writing Insular Minuscule.

The Lindisfarne Gospels. Reputed, in a colophon by the scribe Aldred, written in around 970, to be written and illustrated by Eadfrith, bishop of Lindisfarne.

Previously dated as 698, but recent research suggests that this date may be too early, and one of 718–720 may be more likely.

BL, Cotton MS Nero D. iv, f. 208.

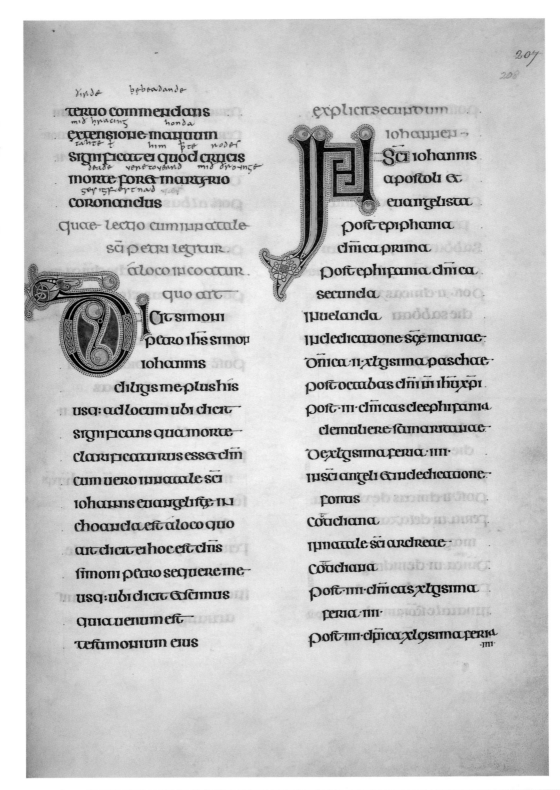

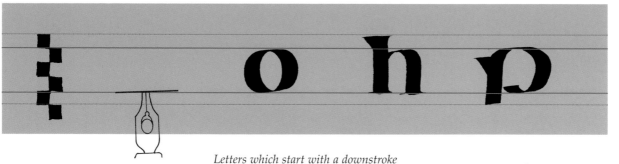

Half-Uncials letter-forms.

KEY FEATURES

Pen nib angle – *2°*

x-height – *3 nib widths, ascenders and descenders 4 nib widths*

Letter **o** form – *round*

Slant – *upright*

Speed – *slow*

Serifs – *built up wedge-shape*

Letters which start with a downstroke

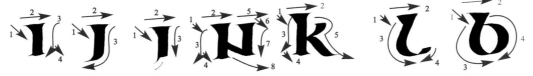

Letters which start with a downstroke and then arch

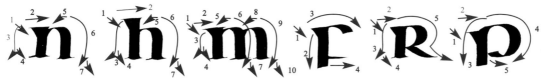

Letters which start with a stroke to the left

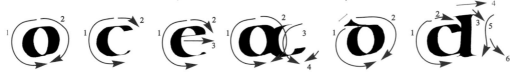

Letters based on the letter **a** *Letters based on the letter* **u**

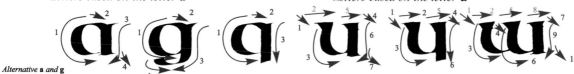

Alternative **a** *and* **g**

Letters which are exceptions *E/t ligature*

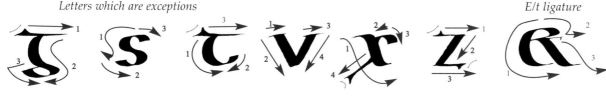

Dotted lines indicate strokes made with the left-hand corner of the nib.

For fishtail serifs, write the down stroke first, and then use the left-hand corner of the nib to pull the ink out to the left and up. See page 72.

Numerals *Punctuation*

0123456789 :;'"?=!?

zhxmwvuτꞅꝚqpoᴚu

*Writing Caroline
Minuscule.*

Polished desk -

scent of box-hedge -

an open mind. Here, write this.

1 will rejoice.

is the example chosen, written in Jarrow or Monkwear-mouth, north-east England, in the second half of the 8th century. As its name suggests this is a hand of minuscules, where there are clear ascenders and descenders to the letters.

The appearance is of a fairly quickly written hand, yet closer study reveals that many of the letters are, similar to previous lettering styles, composed of two or more strokes. The pen has been lifted between strokes for the letters **n, m, p** and **o,** for example, which you can see if you look closely at the historical example.

Some of the letters are unusual. The letter **g** is unfamiliar to us, retaining the Half-Uncial style, and there are some un-usual quirks, such as a letter **c** which is as tall as the ascenders, as is the occasional letter **e.** There can be some confusion too between the letters **p** and **r** which are very similar in the manuscript. When writing these, perhaps it is better to make a clearer distinction between the two. The letter **a** in some examples is open at the top; again it may again be better to write this more conventionally so that your writing can be understood.

were a means of communication used from the second century to the Middle Ages and beyond and were most often carved on wood, bone, stone either separately from – or sometimes in conjunction with – a more recognised hand. They were used throughout Europe, and are found in the British Isles mainly in the Isle of Man, the highlands of Scotland and Ireland.

Their style is characteristic, being formed of straight strokes, determined by the material and tool being used. It is quicker to cut straight strokes in wood, especially when it has a def-inite grain direction, than it is to try to carve curved strokes.

In the Isle of Man many of the Runic inscriptions are on cross slabs and are preserved in churches. The cross slabs are usually richly decorated with patterns of Celtic knotwork and the Runes may be carved up the narrow side of the slab or to one side of the cross. The messages are often poignant:

*Aleif Ljótolfsson erected this cross to the memory of Ulf
his son.*

*Sandulf the black erected this cross to the memory of
Arinbiög his wife.*

*(Joalf) son of Thorolf the Red erected this cross to the
memory of Frida his mother.*

Runes

Runes are not letters made by a pen with a broad-edge nib, nor indeed were they usually made with a pen at all. In fact Runes

Writing Runes

The alphabet for Runes is called the ***futhork,*** because this is the word made from the first seven letters. The strokes are

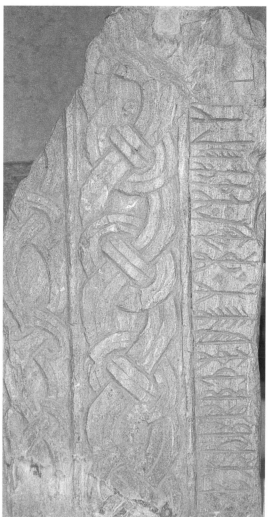

Runic inscriptions from crosses in the Isle of Man.

f u th o r c g w h n i j ᛝ p x s

t b e m l ŋ œ d a æ ea ḡ k k̄

The Anglo-Saxon Runic Alphabet is called the 'futhork' after the first six letters of the alphabet.

61

Caroline Minuscule from a delightful manuscript written mainly in a vibrant red. The show-through from the previous page is the Incipit *page for the Gospel according to St. Matthew. The large-size square capital letters, constructed by a number of separate strokes, can just be made out.*

BL, Harley MS 2795, f. 13v.

pori · &sequodest & ostender & & di inseopus mons

trans · &iaminhis quorum genus posiut · xpi operan

tur aprincipio testimonium nonnegat & · Quarum

omnium rerum · tempus · ordo · numerus · disposi

tio uel ratio · quod fidei necessarium est · ds xps

est · quinatus est ex muliere factus sublege ·

natus ex uirgine · passus incarne · omnia incruce

fixit uttriumphans ea insem & ipso resurgens in

corpore · & patris nomen inpatribus filio · & filii

nomen patri restituer & in filius · sineprincipio

sine fine ostendens unum secum patre esse quia

unus est · Inquo euangelio · utile est desiderantibus

dm sic prima uel media uel perfecta cognoscere ·

ut & uocationem apostoli & opus euangelii & dilec

tionem di incarnenascentis per uniuersa legentes

intellegant · Atque ineo quo adprehensi sunt & ad

prehendere exp&unt recognoscant · Nobis eni

hocinstudio argumenti fiut & fidem faccere tra

dere & operantis di intellegendam diligenter

et sedispositionem quererentibus nontacere ·

EXPLICIT ARGUMENTUM ⁙

abcdeefghijklm

Caroline Minuscule letter-forms.

KEY FEATURES

Pen nib angle – *27°*

x-height – *3 nib widths, ascenders and descenders 7 nib widths.*

Letter **o** form – *flattened round*

Slant – *5°*

Speed – *moderate*

Serifs – *built up club-shaped in historical model, or simple hook serifs to modernise the hand*

Letters which start with a downstroke

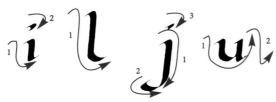

Alternative club serifs

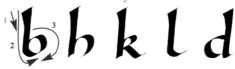

Make a downstroke to the right first, and then construct the letter.

Letters which start with a downstroke and then arch

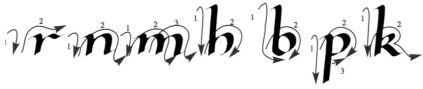

Letters based on the letter **o**

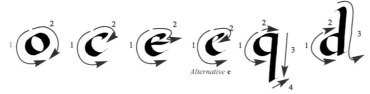

Alternative **e**

Diagonal letters

Alternative **y**

Letters which are exceptions

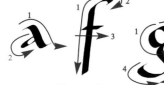 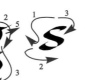

** Flatten the nib to 10° for the diagonal stroke.*

Ampersand

Numerals

0123456789

Punctuation

P q r s t u v w x y y z

Insular Minuscule from a slightly worn manuscript. The regular nature of the hand, which here is elevated to an impressive book hand, makes an even texture on the page. The long descenders which narrow gradually to end in a point are obvious. They are made by turning the nib slowly to 90° as the stroke is constructed. This takes a little practice to achieve, but is not difficult to do.

BL, Royal MS 5 F iii, f. 4v.

abcddefghijklm

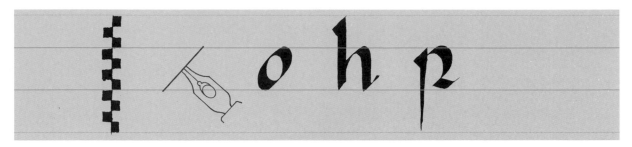

Insular Minuscule letter-forms.

KEY FEATURES

Pen nib angle – *48°*

x-height – *4 nib widths, ascenders 7 nib witdths and descenders 7 nib widths.*

Letter **o** form – *oval*

Slant – *upright*

Speed – *moderately fast*

Serifs – *built up club-shaped, exit strokes minimal in some cases.*

Letters which start with a downstroke

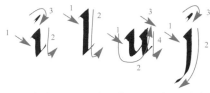

Letters which start with a downstroke and then arch

Alternative letter **r.**

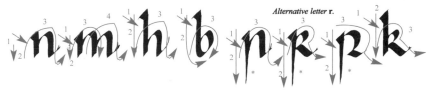

Letters which start with a stroke to the left

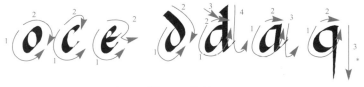

Diagonal letters

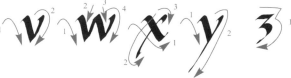

Letters which are exceptions

Et ligature

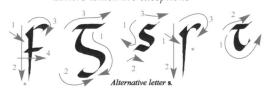

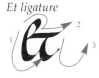

Alternative letter **s.**

* *This stroke is made by gradually turning the nib to 90° as you write.*

Numerals

0 1 2 3 4 5 6 7 8 9

Punctuation

65

The Ramsey Psalter, Winchester (?), late 10th century. This shows a strong regular script and its boldness indicates one of the reasons why it was chosen by Edward Johnston (who did much work at the beginning of the twentieth century to advance calligraphic knowledge) as a good foundation for the study of historical manuscripts.

BL, Harley MS 2904, f. 36.

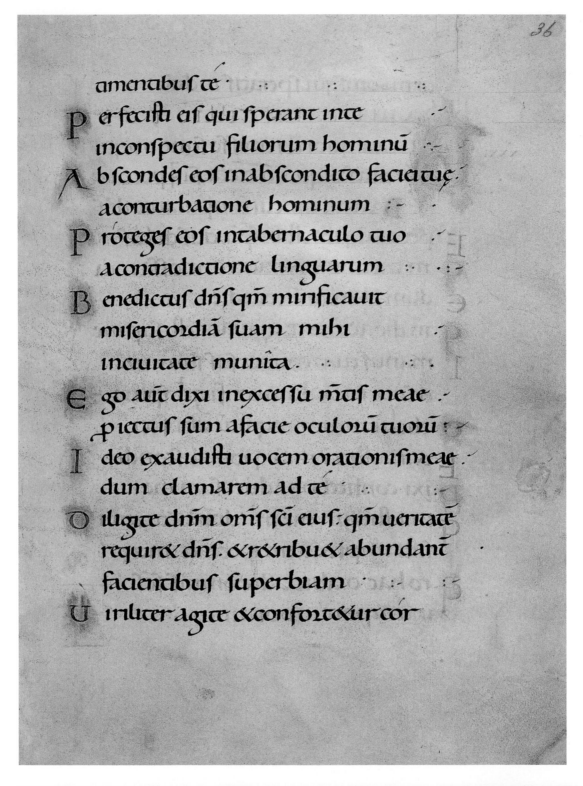

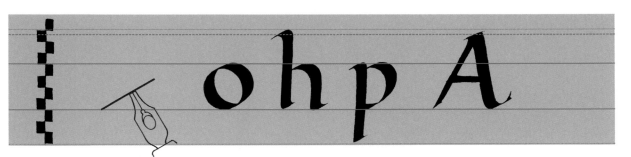

*English Caroline
Minuscule letter-
forms.*

KEY FEATURES

Pen nib angle – *30°*

x-height – *4 nib
widths, ascenders
and descenders 7
nib widths.*

Letter **o** form –
round

Slant – *2°*

Speed – *slow*

Serifs – *simple entry
and exit strokes, club
and beak serifs on
others.*

Letters which start with a downstroke

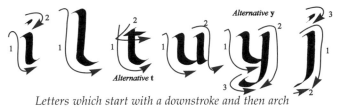

Letters which start with a downstroke and then arch

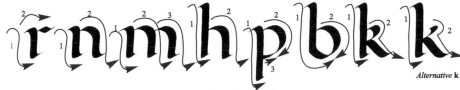

Letters based on the letter **o**

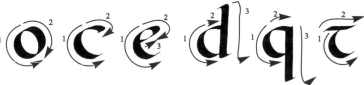

Diagonal letters

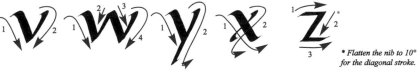

* *Flatten the nib to 10°
for the diagonal stroke.*

Letters which are exceptions *Ampersand*

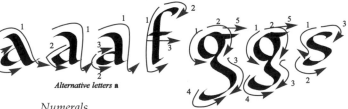

Numerals *Punctuation*

0123456789 .,-"" ::!?

opqrstΤuvwxyz

Writing English
Caroline Minuscule.

Listen. On this page the
heartbeat talks
Once this fine quill knew
wind-wide freedom.

usually single line which has the same width (no thicks and thins as on letters made with a broad-edge nib), and this creates an effective contrast between a gloss and text.

The Anglo-Saxons were particularly fond of riddles to the extent that one was carved around the front edge of the Franks Casket indicating that it was made of whalebone. Writing out riddles in Runes is a good way of combining them and another hand.

Caroline Minuscule

The bringing together of these various broad-edge nib styles into one manuscript developed to a high degree during the Carolingian period. The *scriptoria* in Europe were encouraged and developed by Charlemagne (742–814), King of the Franks from 768 and Holy Roman Emperor from 800. Interestingly enough Charlemagne's biographer writes that he never learned to write, yet he gathered around him a group of intellectuals and through them not only promoted Christianity but also encouraged the arts, reformed civil law and was responsible for the development of a Frankish grammar. More importantly for us he favoured the promotion of a beautifully clear and efficient style of writing.

In 781 Charlemagne encouraged Alcuin of York to enter his service. Eventually Alcuin settled at St Martin's Abbey at Tours in France. This was the abbey which produced many of the great Carolingian books – the Tours Bibles.

A hierarchy of scripts was also developed for use in these Carolingian books. The large initial which started one section and the beginning part of that section, the *Incipit* (often abbreviated to INCP), would have been written in Versals –

majuscules or capital letters made with more than one stroke of the pen. A single Versal was also often written at the beginning of each paragraph. The start of the text was then usually written in Uncials of decreasing size, and again these letters were used as initials for the verses. In some sections Rustics were used at the ends of chapters the *Explicit* and Square Roman Capitals at the most important beginnings.

The main text was written in Caroline Minuscule. Even at a tiny size, when lines are just about 2 mm (0·1 inch), the text is legible and easy to read.

The hand is cursive, with fewer pen lifts than in previous historic styles. Letters such as **n, m, r** and **h** are usually written either without lifting the pen, or with a very slight pause, but pushing the stroke up from the baseline for x-height.

Because of its many excellent qualities it was to Caroline Minuscule that Italian printers referred in the Renaissance to find the best designs for their type styles. We do not use a two-storey letter **a** in our ordinary writing today, nor a **g** with two bowls, yet we accept it and read it without thinking in the text in this book. These letter styles have been used for hundreds of years as the basis of many type designs, and so we are familiar with their shape.

English Caroline Minuscule

Edward Johnston, the reviver of calligraphy in Britain in the twentieth century, used the formal round letters in the Ramsey Psalter as the inspiration for his Foundational Hand. He wrote *'this extremely legible manuscript would form an almost perfect model for a modern formal hand.'*

Compared with some of the previous historical styles the

Writing now, a feather
follows my thoughts.

Always allow slow sounds

time to shape their music

*Writing English
Caroline Minuscule
Compressed.*

letters in the Ramsey Psalter are large with an average x-height of about 5 mm (0·25 in), ascenders and descenders being 8 mm (0·4 in), though there are many variations in size.

It was written in the south of England, possibly at the Cathedral Priory at Winchester or at Ramsey Abbey in the last quarter of the 10th century. The style is an anglicised Caroline Minuscule, and with a similar maturity of style. The letters are clear and consistent, based on a round letter **o.**

Looking closely at the manuscript it is easy to feel the pleasure the scribe must have had in writing out these grand letters.

The individual letters are spaced closer than we would place them today, which gives a slight air of compression to the page. The letter-forms are based on a round letter **o,** and the other letters of the alphabet take their shape or width from this. It is possible to write a series of letters **o** and overwrite most of the other letters of the alphabet using

Spaces hold the tensions
of the heart.

Whenever man writes
there are stones assembled.

*Writing Gothic
Script.*

The elegant letter-forms of Eadui Basan in the Grimbald Gospels, written probably at Christ Church, Canterbury in about 1020.

BL, Additional MS 34890, f. 39v.

uidimuf hofpicem &collegimuf te:· Auc nudum & cooperui
muf te:· Auc quando te uidimuf infirmum · Auc in carcere &
uenimuf ad te:· Et refpondenf rex · dicc illif · Amen dico uobif ·
quam diu feciftif uni de hif fiuoribuf meif minimif · mihi fe
ciftif · Tunc dic & hif · qui a finiftrif eiuf erunc · Difcedice
a me maledicti in ignem æternum · qui paracuf eft diabolo
& angelif eiuf · Efuriui enim · & non dediftif mihi manducare·
Siciui · & non dediftif mihi pocum · hofpef eram · & non colle
giftif me · Nuduf · & non operuiftif me · Infirmuf & in carcere ·
& non uifitaftif me · Tunc refpondebunc ei · & ipfi dicencef ·
Dñe · quando te uidimuf efuriencem · Auc fiuencem · Auc
hofpicem · Auc nudum · Auc infirmum · uel in carcere & non
miniftrauimuf tibi · Tunc refpondebic illif dicenf · Amen
dico uobif · quam diu non feciftif uni de minoribuf hif · nec
mihi feciftif · Et ibunc hi in fupplicium æcernum · Iufti autem ·

in uitam æcernam

FXXVI **E**T FACTUM EST CUM CONSUMMASSET IHS
ſermonef hof omnef · dixit difcipulif fuif ·
Ꞇ **S**CITIS QUIA POST BIDUUM PASCHA FIET · ET FILIVS HOMINIS
Ꞇ ſtradecur uc crufigacur·

Tunc congregaci funt princepef facerdocum & fenioref po
puli in acrium principif facerdocif qui dicebacur caiphaf·
& confilium fecerunc uc ihm dolo tenerenc & occiderenc ·
Dicebanc autem · Non in die fefto · ne forfte tumulcuf
fierc in populo ·

Cum autem ihc effec in bethania in domo fimonif leprofi·
Accessic ad eum mulier habenf alabaftrum unguencu

aabcdefghijkln

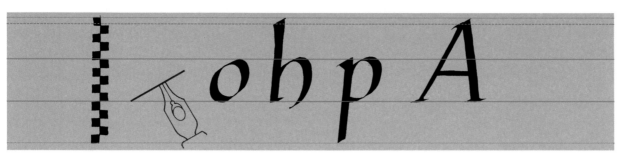

English Caroline Minuscule Compressed letter-forms.

KEY FEATURES

Pen nib angle – *30°*

x-height – *5 nib widths, ascenders and descenders 9–10 nib widths.*

Letter **o** form – *forward slanting oval.*

Slant – *5°*

Speed – *slow to moderate.*

Serifs – *wedge-shaped entry strokes to letters without ascenders, club-shaped serifs to ascenders and tick serifs as exit strokes.*

Letters which start with a downstroke

*Letters based on the letter **o***

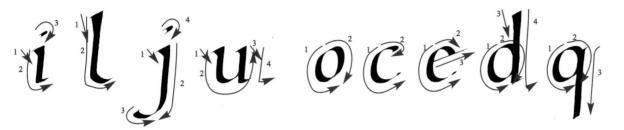

Letters which start with a downstroke and then arch

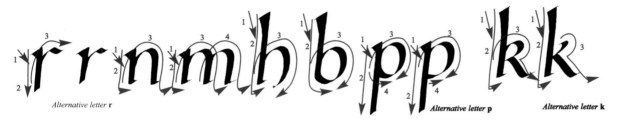

Alternative letter **r**

Alternative letter **p**

Alternative letter **k**

Diagonal letters

Letters which are exceptions

Alternative letter **g**

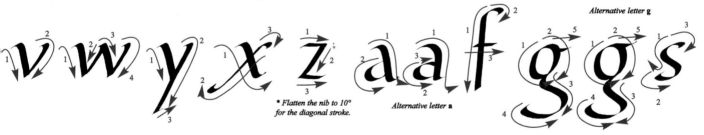

Flatten the nib to 10° for the diagonal stroke.

Alternative letter **a**

Numerals

Punctuation

Ampersand

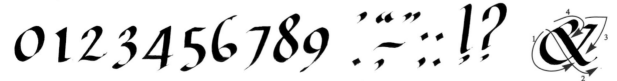

portions of this letter. Problems in some letter-forms are made when the arch starts too low down on the stem, not following the natural curve of the letter **o**.

English Caroline Minuscule Compressed

Eadui Basan (see also page 155 and 158) wrote a number of manuscripts in the 11th century, and his style of writing is quite distinctive. He took the English Caroline Minuscule letter-forms and made them his own by slightly narrowing the letter **o** and extending the heights of the ascenders and descenders, producing an elegant flowing hand which is a good one to copy and adapt. Unusually, the letters **b**, **d**, **p** and **q** are formed by writing a complete letter **o**. For the letters **b** and **p** the ascender is written first followed by the letter **o**, but for **d** and **q** the letter **o** starts the letter-form. In the case of the **d** and **p** this makes for a juxtaposition of thick strokes between the bowl and the ascender which you may wish to avoid by constructing these letters in a similar way to those in other alphabet styles, by flattening the second stroke of the bowl so that a thinner stroke meets the ascender.

Gothic Script

The roundness and fluidity of Uncials, Caroline and English Caroline Minuscule gradually gave way to a more rigid, tighter style. As with all changes in writing styles, this did not happen overnight, but took place over many years. The roundness of Romanesque architecture also gave way to the soaring upright and elegant shapes of the Gothic style.

This narrow style of writing had a distinct advantage, not lost on the scribes of the time. Far more could be written in less space, and as an increasing number of people became literate, more and more books were required.

The idea that we may have of monks and nuns at this time writing books in cold monastic cloisters does not quite match the evidence. Book production had become a business, often sited close to major monasteries, cathedrals and abbeys. Scribes, illuminators, painters of miniatures and book binders all played their part. Scribes wrote out examples of their work, and customers could choose their preferred style from books

or pages of samples. Other samples, references or teaching manuscripts illustrated the various stages in painting and decorating the page.

The old style of marking out the positions for guidelines using a pointed stylus had also by this time given way to large frames which were strung with cords at appropriate intervals. Sheets of vellum for one text would be placed within the frame on which pressure would then be exerted. The cords were pressed into the vellum at the appropriate places to mark the lines, headings and so on. Through the book the markings on the first pages pressed were heavy, and these gradually became less marked on successive pages.

Gothic Script is a tight, dense hand looking black on the page, and is often thought to resemble a picket fence. The white spaces within and between the letters are balanced by the black lines and it will take some practice to achieve that even effect. Gothic is a style which many beginners want to learn, however it is particularly difficult to read because there are so few curves in the letters. It is almost impossible to read words written in majuscules only and this should be avoided.

There are many variations in Gothic Scripts. At first the rounded letters were only slightly compressed in Protogothic scripts, then they became more angular, and finally so compressed that the individual letters became very difficult to distinguish. Looking at some historical manuscripts you can see why dotting the letter **i** became essential at this time. With that a word like *minimum* is legible; without, it takes time to decipher the letters.

Majuscules

Majuscules, unusually taller than ascenders, and indeed the only calligraphic hand where this is so, are also very elaborate. By tradition they are filled with flicks, ticks, diamonds and vertical hairlines to fill in the white spaces so that there is less contrast between them and minuscules. Look at as many examples as you can and either choose a style which appeals to you, or devise your own design of decoration. As before, be consistent in maintaining the flicks, ticks and diamonds in all the letters.

Bâtarde

Bâtarde is an elegant style written impressively with great panache and many flourishes in a number of manuscripts including the historic example shown on page 78.

Bâtarde has much rhythm and swing to it. After the careful and meticulous pen movements of previous styles which slow down the writing, it is refreshing to find this flowing style. But its essentially cursive nature is deceptive. There

Constructing the fishtail serifs with the corner of the pen nib. Write the main stroke of the letter then press the nib into this to ensure that the ink is flowing. Now turn the nib on to the left-hand corner and pull out a hairline of ink to make this stroke.

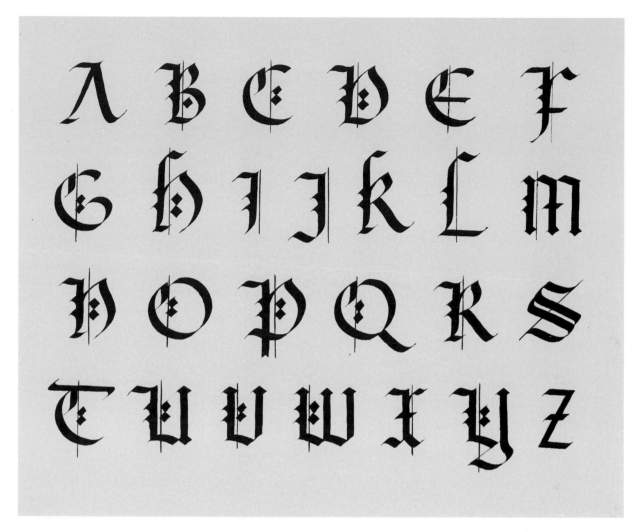

Majuscules which can be used with Gothic Script.

are many fancy flourishes and pen manipulations in this hand, too, and this was a hand definitely written to be seen, if not always to be read easily! It is a style which, when written well almost leaps off the page with the joy of writing.

The long **s** and **f** and the descender of the letter **p** are very obvious in almost all examples of Bâtarde, and, similar to the descenders in Insular Minuscule, are made by gradually turning the pen to a steep angle, indeed to 90°, towards the end of the stroke whilst writing. This requires a free and relaxed elbow and so is not a script to be attempted when you are tense and under pressure.

The style uses the corner of the nib in the construction of many of its letters. Remember to press the nib down within the previously written thicker stroke first to release the ink, which can then be pulled where you want it to go by using the left-hand corner of the nib. Although there are no fishtail serifs in Bâtarde, the diagram opposite may clarify this.

Majuscules

The majuscules for this hand are usually quite magnificent! They are exaggerated and written with a swagger, often much wider than you would think. There are rarely the flicks and ticks, diamonds and hairline infilling strokes of Gothic Script, yet the style of the hand does seem to be able to carry off the amount of ensuing white space. The majuscules shown on page 80 are copied from those in Christine de Pisan's manuscript.

Italian Rotunda

While the manuscripts in northern Europe were being written in an increasingly narrow and tight style of Gothic, those in

73

Gothic Script letter-forms from a 13th Century manuscript, with small raised gold letters written at the left margin, and made by applying leaf gold on to gesso.

BL, Additional MS 44949, f. 100r.

74

a b c d e f g h i j k l m n

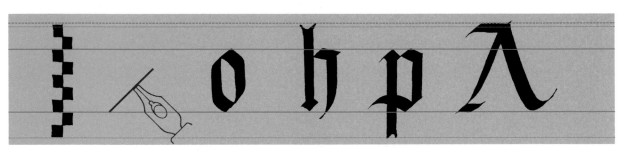

Gothic Script letter-forms.

KEY FEATURES

Pen nib angle – *45°*

x-height – *5 nib widths, ascenders and descenders 6·5 nib widths*

Letter **o** form – *angular*

Slant – *upright*

Speed – *slow*

Serifs – *starting diamonds with some fishtail serifs*

Letters which start with a downstroke

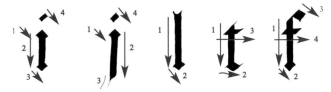

Letters which start with a downstroke and then 'arch'

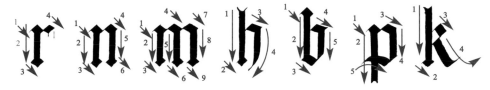

*Letters based on the letter **o***

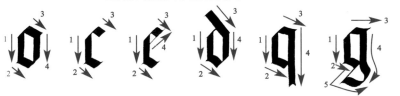

*Letters based on the letter **u*** *Ampersand*

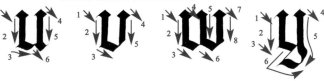

Dotted lines indicate strokes made with the left-hand corner of the nib.

For fishtail serifs, write the down stroke first, and then use the left-hand corner of the nib to pull the ink out to the left and up. See page 72.

Letters which are exceptions

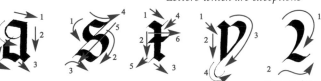

*Alternative letter **r***

* *Flatten the nib to 10° for the diagonal stroke.*

Numerals *Punctuation*

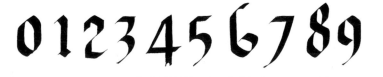

0123456789 .,–''::!?

qr2stuvwtyyz3

Writing Bâtarde.

Tremble before the moment

of your birth.

Light burns in these words.

Come warm your eyes.

Majuscules which can be used with Bâtarde.
These are copied from those in the manuscripts written by Christine de Pisan herself, one of which is shown on page 78.

A B C D E F

G H I J K L M

N O P Q R S

T V V W X Y Z

Italy and Spain, while having Gothic characteristics, were nevertheless much rounder and less compressed – thus the name of Italian Rotunda.

This hand was used both for small manuscripts bound into tiny personal Books of Hours as well as for very large volumes, where the hand was often combined with lines of musical annotation, and where Rotunda often can look at its grandest. These impressive choir books would be placed on a central lectern-style support and read by most of the choir at once.

Many of the uprights in Rotunda start or end with a horizontal shape to the stroke. This is not easy to achieve for a beginner. You may find it easier to start these strokes with a simpler diagonal. To make the flat-ended stroke, or **prescissus terminals,** use the left-hand corner of the nib to outline the flatstroke at the top or bottom of the downstroke and then fill in the white space with ink. The alternative is to start with the nib at 0° to the horizontal, gradually turn it for the downstroke, and finish by easing the nib around again to 0°. However, in practice, and looking closely at original manuscripts, it is unlikely that this was the way in which this stroke was constructed because there is little 'waisting' of the down-stroke or minim (which is what would occur when written this way) in evidence in historical mansucrips.

Humanistic Minuscules

Humanist scholars wrote and produced their own and class-ical texts during the Renaissance. It is possible that they were consciously looking for a Roman or classical revival and so went back to what they considered was a style of writing used during these times, but this was, in fact, Caroline Minuscule. Hand-written letter-forms and typeface designs developed from this and have been passed on down the centuries to us. So we have the two-storey letter **a** and looped **g** which can be seen easily in the Times New Roman typeface used for this book.

Humanistic Minuscules can sometimes be rather stilted and it is important to select examples which have life and spirit to them rather than ones which look as if they, too, are merely printed typefaces.

These letter-forms have such grace and elegance and are a good style to learn soon after you have covered the basics as there are few pen manipulations or difficult letters to write. The arches have a smooth inner curve or counter, and to achieve this it is important to push the pen up from the base line. If you start this stroke halfway up the downstroke there will always be a slight angle or 'corner' where the two strokes join.

Use Renaissance Capitals as majuscule letters when writing in this hand.

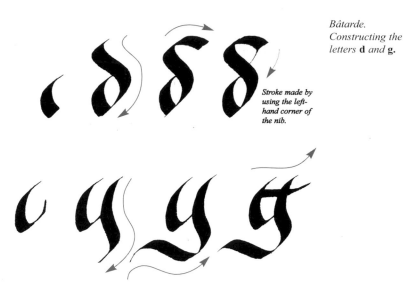

Bâtarde. Constructing the letters **d** *and* **g.**

Stroke made by using the left-hand corner of the nib.

Renaissance Capitals

Writing Renaissance Capitals involves a degree of pen mani-pulation and as they are usually widely spaced they were not often used for solid blocks of text. These Capitals were written by humanistic scribes particularly Bartolommeo Sanvito as in the example on page 90, such that they became typical of his work. Sanvito wrote a number of manuscripts, and he often used Capitals in them, writing the letters with great vigour and verve, yet beautifully spaced. Typically the letters were coloured and gilded; the first line he uses gold and blue, the next gold and red, then gold and green foll-owed by gold and purple and then back to gold and blue.

The letters are similar in proportion to Roman Capitals, with round letters being based on a slightly squashed hori-zontally round letter **O** – looking a little like an orange. The remaining letter-forms take their shape and width from this.It is probably better to become familiar with Roman Capitals first before you tackle this hand.

Humanistic Cursive Book Script

This is an interesting hybrid hand invented by Niccolò Niccoli as a book hand by about 1420. You can see from the illustration on page 92 that there are elements of Humanist scripts in the roundness of the bowls of the letters, such as those on the letters **a**, **d**, **p** and **q**, and particularly a round letter **o**, yet a narrowness to other letters such as **b**, **h**, **n** and **m**. Perhaps this was because it was an invented hand and not one which evolved naturally. This does, however, give a more informal effect to the hand,

77

Christine de Pisan was a remarkable woman in being possibly the first woman to earn her living as a scribe and writer. This is an example of her writing the Bâtarde script, a particularly lively and vibrant hand when written as well as this. Paris, c. 1415.

BL, Harley MS 4431, f. 244r.

a b c d e f g h i j k l m

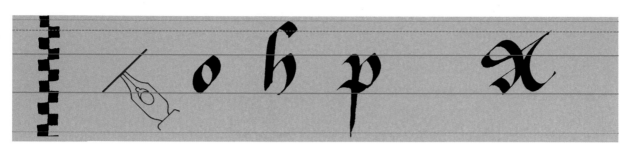

Bâtarde letter-forms.

KEY FEATURES

Pen nib angle – *45°*

x-height – *3·5 nib widths, ascenders 7 nib widths and most descenders 7·5 nib widths. Letters* **g** *and* **y** *shorter*

Letter **o** form – *narrow oval with a pointed counter*

Slant – *5°*

Speed – *moderate*

Serifs – *starting diamonds on some letters, arched serifs to the right on ascenders*

Letters which start with a downstroke

Letters which start with a downstroke and then arch

** Gradually turn the nib to 90° as you make this stroke.*

Letters based on the letter **o** *Letters based on the letter* **a** *Tironian et symbol*

** Gradually turn the nib to 90° as you make this stroke.*

Dotted lines indicate strokes made with the left-hand corner of the nib.

Letters which are exceptions *Letters* **v** *and* **w**

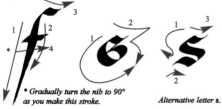 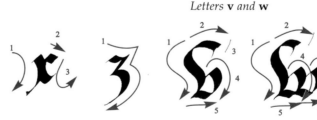

** Gradually turn the nib to 90° as you make this stroke.*

Alternative letter **s**.

Numerals *Punctuation*

0123456789

Writing Italian Rotunda.

Evening brings this

hand a long shadow

Majuscules which can be used with Italian Rotunda.

A A B C D E F
G H I J K L M
N O P Q R S T
U V W X Y Z

Writing Humanistic Minuscules.

Only an end can forsee a beginning

and is similar to a very regular, careful handwriting.

Although the style is called cursive, do not feel that every single letter needs to be joined to the next. As can be seen in this historic example letters such as **p** and **b** are often not joined to the following letter.

Italic

After all the extravagance of mediæval lettering, the purity and clean lines of the Italic hand must have been refreshing. Styles were changing. Italic was used for writing business documents and communications, but it, too, was a book hand, written elegantly in the historical example by Ludovico degli Arrighi (see page 94) who was employed by the Apostolic Chancery. The slightly forward sloping script helps to give the style clarity and grace, and together with the wide spacing of letters and lines, make this a good choice to study more closely for the characteristics of the Italic hand.

Italic is a very versatile hand, and can be used for formal and informal pieces. The letters can be squashed down or pulled up to many times the conventional x-height. However, before being too experimental, do make sure that you are familiar with the essential letter shapes.

The characteristic feature of Italic letters is the springing arch. Although you may make a pen lift between the first and second strokes on letters such as **n** and **h,** that second stroke starts from the bottom guideline, as with Humanistic Minuscules. This is mirrored in the pen pushing up to the upper guideline for the first stroke of letters such as **a, d** and

u. Do not stop midway on these letters, nor start half-way up the stem on arched forms. Look at the counter, or white space, within the letters. There is a beautifully smooth curved shape within the letters. No matter how hard you try to avoid it, if you take your pen from the paper or start half way up the stem, there is always a slight angle and sharpness to the join, which you do not want. With a wide nib and paper with a texture, this smooth stroke can be a problem, but the flow and character are lost if you do not push from the bottom. Take as much pressure off the pen as you can for this stroke, and breathe in as you write. Soon you will be creating beautiful springing arches without any problem.

The hand is narrower than Caroline Minuscules or English Caroline Minuscule. It is based on an oval letter *o* which slants slightly forward, so that the counter (white space) within the letter is actually upright. Counters in all letters matter a great deal, and soon you will be checking the counters as much as you inspect your letters. The narrower style means that you can use Italic for pieces where long lines cause problems with a wide lettered alphabet.

Italic letters lend themselves to flourishes. The top line in an impressive panel written in Italic may have some extended ascenders with exaggerated flourishes. Or initial letters may be flourished on the left-hand side of a piece. (See page 88 for flourished minuscules and page 89 for flourished majuscules.)

Make sure that you are familiar with the essential form of letter-shapes before you attempt to flourish, and do not lose that shape as a result of the flourish. The flourish extends one aspect of the letter, perhaps the ascender or the lead-in stroke, but it does not alter the essential character of the letter.

The letters which are difficult to flourish properly are the

Italian Rotunda. It seems rather appropriate that these letters are used for an Italian text – Dante's Divine Comedy. *This book was written less than fifty years after Dante's death in 1321, and already his poem was providing inspiration for scribes and illuminators. The strong, bold letterforms are a suitable match for the lively, vibrant paintings. Naples, c. 1370.*

BL, Additional MS 19587, f. 44v.

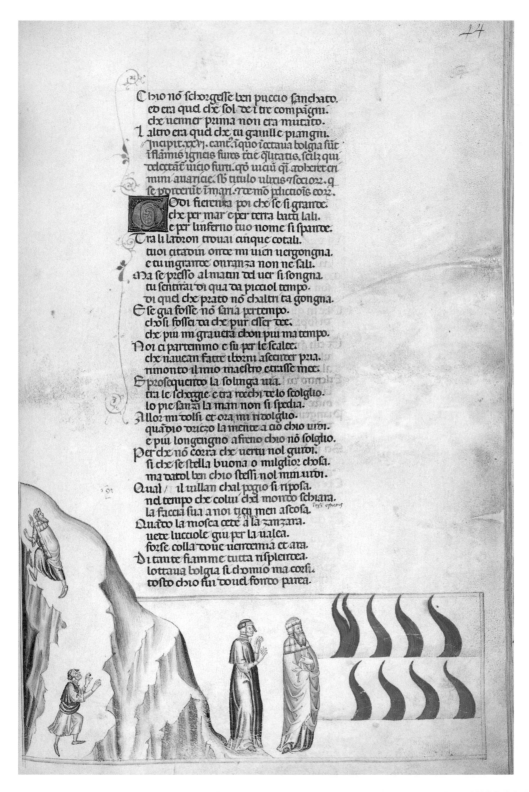

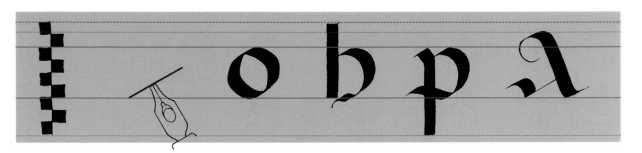

Italian Rotunda letter-forms.

KEY FEATURES

Pen nib angle – *30°*

x-height – *4 nib widths, ascenders 6 nib widths and descenders 7 nib widths*

Letter **o** form – *angular/round*

Slant – *upright*

Speed – *slow*

Serifs – *mostly hook serifs with some prescissa terminals*

Letters which start with a downstroke

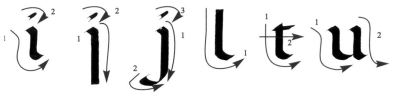

Letters which start with a downstroke and then arch

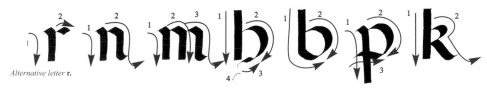

Alternative letter **r**.

Letters which start with a stroke to the left

Diagonal letters　　　　　　　*Tironian e/t symbol*

Letters which are exceptions

Alternative letter **r**.

Dotted lines indicate strokes made with the left-hand corner of the nib.

Numerals　　　　　　　　　　*Punctuation*

0123456789　　　:;,-.::!?

opqrzstuvwxyz

Writing Renaissance Capitals.

ALL WORDS ATTEMPT TO KNOW TRUE SILENCE

letters *O, S* and *C,* both minuscules and majuscules. The best solution is simply to enlarge them, perhaps opening the letter *O* to incorporate an inward curve, and to extend the upper or lower curve of the letter *C,* as shown in the examples.

Remember that it is better to flourish once and well on one letter, rather than extend and twirl every stroke that is possible!

When starting to flourish letters, use a pencil or a calligraphy felt tip pen in a small nib size. It is easier to push these around the paper without it getting stuck in the fibres. Then use a calligraphy dip pen nib, remembering that it is easier to flourish with a smaller nib.

Choose a pencil again for working out flourishes for a whole piece of lettering. Try to have an even balance of flourishes both along a top and bottom line and at either side of a block of text. Choose to flourish some letter and leave others alone to achieve this.

Majuscules

Renaissance Capitals such as those written by Bartolommeo Sanvito (see pages 90–91) usually work well with the Italic hand, but you may choose to use upright Roman Capitals to form a contrast (see pages 46–47 for these). Often lines of poetry were written with an upright majuscule at the beginning and the rest of the word spaced a little way away so that the majuscule looks quite separate.

Copperplate

All the previous alphabets have been written with a pen with a broad-edge nib, where the differences between the thicks and thins are made by the angle at which the nib is held. Copperplate is different; these letters are written with a pen with a pointed nib, and the thicks and thins here are made by pressure on this flexible nib. This style reached dizzy heights of competence in the eighteenth century, with pen manipulation and the resulting flourishes and curlicues very often detracting from what was meant to be read.

Copperplate was named after the new printing method of engraving letters and designs back-to-front on sheets or plates of copper with pointed metal burin. When inked and then wiped clean the image was transferred on to printed pages.

The result of lettering with a burin was beautiful letters which did not always fit the natural movement of the letter-form or the hand. Very often almost all the letters in a word joined, and such joins were sometimes quite contrived. Dots and patterns may have ended letters, which, although attractive, was not conducive to speed nor, sometimes, legibility.

Copperplate became the lettering style of the clerk, and was taught to children at elementary schools in the nineteenth century so that they could be efficient in their future careers in the offices of companies which serviced the expanding British Empire. Nowadays we look at examples of the 'ordinary' handwriting of this generation and comment favourably on the effect produced by the repetitive and seemingly

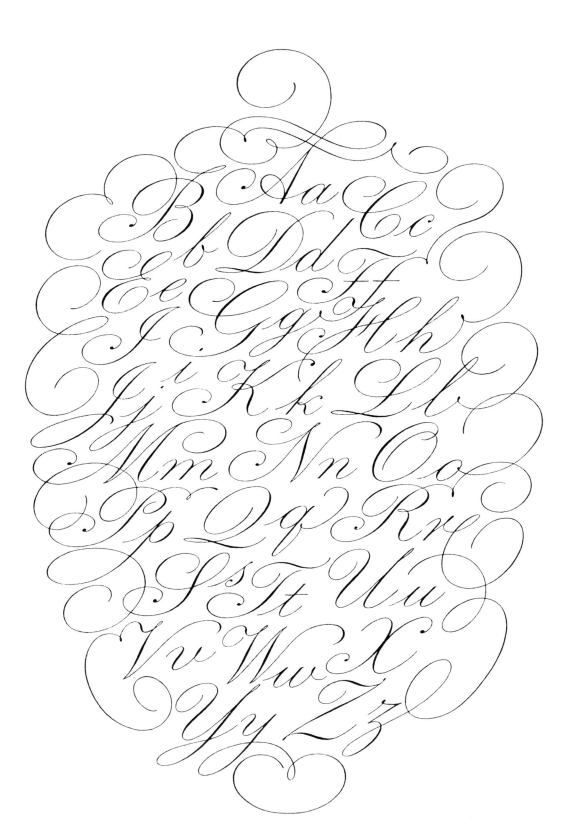

A page of beautiful
Copperplate letters
by modern scribe
Fred Marns.

This tiny book, with page sizes of 9 cm by 16 cm (3·5 inches by 6·5 inches) and decorated borders shows how elegant Humanistic Minuscules can be. The letter-forms are just over 1 mm (less than 0·1 inch) high.

BL, Lansdowne MS 831, f. 56v.

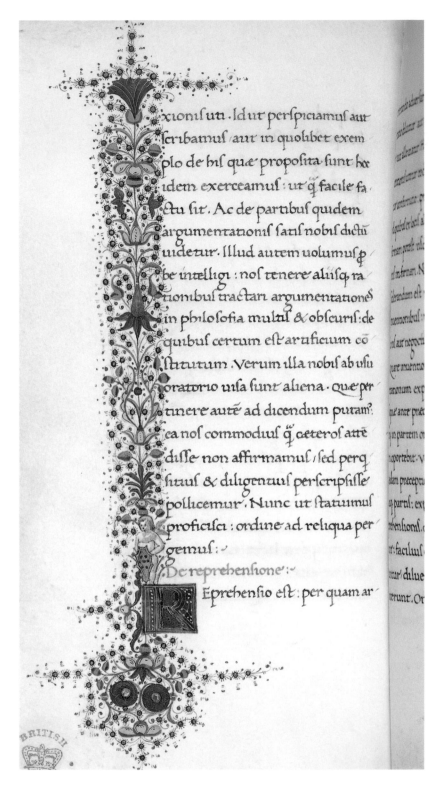

abcdeefghijkl

Humanistic Minuscule letter-forms

KEY FEATURES

Pen nib angle – *30°*

x-height – *5 nib widths, ascenders and descenders 11 nib widths*

Letter **o** form – *oval*

Slant – *1°–2°*

Speed – *moderate*

Serifs – *Simple entry and exit strokes*

Letters which start with a downstroke

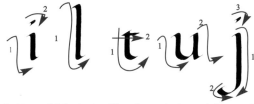

Letters which start with a downstroke and then arch

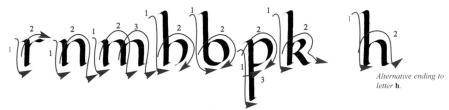

Alternative ending to letter **h**.

Letters which start with a stroke to the left

Diagonal letters

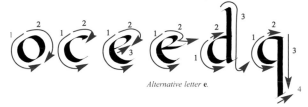

Alternative letter **e**.

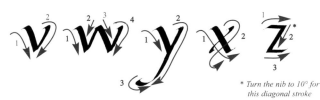

Turn the nib to 10° for this diagonal stroke

Letters which are exceptions

Ampersand

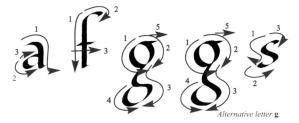

Alternative letter **g**.

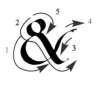

Numerals

Punctuation

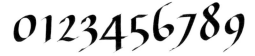

opqrstuvwxyz

*Flourished Italic
minuscules.
Extend one part of
the letter without
distorting the basic
shape, and use
sparingly.*

endless copying of lines again and again to perfect the form. At the time, this style was often ridiculed by the ruling classes as that fit only for the status of mere clerks!

True Copperplate is impossible to write unless you have a flexible pointed Copperplate nib. These are still manufactured and available at specialist suppliers, but it is also possible to find suitable nibs at antique fairs or shops. Many millions of nibs were produced in all sorts of decorative styles, some shaped like a hand, a bird or even the Eiffel Tower!

A variety of manufactured Copperplate nibs have an elbow shape to them. Some people find this helps with their Copperplate writing, others, including myself, find it a distraction to use a nib where the writing end is not where you expect it to be. Try an ordinary Copperplate nib before you buy one of these – the elbow shape may help you or not.

Because the nib must be flexible, you should not use a reservoir with these nibs. This means that you will need to dip the pen into ink fairly frequently. As well as this, Copperplate nibs cannot be sharpened to improve their flexibility and the crispness of letters. Once a Copperplate nib has lost its flexibility it must be discarded and a new one used.

Copperplate is a difficult style to perfect, after all, it took generations of Victorians hours in a week copying line by line, with yet more recopying, if the copy books which can be seen in museums are any indication. It also requires a

different movement from the other styles of lettering. Letters are written in one stroke, it is cursive, and there is an almost leisurely feel about the hand. Persevere if you like the style, but do not get too despondent if evenness and regularity take a while to develop.

The same nib can be used to write letters of almost any size in Copperplate, so the x-height does not relate to the width of the nib. The heights of ascenders and descenders, though, are long, and they are often looped and elaborate.

The emphasis in this lettering style is made by pressure on the nib on the downstrokes. The lightest pressure is on upstrokes and joining strokes.

To increase the size of letters, write larger and press harder on the down strokes so that these are thicker.

Unlike other lettering styles considered, where the angle at which the pen is held determines the letter-shape, there is no set angle to hold your pen nib in Copperplate writing. However, the pen should be held at a consistent angle, and is regarded almost as an extension of the hand.

There is a difference in the paper position, though. For every other alphabet it is best to have your sheet of paper placed upright on a sloping board, although left-handers may choose to change this angle for comfort. It is easier, however, to maintain the slant of the Copperplate style if the paper is positioned here at an angle. The left-hand corner should be

A A A A A A B B B C C

D D E E E F F F

G G G H H H I J J

K K K L L L M M M

& M N N N O P P P Q

Q Q R R R R S S T T T

U U U V V V W W W

& W X X Y Y Y Y Z Z

89

Renaissance Capitals. The delightfully elegant majuscule letters written by Bartolommeo Sanvito. Note his characteristic use of colour. In the first line the letters are written in gold and blue, the next gold and red, then gold and green followed by gold and purple and then back to gold and blue again.

BL, Royal MS 14 C iii, f. 2v.

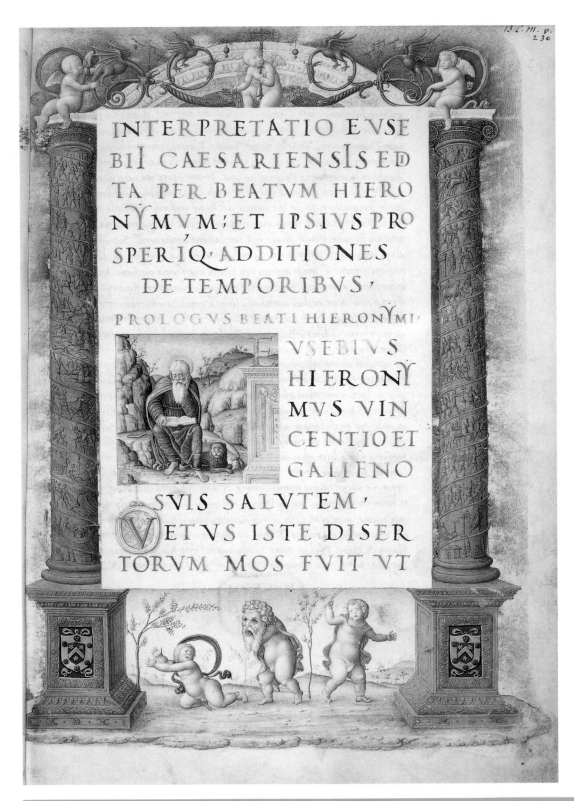

90

ABCDEFGHIJKLM

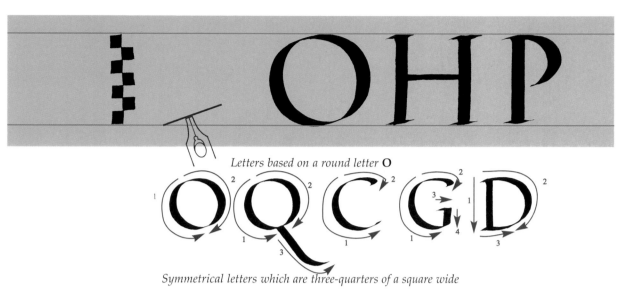

Renaissance Capital
letter-forms.

KEY FEATURES

Pen nib angle – *20°*

x-height – *7 nib
widths*

Letter **O** form –
*Round but slightly
squashed*

Slant – *1°–2°*

Speed – *slow*

Serifs – *as chosen*

Letters based on a round letter **O**

Symmetrical letters which are three-quarters of a square wide

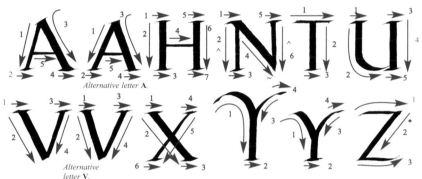

Alternative letter **A.**

*Alternative
letter* **V.**

*^ Turn the nib to 60°
for this stroke*

*~ Twist the nib so that it
is 90° at the end of this
stroke*

** Turn the nib to 10° for
this diagonal stroke*

Asymmetrical letters which are half a square wide

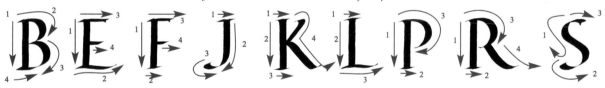

Letters which are exceptions

Ampersand

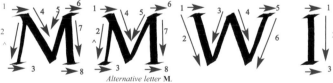

Alternative letter **M.**

Numerals

Punctuation

OPQRSTUVWXYZ

Humanistic Cursive letter-forms. This herbal, written on vellum with delightful drawings of the relevant plants, has a dedicatory epistle from Johannes Phillipus de Lignamine, physician to Sixtus IV, to Cardinal Francesco Gonzaga who died in 1483.

BL, Additional MS 21115, f. 41v.

A grecis dr calamentes : alij elethon agrion . alij
osinites bremu . alij thesboostanes . Propter gonos
apollonos . Itali mentastrum uocant .

A d aurium uitia uel dolores .

h erbe mentastri sucus cu uino austero mixtus
& in auricula coniect umes natos necare credit .

A d elefannosos .

h erbe mentastri folia adhibentur comanducata
sanare certum est .

v t scias cuius stelle tutela sis .

h erbam mentastrum tollis mundus in linteolo
mundo habeto , ut qn in pane cocto granu fru
menti integrum inueneris , qd simul cum her
ba ponito & precare septe . i . solem Luna mar
tem mercurium jouem venerem saturnum
& sub puluino pone ut tibi per quietem osten -
dant in cuius stelle tutela sis .

N omen herbe hebuli .

A grecis dr camesete . alij meros aphrodites . alij
cameatte . alij aliatehuc . Galli eubocone . Dacij
olma . Itali ebulum dicunt .

A d calculosos .

h erbam hebulum tenerum cum folijs tritu ex
uino potu dabis , calculos expellit .

A d splenem .

R adice hebuli cocta ad tertias cu aqua bibat .

A d colubri morsum .

abcdefghijklr

Humanistic Cursive Book Script letter-forms.

KEY FEATURES

Pen nib angle – *45°*

x-height – *4 nib widths, ascenders 9 nib widths and descenders 8 nib widths*

Letter **o** form – *slightly forward slanting round*

Slant – *3°*

Speed – *moderate*

Serifs – *simple entry and exit strokes on most letters*

Letters which start with a downstroke

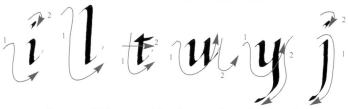

Letters which start with a downstroke and then arch

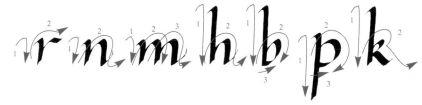

Letters which start with a stroke to the left

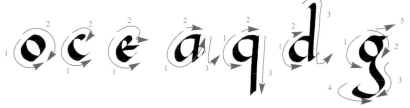

Diagonal letters | Letters which are exceptions | Ampersand

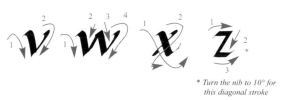
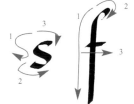

** Turn the nib to 10° for this diagonal stroke*

Numerals | Punctuation

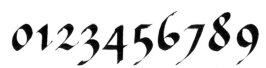

93

opqrstuvwxyz

Italic.
A beautiful page design of illumination and lettering in a book presented to King Henry VIII of England by Geoffrey Chamber. Note the coat of arms at the base of the page where the fleurs-de-lis of France are placed in the most important quarter of the shield (the dexter chief, see page 217) indicating the King of England's claim to lands in France.

BL, Royal MS C. VIII, f. 4.

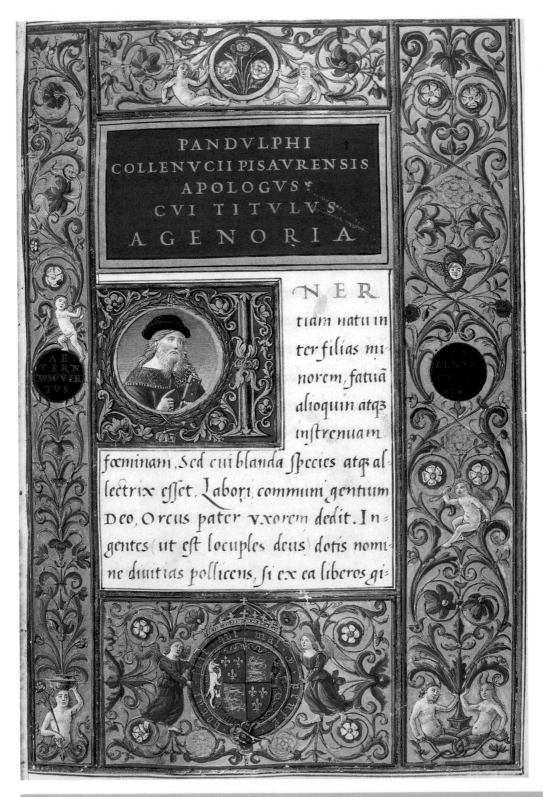

94

abcdefghijkkl

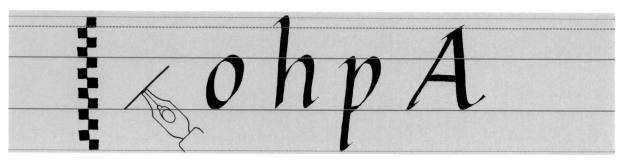

Italic letter-forms.

KEY FEATURES

Pen nib angle – *45°*

x-height – *5 nib widths, ascenders and descenders 9 nib widths*

Letter **o** form – *slightly forward slanting oval*

Slant – *5°*

Speed – *moderate*

Serifs – *simple entry and exit strokes on most letters*

Letters which start with a downstroke

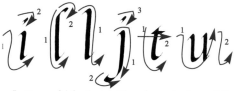

Third letter from left shows an alternative letter **l** *with a simply hook serif at the head of the ascender.*

Letters which start with a downstroke and then arch

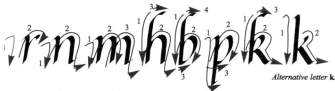

Alternative letter **k.**

Letters which start with a stroke to the left

Diagonal letters

** Turn the nib to 10° for this diagonal stroke*

Letters which are exceptions

Ampersand

& &

Numerals

0123456789

Punctuation

., '"" :; '!?

opqrstuvwxyz

Historical
Copperlate.
A page of beautifully
written (inscribed
with a burin into a
copper plate in
reverse) Copper-
plate by B. Whilton
from 'The Universal
Penman' with a
message which is
appropriate to us
all perhaps.

BL, 1269 i 23.

31.

Study.

*The whole Universe is your Library:
Authors, Conversation, & Remarks
upon them, are your best Tutors.*

*There is not a wider Difference betwixt Man and Beast than betwixt Man
and Man. And to what is this Difference owing, but to the Distinguisht
Improvements of the Mind by Study and Meditation? without these
Helps, no Distinction of Faculties will render us Conspicuous. 1734*

*Study to be Eminent. Mediocrity is below a
brave Soul. Eminency in Knowledge conjunct
with equal Goodness will be to you of all others,
the most commendable Distinction. May. 16.*

B. Whilton script.

How to write Copperplate. (Letters by a student of Fred Marns.)

Formation of the Letters

• = Start of stroke. Up strokes thin. Down strokes thick. Alter pressure gradually.

A a A a B b B b C c C c

D d D d E e E e F f f f F f

G g G g H h H h I i I i

J j J j K k K k L l L l

M m M m N n N n O o O o

P p P p Q q Q q R r R r

S s S s T t T t U u U u

V v V v W w W w X x X x

Y Y y Y y & Z z Z z

*Writing Humanistic
Cursive.*

Still on the page

one sharp word sickens;

death is the leap

mind takes to find us.

Candlelight

casts a glow

these letters magnify

Writing Italic.

veniently may. ¶The same order shall the Curate use with those betwixt whom he perceiveth malice & hatred to reign; not suffering them to be partakers of the Lord's Table, until he know them to be reconciled. And if one of the parties so at variance be content to forgive from the bottom of his heart all that the other hath trespassed against him, and to make amends for that he himself hath offended; and the other party will not be persuaded to a godly unity, but remain still in his frowardness & malice: the Minister in that case ought to admit the penitent person to the holy Communion, and not him that is obstinate. Provided that every Minister so repelling any, as is specified in this, or the next precedent Paragraph of this Rubrick, shall be obliged to give an account of the same to the Ordinary within fourteen days after at the farthest. And the Ordinary shall proceed against the offending person according to the Canon. ¶The Table, at the Communion-time having a fair white linen cloth upon it, shall stand in the Body of the Church, or in the Chancel, whered Morning and Evening Prayer are appointed to be said. And the Priest standing at the North-side of of the Table shall say the Lord's Prayer, with the Collect following, the people kneeling.

The Communion Service written out by Graily Hewitt and partly illuminated by Allan Francis Vigars, the decoration left incomplete at the latter's death in 1921. This page shows a strong rhythmic script with a decidedly backward slant. The elaborately decorated page with the Lord's Prayer, the opposite page at this opening, is shown on page 149.

BL, Additional MS 40144, f. 1v.

99

*Example of lettering
by Edward Johnston.*

*BL, Additional MS
46173, ff. 1v–2.*

much lower than the right for right-handers. Left-handers may find it easier, on this occasion, to have their paper upright. Draw parallel guidelines at 28° to give the slant of your letters, and then position the paper such that you can easily maintain this slant

As can be seen from Fred Marns's exemplar on page 85, majuscules can be very decorative and extremely beautiful. They can be lower in height than looped ascenders or higher than plain ascenders. The choice is yours!

Calligraphy today

Lettering did not stop with the nineteenth century, although for a time the use of the pointed nib of the Copperplate pen pushed to one side the use of the broad-edged nib. Calligraphy and lettering is alive and well at present even though it has had a rather chequered history.

The teaching of lettering in most art schools stopped in the 1950s with the rise of Letraset and similar forms of 'instant lettering', and many of the tedious and repetitive tasks are nowadays done by computers. However, it is the very use of computers which emphasises more than ever the need for good and well designed letters, and for people with a knowledge of their form and use in technology.

Many are now turning from the 'manufactured' letter and want to write their own. Those who use letters as part of their daily lives – graphic designers, typographers and letter designers, architects, type designers for the computer and the like – are often great enthusiasts of calligraphy, which is understandable. Making your own letters is creative, exciting and eminently rewarding. It also emphasises the personal touch – the fact that time and trouble has been taken over a job, and many advertisers are now using hand lettering in their campaigns to good effect.

Use the letters in this historical section to study and perfect the various scripts, and, when you wish, experiment with the letters to make them your own. The next chapter gives you some ideas.

It is always difficult to avoid Titivillus, however. There is no patron saint for scribes but there is always Titivillus, the demon. His task is to spy on letterers, and he is always on the look-out for errors and mistakes. These he collects in a large bag to hold against the scribe on the Day of Judgement. So beware!

Experimenting with Letters

It is important to be familiar with the letter-forms before you begin to break free from pen angles, x-heights, slant and so on. When you have a working knowledge of a set of basic styles of lettering and are familiar with the various x-heights, the form of the letters, their construction, the stroke sequence and rhythm, then you can experiment with letter-shape and form. Occasionally a few people with only very limited experience of letter-form try to be free before they fully understand what it is they are breaking away from.

Once there, however, the world of lettering is open to you. Letters can be expanded, elongated, 'made to dance' and manipulated to fit your mood or the words you are writing. Be uninhibited – the only rules are yours! This chapter gives a few ideas and pointers but your own experiments are half the fun.

Proportions of x-height

The previous chapter used the proportions of letters from historical manuscripts to gauge the x-height in relation to the thickness of nib being used. It is now time to experiment with that.

Extending the x-height

Many styles of letters work well when the x-height is extended. Italic majuscules and minuscules particularly fit this treatment. Unusually, it is better to write these with a smaller nib than larger at first. It is sometimes difficult to push up a large nib full of ink without it spraying and ruining your work. A narrower nib is more tolerant. When you are used to writing at an extended x-height, then try the larger nibs because you will then be aware of when you need to take off pressure and let the nib simply float over the surface of the paper when making the strokes. It also helps to breathe in for these parts of the letters.

Reducing the x-height

Similarly letters can be made chunkier and fatter by reducing the distance for x-height. Some letters in particular are awkward to write in this way – letters which have curves within the body of the letter, such as **s** and **R,** for example – and you may need to practise these to achieve consistency.

Try writing with a pen made from balsa wood (see page 19), or a one-stroke brush at a very low x-height. Writing on a rough, hand-made or textured paper can often be rewarding when using letters which are fat and squat.

Do experiment to find out what you can do with your pens, ink and paper.

Changing the basic shape

Most alphabet styles are based on a round or vertically oval shaped letter *o*. You can have fun with letters by pulling that round or oval shape widthways or distorting it and relating letters to the new shape.

It may be better to start with majuscules, perhaps using a smaller nib again to make skeleton letters. It seems easier at

Right.
Changing the x-height of traditional letter-forms as shown here indicates that, once you understand and can write the basic letter-forms, there are no limits to what you can do with them. It is suggested, though, that for the best results you do not create an artwork using this number of different lettering styles!

AGE CANNOT WITHER HER,

nor custom stale her infinite variety;

other women cloy the appetites they feed, but she makes hungry

where most she satisfies;

first to gauge the width and form of these letters, rather than minuscules. Pull the letter **O** into a fat oval to make an interesting textural pattern on the page. You may also like then to distort the shape of letters in the **O** related family – **C, D, G, Q** – to match your distorted letter **O**.

For minuscules you could change the shape of the **o** to a rounded triangle. This will affect the shape not only of the letter family based on the letter **o,** but also all of the arched letters. Try also to round the pointed shape of diagonal letters to fit the new pattern. You can see how useful it is to learn alphabet styles by linking the letters into related families. Making a completely new alphabet yourself is easier

to do when you know about related strokes.

Using nibs of different thicknesses

For real variety why not write with nibs of two, or even three thicknesses in one piece. This may give you just the effect you want, perhaps for a fun or lighthearted piece.

Choose your nib sizes carefully; you may feel that they should not be too different, perhaps only three of four half sizes between them. Experiment to find the best contrast

Right:
The low x-height of these letters, the increased slant and the brisk hairline serifs suggest the movement of that blowing winter wind.

Blow, blow thou winter wind,
thou art not so unkind
as man's ingratitude
Thy tooth is not so keen,
because thou art not seen,
although thy breath be rude.

Distorting the shape of the letter O can lead to an interesting texture in your writing.

THE WEB OF OUR LIFE IS OF A MINGLED YARN,
GOOD AND ILL TOGETHER: OUR VIRTUES WOULD
BE PROUD IF OUR FAULTS WHIPPED THEM NOT
AND OUR CRIMES WOULD DESPAIR IF THEY WERE
NOT CHERISHED BY OUR OWN VIRTUES.

THE MISERABLE CHANGE
NOW AT MY END
LAMENT NOR SORROW AT
BUT PLEASE YOUR THOUGHTS
IN FEEDING THEM
WITH THOSE MY FORMER FORTUNES
WHEREIN I LIVED
THE GREATEST PRINCE O'THE WORLD

Using two different weights of nibs with the same letter-forms. It is difficult to build up a rhythm with this, though, as you have to change pens for every letter.

103

Writing along a curve can help to interpret the text. Here the idea of a sloping, curving bank of wild flowers is suggested by the shapes of the lines, and the varying colours fed into the nib as the pen is used. It is not always easy to achieve a balanced effect with curved lines, and this piece needed one line to have a little less downward movement and be positioned slightly further over to the right ('Lulled in these flowers...') to make the design work.

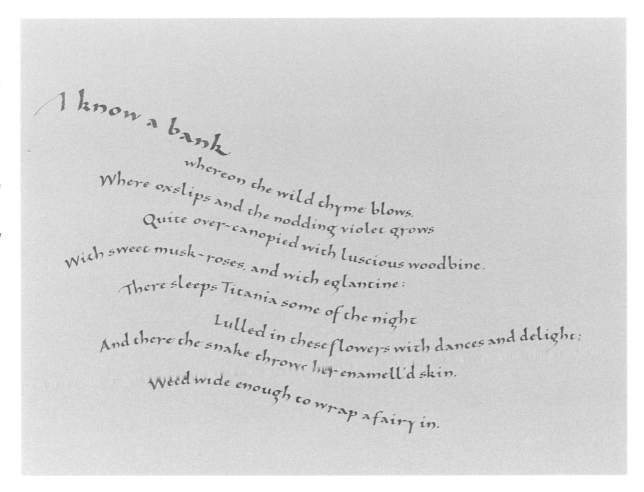

which works for you and the piece you have in mind.

It may take a little while to become used to dealing with two pens in one word. You should write reasonably quickly so that the ink does not dry on the nib, and also have a jar of clean water to hand to rinse the nib and reservoir if this does happen. It does not work if you try to write all the letters with one nib and then fill in the others with the second nib. This will make spacing almost impossible for you, and result in uneven and patchy lettering.

Cursive writing

It is difficult to get a rhythm to your writing when using two nibs to create different textures of letters. However, it is much easier if you write in a cursive way, with joins between most of the letters, the effect being that the pen rarely left the surface of the paper in one word. Some joins will need to be contrived, but this can look most effective as a contrast

to a very formal piece of writing, or as a background pattern in a pale wash of the same or contrast colour, which you then write over. See page 297 for using gum sandarac to do this.

You could also use your own handwriting as a pattern. It does not need to be particularly 'artistic' but you may have to practise to achieve an even and regular feel to it. Write without taking your pen from the paper at all, even between the words, with a ball point or fibre point pen so that there is little resistance to your letters. This will help you to achieve an even feel to the lettering and create a sense of rhythm. You may need to write yourself in to a piece in this way if you are using this as a background pattern to avoid the top few lines being more stilted and tight than the rest.

Making your letters dance

So far, almost all the letters shown have used a baseline which is horizontal. Why not change that rigid line? Write

an interesting and unusual effect.

Writing in a spiral

A most unusual and effective use of calligraphy is to write an invitation or quotation in a spiral. One advantage of this is that is does mask any difficulties in maintaining a consistent angle of slant, as well as being very attractive.

Writing in a spiral requires the base spiral to be constructed carefully, but it is not difficult to do. See the diagrams on the left.

The spiral drawn is your baseline for writing. It is possible to draw another set of lines to give you parallel guidelines, using the same central points for each semi-circle. Measure the x-height of the letters and open the compass points by this amount. Draw another spiral set around the first.

Writing in a circle

Writing in a circle, perhaps with flourishes decorating the edges and some floral decoration in the centre is much less complicated than writing in a spiral.

Far Left: How to construct a spiral.
*1 Draw a horizontal line and with the compass point at **a** draw half a circle.*
*2 Move the compass point to **c**, (this can be anywhere along the line and will determine the coil of the spiral), widen the compasses so that the pencil point is at **b** and draw another half circle.*
*3 Replace the compass point at **a**, widen the compasses until the pencil point is at **d** and draw an-other half circle.*
*4 Repeat this operation by placing the compass point at **a** or **c** until the spiral is as long as your text.*

along a curve, in a spiral or make the individual letters dance.

Writing along a curve

Writing along a curve is not difficult once you appreciate that it may be better at first if your letters are at a consistent angle to the baseline, rather than the vertical. This is easier to see in the illustration opposite.

It is a good idea to make yourself a template of a curve or curves from cardboard, manufactured thick plastic bendy material or to use French curves. Decide on the shape of your curve, and experiment with the spacing between lines. You can move the curve very slightly to the right and left to break up the pattern if you wish.

Spacing of letters and words can be a problem when writing along a curve, so too can achieving a balanced centred effect. It may take a few experiments to find the effect you want, but it is worth persevering for

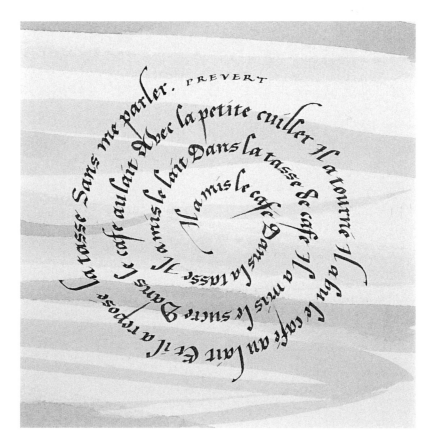

Left: writing in a spiral can interpret text, such as the beginning of this poem by Jacques Prevert(1900–1977) where the background wash suggests milky coffee and the spiral gives an idea of stirring a cup of coffee:
He put the coffee in the cup, he put the milk in the cup of coffee, he put the sugar in the milky coffee with a small spoon, he stirred…

105

*Even formal maju-
scule or capital
letters can be made
to dance.
Here Compressed
Italic Capitals con-
trast with Renaiss-
ance Capitals in a
piece where no
guidelines were
used.*

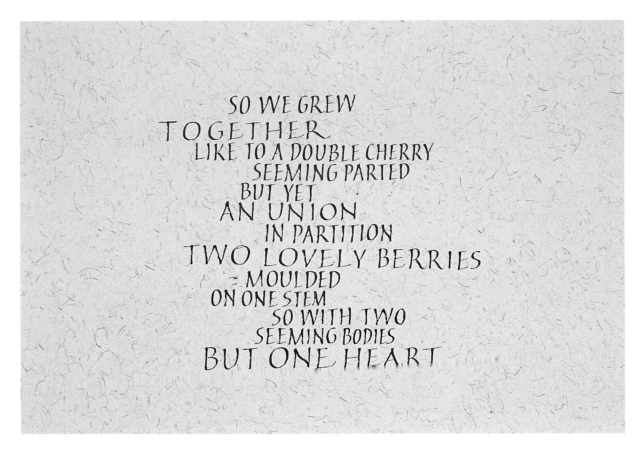

Write out the words in a straight line, using your chosen nib size and style of letters. It is probably better to select shorter texts, otherwise the final circle may be very large! Measure the length of the line to give an indication of the circle size.

Although it is a matter of trial and error to convert a straight line into a circle, as a rough guide divide your straight line by six. Use this measurement as the distance between the compass point and the pencil point and draw a circle. Draw guidelines through the centre of the circle to help keep your letters pointing towards the centre. Remember that your letters will be wider at the top than the bottom, and this will be more obvious in smaller circles than larger ones.

It may take a little adjusting of letters and spacing to achieve a balanced effect. Select ascenders which can be flourished so that it looks reasonably regular and even

around the circle. You may have to cheat a little here, but try not to over-flourish.

Dancing letters

Some words or phrases seem too constrained by being written along a straight baseline; for them the individual letters need to dance. It can be fun designing a piece where the letters are not confined to a single baseline, though do try not to be tempted to make the word look too jumpy, and certainly not to write too many words in this way. The essence is contrast, which is lost if every single letter is violently hopping up and down. Instead select a word or two for this treatment, or be just a little restrained with the whole piece.

Working to Commission

It will not be very long after you have started to learn calligraphy before friends and colleagues ask you to letter names on greetings cards, certificates or invitations. Your newly found skills will be very much in demand. You will no doubt be pleased to do most of these early lettering projects for the experience. Each one will present a different set of challenges for which you will have to work out a solution. Because each task is small, even though it may take you a long time, it is unlikely that you will charge, or that money will even be mentioned. Later, you may be asked to write out a favourite quotation or poem for someone, which will take much longer, and the costs of such things as paper will be more. Should you charge or not?

Early on any form of charging is difficult. It will take you much longer to letter a piece than someone who is more skilled, and who will not have to make three of four copies to ensure that at least one is presentable without mistakes. To charge for four hours' work – the time it may have taken you – for something only a few lines long does seem a little extreme.

As well as this, each new commission will bring new experience for *you* – how to write in a Book of Remembrance, lay out a piece which is to hang on the wall, write out a poem which will be read at a funeral, design a wedding invitation with menu, envelopes and place names or letter the information cards for a flower festival. That experience is personally valuable and will stand you in good stead for the future. Once done, you will know how to approach something similar in the future.

This experience will also give you a better idea of how long certain projects will take. Names on certificates which have to be written out first as a guide for centring will be different from names on envelopes where you can simply write starting from the left. Before long, you will have a good idea of the size of nibs to use, the most appropriate alphabet for the piece, inter-linear space and the size and type of paper required for different lettering requests. In addition, having written one set of names, with associated problems, on coated papers which printers favour, you will know that this will then have to be treated with pounce or powdered with gum sandarac when the next batch arrive. With luck, you may even be there at the point when decisions are being made about suitable card or paper and be able to make a contribution as to a more appropriate one for you and the printer to use.

Starting out, one approach which you could adopt is not to mention charging as a monetary transaction at all. For charities or close friends, probably the thought of paying for something which you would do out of kindness for them and enjoy doing for your own satisfaction would be unthinkable anyway. For others perhaps you could say how long it will take you to do and suggest a book, plant or something similar as 'payment'.

At some point you may decide to try to make your new found skills, and worthwhile hobby, pay. After all, the time you spend on one particular piece may be considerable and not every task is going to be enjoyable and challenging. So how should you go about it?

Charging for commissions

I am asked more questions about charging than any other topic by aspiring scribes, and it is difficult to answer.

As a 'jobbing' scribe, the most appropriate and fairest way to charge for pieces of work which are commissioned once

you are competent at lettering is by the hour. This will vary with circumstances. Working from a corner of the living room, which is already heated, with electricity and water accessible, will be different from renting a separate studio with additional costs for utilities. Nevertheless some account of these costs at home should be made and included in your rate. Ask colleagues and friends, too, working in similar areas what their charges are to form a basis for yours.

Early on I was advised *do it for nothing or do it and charge, but do not do it cheaply.* Not charging the going rate debases your own work as people perceive it to be worth only what they have to pay. This also lowers the price of calligraphy – and often people's view of it – for those who work at the craft professionally. It may help, when you have decided to do a piece for nothing, to include an invoice of the actual costs of the work, with 'no charge' written on it, so that there is an indication of the time and what was actually involved. The recipient will see that more than a few minutes have been spent on what they may have considered to be something which 'you could do in your spare time'.

You may have different charges for various tasks, and could decide that the preliminary discussion will be free. Postage, fax and telephone charges, however, should be taken into account in your costs.

Because it is so accessible, some view calligraphy as simply putting a new cartridge in a pen and then writing, without realising the problems of nib size, lettering style and size, paper, colour, design, margins, decoration and so on which all have to be taken into consideration when carrying out a commission. Without labouring the point it is worth explaining this to future clients, which can easily be done when you are discussing the very many possibilities there will be in approaching their commission.

You may occasionally, along with other scribes, be asked to submit an idea or a rough to a client so that they can choose which one they prefer and then commission the work from that scribe. It is acceptable to charge for this, and to make this clear when the idea/rough is asked for – after all, you may not get the final job and you have put in some work. Always mark this work, or any other work of yours if it is a one-off with the copyright sign ©, the date and your name. Some clients may use your work in a printed version and only pay you for the original artwork. Others may take your ideas to another, cheaper, calligrapher! It is hoped that the copyright symbol may at least make an unscrupulous client think twice, as you do then have legal redress.

Dealing with clients

Some people who contact you will have had little experience of dealing with a craftsperson and will need to be put at their

ease. It is also important to be sure from the outset what job they want done. These questions, not in any particular order, may help:

1 *When is your deadline?*

They may want the work by a time which is impossible to fit into your schedule, and if this is the case then there is not much point continuing the conversation. Always try to suggest another contact who may take on the work if the difficulty is your own pressure of work. However, it may be that the client requires a set of fifty certificates designed and lettered and then signed by the Directors for their conference the following day, and rather than use a computer they thought they would use a calligrapher. An excellent idea, but do suggest to them that a little forward thinking next year will be all that is needed for you to complete the job to time.

2 *How much did you think it would cost?*

This will give you an idea of what budget they are working to and whether you can complete the commission within their remit.

On the other hand, if they have no idea, it is worth giving choices. If they want a poem written out, the cheapest way would be on paper, a single colour ink/paint and from a left margin. You will need to write out only a few lines to determine nib size, inter-linear space and finished size of paper. The expensive option would be to write on a stretched vellum panel perhaps with some gilding. A middle road would be to write in colours, interpreting the words and lines as you think best. The design time here would have to be taken into account.

Do make sure that you refer to your ideas of cost as an **estimate.** This will allow for some leeway in the final figure. A **quotation** is what the charges will actually be, and unless you are certain of your costs, you may lose out when the work is done. Also ensure that the client knows that any changes made by them will incur extra cost in the final invoice.

3 *What and whom is it for?*

It is always interesting working with clients who want to use calligraphy. This may be for their own friends or relatives, where you could suggest alternatives which may make the piece that much more personal. A special poem or piece of prose, for example, written in a small single section book would be more intimate than a panel hung on the wall, especially if the recipient has limited space. Adding a decorative

touch which relates to the individual is often appreciated, too. Those with impaired vision may appreciate a larger size of script, and it may even be possible to use some embossing so that they can feel the letter-shapes.

4 *How big do you want it to be?*

Letters do need space around them to breathe, yet clients often want a poem of six verses to fit into an A4 frame. Do always take maximum measurements into account, and work within that remit if possible. If not, say that it cannot be done easily, and suggest that perhaps one or two verses, or a shorter extract be chosen.

5 *Have you any preferences for colour of ink, paper or lettering style?*

A number of people regard calligraphy as only possible in Gothic or Italic style written in black ink on white or cream paper, with perhaps a touch of red. Enlightening them to all the myriad of possibilities of style, colour of ink and colour and texture of paper may take more time than you have, but it is worth suggesting matching or toning colours for a particular room or selecting favourite colours, if the text does not suggest colours and textures itself.

6 *If I give you a rough idea of how it will look, do you want to leave the rest to me?*

This question may need leading up to, but is worth asking because if the answer is positive, then this is the best possible situation for you.

If the client would like to have more say in the final piece, then work out a few different ideas as sketches – pointing out that this will increase the final fee – and then it is up to you to emphasise the many advantages of selecting the one which you think will work best.

Above all else, the client is paying and so should have what is wanted. However, this may be something which you do not feel that you can do. Your reputation as a scribe is at stake and it is important that you decide yourself whether that is more important than the fee. If you do feel that you cannot be compromised explain carefully and suggest someone else – although it may be advisable to warn that person first!

Presuming that the commission is going ahead, follow this up with a letter (preferably on your calligraphically-designed letter-headed note paper) giving details of the decisions reached, what you will do by when and an approximate indi-

cation of cost. Generally speaking it is better to estimate more rather than less. If it takes less time and so the final figure is lower, then this will please the client. If it costs more, there may be some problems about paying more than you originally estimated, although if the changes are made by the client then this will increase the figure from that originally estimated as you will take longer over the commission. Keep copies of all correspondence, particularly if you included any estimates of costs. You may wish in this letter to include also some samples of paper or even first thoughts of ink colour and style of lettering.

You may or may not decide to ask for a deposit. In my experience people are usually quite willing to pay a part of something where they realise that it is commissioned especially for them. If you are to have large initial outlays on paper or vellum, then it is wise to ask for these costs to be met at the outset. It is also acceptable to add a percentage on to these as handling fees. You will have had to spend time ordering these materials, perhaps even have to collect them personally, and all this should be taken into account in your costs and charges.

I find it helpful to have all the clients' details together either in a book, or on sheets of paper which can be filed. Correspondence, estimates and so on can then be included and are easily to hand for reference. It is useful to note telephone conversations here as well, so that all decisions made are clear and ready for future reference.

If there are unforeseen problems such as delays in paper or vellum supply, or ill-health, do alert the client if there may be any difficulties about meeting the final deadline.

When you have finished the commission prepare a proper invoice, detailing the materials used, the paper, type of pen, hours spent at what cost and any sundries such as postage and telephone calls. This should be headed to the client and signed and dated by you.

You may also want to design and have printed or photocopied a small piece of your headed paper – not much bigger than 6 cm by 2·5 cms (2·5 in by 1 in), which has your name and contact details, and where there is a space for writing information about the tools and materials used. This can be given to the client to paste on to the back of any work which is framed. This is ideal for future reference for them – and you can then be found easily for the next commission!

Getting commissions

Good lettering skills are still quite rare, and when a letterer with imagination is found, the news spreads by word of mouth. A number of professional calligraphers have never had to advertise. Getting started can be a problem, but if

A possible record form for a working scribe.

CLIENT'S NAME

My reference number

Address

Post/Zipcode

'Phone no (day)

(evening)

Fax no

e-mail

Date by which work required

Nature of commission (include tools and materials)

ESTIMATE

Sent on

Agreed by client

Deposit paid

COSTS

Materials – paper, vellum, gold, etc

Telephone calls

Postage

Hours @ £/$ per hour

TOTAL

Less deposit

Work sent to client on

Client paid on

Details of phone calls, postage, verbal decisions, etc overleaf:

people who can write a date at the bottom of a photograph to be framed, or write names on certificates which have been printed.

The Internet is another place to advertise. If you have an e-mail address then you can probably arrange to have a couple of pages of a website as 'home pages' at no extra charge. It is not difficult to compose a sheet or two of examples of your work, what you specialise in and how you can be contacted. If you do not have the necessary equipment to get your artworks from originals to computer imges then this can be done quite cheaply.

You may then receive different responses, from those who want a name written under a photograph to others who could request complicated commissions. Above all your name will be mentioned as someone who does lettering and an interesting calligraphy project often turns up in the future as a result.

Design a beautifully hand-lettered business card and carry copies of them always. They can also be left at libraries or given to people who express an interest. If it really is beautiful they will not throw it away and so can contact you when-ever they want something designed and written.

Also take photographs or good colour photocopies of everything that you do. Keep these in a folder so that a potential client can leaf through and see the wide range of work of which you are capable. This may also give them ideas for other commissions.

A calligrapher's work station. The author in front of a surprisingly clean sloping board. Pencils with a hard lead and a pencil-type eraser are within easy reach balanced on top of the sliding rule of the board. Items which are used most of the time such as quills, pens, pencils and brushes are stored in jars just out of shot on the right, and those items which are used less often are within easy reach on the shelves on the left. I also have a small trolley to the left where the ink and paint being used at the time, straight edge, brushes and pens and quills for the same piece are placed ready for use straightaway.

you are determined then there are certain routes which may be fruitful.

Send your photographs, probably slides are best here, to your local paper and suggest that they write a series of articles on craftspeople in the district – starting with you!

Advertising

Prepare a well-lettered advertisement which you can use in local arts and crafts centres, libraries and museums, advice centres, city halls, galleries, picture framers, photographers, and anywhere where they will display it at no charge. You can photocopy the original, and add a few letters in colour for maximum impact. Because it is being printed you can cut and paste the very best examples of your calligraphy.

It is also worthwhile visiting and making friends with printers and picture framers. Both are often asked to recommend

Teaching

Scribes can rarely make a living solely by their lettering; usually they teach as well. This can be rewarding in many ways but particularly because you will be carrying on the traditions of the craft workers of old, who felt that it was their duty to pass on the skills and knowledge they had acquired. As well as this you may well see some of those in your class become as hooked as you on letters. Watching

such students grow and develop their skills, and then launch into their own studies and careers, is very gratifying.

If you are the calligraphy teacher for a local arts/education centre people who want commissions will make contact, and from this more work will grow. Even your own students may ask you to write out pieces which may be a little more complicated than they can manage at their stage.

Contacting appropriate people

Many people are now realising the value of hand-written and crafted work. Companies, industry, and local government may all at some time want certificates, presentation scrolls or town-twinning arrangements recorded. They may not respond immediately to your initial approach, but once on file, there may be future occasions when you will be asked. Your advantage here is that you are local.

Copyright

Copyright does need to be taken into account by calligraphers. In the same way that you would not want copies of your lettering work printed and sold without your benefiting from it (unless you had agreed to this) so authors have a right to share in your profits if you use their words.

Copyright regulations differ according to a country's laws; in the UK and Europe copyright exists for 70 years after an author's death, and in the USA it is 50 years. Copyright of work in translation belongs to the translator who may still be living.

Write to the publisher of the author to request permission to use the text if you are doing anything other than a one-off which will be used by you alone. Work for exhibitions, for others and which may be printed needs copyright permission which may be refused. Alternatively they may ask you for a share of the proceeds on what you sell. If you benefit from the author's words then they have a right to benefit, too.

As well as this, do determine and establish the copyright on your own work. A piece of calligraphy sold at an exhibition should still remain under your copyright so that if it is used in reproduction for postcards, or in any publication (apart from the exhibition catalogue) then you are acknowledged and may even receive some fee for it. To clarify this, it is useful to write '©' and the date together with your name on the back of all your artwork which is for sale or has been commissioned. At least then you will have the law on your side, even though it may well be beyond your budget to actually sue anyone who disregards this! See also page 108 for establishing copyright when commissioned to submit ideas.

Commissions

Working to commission is very different from working to your own requirements and ideals. Various factors have to be taken into account, such as limits of size, colour specifications and the client's preferences. As well as this, there is often a time constraint of not only a deadline but also of a limited number of hours for which you can charge. When working out pieces for yourself you may have the luxury of being able to try out many different ideas for one piece, spending much time with experiments of pen size, lettering style, colour combinations and pasting up all these various possibilities. When you are working and charging by the hour you will often have to make a compromise of the very best that you can do within the time allowed.

Ideas with Letters

Having learned the letters in some alphabets, and practised them so that the form, shape, spacing and everything else is as good as you can make it, you will soon be wanting to write out names, make cards, transcribe poetry and prose and put your newly developed skills to good use. This chapter gives you some ideas of how your calligraphy and lettering could work for you.

Cards, bookmarks and envelopes

Personal, hand-made cards are always well received; they show the recipient that you cared enough to spend a little time and effort to make something yourself, and, if you include their name or initial, it makes it even more special. Look at page 188 to see how you can make a variety of cards using gold gouache and colour. If you do not want to use gold, these cards are just as effective using contrasting or toning colours alone.

Use an automatic, coit, balsa wood, cardboard or ruling pen to write an initial letter on a coloured wash (see page 297). Make the letter about 4 cm (1·5 inch) high and allow it to dry.

Making a deckle edge

You can simply trim the paper with a knife and metal straight edge so that the letter is centred, but it looks a little better if the papers give the appearance of being hand-made with a deckle edge which is a slightly rough and uneven border. A deckle edge is not difficult to achieve.

Use a ruler and pencil to draw straight lines, as faint as possible, as guides for a rectangle around your letter. Turn your ruler over so that the edge is not actually resting on the paper and dip a clean fine paintbrush in water. Run the brush along the four lines of the edge of the rectangle, wetting the paper. Allow the water to soak into the paper, depending on how thick it is this may take from 10 seconds to a minute. Do not allow the water to dry, though, and before it does either gently pull the paper apart along the dampened line, or tear the paper along a ruler. While the paper is still wet, gently push in some of the torn edge so that it looks a little less even.

Making the card

Now you know how easy it is, you can make a deckle edge on all your papers for the card. or you may choose to do this for only a few pieces, to make a contrast. Select coloured papers which tone with the paint you have used, and include perhaps one which has a texture. Cut or tear increasingly large rectangles of paper and paste these together as shown.

Always choose good quality paper for the card itself. An A5 size piece (8 by 6 inches) will not cost a great deal, but will make a lot of difference to the quality feel of your card. A piece of standard photocopying paper folded in four to make a card shape looks and feels cheap, so why waste your time on something which is not going to look impressive?

Decide on whether your card is to have the fold at the top or the side. Usc a bookbinder's bone folder or the clean edge of a plastic ruler to make this fold clean and sharp.

Finally paste your coloured papers on the card and write your message inside.

Cards with deckle edged papers; and on the far right is a card where different colours were fed into the nib while writing the letters. This does not help the rhythm and flow of the calligraphy but it can look very effective.

A selection of coloured cards using scraps of calligraphy.

114

Bookmarks using scraps of calligraphy and paper.

More cards or bookmarks

There are lots of different ways in which you can use single letters to make cards, write out the person's name, and so on, but here is a way where you can actually use up your practice pieces!

Collect together interesting pieces of coloured and textured papers. These pieces can be quite small – some only as big as 4–5 cm (1·5–2 inches) by 1 cm (0·5 inch). Separate the papers into batches by colour. When practising individual letters or lines of poetry or prose which you wish to write out, use a colour of gouache which will match with some of the papers you have collected together. Alternatively, you may choose to write out letters or words specially for these cards, perhaps the recipient's name. (See also page 188.) Do remember to select your colours carefully.

For something different feed similar or toning colours into the nib as you write. Mix up a few colours, probably not more than three. Put the tiniest amount on the edge of the pen nib and make only one stroke, and not more than two before feeding another colour into the nib by stroking the smallest amount on to the tip. Continue in this way ensuring that you have a balance of colour along the line and then throughout the piece as you write. Clean your pen nib at frequent intervals to prevent the colours mixing into mud!

You can use these scraps of lettering the right way up, sideways, diagonally or even upside-down! Try out different ways

with the lettered paper and the coloured papers. You may choose to have lettering on the top, or as a pattern beneath with a single letter on the top. Half the fun of making these cards is the variety that you can make with a single idea. To make them even more different, collect small leaves, tiny flowers, feathers or even the smallest beautifully coloured shells and paste these on your cards. For more ideas look at the selection above. Paste the papers together in the way which you think is best, each piece of paper being slightly larger. Place this on your card and you may like also to add some narrow strips at the base of the pasted papers. When the card looks the best it can be, paste everything down on the card itself after you have decided whether the fold is to be at the top or the side of the card.

All these ideas for cards can also be made as bookmarks.

Making envelopes

Your hand-made card may not fit the standard size of envelope, or you may prefer to make your own envelope perhaps using a piece of paper matching one of the papers on the card.

To make an envelope first measure your card. The paper should be 4 cm (1·5 inches) wider than the card, and twice its height plus 2·5 cm (1 inch). The directions for making the envelope are shown below. Instead of simply pasting down

115

the envelope flap with stick glue, you could make a diamond shape, perhaps with some paper left over from the card so that it matches, and paste this on to the flap to seal it.

Gift tag and gift wrap

Use your lettering skills to make unique and attractive gift wrap and matching gift tags. To do this you will need a piece of paper which covers the gift and which is not too heavy in weight. Wallpaper lining paper, which is very cheap, can be used to cover large presents, although for something smaller a lighter weight paper would be preferable, possibly a piece of large photocopying paper.

On a piece of rough paper experiment with letter-forms of the initial letter in the name of the recipient. You do not have to choose calligraphic letter-forms, some which are more graphic may be more to your liking.

You will be using an eraser to make a stamp for this gift wrap and tag so make sure that your final choice fits on to the size of an eraser, but do select one which is not too small.

Thicken the thinnest parts of the letter and then trace it carefully using an HB or softer pencil. Turn the tracing over and tape it carefully to the eraser. Go over the outline with a harder pencil so that it transfers to the eraser. The letter on the eraser should look back-to-front.

Now use a sharp knife to cut away everything on the eraser but the letter. You may find it easier to go round the outline with the point of a needle held in a cork for safety. Make sure that you do not undercut the letter, otherwise it may not stand up to what you will be doing.

You can either decorate the paper all over in a random way, or have a more regular design. For the latter you may choose to measure out guidelines so that the paper for wrapping is divided into squares or rectangles by pencil lines, or you may fold the paper so that the squares or rectangles are indicated by folds in the paper, and these become part of the decoration.

Either use a stamp pad which you have purchased from a stationery shop, or make your own. You can do this by making a pad from folded paper kitchen towels and placing this in a saucer. Add liquid watercolour paints from a bottle, or make up your own mix with gouache. You can even add two or more colours to the pad for a multi-coloured effect.

Press the rubber stamp on to the pad and make a few trial stamps to ensure that none of the surrounding eraser remains, then stamp away on the wrapping paper, either in a random way all over, or within the squares or rectangles indicated.

Make a gift tag to match by stamping a single initial on a small piece of the same paper and pasting this on a card. The card can go in an envelope or you can punch a hole in the top left-hand corner and thread narrow ribbon through so that the tag can be attached to the gift.

This will make very special wrapping paper and gift tag which will be valued almost as much as the gift inside. The advantage is that the eraser stamp can be used again and again, and you could build up an alphabet of stamps to use for all your friends and relations!

Menus

Hand-written menus do add a touch of class to any occasion,

*Making an envelope. These directions can be applied to any shape of card with straight sides (although) you may want to re-duce the size of the flaps for tiny cards).
The paper should be 4 cm (1·5 in) wider than your card and twice its height plus 2·5 cm (1 in). Trim along the dotted lines to remove the corners. Score along the heavy lines which should be about 0·5 cm (0·2 in) from the edges of the card on three sides. Fold in the side flaps. Paste along the shadow lines A and B and stick these on to the side flaps. Put the card inside the envelope and then run a line of stick glue under the flap to seal the envelope at shadow line C.*

and with modern cheap copying methods, it is not necessary to write out a number of identical menus.

On layout or photocopying paper experiment with nibs and sizes of letter-forms and different alphabet styles so that you can see which style and size of writing is most appropriate for your design. When you print or copy your lettering, you do not need always to write perfect letters the first time. If you are not happy with a letter, or if you make a mistake, simply re-write it and use the better one.

Menus are usually portrait shape (longer downwards) so that they stand on the table without getting too much in the way of the place setting and table arrangement. Choose a script which is narrow (such as Italic, Gothic or compressed Humanistic Minuscule) rather than a rounder one (Uncials or Half-uncial) if it fits the shape of the menu better.

Once you have decided on the alphabet style then write out the menu on good quality white paper using black ink and a sharp nib. Your letter-forms will be crisper on better quality paper. You do not have to write the words to the exact final size required, they can be bigger if you find this easier. Remember that if you make a mistake, or if a letter is not to your liking, simply write it again. When the ink is dry, cut the courses of the menu into strips and place them on a piece of clean white paper. Using scissors or a sharp knife, cut out any letters or words with which you are unhappy and replace them with better ones. Keep the separate sections of the paper strips in place with masking or magic tape used underneath the paper so that they do not show.

On another piece of white paper use a sharp pencil and ruler to measure out the required distances between the different courses, and between the menu heading, side dishes and so on. Draw faint parallel lines to show where the strips of paper should be positioned. With stick glue, cow gum or PVA carefully paste the strips in place, using the guidelines to ensure that they are horizontal and in the correct position. Allow to dry.

Erase any visible pencil lines, and if there are any smudges or dirty marks paint over these with opaque white gouache. This is your paste-up which can now be photocopied or sent to a printer. Although you have written it in black, a printer or a good photocopier will be able to print it in any colour, and even reverse out the lettering so it is white (or the light colour of the paper) on black or a dark colour.

If you have written the words larger than the final version, you will need to add marks as guides for the printer. Work out the proportions for the finished size and mark these in pencil on your artwork. With a fine back pen draw two lines at right angles which are about 1 cm (0·5 inch) from each corner. These are the crop marks and will show the printer where the printed menus should be trimmed. On your written instructions explain that the artwork is not to size, and that it will need to be reduced for print.

For a photocopied reduction, either take it to a copy shop and ask them to reduce it to fit on to the correct size, or have a few trials yourself to get it to fit. If you have done the artwork twice the size it is required, then the reduction on a photocopier will be 71% (most use 70%).

Choose a paper or card which is of a good weight as something flimsy will not stand up on the table surface.

Your finished menus may be printed but it is more special to add a hand-done touch of difference to them. If they were printed, unless you specified otherwise, the paper used was probably coated. This paper works well for printing inks but not for calligraphy and painting, so it will be difficult to write crisp letters for a monogram in a different colour, or paint something on to add that little bit extra. It is possible to do so if you treat the surface with gum sandarac, see page 297, but you may prefer to use embossing.

Embossing

Embossed letters stand out from the surface of the paper or card. When designing lettering for embossing it is best to be bold, as very fine lines tend to disappear. Decide what you are to emboss and make some rough drafts on layout or photocopying paper. Note the size of the menus – your lettering should not be huge, nor so small that it is not noticed.

Thicken up any thin parts of your letters, and trace them using a 4H pencil with a sharpened point. Transfer this tracing using Armenian bole paper (see page 189) to a piece of thin cardboard. The cardboard which is used for cereal packets or as stiffener in shirt packaging is ideal. Using a sharp pointed knife rest the cardboard on a cutting mat or layers of packaging and cut out the letters carefully. Unusually the cut

Paste-up ready for printing or photocopying.

Right.
Matching gift wrap and tag made easily with a stamp from an eraser.

Below.
On the left, an invitation with a paste-paper cover. A small amount (about a small pinch) of powdered wallpaper paste was mixed in with the coloured gouache and water, to dilute. The wallpaper paste allows time to man-ipulate the paint into a pattern. Here a piece of balsa wood was used to make vertical strokes and wavy upright strokes – simple, but effective.
On the far right, two menus printed in colour from a calligraphic paste-up. The white menu has an embossed number. The paste-up on the previous page, in sharp black and white was the original for both menus. A colour photocopier was used first to print the text in blue on white paper, and then to produce a menu where the text itself is white and the background blue. To complete this menu the reverse was printed in the same colour blue, too.

cardboard letters themselves are not used for embossing (although they can be used for indenting where the letters are pushed in to the paper). Instead the outline from which the letters were cut is used – so do take care when cutting not to let the knife slip into this area. When cutting round curves it is often more successful to move the cardboard rather than the knife.

Using stick glue, PVA or cow gum, paste the letter outline on to another piece of card and allow to dry. On the reverse of this second piece of card, draw lines which mark the mid-point of the letters, and their width and height. This will help you position the letters on the menus. Use your tracing to try out the letters in different positions on the menu until you feel that it sits well with the printed lettering. Mark the centre point and top and bottom points of the letters with faint pencil lines, although there should be no pencil lines over the area where you are to emboss as it is difficult to erase lines from an embossed area.

With small pieces of masking or magic tape secure the card with the letter outline to the front of a menu. As you emboss from the back, any slips or mistakes will not be seen. Turn the menu over to the back and using a dog tooth burnisher (see page 168), a wooden clay modelling tool or the rounded end of a paintbrush feel the outlines of the letters first by

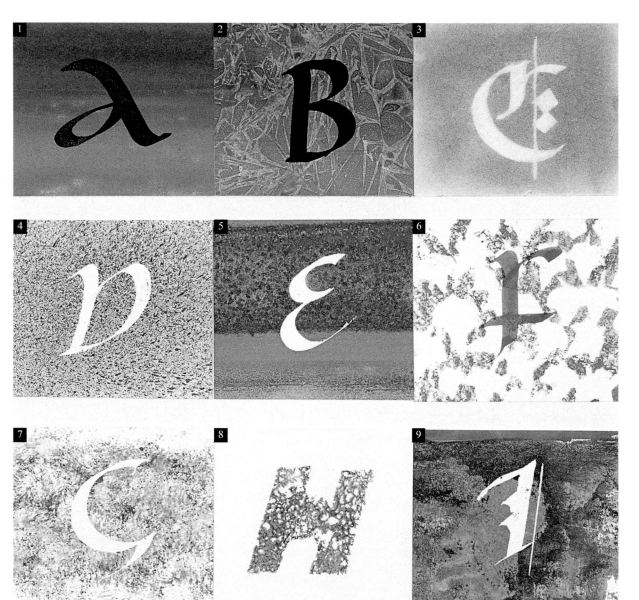

Creating different coloured backgrounds.

1 Two coloured gouache wash.

2 Wash with cling film (saran wrap).

**3 Powder scraped from sticks of pastel or Conté crayon, and applied with a cotton wool ball or an old toothbrush.*

**4 Spattering with an old toothbrush.*

**5 A wash and a sprinkle of ordinary cooking salt.*

6 Using leaves as stencils.

**7 Random sponging with a piece of kitchen sponge.*

8 Sponged letter, using a shape cut from a bathroom sponge.

**9 Using a paint roller and two colours.*

** Letters were first written with a resist, in this case masking fluid (available from art shops). This was allowed to dry and then the wash or effect applied. When this dried the resist was removed using an eraser, revealing the white paper beneath.*

(See also the end papers)

rubbing over the menu, and then work slowly and steadily to push the menu into the areas from which the letters have been cut.

Erase any visible pencil guidelines, and repeat this with the remaining menus.

Invitations

Everyone who sends out invitations wants theirs to be noticed and what better than to have one which is really eye-catching! These invitations use a bright and bold outer cover, and the inside can be photocopied as the menus, and simply pasted (or 'tipped') in. If you wish to use subtler colour schemes for your invitation then it is easy to change the palette. There are many different ways in which you can produce exciting covers, and some of these are shown above. When using paint as a wash, do stretch it first unless the paper is heavy-weight (see page 299).

The method selected was to use paste papers. Select a paper for the outside of your card which is of a good weight, at least 180 gsm and preferably a little heavier. Stretch the paper on a board (see page 298). Allow the paper to dry. Mix the

colours of gouache which you wish to use and add half a tea-spoonful of wallpaper paste to each. Mix round until all the paste has dissolved. (There are other recipes for paste papers, but this is the easiest.) The paste paper will allow you to spread the colour in the way you wish before drying too quickly.

Apply the colour in whichever way you prefer – with a paint roller, sponging, a brush, and use a sponge, brush or even a piece of cardboard to move the paint into patterns and shapes.

When the paint has completely dried, remove the paper from the board. The decorated paper you have made will form the folded cover for invitations. Using a sharp pointed pencil and a ruler, measure out the dimensions of the finished size. Use a knife and metal straight edge to cut the invitations to size, or you could create a deckle edge for something really stylish (see page 113). The advantage of making covers in this way is that you produce a number at a time.

Now write the invitation using the guidelines for making a menu, see pages 116–117. Note the dimensions of your cover and ensure that the resulting invitation will fit. You may even be able to photocopy more than one invitation on to standard size paper, and so save money. The resulting paste-up can then be photocopied as many times as you wish. It can even be photocopied in a colour which will match the outside cover.

Trim the photocopies until each one is slightly smaller than the covers; again you can cut a straight or make a deckle edge. Fold them in half and using stick glue, PVA or cow gum, paste a strip along the back fold into the covers.

If you wish you can add a calligraphic letter to the front (or a number if the invitation is for a significant birthday or anniversary), and also write the invitee's name(s) on the photocopy inside.

Interpreting prose or poetry

One of the many joys of calligraphy is being able to write out your choice of words in a meaningful way. Poetry and prose can suggest colours, textures, rhythm and changes of rhythm, style, weight and size of letter-forms, spatial balance and so much more. To start with it is better to choose shorter rather than longer extracts. Until you are confident in your lettering you will be frustrated if you make a mistake at the very end of a long piece of calligraphy. A shorter text means that you do not have so much to re-write.

How to start

Select your text and write it out on layout or photocopying paper using a variety of nib sizes and different letter-forms.

Choose which you think works the best and is most suited to the text. Often this is suggested by the text itself. A light and airy modern piece would be more suited to a flowing Italic style than Gothic, for example.

Now write out the piece in your chosen letter-forms and with the size or sizes of nibs which will be large enough so that the words can be read, but small enough to fit on the size of paper. The words and lines do not have to be all the same size; it is an interesting experiment to write some lines, phrases or even individual words, in a larger or smaller size; this often makes for better visual impact.

Think also about the layout. Is it to be conventional with the piece either centred, or aligned left? All layouts have advantages and disadvantages. Those which are centred often draw the eye more to the outside shape which the lines make rather than the words, and a piece which is aligned left may result in line length difficulties if they are not mostly of a similar length. Try different shapes of paper, too, and placing your text in unconventional positions on the paper.

Play around with your text and layouts by having it written on strips of paper and placing these on another piece of paper which is the shape and size of the finished piece. Use tiny pieces of masking or magic tape to secure each end. Re-write one word or a whole line in a larger size nib and place that in position. Does it look better or worse? Should you now write a line or two in a smaller nib? What about writing a line or two in majuscules only? How does that affect your design?

Once you have decided on the approximate sizes and letter-forms you may choose to introduce some colour. This is where you can really have some fun. What colours does the text suggest to you? Rather mournful words will probably not be in bright, joyful colours, nor a poem about the delights of spring in sombre navy and purple. Remember also that you do not have to write the whole piece in the same colour. Adding colour may affect your layout, so try the lines written in colour before your commit yourself to best quality paper.

Transferring your design

With the strips secured by small pieces of masking tape at the sides, draw a vertical straight line through all the strips so that this will be a reference point for you. It is likely that this line will appear on the supporting paper through the gaps between the lines. Measure the position of this line in relation to the dimensions of your finished piece. Tear a strip of magic tape which is the length of your layout and carefully place this vertically over all the strips. If your piece is large, then use another piece of masking tape to the right or left of the first one. Remove the strips from the supporting paper with the long piece(s) of masking tape in place.

Select a sheet of good quality paper and carefully mark on the dimensions of your finished piece. Now draw a very faint

Layouts.

Generally the top, right and left side margins often look about the same width, with a wider margin at the bottom (otherwise it looks as if the piece is falling off the page). Layouts may be conventional or not. Here are some ideas.

1 *Aligned left.*

2 *Aligned right (more difficult to write because of maintaining the straight right margin).*

3 *Centred.*

4 *Visually centred.*

5 *Placed low on the right with wide margins.*

6 *Aligned on alternate lines (useful for poetry, but it should be placed so that it is visually centred).*

7 *Placed low and visually centred.*

8 *Visually centred with different weights of text.*

9 *Aligned left with one large vertical line and different weights of text.*

10–13 *Layouts to avoid.*
10 *Strong diagonals are uncomfortable to read.*
11 *Weak centre.*
12 *No central focus or spine.*
13 *Bottom heavy.*

121

vertical pencil line in the same position as it was on your rough. This is your reference point.

Place the paper strips, held together with masking tape on your best piece of paper and line it up with the vertical reference line. You can choose to make the markings for guidelines for your piece in one of two ways. If the layout is regular, with lines spaced at equal intervals, then simply measure this distance, mark where the first line starts, and take your measurements from there using either sets of dividers or a ruler (see page 32).

If your design is more involved then use the paper strips themselves as your guides. They will be positioned for your final design so simply make faint pencil markings on the paper to indicate the positions for horizontal guidelines and where the lines should begin and end.

Now you have the task of ruling the lines; this is made much easier if you have a parallel sliding motion on a drawing board, or a ruling device which maintains parallel lines. If not, you will need to make three or four marks to ensure that the lines are straight and parallel.

Writing the final piece

Even the most experienced of calligraphers tenses when they see a piece of best paper waiting expectantly for them to make a mark. It would be unnatural if you were not the same. However, there are ways in which you can overcome this.

Experimental layouts.
Try out lots of different ideas for your selected quotation(s). Here it took some time, different pen sizes, different lettering styles, and much trial and error to arrive at a satisfactory conclusion.

The finished piece.
© Archbishop Desmond Tutu for the words.
The word Yippee *can only be written in a flamboyant and exuberant way – it is not a shy and retiring word! In white, on torn black paper, it was written with a balsa wood pen with added over-writing with a ruling pen. This contrasts with the rest of the quotation which, although joyful, is more serious.*

122

You can use the five easy exercises on page 36 to help you relax first. You can also write a few lines on another piece of paper, adjusting your hand to the rhythm and flow of the text, then simply start on the best paper as though it is the fifth line of what you are writing. The paper strips on which you wrote your rough for layout can also help. You would have written those when you were relaxed and so the lettering is unlikely to be tense and tight. Before you separate these strips, make sure that you have taken a photocopy so that the exact position, weight of lettering and so on is recorded. With tiny pieces of masking or magic tape attach the top strip to your best paper positioned so that is is just above where you are to write (allowing for ascenders). Then simply copy the letters and spacing from this. Allow the paint or ink to dry before attaching the second strip if it is close to the top line. Check to ensure that you have made no mistakes and then you can use a hairdryer to speed up the drying process.

Another way which takes out the tension is to rule out two pieces of paper for final pieces. As you are writing the first one, bear in mind always that if you make a mistake, you have another piece of paper ready and waiting. This takes the pressure off and it is unlikely that you will make errors. Then when you are writing the second one you have the reassurance that there is always the first one which will do. It is likely that you will end up with two perfectly good copies, and can sell one of them, or give it to a friend and still have the best one for the client, or to put on your wall.

When you have finished, erase all visible pencil marks, taking particular care near the ink or paint. Do not be tempted to brush away the rubbings with your hand or blow them away, any moisture will smudge the lettering. Use a large soft paint brush instead, or, to be very traditional, a large feather. Trim the margins according to your pencil guide-lines, and your piece is ready for framing.

What to do if you make a mistake

It is so easy to make a mistake in calligraphy. You have to concentrate on so many different aspects – the letter-forms, pen nib angle, heights of letters, consistency, spacing and so on. All this means that, although you know how to spell words, omitting a letter, or transposing letters or words, happens all too frequently.

If you have chosen your paper carefully, and it is good quality of a reasonable weight (at least 160 gsm), it is not too difficult to remove small errors. However, it can be time-consuming and you must decide whether it will be quicker to rule the lines on another sheet of paper and start again. If the mistake is near the beginning of the piece, in the first or second line, or if it involves a whole line, a very large letter, or will affect the spacing, it will probably be

Page layouts for conventional book pages.

1 *Use a piece of paper which is the exact size of two pages (a folio) of your book and fold it in half. Draw a diagonal line from one corner to the other, and then from the bottom corners to the middle fold.*

2 *Draw a horizontal line marking the top of your text block as shown as line A. This should be long enough for between 6 to 9 words of text using your chosen pen nib size.*

3 *Now draw a vertical line which marks the depth of your text. This starts from line A and extends until it hits the page diagonal, as shown as line B. This makes the right hand margin.*

4 *Complete the text block by drawing another horizontal and vertical line as shown. Then match up the text block on the left-hand page by taking measurements from the one already drawn. The two text blocks are shown as darker shades.*

best simply to start again, using the rest of the paper which has not been written on for smaller projects once you have erased the lines. If you are near to the end of a piece of work and it involves only a letter or two to correct then it may be worthwhile trying to rescue.

There are two main ways in which you can remove an error. If you are skilled at handling a sharp knife, then you

can make a very slight scoop cut which just takes out the error. Easier to control, but more time-consuming is to remove the error with clean water and a clean fine brush. Mask all around the error with paper kitchen towels so that any water which falls by mistake does not ruin your work, and also have a pad of clean paper kitchen towel in your hand. Dip the brush in the water, wipe it on the side of the water pot and paint over the error. Immediately blot with the kitchen paper. Repeat this until as much colour has been removed as possible, and no more is coming out on to the pad. Allow to dry completely. Then use a pencil-shaped ink eraser to gently remove the rest of the colour. Do this slowly and carefully; if you rush you may rub away too much paper and even make a hole. Rub over the area of roughened paper through a piece of lightweight (photocopying?) paper with a burnisher, the end of a bone folder or your fingernail.

On a small piece of the same paper, take off the surface with a knife or ink eraser and write a letter. If the letter is crisp and sharp then the paper is tub sized. This means that there is size is throughout the paper and you can write safely in the area where you have removed. If the ink or paint bleeds into the surrounding area then the paper is only surface sized. Paint a little dilute PVA (50:50 mix) over the area and allow to dry. Now test again. The PVA mix should have prevented the paint from spreading. Repeat this on your best piece of paper and then write to correct your mistake.

Manuscript – hand-made and hand-written – books

Making manuscript books is one of the most delightful ways of presenting your calligraphy. Although this is how most of the lettering appeared in historical times, we are not used to hand-written books now, and they are as pleasurable to create as they are to receive.

Single-section manuscript books

These are the easiest of all to make as they require only basic sewing, however you can use your imagination on the cover or inside the book, so they may be simple but do not have to be boring or dull.

Designing the book

Start by planning what is to go inside your book. You may wish to make a manuscript book of classic proportions. To do this look at the directions for page dimensions on the previous page. This is the easy way to determine your margins and relates to the diagram below on the left. You may, though wish to write only on one side of the page, or make your page size much longer and narrower, or wider, and position the text in an unconventional way. It is your book, so you should decide what you want to do.

If you are writing out prose, it is best to aim for about 6 to 9 words on a line. Fewer than this will mean that the eye has to move too frequently to the next line, and lines which have many hand-written words may become tedious to follow.

Write out a couple of pages in rough if your book is essentially to be text, to make sure that everything will fit in. If your book is more 'designed' than this, then you will need to plan each page or spread in rough first.

Books need careful planning as the pages do not follow on numerically. The folios are folded, so in an eight page booklet pages 1 and 8 will be on the same side of paper, and 2 and 7 on the reverse. Always make a mock-up of your book so that you know which pages go together.

Choose a paper which is not too heavyweight, but not flimsy either. The pages in a book do need to be turned to be read, and should not be too bulky or so thin that they cannot bear the page movement without tearing. On the other hand if you are having only a few pages, a thick hand-made paper looks very luxurious. Traditionally the weight of the paper should be such that, when you hold a folio (fold of two pages) in your hand at the fold, then the paper should just flop over.

Although the direction of the paper does not matter if you are using the whole sheet unfolded or are using it to write a broadsheet, it is very important to bear in mind when making books. See page 292 for information on this. Grain direction in whatever papers and cardboard you are using should always be parallel to the fold or spine of the book. This means that when the paper fibres expand slightly if they get damp the shorter fibres will move outwards from the spine. If the grain direction is the other way, the expansion will cause the paper to cockle and bend within the binding.

Rule the lines for your book and write out the text. Add any decoration or illustration that you have planned. Take care not to make this too large, as books are held in the hand and the decoration should not overpower the text.

Classic proportions for text area of a book. The top margin (2 units) is half the depth of the bottom margin (4 units), and the right and left sides and the middle (3 units) are one and a half times the top margin. The units can be any measurement.

2 units	2 units	
text area	text area	
3 units	3 units	3 units
4 units	4 units	

When you have written the book you can consider the cover, although this will probably have been part of the original design anyway. The cover can be a simple fold of slightly heavier-weight paper or card, perhaps even in the same colour. Or it may be decorated (see page 119 for ideas on this), have the title written on the front, or the name of the person who is going to receive the book, the date perhaps if the book has been written to commemorate an event, or what you will.

For these books the cover is sewn in with the text pages. Add pages for title, dedication and colophon (the personal note that a scribe may add) if you wish, although try not to make the book too bulky. There are ways in which more than one section can be sewn in a simple way, and these are shown on page 126.

Making the book

Assemble the text pages, making sure that the edges are square, and fold them in half. Rub over the fold using a bookbinder's bone folder, or the edge of a clean plastic ruler. Using a sharp knife and metal straight edge trim the fore edge (front edge) so that it is neat and tidy, and if necessary trim any other cut edges. Now fold the cover in half and rub over the fold as before. Place the text pages inside the cover and hold them all firmly. Secure these with at least four paper clips (use plastic coated rather than steel, as the latter may mark light coloured papers).

Measure the length of the spine, and mark the mid-point with a pencil. Now make two more pencil markings which are about 1·5 cm (0·5 inch) from the top and bottom edges. If the book is large you may wish to make two more pencil marks which are mid-way between these points. Open the book out and use a needle to make holes right through the cover and text pages. Push the needle into a bottle cork for safety if you wish.

Decide whether you want a bow on the outside of your

cover or inside the book. Use thick cotton, thread, bookbinder's linen thread, embroidery silk or even very narrow ribbon to match your chosen colour scheme. Start sewing on the outside for a bow on the outside, and inside to finish on the inside. Follow the diagrams for sewing shown below, making sure that you push the needle in straight rather than at an angle. When you pull the needle to tighten the thread the paper will tear if you have sewn at an angle. When you have finished tie a bow on the outside, or a knot on the inside and trim the ends neatly. Use a needle to slightly fray the thread or cotton.

Hard-backed books

It is not that much more difficult to make a hard-backed book if you have already made a single-section manuscript book. The principles are the same, only the cover is different. If you wish to bind more than one section and make a rounded spine and backed book then you should refer to a specialist text.

As before you should write your book first, working out how many pages you will require and in what order the writing should be. Refer back to the previous page for this. Remember also that the grain direction of the paper should be parallel to the fold of the book. (See page 292.) Complete the writing in your book.

You will need two endpapers for this style of book binding, which should be the same dimensions as a folio (two pages) of your book. Usually endpapers are patterned because they then hide the bumps made by turning in the covers.

Marbling paper

To marble paper you can use kits which have a gel made from carrageen moss, or you can use wallpaper paste as the

Below left.
Always make a mock-up of your book using scrap paper so that you can see the page numbers and the positions of the pages which appear on the same side of a piece of paper. Here five pieces of paper will fold and make a 20 page booklet.

Left.
Sewing books – NB dotted lines represent inside the book.

1 Three-hole booklet starting from the outside (tie a bow on the outside to finish). Mark the centre point and two points about 1·5 cm (0·5 inch) from the top and bottom. Push a needle through from the outside to make the holes. Start on the outside and push the needle through the middle hole, out through the top hole, then miss the middle hole and come in through the bottom hole. Tighten the thread as you do so. Finally come out of the middle hole making sure that the two pieces of thread are either side of the long stitch. Tie a bow.

2 Sewing from the inside ends inside the book.

3 Five-hole sewing, follow the arrows and numbers.

Simple sewn books.

Ideas for sewn books.

1 *Three-hole book.*

2 *Five-hole book.*

3 *Five-hole book with fold and turn up (turn up secured with a spot of stick glue).*

4 *Five-hole book with additional folds of paper and a turn up.*

5 *Five-hole book with a flap (secured with a touch of stick glue). This flap can be turned in to slot in to end papers, or to hold a dedication card.*

6 *Five-hole book with a triangular flap pushed through from the end paper (the inside has a contrast colour triangular section which is the colour of the cover).*

7 *Two-section book with a concertina fold (sew as two separate books).*

8 *Two-section book sewn in (open the book out and sew through all sections).*

9 *Multi-section book, each section sewn on to a paper spine with one single stitch as shown on the right. The individual sections of the book would be much closer than this.*

Far right. Bookbinder's corner.

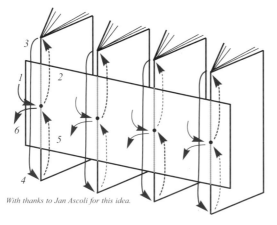

With thanks to Jan Ascoli for this idea.

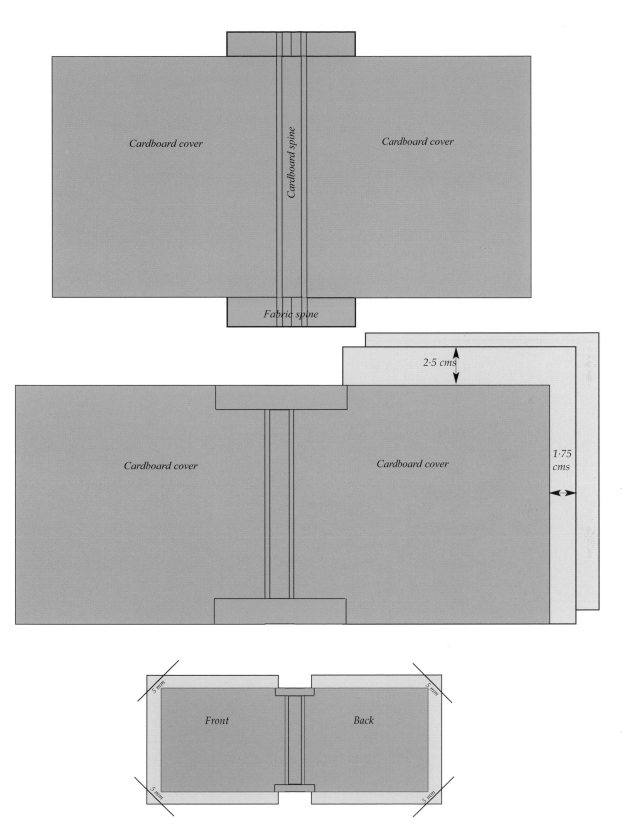

Cardboard cover

Cardboard spine

Cardboard cover

Fabric spine

2·5 cms

Cardboard cover

Cardboard cover

1·75 cms

5 mm

5 mm

Front

Back

5 mm

5 mm

Top left.
The fabric spine should be narrow and about 4 cm (1·5 in) longer than the height of the pages. Paste it on to the cardboard covers which are carefully positioned so that they are parallel, straight and about 1 cm (0·5 inch) apart. Paste the cardboard spine in position. Turn the fabric over the cardboard covers and spine at the top and bottom to give a neat edge.

Middle left.
Cut two rectangles of paper which are 2·5 cms (1 in) more than the height of the cardboard cover. Measure the width of the cardboard which is not covered by the fabric and add 1·75 (0·7 in) to this.

Bottom left.
Cut the diagonals from the corners as shown, 5 mm (0·25 in) from the corner of the cardboard cover. When you turn over the sides of the paper cover there will be a little 'ear' of paper at each corner where you made the diagonal cut. Push this down with the point of a bone folder or your thumb-nail before you turn over the top and then the bottom edges. This ensures that you have a good fit at each corner, and that the cardboard is well and neatly covered. See photograph on opposite page.

base, or you can use oil paints as the colours. The method below, which is very quick and easy, uses waterproof inks. The shellac in the ink holds the colour just long enough on the surface of a bath of water to take off a pattern.

Select two or three colours of waterproof ink. You will need a container large enough to take a sheet of paper (note the folio dimensions of your book); often a roasting tray from an oven, or a photographic developing tray will be large enough.

Cover a flat surface with old newspapers for protection. Fill the container so that it is about 4 cm (1·5 in) deep with water. Allow the water to settle.

You need to be speedy with this method, so have everything you need to hand. Place a pile of paper ready to be marbled away from the tray of water. This should not be too thick, probably not more than about 130 gsm. Check the grain direction. Ordinary photocopying paper is ideal if it is large enough for your book. Also have some ink droppers, or enough paintbrushes for each of the colours you are using.

When the water is steady, drip waterproof ink colours into the tray using the ink droppers or the ends of paintbrushes and immediately stir the surface around with the last ink dropper or brush. Straightaway place a piece of paper on the water, tapping it down where there are any obvious air bubbles. Lift the paper and allow it to dry.

Add more inks and repeat the process. You will probably now need to change the water, otherwise it becomes rather murky. You can make a number of sheets of marbled paper in this way quite cheaply and with easily obtainable materials.

Select the best papers to use as the marbled endpapers for your manuscript book.

Preparing the book

Place the text pages together in the correct order and add another complete page to the start of the book – this will be pasted to one endpaper. Then add the two patterned end papers which have been trimmed to the same size as the book papers to the start/end of the book. Importantly the first endpaper should have the pattern facing in to the book and the second endpaper should have the pattern facing away from the book so that the patterned sides face one another.

Hold the papers firmly and fold them in half to make pages;

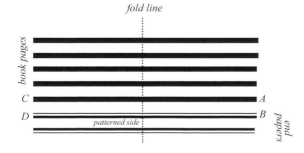

Assemble the book so that the end papers are at the start of the book. The patterns on the end papers should face one another.

go over the fold with a bookbinder's bone folder or the clean edge of a plastic ruler. Sew the pages together using three- or five-hole sewing, depending on the size of the book. Use a sharp knife and metal straight edge to trim the fore edge.

Paste the second endpaper to the last page of the book, indicated as A and B in the illustration on the left below. Note the points on using adhesives below. Fold back all the pages in the book apart from this endpaper and last page. Now fold back the last page. Place the endpaper face downwards on a magazine page as waste paper. Paste all over the endpaper, remove and replace the waste paper, and quickly place the last page into position. Put a piece of silicone paper on top, rub over with a bone folder and allow to dry. Repeat this with the first page in the book, C, and the endpaper marked as D. Put to one side under weights.

Using adhesive

It is important when book-binding to use an adhesive which will hold the binding firmly, but which will also allow a small degree of movement before it dries. Professional bookbinders use various sorts of animal glues and vegetable pastes, but PVA is a good substitute for both. If the PVA you have is very thick dilute it a little with water. It should be the consistency of cream.

Care should be taken with any adhesive. It is so easy not to notice that a small amount has oozed out on to a piece of waste paper, and for that then to transfer to an important part of the book. Be meticulous about using a clean piece of waste paper for every stage when using adhesive, and discard used paper. Keep your hands clean from adhesive, too, and keep the adhesive away from the surface whenever it is not being used.

Old magazines and colour supplements are ideal to use as waste papers as they are coated and so any printing ink should not transfer on to your book. Place the paper to be pasted on to a magazine page and apply the adhesive. Remove the magazine page (simply throw it on the floor for now) and place a clean page underneath the paper ready for the next stage. Before you make the next pasting, use another clean page.

Use non-stick silicone paper (baking parchment) to prevent the adhesive oozing on to the rest of your book, checking before each use that there is no PVA on this silicone paper from a previous pasting session.

A proper paste brush is ideal to use, but an ordinary clean home decorating brush will suffice. When applying the adhesive, try not to overload the brush. Hold the paste brush in your right hand (left hand for left-handers) and spread the fingers of your other hand out over the area to be pasted. Apply the adhesive from the centre outwards to avoid the paper curling and the PVA getting on the other side. When most of the paper has been covered with adhesive, lift each finger in turn and apply the PVA to those areas. Immediately

stick the papers together, place a piece of silicone paper over the top and rub over with the long edge of a bone folder. This distributes the PVA evenly over the area. It often helps to place pasted papers and cardboard underneath a weight for 10 minutes or so so that they dry flat. A proper nipping press is ideal, but a wooden board to distribute the weight evenly, and a couple of heavy books will do just as well.

Always go through the stages as a dry run first, so that you know exactly what part has to be pasted and what has to be attached to it.

Making the cover

The cover is made separately from the book and attached when it is complete. Choose a cardboard which is an appropriate weight for the size of your book. A large book will require a more substantial weight of board than a tiny book no bigger than a slide transparency. Check the grain direction. It should run parallel with the fold of the book.

Cut two pieces of card of which the dimensions are 3 mm (0·15 in) larger than the top, bottom and one side of a page of your book. Mark the grain direction on this card with an arrow in pencil. Also cut a narrow piece of card which is as long as the cardboard cover and 5 mm (0·2 in) wide, with the grain direction along the length. This will be the cardboard spine.

You will also need some fabric for the spine. This should be closely woven cotton or natural fabric which is not too bulky; cotton sheeting or similar is ideal. It should be 4 cm (1·5 in) longer than the cardboard cover; the width will be determined by the size of the book. This fabric should not extend more than about a quarter to a third across the cardboard cover. Measure this distance, double it and add 1 cm (0·4 inch) to allow for the spine and a slight overlap. Cut a piece of photocopying paper which is slightly larger than the fabric. Paste all over it and place the back of the fabric on top. Put a piece of silicone paper over this and rub over with a bone folder. When it is dry, trim the excess paper from the fabric with a sharp knife and metal straight edge.

Place the fabric down on a flat surface so that the paper is on top. Measure the mid-point of the fabric and draw a straight vertical line with a pencil and ruler. From this mid point measure two points 2·5 mm (0·1 in) either side, and then two points 1 cm (0·4 in) either side. Draw four vertical parallel lines on the paper at these markings.

Now make two horizontal measurements. Measure 1·5 cm (0·75 in) from the top and bottom and draw horizontal lines. These lines are guides for the cardboard covers so place the covers and the cardboard spine as shown in the top diagram on page 127. These should now be pasted on as follows.

Remove the covers and place the fabric again with the paper side up on waste paper. Apply adhesive all over with a brush. Quickly put the cardboard spine in place, then the two cardboard covers. Press firmly down with your fingers. Remove the waste paper and replace with clean. Turn the fabric and cardboard over, place a sheet of silicon paper on top and rub all over with a bone folder. Allow to dry.

Now paste the small flaps of fabric at the top and bottom of the spine and covers and turn these over on to the cardboard covers and the spine. Rub with a bone folder over a piece of silicone paper. Also rub the edges of the fabric with

The assembled book cover ready to be pasted to the endpapers of the book.

129

A variety of different covers on hard-backed single-section books.

1 *Hard cover covered front, back and spine in fabric.*

2 *Spine covered in fabric and most of front and back covers in paper (as in the diagrams on page 127).*

3 *This cover has an extended flap (also a hard cover) which tucks just inside the front cover to protect the book.*

4 *Here the book has paper flaps, pasted inside the back cover, and these enclose the book keeping any loose sheets safely.*

5 *Ribbons pasted to the back cover before the endpaper was pasted down keep the book securely closed when it is not being read.*

the flat of the bone folder to ensure a snug fit and to make a sharp edge. Push the fabric into the space between the spine and covers. Allow to dry.

The cardboard covers should now be covered with paper. Choose plain or patterned paper, again checking that the grain direction is parallel to the spine of the book. Cut two pieces which are 2·5 cms (1 in) more than the height of the cardboard cover. Measure the width of the cardboard cover which is not covered by the fabric and add 1·75 cm (0·7 in) to this.

The process of covering the cardboard covers is similar to covering a school text or exercise book with paper, but with one difference. It is important to ensure that the corners are

well covered with paper. To do this look back at the lower diagram on page 126. Put the paper face downwards on a cutting mat and draw a vertical line which is 1·25 cm (0·45 in) from the right hand edge. Now draw two lines which are 1·25 cm (0·45 in) from the top and bottom edges. Place the back cover of the book on top of this paper. The lines you have just drawn should mark out the edges of the cardboard cover.

Measure a point which is 5 mm (0·2 in) from the top and bottom corner. Draw two diagonal lines at 45° from these points as shown. Cut these away using a sharp knife and metal straight edge.

Repeat this for the front cardboard cover and paper,

Zig zag or concertina books and star books

1 *Ribbons attached to the front and back covers secure the book.*

2 *A long ribbon wraps around the book once or twice before being tied in a bow.*

3 *A narrow strip of paper keeps the book together.*

4 *'Hard backed' zig zag book.*

5 *A ribbon threaded through a hole punched through the cover and towards the back of the folds. The ribbon pulls the book together and secures it when tied in a bow at the front of the closed book.*

6 *A star book (the word 'Congratul-ations' has been written on the pages and decor-ations added).*

remembering to measure from the left-hand edge of the paper, and cut away the diagonals at the top and bottom corners on that left side. Put this front cover paper to one side.

Place the back cover paper face downwards on some waste paper. Paste all over and place the back part of the cardboard cover on the paper using the pencil guidelines you have already drawn. Remove the waste paper and replace with clean. Turn the cover over and rub over placing a piece of silicone paper between the bone folder and cover.

Turn back again so that you can work on turning over the edges. Turn over the top edge first. Use the bone folder to help you get a snug, neat edge and for the paper to lie flat on the cardboard. Do this for the bottom edge. There will be a little 'ear' at each corner. Use the point of your bone folder to press down this 'ear', or you can use your thumbnail. Now fold over the side, rubbing over again with the bone folder to make a neat finish. Allow to dry under weights. With a pencil write 'back' on the back cover you have just finished.

Repeat this process with the front cover, writing 'front' with a pencil on that cover.

Assembling the book

This cover should now be attached to the text pages and endpapers. Place the text pages inside the cover and make sure that is fits well, noting that the text pages are not pushed right into the spine of the cover, otherwise the book will not open easily after it has been pasted together.

You will have to work quickly here, so, as you have done before, go through the process as a dry run before you use any paste. Place a sheet of waste paper between the back endpaper and the rest of the text pages. Place the closed text pages on a sheet of clean waste paper. Paste all over this endpaper. Replace the waste paper between the endpaper and the rest of the text pages and also the waste paper underneath. Place the cover outside downwards, and position the text pages so that the endpaper is on the back cover (note that it is the *back* cover!). Slide the endpaper around so that there is an equal amount of about 3 mm (0·1 in) of cover visible at the top, bottom and side. Press down with your fingers, and place a piece of silicone paper over the top. Rub over with a bone folder. Replace the silicone paper

with clean, close the book and allow to dry under weights.

Repeat this process for the front cover, and your book is complete.

Zig zag or concertina books

These are very easy to make, consisting simply of a strip of folded paper with heavier weight paper covers, although you can make something a little more elaborate if you wish.

As you will be folding the paper, check the grain direction (see page 292) and make sure that it will be parallel to the folds. As before it is better to write the text before you make your book. These books can be of any size and shape, and because they are made from one or more long strips, the lettering can go over the folds, so page design can be very exciting. Always aim to have an even number of pages and an odd number of folds, so that the book works with the covers.

So that any joins hardly show, overlap behind a page on an inner fold, as shown below. Use PVA to paste together.

The covers are cut very slightly larger all round to give protection. Depending on the size of the book you may wish to make the covers 2–4 mm (0·1–0·2 in) larger all round.

When you have finished writing the book, fold it carefully. It is important to ensure that the folds are square and crisp for the book to work so take careful measurements and score the paper on the back with a dull edge (such as the back of a blade of a pair of scissors) and a ruler.

Place the folded book on wastepaper with the back at the top. Slip a piece of clean silicone paper underneath the last page to protect the rest of the book from the adhesive. Use a brush to apply PVA all over the last page. Remove the silicone paper and waste paper and replace. Quickly place the fold on to the prepared cover and slide around until all the visible parts of the cover show an even amount. Allow to dry and repeat this for the front cover.

Variations

1 Attach ribbons to the front and back covers to secure the book when not opened out. Do this by pasting ribbons of suitable length and width to the covers *before* you paste the covers to the pages of the book itself. Tie the ribbons into bows.

2 Attach a ribbon to the back cover before pasting it to the book. This ribbon should be long enough to wrap around the book once or twice before being tied in a bow.

3 Paste the ends of a narrow strip of paper together to make a shape which is large enough to slide over the book to keep it together. You could write the title or a dedication on this paper.

4 Make paper-covered cardboard covers in the same way as you covered the cardboard for the hard backed manuscript book, only this time you will need to allow for overlap on all four edges, and make book binder's corners on all four corners. You can also attach ribbons before pasting the book together.

5 Thread ribbons through slits cut, or a hole punched, in the back of the folds and the cover, so that they tie round the top and bottom of the book when closed.

6 Make a zig zag book into a star book. Cut two narrow strips of paper and write or decorate them. Fold them as for a zig zag book. Then paste the back fold of one the strips of paper to the back fold of the other strip (making sure that they are both up the same way before you do so). Now paste the other two folds together. Thread each fold through a single loop of embroidery silk and then thread the ends of these in turn through a bead with a large core. Tie a knot to secure. Open out the book into a star shape and hang if you wish.

Zig zag books should have an even number of pages and an odd number of folds. If you need to make a join, do so where it will hardly show. Overlap about 7·5 mm (0·3 in) behind a page on an inner fold, as indicated by the dotted line.

Handwriting and Calligraphy
Rosemary Sassoon

This chapter does not set out to be practical. It starts by attempting to disentangle the terminology used in different ways to describe the formal and informal use of writing. In doing so it may provoke more questions than provide definitive answers. A precise terminology, however, is something that is needed in order for intelligent discussion to take place. In the two subjects appearing in the title of this chapter calligraphy has become 'big business', maybe to its detriment. Handwriting on the other hand has become the forgotten facet of literacy, neglected or inappropriately taught. Neglected, as much skill training has been recently, in the mistaken belief that it is repressive to teach handwriting, that it stops children being creative – anyhow, as the saying goes, they should be able to pick it up by themselves. This has resulted in several generations not being taught and then being blamed for being unable to write in a satisfactory manner. As for being inappropriately taught, where handwriting has been taught it has too often been in such a way that forces pupils to copy a strict and often arbitrarily chosen model. This does not encourage children to develop a natural hand which enables their script to be a flexible tool for the various tasks that face them today in school and afterwards.

There is first a need to clarify the difference between calligraphy and handwriting. This is no small task. It seems that there are different attitudes between the West and those great cultures which have long had a calligraphic tradition – China and Islam in particular; there are different attitudes between different professions and within those professions there are also very different personal views.

The definition *calligraphy means beautiful writing* is just not enough. As the letterer Fernand Baudin said when app-roached for a quote on the subject for this chapter – 'No one is any longer satisfied with a pat answer such as: handwriting is just handwriting as opposed to printing or lettering; while calligraphy is supposed to mean something like fine handwriting and eventually a highly creative art form'.

Calligraphy or lettering

When I trained in the late 1940s, it was as a scribe. What I learned was called lettering, or pen lettering if anyone wanted to be more specific. Edward Johnston's book, which might be considered to mark the revival of lettering art in Britain, did not use the word calligraphy in its title. It was called *Writing, Illuminating and Lettering.* My own teacher, M C Oliver, who would certainly have considered himself a crafts-man, contributed a chapter to a book entitled *Fifteen Craftsmen on their Craft* in 1945. In it he talks about the essential virtues or principles of what he termed *formal writing*. Alfred Fairbank, another notable authority on the subject, con-tributed a text in the publication *Lettering of Today* in 1937 entitled *Calligraphy*. He does not help to clarify the picture. 'Calligraphy is handwriting as an art', he begins. 'To some calligraphy will mean formal penmanship, others may think of calligraphy as the cursive handwriting used for correspondence which has legibility and beauty in spite of a swift pen. Calligraphy then may be considered as covering formal or informal handwriting, and to be found in the enduring and precious manuscript or on the envelope already found in the waste-paper basket.'

The next Studio publication, *Modern Lettering and*

Calligraphy, was published in 1954. It contained work produced since 1945. By then the terminology had altered, separating calligraphy from lettering. Maybe this is part of the age-old battle between those who consider themselves artists, and think of a craftsman as a lower order of person, and those who are proud to consider themselves as craftsmen. Lettering is a craft. Do those who limit themselves to the pen alone perhaps wish to be thought of as artists?

Admittedly there has been a change in the usage of lettering. After the Second World War the subject of lettering was dropped from most art schools (along with drawing from the antique) on the excuse of their being repressive (that word again). Soon Letraset freed designers from the tedious task of hand lettering, at the same time beginning a sharp decline in the demand for skill. When I worked in a packaging studio in 1950 the level of hand lettering accomplished by boys leaving technical schools at the age of 15, was impressive. Today the resulting ephemera would be hailed as calligraphic masterpieces and such work command a high fee. Then it was ordinary commercial lettering.

Everything goes in cycles, however. After a time the uniformity of automatically produced letterforms became over-familiar. Everyone in advertising, book production etc, suddenly wanted something different – something uneven, hand-done, in appearance. Lettering once again became fashionable and sought-after. For a while there was a dearth of letterers to fill this gap. Those few who had been trained before the war were teaching or using their skills in various ways, far removed (with a few exceptions) from the commercial market place. The demand was obvious, certainly by the 1970s. It created the environment for another revival. Of course there were differences. As technologies altered so letterers adapted their skills, as they always have for new printing methods, and do now in the computer age.

The recent revival in calligraphy is impressive. However, as the word calligraphy has crept in to the consciousness of the public in the Western world, it has brought with it somewhat different connotations – much more amateur in one sense. It often appears to present what was a craft with a useful part to play in society, as something less. Peter Halliday, in an advertisement for CLAS (the Calligraphy and Lettering Arts Society), describes it as 'The fastest growing leisure pursuit'. No one would wish to deprive the many amateurs of the pleasure that they gain, but it seems that in recent years calligraphy has become an occupation on its own. It has become somewhat divorced from the discipline of lettering. Instead of being taught as a part of a general art course where students would learn about design, composition and colour in a wider field, all that many pupils are getting is a period of learning to copy various models. All too often they are taught by people who themselves have only had the same limited training.

Serious letterers, letter designers and type designers are usually happy to give the credit for early training to what they might call either pen lettering or calligraphy – depending on their age – but most would agree that any calligraphic training was just a beginning. Their real training probably started with the discipline of drawn lettering before embarking on whatever speciality they chose to follow – wood-carved, stone-cut, engraved, type design or whatever. Later in their careers they often attach the term *calligraphic* to freer letterforms as well as to those based on the broad-edged pen.

Calligraphic handwriting

There is still a missing link. The informal writing of many (perhaps most) of those involved in the world of letterforms could be called *calligraphy* in the widest sense. As one type designer (who has a natural italic hand) has said: 'It depends on the degree of skill of the writer and the amount of effort put into it – whether it should be called handwriting or calligraphy'. Maybe, at this level, it is calligraphy if the writer means it to be. Another letterer, when pushed, argued that it was a matter of art or utility – or maybe how much one was paid for it, certainly a valid point today. More seriously he pointed out the difference between a cursive as handwriting and the formal hands that constitute lettering. '

In the past I have had elderly students whose personal handwriting was so beautiful that in my eyes it certainly attained the level of calligraphy. In those cases it seemed a crime to try to teach them a formal classical model, which would be ill-suited to the way their hands worked and never likely to do justice to their personality. I have already written elsewhere in a paper on the psychology of Western calligraphy, that striving consciously for a 'decorative' italic, or any other formal model of handwriting, all too often betrays the affectations of the writer and seldom achieves his or her intentions. If you are born with the ability to prod-uce a natural flowing oval slanting hand, then you are lucky. If not, any attempt to appear to be what you are not is likely to look artificial.

Calligraphy in other cultures

What connotations do the words calligraphy and handwriting carry with them in other cultures? It is usually something deeper than just recording – the calligrapher in most cultures would be bringing something of him or herself to the written stroke. Be it a religious emotion, or a philosophical depth of feeling, it is seldom just perfection of form, but something more difficult to attain. What then is the difference between handwriting and calligraphy in those cultures which have a

strong tradition in the subject? I posed the question to three Chinese colleagues, who were interested in the subject rather than professionals. I received three quite different answers. One said: 'Handwriting is anything that you wrote by hand. It is used to convey information. For calligraphy you have to have special training and exercises – it is an art.' He then specified two kinds of calligraphy:

1 To show inner feeling and self-actuality through the writing.

2 For social rank. Very highly educated people or high-ranking officers traditionally had to have beautiful handwriting which could be termed calligraphy.

Another described calligraphy as an impression of the outside world in graphic form – calligraphy as a medium for thought, with intrinsic motivation and a desire for perfection.

A third called calligraphy a conversation with yourself. He made an interesting parallel between the classic Chinese calligraphers of past centuries and avant-garde painters such as Van Gogh. He explained that the greatest Chinese calligraphers were not honoured in their lifetimes. All classical calligraphers were skilled in, and had the choice of, the same traditional styles, so it must be assumed that it was the personal deviations from those styles that were met with contemporaneous criticism. Those personal variations by the master calligraphers of centuries past are precisely what are now valued so highly by connoisseurs.

Albertine Gaur defines the difference like this: everyone can learn handwriting and it is a tool for everyday use, but calligraphy (or the work of a scribe) needs a certain talent and commitment. She separates beautiful handwriting from calligraphy, a distinction which I can understand coming from a historian's stance but not necessarily from a professional letterer's.

The terminology is further confused by the two terms: scribe and calligrapher. A scribe could be described as one who strives for, and is trained in, uniformity and legibility. A calligrapher adds something of himself. Being a scribe or a calligrapher, and even more so a letterer, presupposes some sort of training. But what does *training* entail – half a lifetime under a master as many Chinese calligraphers might consider reasonable, three years at an art school studying, amongst other subjects, lettering on hypothetical jobs, an apprenticeship with a working scribe or in a lettering studio, or a quick adult education course? It all depends where you come from, and where you are going. All this will colour your views as to the definitions of these terms.

To sum up, here are some attempts at definitions of some of the terms that would enable an informed discussion to take place:

Scribe – one who undertakes professionally written tasks for a variety of purposes at a variety of different levels.

Calligrapher – One trained and practised in both formal and informal classical pen and brush written forms. Today it would be expected that a calligrapher would be able to develop personal informal letters too.

Letterer – one trained to undertake various letterform tasks in a variety of media.

Handwriting – a means of graphic communication. It can be at various levels of perfection.

Calligraphic handwriting is likely to be the consequence of a hand trained in letterforms and can also vary in levels from formal to informal.

From definitions to æsthetics, criteria and critiques

Thoughts do not have beauty – but people find beauty in things. Therefore different training, different cultures, backgrounds and even different personalities are likely to differ in their concept of beauty. The influences of personal taste have long been documented in typographic matters, and to a certain extent they could be seen as the reverse side of the study of graphology. I personally know many people who think that the only acceptable style of handwriting is Italic, whether they write it naturally themselves – or strive unsuccessfully to do so. I also know many people who intensely dislike Italic, who find it affected and false, and others who have suffered at the hands of teachers trying to force them to write in an Italic style.

People's concept of beauty is often associated with a bygone age. What may be an example of an artisan's hand a hundred years ago – a simple bill perhaps or a list – is drooled over as calligraphy by present day writers. They marvel at the Copperplate which they are unable to replicate. In reality this disciplined hand speaks of a more limited elementary education with more discipline and less creativity fitting the masses for a life of a clerk a century, or a century and a half, ago.

As for æsthetics: to my Chinese informants, calligraphic beauty lies in the structure of the stroke, how it is organised and the configuration. Proper spacing comes into the judgement as does correct positioning of the radicals. Connoisseurs of classical Chinese calligraphy have assured me that, looking back, the most honoured features of their work, within the many classical hands that they needed to perfect, were their personal deviations from those models. For M C Oliver the criteria were sharpness, freedom and unity. It is useful to pursue his views on the essential virtues of *formal writing* – his term in 1945. Sharpness is predictable – he says that it is dependent on the right use of tools and materials – but what he said about freedom is less obvious and far less

understood today: 'Freedom or spontaneity imparts a quick liveliness to writing which can only be attained by skilled practice and unaffected boldness; on the whole freedom with knowledge is preferable to mechanical precision.'

It is amusing as well as informative to look at letters (good and bad) through critiques from bygone ages. Judgements concerning letter-forms alter dramatically with fashion. What is admired by one generation is abhorred and ridiculed by the next for reasons that themselves will appear outdated by the following generations. Then a few decades later, any such work will be hailed as a masterpiece. This should be a lesson to those who proclaim that their version of whatever model they have laboriously learned and are now trying to claim as their own, is far better than the preceding one. You think that this kind of behaviour is not still happening? I heard from lettering colleagues in Australia, who recently attended an expensive workshop, that a well known calligrapher from England announced to them that Copperplate was not calligraphy at all and that she would not allow anyone to practise it. This did not go down well at all in a country where the written forms of many older people are still influenced by the Copperplate-based model which was taught, until quite recently, in some Australian states. This is why many Australians are excellent proponents of Copperplate – and why many British are not! Another instance was reported to me of a student from Northern Europe who is attending an advanced calligraphy course. Not unnaturally she enquired why the Gothic hand was not included. The answer was ominously similar: we do not teach the Gothic hand because it is not calligraphy. I could have sympathised a couple of decades ago when I was teaching adult education classes, because a fair proportion of the general populace considered that calligraphy consisted solely of *Olde English,* otherwise known as Gothic Black Letter. They had to be weaned away from over elaborate forms and taught to value the proportions of foundational, condensed and Italic, all of which would assist them if they wanted to return to a simpler form of Gothic in the future. At a higher level, however, it seems inexcusable as well as ignorant on the part of a tutor to deny the calligraphic credentials of a hand that is part of the cultural heritage of a large proportion of the world's best letterers.

The place of handwriting in the past

Handwriting, like other letterforms, has altered over the centuries to comply with the tastes and priorities of different times. Different writing tools have affected the letterforms, and the needs of society have affected the speed and attitudes to how the letters are written. When trade and industry, as well as academic learning and personal communication,

depended entirely on handwriting, then universal legibility was of primary importance. While writing material, in the shape of treated animal skins, was so expensive, economy of style of letter-forms was a necessity – hence condensed scripts. Speed was not such a high priority. When paper became generally available, and printing took over many of the tasks of the scribe, beautiful handwriting, for a while, became the mark of the leisured class. As trade and industry expanded it was the clerks for whom a clear script was of utmost importance, and much of the time in elementary school was expended in drilling this into the pupils who would fill the desks of counting houses and the burgeoning offices. The typewriter brought about another change of focus; the relief pen and then the fountain pen brought freedom from the quill and pointed metal nib. All this allowed the development of simpler written forms.

Handwriting today

Today the computer has taken over even more of the tasks that were once, of necessity, handwritten. Some may deplore this, but in reality it is a blessing. With the speeding up of all our lives, our hands are often being asked to perform a task beyond their capabilities. Looking at the act of writing from a completely different perspective: our hands were not designed to hold a small stick, to make accurate marks, neatly, at considerable speed and often under intense pressure. There has been a serious increase of physical pain when writing, particularly among high-achieving students. This has arisen because of a misconception of the task, which places neatness and sometimes an ideal style, as the first priorities of handwriting, while ignoring the vital factor which our forefathers understood – the training of the body for the task in hand.

Handwriting is still a necessary communication skill, and is likely to survive the advent of the computer, but probably in a slightly different form and for different purposes. The priorities must alter to suit the tasks. These are likely to be note-taking, list and memoranda writing and some forms of personal correspondence rather than the transcription of lengthy essays. Legibility is still necessary, but owing to the more personal nature of the tasks, the reader is likely to be the writer him or herself, rather than a second person. Speed will be the next priority, coming before traditional æsthetic considerations. For speed we need efficient letter-forms, for effortless writing we must train the writer to develop good strategies and writing posture. Attitudes to how the pen is held may have to alter to relate to modern tools. How the writer writes in physical terms is as important as what the writer can produce in terms of letters. The two factors are inextricably involved. We must consider the writer and not

only the reader. A new attitude to the writing is long overdue.

In those circumstances, and from the calligraphic stance, what is beauty in handwriting? What conceivably makes a hand beautiful? Can such a quality be generalised or only considered through the eyes of the perceiver? Let us return to legibility and speed. For everyone who says that speed is the enemy of good handwriting there is another who knows that it is usually the speed of a fluent hand that makes it pleasing and that a slow and overcareful hand shows its artificiality only too easily. Its artificiality? – handwriting is the mirror of the writer and the reader must draw his or her own conclusions. When these sentiments are extended to consider the plight of the writer, then a consistent personal writing which is legible, however unconventional in the eyes of the traditionalist, becomes beautiful in the true letterer's sense of being appropriate for the job in hand and expressive of the writer's personality.

Teaching handwriting today

It is the teaching of handwriting today that most concerns me. Far from the recent idea that handwriting need no longer be taught, whether because it is repressive, easy to pick up without any training at all, or because it will become unnecessary in the near future – I believe that we should be directing this essential training to reflect those tasks which are still best written by hand. At one extreme these are likely to be fast personal note-taking – either at school, in higher education, or later on in most forms of employment. The second usage, at quite a different level, is for show – whether in the primary school to display on the wall, when writing a thank-you letter, or even a love letter, and perhaps for use when applying for a job. If handwriting is to survive then it should be flexible. If fast, then from the beginning efficiency will need to be built in to the letters that are taught to children at school. What is essential needs to be taught strictly and what is not essential is best left to personal choice. The act of writing is a motor skill. The teaching of writing is, in reality, the training of the body in the movements that, when a pen is in the hand and that pen is in contact with the paper, will result in the trace of a letter. For efficiency the movement that occurs when the pen is not in contact with the paper is as important as that when it is.

The essential aspects that need teaching at school are what might be called the rules of our writing system. Any of these rules are difficult perceptions for young children, as well as difficult for them to produce. Together they may prove to be a barrier to the acquisition of writing. They are –

1 The direction of writing.
2 The point of entry and direction of the strokes of individual letters.
3 The height differentials.
4 The difference between the two sets of letter – capitals (majuscules) and small letters (minuscules).
5 The spacing between letters and words.

Different writing systems have different rules which must be understood when you are learning another writing system. Yet it is this analytical approach to handwriting which teachers need. With this understanding, they should be able to teach or correct the writing of most ages and abilities. They should be able to provide any necessary explanations or exercises, while understanding that very young children may need pre-writing exercises to help develop both the discrimination and the physical co-ordination to produce letters.

What seems far less necessary is a strict emphasis on the exact proportion, slant or detail of letters as dictated by whichever model has been chosen by a school. The slant and proportion of letters depends on the position and flexibility of the hand, the proportion often on the position of the fingers on the pen – those features which are often determined by how a person manages his or her body. Hence one aspect of the person being reflected in the handwriting. Generally, an out-going person will have a relaxed, generous, perhaps rounded writing reflecting the relaxed movement of his or her body. A tense, introspective person will have tighter writing reflecting the less relaxed movement, on a sliding scale from pleasantly oval and slanting, to minuscule or tortuously crowded and jagged.

Efficient writing develops from a first model which includes exit strokes but not entry strokes. Exit strokes train the hand in a more relaxed movement than did the truncated print script letters so popular in past decades. With them the maximum pressure was at the baseline, necessitating a radical alteration to achieve a joined hand. Exit strokes also allow for adequate letter spacing and, once the correct movement of basic letters is established, with growing confidence, spontaneous action along the baseline can occur. Top, cross-bar and reverse joins (those to the round family of letters such as **c o a d g** etc.) then need to be taught. But there must be an understanding that lifting the pen is desirable during the writing of long words. This is a consequence of the way we handle modern writing implements. We no longer live in the age of the pointed quill where it was a disaster to break a word for fear of a blotted copybook. Our hands need to move freely along the page. If adults inspect their own handwriting they would find that they usually need such penlifts, so why should children be expected to make such a stream of complex movements without a rest? The consequence of such training is not only a painful hand, but a muddle of letters towards the end of a word and no improvement in speed. Joining letters is only a matter of going from where you finish one letter to where you start

the next – but keeping the pen on the paper. There is little penalty in the terms of speed for lifting the pen from time to time – and much to be gained in terms of comfort and clarity.

Where handwriting and calligraphy meet and sometimes conflict

Controversy is likely to result when calligraphers, however well meaning they may be, interfere with the education of children. From Fairbank onwards, the effects of imposing their calligraphic models on all children has not been successful. This is because the concern with the æsthetic appearance of the models that they proposed was not balanced by their understanding either of the physiological aspects of the act of writing, nor the reality of the task. There is another factor ignored by the proponents of Italic for children. That is the difficulty of teaching a strict Italic model to all children, and the difficulty that unskilled teachers find in reproducing its details or its movement. With a skilled hand, Italic develops into a magical, flowing semi-cursive. However, all too often, children develop a zig-zag disaster of slowly produced, triangular separate letters. To achieve a consistent Italic a specific hand position and finger position is required. This may be easy for those whose artistic tendencies predispose them to a relaxed penhold that encourages a forward-slanting oval letter. For those with a more pronated (flattened) hand and fingers other than in the optimum position on the pen to allow this movement (the majority, according to my own research) – the result is not likely to be successful. Even in the majority of calligraphy classes these details that relate to the hand are not understood and taught. So what chance have the majority of school children got to develop a successful Italic, in the short time available before they are expected to use their handwriting? Another matter, that those involved in the educational aspects of handwriting are well advised to remember, is that with a motor skill bad habits once learned are increasingly difficult to correct. The earliest errors of detail and movement – often picked up from the teacher's perception and production of a model rather than the book model – remain to plague the unfortunate children and prevent them from developing the fast efficient natural hand that they need.

There is more than that. It is my belief that we should be teaching children to write automatically as soon as possible, not teaching them to be competent forgers by forcing them to copy any imposed style. The relationship of the handwriting and the creative side of writing must be balanced in school. Where children are having to adhere to an inappropriate model which does not come naturally, they will need to concentrate on the actual letters in order to escape the inevitable criticism,

long after the production of all this should have become automated. This automation of the act of writing leaves the mind free to concentrate on content.

Sadly I have also seen the results of the imposition of too high a standard of writing. Pupils have come for help when they failed important examinations because they felt that the standard of their much praised calligraphic handwriting could not be compromised by speeding it up. They had to be told that, though unlikely, a few marks might be taken off for handwriting that was particularly difficult to read. However, no marks at all could be given for words that were not there. Too slow a hand, however decorative, might mean that the candidate would never get enough written down. Such students needed techniques for speeding up and developing a more relaxed joined hand. In another country, whole schools produced calligraphy of a very high standard to display on the walls, but the boys in their classrooms reported an even higher than usual level of pain in an attempt to get their written work done. Their teachers told me that of course handwriting was painful because it was a discipline. Little hope there for compromise – but I suspect a proportion of these pupils would suffer from writer's cramp in later years. In another country, much envied by calligraphers for its particularly beautiful Italic model, the results could be measured both in the incidence of pain and also in the paucity of the written work. Older pupils, nearing university entrance, were still writing on paper printed with sets of four staved lines spaced widely down a page. Their teachers defended the short, beautifully written essays by saying if students wrote faster their writing would not be so legible. There was little understanding that teachers' duties should include teaching fast legible handwriting as well as a slow beautiful script. It would be a word processor or failure at university for these students, I fear.

Future cooperation

All that I have said is not meant to advocate poor handwriting – quite the opposite. My concern is to make handwriting relevant and practical in the computer age. Attitudes will need to change, but those who have studied the history of writing should have little trouble in understanding that suitability for the task is a prerequisite of letterforms in any media. Good handwriting therefore will make the most of modern pens, and exist at various levels to work for the writer. Understandably there will be alterations in appearance. This should not always be a matter of alarm. It has been the same throughout history. Writing masters always understood the tripartite relationship between the pen, the hand that writes and the model in use. When one altered, so did the others of necessity. Add those factors to the changing priorities in order to co-

Since weather is quite unpredictable in this country, I was not able to fix a date nor announce the performance in advance, but had a weekend on or as close as possible to winter-solstice in mind. Here in The Netherlands, solstice is not celebrated by whom so ever, at least as far as I am aware of, so I thought it a rather neutral date, possibly accepted by everyone, no matter what the cultural background is.

To end the gathering, I thought to invite everyone attending, to take one of the burning candles off the ground, starting from the outer points of the sign, dismantling one symbol after the other. Then I'd suggest to carefully keep the flame alive and carry it into the home and keep it lit until the candle is burned down...

Lettering by Karina Meister from The Netherlands. Sometimes it is difficult to categorise her work as handwriting or calligraphy.

ie hiervoor,
de eerste maal
als een
pasgeboren kind
dat geen
naam heeft.

RABINDRANATH TAGORE

NIEUW ADRES
NEW ADDRESS
NEUE ADRESSE

exist with computers and the future could be seen as a challenge, not a disaster area.

We need the knowledge of all those experienced in the different disciplines of letterforms – but offered in an openminded way when it comes to children. What I learned as a scribe helped me to tackle the ignorance in our schools concerning paper position, posture and penhold. What I knew of the effects of tension dated back to my own experience of stilted letters produced by a tense hand when starting out on a clean (and expensive) piece of vellum. What I knew about the movement and pressures of strokes came from knowing letters from the inside, and that also gave me the confidence to ask children what kind of type they found easiest to read – and to design typefaces specially for them.

Long may the work of calligraphers inspire children to greater efforts. Those pupils who wish to emulate them should be encouraged to do so once they have developed competent handwriting and understood the different levels of writing required for different tasks. That is very different from imposing something on everyone at an early age. Far from depriving children of examples of good lettering, precisely the opposite should be the case. There are other ways of interesting children in letterforms. The study of the history of letters is one of the most fascinating. It traces the rise and fall of civilisations and is a window into the social history of mankind. Tool-making can be another route into understanding handwriting, more formal letter-forms as well as the various allied crafts of cutting and engraving. The designing of personal letters should be part of every primary school art class well as at secondary level. Those of us whose interest in lettering was aroused while we were very young, know only too well how compulsive and satisfying an occupation, and sometimes a profession, it can become.

Calligraphy and Typeface Design
Hermann Zapf

Calligraphy has influenced typeface design since Johannes Gutenberg. For the printing of his Bible he took as a model for his type-face a Textura, used by the mediæval scribes to write their manuscripts. The Textura is generally known as Black Letter. It was and is a broad-edged pen script, as the writing tool of these old scribes was a broad-cut quill.

In the centuries after Gutenberg the sources for new type-faces have been mostly calligraphic. The stroke of the broad-edged pen formed the structure also for the Roman typefaces which were based on the ninth-century Carolingian script. It was only in the nineteenth century that this close connection between calligraphy and type design was interrupted by the degeneration of the letters due to the personal tastes of the punch cutters.

This decline of letter-forms, so typical of the nineteenth century, was ended by William Morris who, after 1890, produced the types for his Kelmscott Press. It was William Morris who went back to the historic sources of the fifteenth century in redesigning his Golden Type, which was inspired by a Roman form used by Nicolas Jenson in Venice in 1470. With William Morris the period of types designed by artists began. His reform movement initiated a Renaissance of type design which also spread to mainland Europe during the period of Art Nouveau.

At the beginning of the twentieth century Edward Johnston started the revival of lettering, and new typefaces with a calligraphic background were developed. The type foundries commissioned lettering artists and long-lasting alphabets have been executed since by designers such as Eric Gill, Rudolf Koch, F.H.Ernst Schneidler, and Georg Trump to name only a few. All these designers were outstanding

Detail from the Gutenberg Bible of Johann Gutenberg, Mainz, 1455..

Jubilee, a beautifully clear and calligraphic typeface designed by Eric Gill (1882–1940) in 1933–1934.

Gill designed a number of other typefaces incuding Gill Sans, Perpetua, Joanna, Aries and the Golden Cockerel Press Type.

ABCDEFGH IKLMNOPR STUWXYabcde fghijklmnopqrstuwxy

The Johnston Italic is the only calligraphic typeface designed by Edward Johnston (1872–1944) for the Cranach Press of Harry Count Kessler: cut by Edward Prince, finished 1913. (Original size)

HARRY GRAF KESSLER traf die satzanordnung dieses bandes. ARISTIDE MAILLOL hat auf grund dieser satzanordnung in den jahren 1912/1914 und 1925 in Banyuls an den Pyrenäen die dreiund-vierzig illustrationen gezeichnet und eigenhändig in holz geschnitten. Hierbei verwendete er vielfach motive aus seiner nächsten umgebung und bekanntschaft : so für den reigentanz in der fünften ecloge den alten, angeblich auf griechische Kolonisten im Altertum zurückgehenden cata-lanischen volkstanz, den „Contrapass"; für das grab des Daphnis in der fünften ecloge ein altes grabmonument auf der feldflur von Banyuls; für das brunnenhaus in der neunten ecloge das brunnenhaus auf seinem eigenen weingut ebendort; für den Silen in der sechsten ecloge als modell den maler Terrus in Elne bei Banyuls; für den Silvanus in der zehnten ecloge Auguste Rodin. Eric Gill schnitt in holz die titel und grossen versalien, die ornamente dazu wiederum Aristide Maillol; Edward Prince, unter aufsicht von Emery Walker, die stempel zu den typen, und

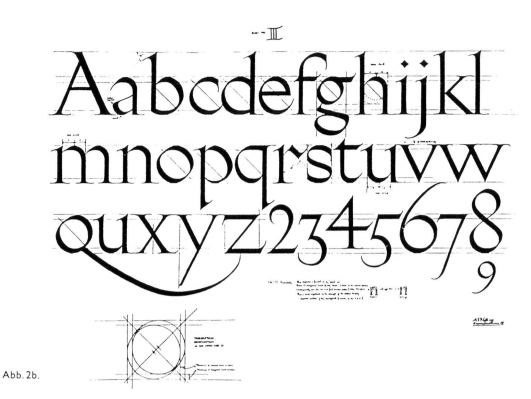

—III

A a b c d e f g h i j k l m n o p q r s t u v w q u x y z 2 3 4 5 6 7 8 9

Abb. 2b.

—IV

A a b c d e f g h i j k l m n o p q q u r s t v w x y z

Abb. 2c.

F H Ernst Schneidler (1882–1956). Drawings for the initials of Zentenar Fraktur (designed 1937–1939). Bauer typefoundry, Frankfurt.

Georg Trump (1896–1985). First sketches for the Delphin type (1951–1955).

Thoma · Trump · hora · Dimitroff Merry Old England und Französische ·

abcdefghiklmnopqrstuvwyzj · 241

Delphin type. C E Weber Typefoundry Stuttgart

Calligraphy by Rudolf Koch (1876–1934). Below, specimen of the Wilhelm-Klingspor-Schrift (1924–1926) by the Gebr. Klingspor typefoundry in Offenbach.

calligraphers and that calligraphic background to written characters is obvious in alphabets produced since 1945, especially in designs prepared for photocomposition.

Many of the restrictions caused by metal type and typesetting machines can now be avoided with the many new possibilities which photo-composition opens up to designers. Nowadays in using digital techniques for designing letters we are much more independent from those technical limitations of the past and we can develop fully all the new possibilities which the different photo-composition systems open up to alphabet designers, including such decorative features as swashes and flourishes.

But now designers, with none of those technical complications or compromises to hinder their ideas, face other problems. Today it is easy to design alphabets and digitise the letterforms quickly using a PC or Mac. In former times it took months or even years to develop carefully a new alphabet in metal. Now it is a question of merely a few hours to design a new face or, what is very often done, to manipulate or copy an existing alphabet. The time-consuming effort in developing a new type for metal required many more selective and careful decisions than we face now when producing a new product on a computer. That is one answer why there is today this inflation of 'new' alphabets

Gudrun Zapf Von Hesse (b.1918): first proposal for Alcuin Roman (above) and the typeface letters below.

GLORIA IN EXCELSIS DEO
Et in terra pax hominibus
bonae voluntatis
Laudamus te · Benedicimus te
Adoramus te · Glorificamus te
Gratias agimus tibi
propter magnam gloriam tuam
Domine Deus · Rex caelestis
Deus Pater omnipotens
Domine Fili unigenite · Jesu Christe
Domine Deus · Agnus Dei · Filius Patris
Qui tollis peccata mundi
Miserere nobis
Qui tollis peccata mundi
Suscipe deprecationem nostram
Qui sedes ad dexteram Patris
Miserere nobis
Quoniam tu solus Sanctus
Tu solus Dominus
Tu solus Altissimus · Jesu Christe
Cum Sancto Spiritu
in gloria Dei Patris
Amen

ABCDEFGHIJKLMNOPQVSTURWXYZ

abcdefghijklmnopqrstuvwxyz

The crisp pure and flowing lines of Zapf Renaissance Italic, designed by Hermann Zapf (b.1918).

Zapf Renaissance · Italic ❦ TABVLA ABCDARIÆ

a a b c d d e e e f f f g g g g h i j k k

¶ A B C D E F G H I J K L M N O

l m m n o p p p q r r r s s s t t u

P Q R S T U V W X Y Z ❦ Æ Œ

u v v v w w x x y y y z z z & fi ff

¢ A B C D E F G H I J K L M

fl ß ff ffi ffl ll qu th sp st & b d h k l ❦

N O P Q R S T U V W X Y Z

❦ 1234567890 ❦ $12,345,678.90¢

❦

everywhere. Of course, there is no question that the type market will make a natural selection, and a lot of today's ephemera will soon be forgotten. Only the good designs will stand, and good designs are always needed, especially for headlines and for advertising purposes.

Many of the mediocre alphabets offered today are alphabets designed by amateurs, some without a serious background in design. It is for this reason that calligraphers are called for,

as they have the training and the taste for new developments. It is a fascinating occupation to develop new alphabets and to put all your skills and ideas into something really new. But it is not an opportunity to earn quick money. For we are facing a sad situation: alphabet design has no protection by international copyright laws. There are pirates everywhere. They do not respect creative work and it is so easy to make money out of the intellectual property of others.

But all these sad facts should not keep young designers away from investing their imagination and efforts into alphabet design.

Calligraphers still have to compete with the letterforms on PCs or Macs. You can already get an impression of 'hand-written' forms, a calligraphic touch, on your computer screen and the printed letterforms looking very calligraphic. But there remains a big difference between an original form written by hand and a printout from your computer using a calligraphic alphabet. You can never express the human touch, the imperfectness of the different letters which expresses your personality. This irregularity creates this specific expression, the expression of the scribe's heart which is the secret of calligraphy, which is also the strength of calligraphy. These personal irregularities should not be done artificially, they must come out of the hand during the process of execution, even if it is the hand of a beginner in calligraphy.

Not everything done in phototypesetting or with a computer is a piece of perfection. This is the same with calligraphy. Our whole world is not perfect and the same is true with any work which is done by the human hand, whether done by professionals or by non-professionals.

Calligraphy is an art and art is a mirror of our society and, as we know, this is an imperfect society and has been for thousands of years.

The whole duty of Typography, as of Calligraphy, is to communicate to the imagination, without loss by the way, the thought or image intended to be communicated by the Author.

THOMAS JAMES COBDEN-SANDERSON

Lively and vibrant calligraphy by Hermann Zapf.

147

15

Calligraphy and illumination by Graily Hewitt.

The Rubáiyát of Omar Khayyám *written out by Graily Hewitt in ultramarine and raised gold leaf on gesso ground. In this book he has experimented with different recipes for gesso and the accompanying notebook (below) records the specific amounts of the ingredients he used for each page of this book.*

BL, Egerton MS 3783 A, ff. 14v–15.

The Vine had struck a fibre : which about
If clings my being – let the Dervish flout;
Of my Base metal may be filed a Key,
That shall unlock the Door he howls without.

And this I know: whether the one True Light
Kindle to Love, or Wrath-consume me quite,
One Flash of It within the Tavern caught
Better than in the Temple lost outright.

What! out of senseless Nothing to provoke
A conscious Something to resent the yoke
Of unpermitted Pleasure, under pain
Of Everlasting Penalties, if broke!

What! from his helpless creature be repaid
Pure gold for what he lent him dross-allay'd—
Sue for a Debt he never did contract,
And cannot answer—Oh the sorry trade!

Oh Thou, who didst with pitfall and with gin
Beset the Road I was to wander in,
Thou wilt not with Predestined Evil round
Enmesh, and then impute my Fall to Sin!

Oh, Thou, who Man of baser Earth didst make,
And ev'n with Paradise devise the Snake:
For all the Sin wherewith the Face of Man
Is blacken'd—Man's forgiveness give, and take!

Graily Hewitt notes the proportions of ingredients for this recipe of gesso. This particular one will give a high burnish but it will be difficult to get the gold to adhere so should be used in ideal gilding conditions. The amount of whiting may also lead to a tendency to crack under a hard burnish (which is in fact what has happened).

BL, Egerton MS 3783 B, f. 17.

P of P. 4½.
w lead 1¼.
whiting 6
Fish glue 1.
Sugar. 1

(16 + RRR)

Illumination

Introduction

The brilliance of shiny gold complementing the jewel colours in mediæval manuscripts shows why so many people want to learn the traditional skills of the illuminator. As pages in the books are turned the natural light is reflected in such a way that it seems as if it comes from the gold, as if that itself is lit. This is why it is called **illumination.**

Different types of golds were used. Gold as a powder could be mixed with a variety of gums so that it would adhere to the vellum. It was then usually polished with a smooth stone, such as hæmatite or agate or even an actual dog's tooth, so that it shone. Occasionally it was left unpolished, and sometimes patterns were pushed into the shiny gold with a pointed piece of agate. Or, tissue-thin sheets of beaten gold – leaf gold – were attached to gum in order to give a different sort of lustre. At the height of mediæval manuscript illumination gold leaf was applied to gesso, a mixture of slaked plaster of Paris, white lead, sugar or honey and glues. This formed a slightly raised smooth cushion providing a suitable surface not only for attaching the gold but also of sufficient hardness for the sheets of leaf gold to be polished to a brilliant shine.

Sadly, over the years, much of the original expertise in handling paints and gold on vellum was lost with the relative cheapness of production and consequent rise in popularity of the printed book.

By the late 1840s, however, there were sufficient numbers of people interested in 'missal painting' or illumination for a large number of instruction books to be published. Companies such as Winsor and Newton sold Illuminating Boxes containing paints, brushes and models to copy. Illumination was considered to be an appropriate pastime for young women, along with painting on glass, watercolour painting

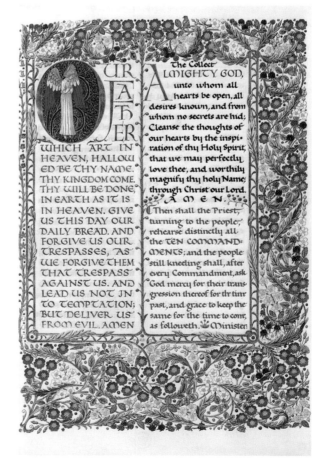

The Communion Service written out by Graily Hewitt and partly illuminated by Allan Francis Vigars, the decoration being left incomplete at the latter's death in August 1921.

This fully illuminated leaf (the other opening folio to that shown on page 99) has an elaborately decorated border of flowers and fruit. The large decorated and illuminated letter O leads into gold versals, which in turn lead into gold uncials – mirroring the Caroline Minuscule hierarchy of scripts. It may be a little too elaborate for present day tastes, but remains a tour-de-force.

BL, Additional MS 40144. f. 2.

149

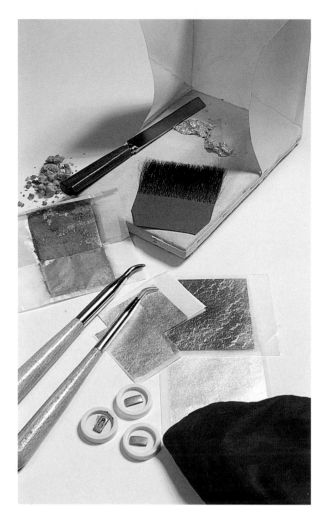

Tools and materials for the illuminator – gilder's cushion, knife and tip, gold powder, and shell gold in small white palettes, burnishers and transfer and loose leaf gold, with silk for polishing the burnisher.

and embroidery. Printed books of examples to copy were popular, and illuminated addresses on scrolls were reviewed in art journals. In 1887, Queen Victoria received over two thousand such addresses for her golden jubilee, and the Royal Society of Arts, for example, paid the illuminator Lewis Foreman Day the large sum of £31·15s·6d for the one which it presented.

By the latter half of the nineteenth century, these addresses were ignored in art journals, and a scathing article in *The Studio*, special winter number 1896–7, states 'The commissioning of illuminated addresses is largely in civic hands… vulgarity creeps in at every point, in the crudeness of a tint, the hardness of a contour, the unlovely sweep of a line. But the most debasing touch of all is the substitution of photographs for miniatures.'

William Morris and others of the Arts and Crafts Movement did much to encourage a return to the original skills and to genuine craftsmanship. Studying historical manuscript books which contained illumination, whether of letter or as part of a painting, at first hand and understanding the expertise used in their production was the key, they felt.

Gilding or illuminating – using gold – has traditionally been regarded as being technically difficult to do. This is not necessarily the case. Certainly using gesso and applying gold leaf needs a degree of practice to perfect, but it is not difficult in itself, and attaching gold leaf to modern adhesives or using gold gouache or powder gold is no more complicated than other skills needed by the scribe – a steady hand and good eye.

The first part of this section by Dr Michelle P Brown, Curator of Illuminated Manuscripts at the British Library, considers the art of illumination in manuscripts. The second part is more practical and details the variety of methods and a number of ideas for using gold.

The Art of Illumination
Michelle P Brown

The term 'illumination' is derived from the Latin *illuminare,* meaning to enlighten or illuminate. It is usually taken to refer to the practice of decorating a manuscript (or occasionally a hand decorated printed book) with luminous colours, especially gold and silver.

Silver has a tendency to blacken and to bleed somewhat when it oxidises (that is, on prolonged contact with the atmosphere) and so is used less frequently than gold, which gave an opulent, vibrant quality to much of the illumination of the Middle Ages.

Gold beaten into a powder might be applied after being mixed with a natural adhesive such as glair (clarified egg white), egg yolk or gum, as an ink or paint. This could be used with a pen or brush for particularly detailed work or for *chrysography* (writing in gold). This meant using a large quantity of gold, however, and it was more usually applied in the form of gold leaf. This leaf, which is quite tricky to handle, could be laid on to an area in a design to which adhesive such as glair or gum had been painted, or it could be laid on a raised ground of gesso (plaster, chalk or gypsum bound together with glue). This had the advantage of increasing the effect of the reflective surface and allowed that surface to be tooled (that is, engraved with a design), if so desired. Such raised surfaces grew in popularity from the thirteenth century onwards. Both flat and raised surfaces, powdered or leaf forms could be burnished, or made to gleam, using a smooth implement such as an agate or other polished stone, although the use of gesso which has been finely ground greatly facilitated this. Sometimes, however, an unburnished matt surface was preferred.

Although gold was an expensive material its application

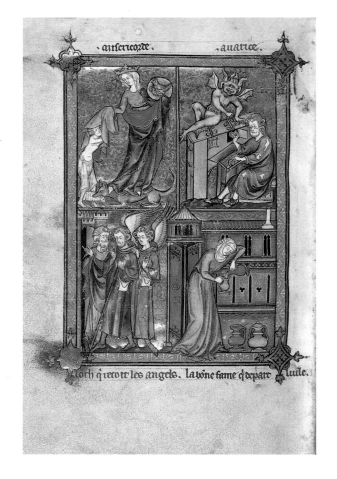

*'La Somme le Roy',
illuminated by
Maître Honoré.
France (Paris), end
of the thirteenth
century.*

*BL, Additional MS
54180, f. 136v.*

The Abingdon Apocalypse. England (London?), c. 1270–75, an unfinished miniature.

BL, Additional MS 42555, f. 41.

Canon Tables from a Gospel book. Byzantium (modern Istanbul). Late 6th or early 7th century.

BL, Additional MS 5111, f. 11.

153

formed the first stage in painting a design in which it was to feature, as it was somewhat messy to apply in leaf form and had to be trimmed with a knife once laid over the area in question. If other pigments had already been applied they would be damaged during this process, so generally gold was applied first, then lighter through to darker areas of colour, with highlights and penwork details being added last, as can be seen in the illustration on page 152. Gilding might be done by the artist, the scribe, or sometimes by a specialist.

produced in Byzantium. Gold ink was also used in Byzantine illumination to provide highlights *(chrysographia),* especially when depicting drapery. In one manuscript of *c.* 600, shown on page 153, the parchment is even stained gold. Within the iconic images of Byzantine art the backgrounds of miniatures were also often gilded, giving an impression of abstract, divine space.

Cycles of illustration also began to appear in late Antique books, although they often only survive in later copies, such as the Creation scenes from the Tours Bible, a Carolingian work illustrated on page 161.

Early manuscripts

Gold and silver writing on parchment, often dyed or painted purple and with luxurious imperial connotations, is known from the early Christian period onwards, especially in books

Anglo-Saxons, Carolingians and Ottonians

Within early Western manuscript production the Anglo-

The Vespasian Psalter. England (Canterbury), c. 730.

BL, Cotton MS Vespasian A I, ff. 30v–31.

Saxons, Carolingians and Ottonians particularly favoured the use of gilding and of golden writing. Hiberno-Saxon (Celtic and many Northumbrian) scribes and artists tended not to favour its use, perhaps feeling that a reflective surface disrupted the subtle rhythm and harmony of their intricate spiraliform and inter-laced designs. It is only used for a handful of tiny spaces in the incipit pages of the Lindisfarne Gospels (illustrated on page 160 where a gilded triangle occurs at the centre of the bow of *q*).The eighth-century artists of southern England loved it though, producing master-pieces such as the Vespasian Psalter (see opposite) and the Stockholm Codex Aureus (see below). Here great areas of display script and elements of miniatures are applied with burnished gold leaf laid on to gum. The artists of the Court School of the Emperor Charlemagne, around 800, were quick to espouse the Byzantine use of purple, gold and silver to produce opulent works redolent of imperial splen-

dour, as seen in volumes such as the Harley Golden Gospels, (see page 156). The Ottonians, the Saxon imperial successors to the Carolingian dynasty during the tenth to early eleventh centuries, continued these trends and injected even greater Byzantine influence into their art, including the use of gilded backgrounds to produce more static, iconic images which inhabit a spiritual plane rather than a more natural-istically depicted space (see page 157). Their neighbours in later Anglo-Saxon England also continued to exhibit a taste for gold, with the highly coloured and gilded images and stately golden display scripts of 'Winchester School' prod-ucts, such as the Benedictional of St Ethelwold (see page 157). However, the aesthetic tastes of both the Carolingians and Anglo-Saxons also extended to delicate drawings with tinted outlines, sometimes startlingly combined with fully painted areas in the same miniature, as in the Eadui Psalter, a Christ Church Canterbury work of the early eleventh cen-

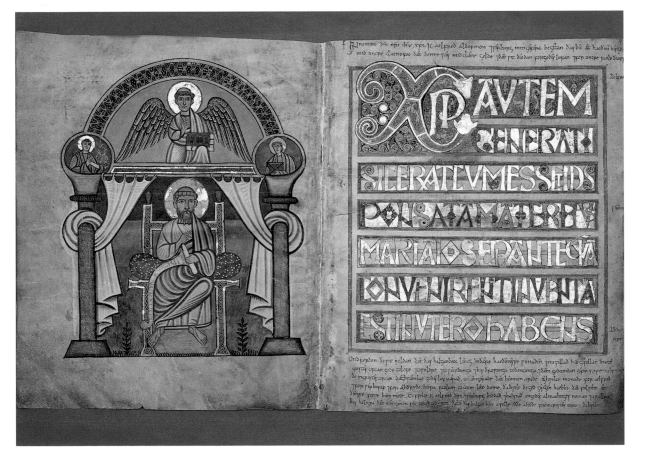

The Stockholm Codex Aureus. England (Canterbury?), c. 750

Stockholm, Royal Library, MS A 135, ff. 9v – 10.

tury, (see page 158), in which the artist-scribe, Eadui the Fat, is shown abasing himself in the same 'sacred', fully painted space as the monastic founder figure, St Benedict. The rest of the Christ Church community approach in the guise of less substantial tinted drawings.

The High Middle Ages

Gilding continued to feature in the pages of Romanesque manuscripts, with their stylised figures and abstract spatial conception, but it is with the thirteenth century and the advent of the Gothic style that it really came into its own. Raised tooled gilded surfaces featured in miniatures and initials alike, and fine filigree-like detailing adorned borders and the plethora of decorated letters which helped to articulate the text. Even with the more naturalistic

landscapes and interiors favoured from the later fourteenth century onwards, gold features as drapery highlights, on architectural features and as grounds to the Netherlandish 'strew borders' featuring closely observed plant and animal forms. This complemented the courtly elegance of the High Middle Ages and reflected the taste of the higher ranking patrons of the day who were increasingly drawn from the ranks of the nobility and the wealthier mercantile classes, as well as from royal houses and the ecclesiastical and scholarly echelons. Such books are illustrated on pages 159 and 164. Not all mediæval books were such expensive commissions, however, and for every highly illuminated example there are ranks of less lavishly produced works for more mundane devotional use, for consultation as library copies, and for the use of students, physicians and others who needed books in the course of their professional lives.

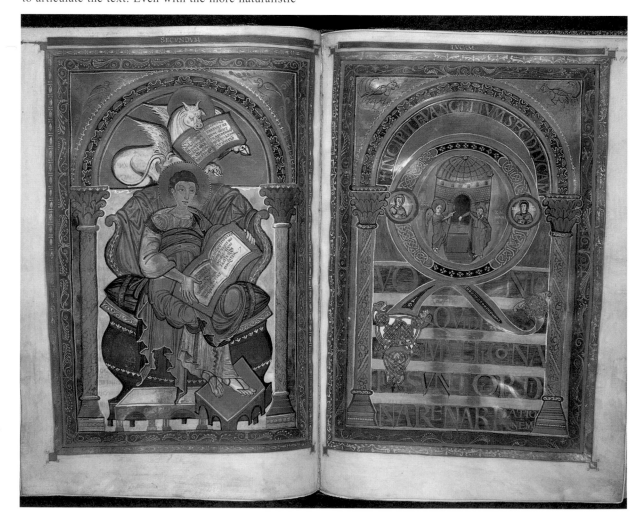

The Harley Golden Gospels. Carolingian Empire (Charlemagne's Court School), c. 800.

BL, Harley MS 2788 ff. 161v–162.

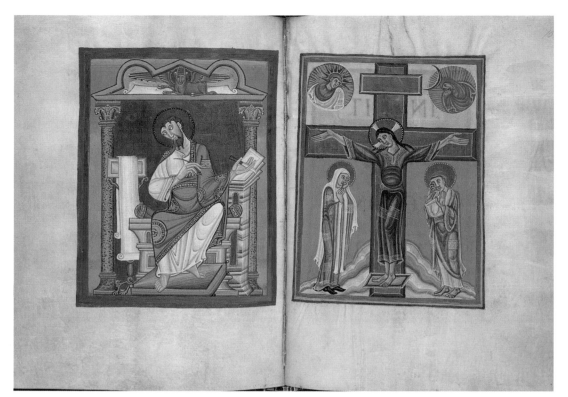

*Gospel book.
Ottonian Empire
(Echternach),
c. 1050.*

*BL, Harley MS 2821,
ff. 100v–101.*

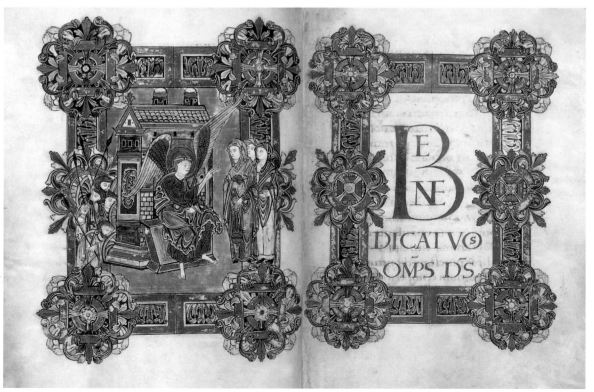

*The Benedictional
of St Ethelwold.
England
(Winchester?),
c. 980.*

*BL, Additional MS
49598, ff. 51v–52.*

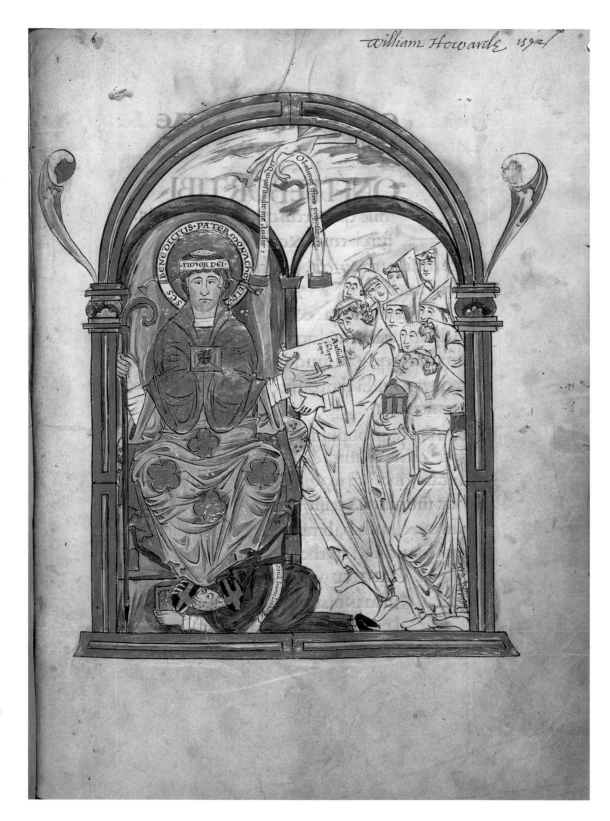

The Eadui Psalter. England (Canterbury) early eleventh century.

BL Arundel MS 155, f. 133.

158

The Queen Mary Psalter. England (London or East Anglia?), c. 1310–1320.

BL, Royal MS 2 B VII, f. 168v.

The Lindisfarne Gospels. England (Lindisfarne), usually dated to 698 but recent research suggests a date closer to 720. Note the use of lapis lazuli in the spirals in the bow of the letter q.

BL, Cotton Nero MS D IV, f. 139.

Moutier-Grandval Bible, one of the great Carolingian Tours Bibles. Tours, c. 840.

BL, Additional MS 10546, ff. 5v–6.

Contexts of production

In the world of late Antiquity the production and 'publication' of books was conducted by professional scribes, artists and publishers. Yet illustrated works were not greatly favoured, being considered by some as 'naive', until promoted by the Christian Church for their didactic value. This received a great boost under Pope Gregory the Great (died 604) who espoused the view that 'in images the illiterate read' and opened the way to the exploration and development of the illuminated book, wherein the supreme synthesis of text and image could occur. The monastic scriptorium (writing office) became the focus of book production, and monks and nuns were the copyists and illuminators, often working under the supervision of the head of the scriptorium. The pattern of work might vary from that found in the Lindisfarne Gospels (illustrated opposite), which was written and decorated by one gifted artist/scribe as a remarkable feat of 'opus dei' (work for God) to the complex scriptorium teams who took turns or worked alongside one another to produce works such as the great Tours Bibles, made for 'export' during the first half of the ninth century in the Carolingian monastery of Tours (illustrated above).

Lay artists may occasionally have participated in ecclesiastical projects, but with the rise of universities and the growth of towns from around 1200 onwards, book production passed increasingly, although not exclusively, into secular hands. 'Authorised' editions of texts would be lodged by the university syndics with approved stationers who would receive commissions for copies and sub-contract the work to local scribes and artists, all with their own specialised functions, as 'piece-work' (which derives from the *pecia* system whereby sections of a manuscript would be hired out to craftspeople for copying). Both men and women could be involved in such work and detailed rates of charging were applied to individual elements such as script type, number of miniatures, types of initials and borders, and binding. Commissions for de luxe devotional aids (such as Psalters and books of hours – the most popular of

161

mediæval volumes which allowed the devout layperson to share in the monastic divine office) and for romances and literary works would also be handled by a stationer, and/or through the workshops of leading artists such as Maître Honoré (see illustration on page 151).

Authors generally dictated their works, but occasionally they can be detected writing their texts and even illuminating them. Such was the case with the chronicler Matthew Paris (see illustration below), a monk of St Albans during the mid thirteenth century who spent time at Henry III's court and illustrated his own histories. His revival of the Anglo-Saxon technique of tinted drawing may have had something to do with the fact that he did not have to interrupt his work with the gilding process. In early fifteenth-century Paris a young widow and mother, Christine de Pisan, took the unorthodox step of earning her living by her pen. Her poems and works on women's rights and how to survive in 'high' places were published by Christine herself, who acted as one of her own scribes (see illustration opposite).

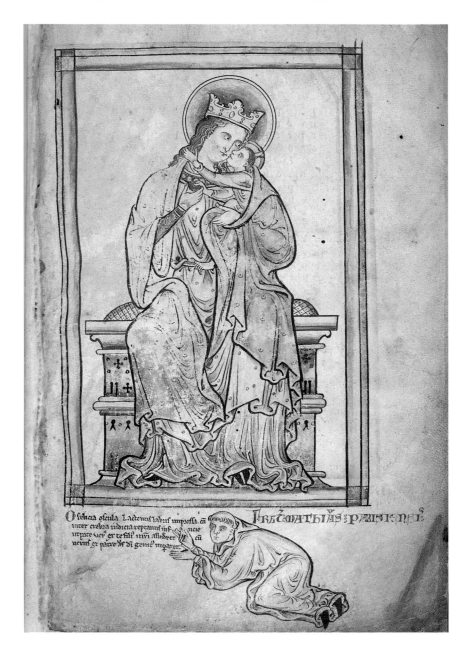

The author/scribe/ artist Matthew Paris kneeling before the Virgin, from his Historia Anglorum. *St Albans, 1250–1259.*

BL. Royal MS 14.C.vii. f. 6.

Christine de Pisan in her study, from a semi-autograph copy of her 'collected works'. Paris, c. 1410–1415.

BL Harley MS 4431, f. 4.

163

The 'Roman de la Rose'. Flanders c. 1500. Note the way in which powdered gold is used subtly to highlight drapery.

BL, Harley MS 4425, f. 14v.

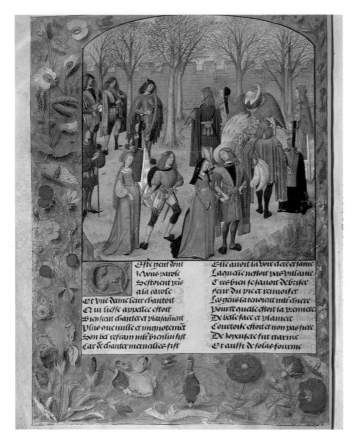

Colours and pigments

Apart from the obvious stylistic differences and variation in subject matter, an important factor which serves to make late mediæval illumination appear so different from that of the earlier Middle Ages is the range of pigments used. Of the many animal, vegetable and mineral extracts which were mixed with glair (clarified egg white) to form paints a number could be obtained locally. Verdigris (green), for example, could be formed by exposing copper to the corrosive effects of an acidic substance. A red or orange could be obtained by roasting lead. The turnsole plant *(crozophora tinctoria)* yielded a dye which could range from red to blue hues of purple, depending on whether acidic (e.g. urine) or alkaline additives were used. Yet even in the Lindisfarne Gospels, which were produced off the coast of North-eastern England at the end of the seventh or early in the eighth century, the palette includes ultramarine, as seen in the bow of the letter **q,** in the illustration on page 160, made from lapis lazuli which at that period could only have been obtained from Persia or Afghanistan. Such details can tell us a great deal about economic and cultural links. From the fourteenth century the growth in trade, especially in textiles, and in experimental sciences led to a greater range of pigments being used, including red lakes (plant dyes) and artificially manufactured copper blues and vermilion, thereby greatly expanding the artist's palette. Underdrawings might be executed in hard point, lead-point or ink, and guide letters or fuller written instructions telling the artists what to paint and what colours to use are occasionally found, especially from the twelfth century onwards.

Conclusion

From this all too brief survey I have attempted to show that the interaction between style and materials is a crucial facet of an understanding of mediæval illumination. So, too, is the social context within which a work was produced – their authors, their makers and their readers – for books are essentially about people.

How to Gild

Despite the association between gold and expense, gilding or illuminating can be done remarkably cheaply using fairly commonplace tools and equipment. Gold gouache is not expensive nor too is Dutch metal or schlag. Both can be used as substitutes for real gold. On the other hand you could invest in specialist tools and materials which will enable you to achieve stunning results.

Gold, silver and metallic gouache

The cheapest way to gild is to use gold, silver or metallic gouache, the last often available in different colours. These can be bought in tubes from most good art shops. The shades range from red to pale yellow gold, silver, bronze and copper and then red, blue, green and sometimes pastel metallic paints. Occasionally shops stock pans of artificial gold and silver gouache, which are about 2·5 cm (1 in) in diameter. This is easier to use and also keeps in good condition for longer – metallic gouache will harden in the tube after some time.

All should be diluted with water until they are the consistency of thin, runny cream. Squeeze out about 1 cm (0·5 inch) of gouache into a small saucer or palette. Add drops of water until this consistency is achieved and then use with a brush or pen.

Because the mixture contains heavy particles of metal these will fall to the end of the brush or nib while in use. For ease of use, then, apply the gouache to the tip only of the brush or nib and recharge often.

Gold, silver and metallic powders already mixed with adhesive

Some specialist manufacturers now supply metallic pigments as a powder mixed with adhesive, usually dextrin. The powders are available in shades of gold and silver and to use these shake a small amount of the powder into a palette and add water until the mix is the correct consistency. The advantage of these is that there is no problem of the pigment hardening in the tube and so it will last much longer.

Shell gold

Shell gold is real gold powder which has already been mixed with gum arabic and is sold in tiny blocks, about the size of a quarter pan of watercolour, in its own little white palette. Because it has been mixed already this is the most expensive form of powder gold. It is called shell gold because it used to be sold in mussel shells; a penny-weight of gold was dumped in the mussel shells with gum arabic, and the shell formed the palette.

Add drops of distilled water to the tablet of shell gold until you have liquid paint to use. At first you may be reluctant to add very much water, thinking that you are saving gold by so doing. What you are actually doing is making the gold difficult to use. Instead, make a good 'puddle' of gold and water until it is the 'runny cream' consistency. However, do have a small, clean jar of distilled water to hand. Ensure that the mixing brush is scrupulously clean and then wash this brush out in the jar of distilled water when you finish. If your pen was really clean before

you started this can also be washed in the water in this jar. The gold 'washings' will drip and collect at the bottom of the jar. When the tablet of shell gold is finished, decant the water from this jar into another clean one, and start to use the gold at the bottom of the jar by adding water as before. It is likely that there will be sufficient gum arabic to ensure that the gold adheres to the writing or painting surface. If, after testing, it does brush off easily then add gum arabic as for gold powder (below).

Shell gold is available in different shades of gold ranging from lemon, yellow, green to red. This is due to the different metals added to the gold to give it the colour – copper to produce red gold, for example. Shell gold is not as pure as the leaves of gold for illumination on gesso.

Gold powder

Gold powder is sold in almost pure form when yellow gold by the gram or half gram. It too is available in a range of similar colours to shell gold when it is less pure. The changes in colour are very subtle, but form an interesting effect when used in combination. For a very special piece, use a colour of gold which tones or contrasts with the paint colours.

Before it can be used the gold powder must be mixed with gum so that it stays on the surface of the paper or vellum;

without this gum it is easily brushed away with the hand or simply by turning the page.

To make your own gold paint carefully shake 0·5 g (a penny weight or about an ounce) of powdered gold, available from a specialist supplier into a small glass jam jar with a lid. Using an ink dropper add 10–15 drops of gum arabic and a little water.

Stir with the clean end of a plastic paintbrush, or a glass rod if you have one. Fill the container to the top with water, stir again and leave, preferably overnight.

Pour off the excess water and the gold is ready to test. Use a fine paintbrush to paint a few small circles of gold. Allow them to completely dry and rub over with a burnisher or the back of your fingernail. If the gold smudges or some of it comes off then you will need to add more drops of gum arabic to the mix. So repeat the process by adding gum then water, stirring and allowing the mix to settle again before pouring off the water. Finally test in the same way. If the burnish is not very bright then there is too much gum arabic, which dulls the shine. This time simply add water, stir and allow to settle before pouring the water away and testing. Repeat either process if necessary until the gold is safely attached to the paper and is shiny.

Although this process is a lot more complicated than simply adding water to a pan of shell gold, the burnish is often better, and so it is worth taking time for an improved end-result.

Gum arabic can be a little hard and brittle in a mix. Some scribes add gelatin or fish glue – seccotine – to the mix instead. You may like to experiment with these and the proportions if you are dissatisfied with gum arabic as a glue. Occasionally the gold works better if the powder is ground first in a fine pestle and mortar.

Shell Silver

Silver powder in a gum arabic base is also available. It should be treated in the same way as a tablet of shell gold. Because it is relatively cheap, compared with gold, it is hardly worth making powdered silver into a mix with gum arabic. Keep the shell silver tightly covered and in a dark, cool place. If left out in the atmosphere, it will tarnish more quickly, and turn black eventually.

Dutch Metal, or Schlag, and Aluminium

Dutch metal is an alloy of mainly copper with a little zinc which has been beaten into thin sheets, and is gold in colour. It is very cheap, but needs a good gum to attach it to paper. Modern adhesives are better than more traditional ones. (See page 174.) Dutch metal also discolours rather quickly, but it

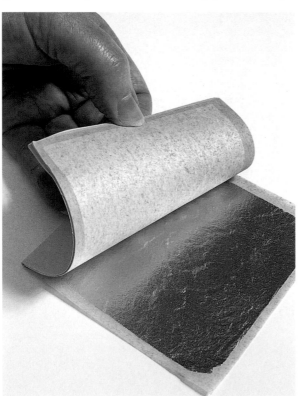

Always handle loose leaf gold very carefully. Hold the book by the spine to avoid the sheets of gold sliding inwards and crumpling.

To use the gold bend back the cover of the book so that it is out of the way and allow one sheet of gold, and its backing sheet, to fall on to the work surface.

Make a snip with a new pair of scissors (which are used only for gilding) through the backing sheet and one leaf of gold. This will help to attach the sheet of gold to the backing and will make handling easier.

Now you can cut the size of gold you need with scissors.

is not advisable to seal using any varnish or sealer with spirit or oil as this may bleed on to the paper or vellum and cause discolouration. You could, however, instead try glair, clarified egg white, mixed with a little water to seal the metal (see page 172).

Dutch metal is usually sold in books of 25 sheets which are about 12 cm (5 inches) square.

Thin sheets of aluminium, sometimes sold as silver Dutch metal, can be used instead of silver. It does not tarnish, but will not give a particularly good and shiny burnish.

There are other metals and foils manufactured which give an interesting coloured sheen which changes with the light; some also have regular or irregular 'laser' patterns on them. These can also be attached to paper and vellum using suitable modern adhesives. Dutch and other similar metals are cheap and fun, but the results cannot compare with gilding using real gold.

Gold leaf

Gold is an unusual metal in three main ways. First, once polished to a shine, gold never loses that brilliance. Secondly, sheets of gold will stick to one another, and thirdly, gold can be beaten until the sheets are extremely thin and fine without any disintegration. All these qualities are important in illumination.

Sheets of gold – gold leaf – should be very nearly pure. For gilding it should be at least 23·5 carat; pure gold is 24 carat. Illumination gold is available from specialist suppliers in books of 25 sheets of gold, which are about 8 cm (3 inches) square. The sheets are separated from one another by a thin, rouged interleaving tissue. Gold is sometimes referred to as fine illuminating gold, at other times you will have to specify the quality.

There are two thicknesses of gold – *single* and *double* (sometimes also called *extra thick*). For most gilding, sheets of both single and double are required.

The gold is also available in two forms – *transfer* and *loose*. The gold in transfer books has been pressed very hard so that it is attached to the interleaving tissue, and is much easier to handle. Loose gold in books is held in place by the pressure of the pages only, and often seems to have a life of its own once it is removed from the book. A single sheet will crumple into almost nothing if handled carelessly, yet can be gently blown flat if it lands on a surface.

Confusingly, in the USA different terms are used. *Patent gold* is transfer gold, that is, leaves of gold pressed very hard and attached to the backing sheet. *Transfer gold* is what is called loose gold in the UK, that is, loose sheets which are

Types of metallic leaves.

Left: Dutch metal or schlag and silver coloured aluminium, with laser-produced metal leaf and tapes.

Right: precious metals (from the bottom) – loose leaves of palladium, platinum, and single and double gold, transfer gold, white gold and silver.

167

not attached to a backing sheet in any way.

For beginners perhaps it is best to start with a book of single transfer gold (patent gold in the USA) and a book of double loose gold (transfer gold in the USA). Loose gold does burnish better, but is very much more difficult to deal with. Getting a piece of single transfer gold on to gesso is not as frustrating as working with loose gold, and once it is attached then you can use double loose gold. Instructions for this are given on page 180.

Books of leaf gold are expensive but they will last a long time. Always store gold leaf flat, preferably between two pieces of cardboard or stiff plastic sheets slightly larger than the books of gold. Gold like this will keep indefinitely, and it will illuminate many letters and miniatures.

Silver, White Gold, Aluminium, Platinum and Palladium

These metals are not like gold: their leaves do not stick to each other so a depth of burnish cannot be built up.

Silver comes in books with 25 leaves about 10 cm (4 in) square, similar to gold, but it is very much cheaper. This may be viewed as an advantage but unfortunately silver reacts with the atmosphere and tarnishes quite quickly, certainly within a few years, and the appearance may not then be the one you worked so hard to achieve.

To avoid this tarnishing you can cover the silver with a very thin layer of varnish or sealer, but as this usually contains some form of oil or spirit great care is needed to ensure that it does not get anywhere else on your work. You can also seal silver or white gold with glair. See page 172 for making glair from egg white. Or you may choose to use another metal to give a silver effect.

As it has a greater gold content than silver, the proportion being about 60% silver and 40% gold, white gold tarnishes at a slower rate than silver, but it will tarnish in the end.

Or you can use aluminium (silver Dutch metal). Sheets of aluminium are larger, at about 12 cm (5 inches) in size. Palladium, a form of platinum, is another alternative – this has a cold bluish tinge, or platinum itself, which has an unusual pinkish brown tinge, both are available in books of 25 leaves about 8 cm (3 inches) in size. All are available from special-ist suppliers, and will give a good silver effect, but none stick in the same way as gold.

Aluminum is much cheaper than silver and palladium and platinum are more expensive than gold; each has a slightly different effect. If you are using any of these with gesso, then prepare a stickier mix to help the metal leaf to stay fixed. This is explained on page 177.

Tools and equipment

To gild successfully using real gold it is important to have the right equipment. Trying to do this too cheaply with poor quality tools may mean that you waste leaves of gold and do not get the best results.

You can gild more cheaply, but it is best to reserve less good quality equipment for when you are using gold gouache and schlag.

Burnishers

You will also need something smooth and hard to burnish gold gouache or schlag to make it shine. To be completely economical this could be the back of your fingernail, but there will be more control if you use the rounded handle of a metal knife, the back of a spoon or something similar. Or, of course, a proper polished smooth stone burnisher as shown on page 170.

Burnishers for real gold come in different shapes and sizes, and also different materials. For almost all manuscript gild-ing you will need just two burnishers – a small **dog tooth burnisher** and a pointed **pencil burnisher.**

Burnishers are made from different stones. Most readily available are those made of agate polished smooth, others are hæmatite, psilomelanite or siliconite. Illuminators have views as to which burnisher works best for them.

Although agate does absorb moisture from the atmosphere when it is very humid, I have used these burnishers for almost all my gilding without problem, always making sure that they are kept clean and free from grease by repeatedly wiping and polishing on a scrap of silk. They are good burnishers for beginners to use.

Psilomelanite burnishers are manufactured from manganese ore and are usually made to form a slanting oval – lipstick – shape. This shape is preferred by some gilders, but I do not find that it moves over the gold in the way in which I prefer.

Hæmatite burnishers are not easy to find, but are worth seeking out as gold does not stick quite so readily to them. They also produce heat when burnishing which some feel aids the process in attaching gold to gesso. Haematite burn-ishers are very much more expensive than agate or psilomelanite. Perhaps it is better to start with an agate burnisher and then progress to a hæmatite one. They are available as dog tooth burnishers, or the lipstick shape similar to psilomelanite.

All metal ore burnishers are improved by very slightly roughening the surface. This is best done with crocus powder, which is similar to jeweller's rouge and is available from specialist suppliers. Sprinkle a little of the red crocus powder on to a piece of finely woven cotton and rub in as much as you can. Shake off any excess. Now rub the burnisher with the crocus cloth for a few minutes. Polish the burnisher with silk afterwards.

Silk

A small piece of fine silk, not much bigger than half a hand-kerchief, is useful for polishing the burnisher and keeping it free from grease. Some gilders used to use silk for initial burnishing, but this has few advantages as the pattern of the silk, imprinted on the gold, has then to be burnished out. It is better to use crystal parchment or glassine from the outset.

Scissors

For manuscript gilding, gold has to be cut into pieces of a useable size in some way. This can be done either with scissors or a gilder's knife and cushion (see below). Although it may seem a little extravagant it is worth reserving a new, good-quality pair of scissors for gilding alone. You will find that loose gold in particular will stick to everything that you do not want it to, apart from gesso. The rough edge of a pair of scissors, or a tiny piece of gum or paint on one of the blades of a pair scissors, will attract the gold leaf. New scissors should have smooth edges to the blades and if used solely for gilding will not cause these problems.

Gilder's tip, knife and cushion

You may prefer to use a gilder's tip, knife and cushion for cutting and handling gold. The **gilder's cushion** is a soft suede pad on which a single leaf of loose gold is placed from the back of the book of gold leaves. Gently blowing straight down on the sheet of gold will smooth it out flat.

You can easily make your own gilder's cushion from a piece of wood, about 20 by 15 cm and 5 mm thick (8 by 6 in and 0·25 in thick). Sand the edges of the wood until they are smooth. Cover the wood with a thick piece of foam, about 1·5–2 cm (0·75–1 in) thick, and then cover this with a piece of soft suede. Attach the suede to the underside of the wood by using a staple gun.

Before use treat the suede with French chalk or Armenian bole. Sprinkle one of the powders over the suede, and use the gilder's knife to work the powder into the cushion. Remove any excess powder. The powder will stop the gold from sticking to the suede or the knife.

You will also need a **gilder's knife,** which is specially made to cut the gold into sections with a sawing action. The gold, cut into pieces of a manageable size, is gently lifted up by the **tip** – a narrow soft brush, usually about 8 cm (3 in) long. The tip should be brushed lightly over your forehead or the side of your nose so that it picks up a tiny amount of grease. This will make the piece of gold stick to the tip. Of course, wearing make-up is not a good idea if you handle gold with a gilder's tip and use the grease from your face! The gold is gently placed into position on the adhesive by the tip. (See page 171.)

Some gilders find handling gold much easier this way, and it may be what you decide to do. However, as a new pair of scissors is cheaper than a gilder's tip, knife and cushion, try scissors first, and if this is not satisfactory then buy the more expensive equipment.

Crystal parchment

Crystal parchment, or glassine, on the other hand, is cheap. Sheets of it cost very little and a whole sheet can be cut into smaller squares and rectangles to last a very long time. Although it is only available from specialist suppliers it is worth adding to your gilding equipment. Non-stick silicone paper is acceptable for gold gouache, but is not really smooth enough for gilding with gold; crystal parchment is better. If it is really difficult to obtain sheets of it, then professional photographers and some graphic artists and printers use bags of glassine to protect their photographs and an alternative may be to cut pieces from such a bag.

Soft brush

When you finish gilding and have cleaned up the work, a soft paintbrush, or a soft mop headed make-up brush is ideal for removing the waste. Blowing on your work, or using your hand to brush away the tiny pieces of gold, though tempting, is not a good idea. Both introduce moisture which will dull the gold, and may even lift it away from the adhesive. As well as this, you may accidentally brush your hand across the gold, which, if it is at all greasy, will smear and dull the shine you have worked so hard to achieve.

Breathing tube

For small amounts of gold, or where you may need to make a repair, a breathing tube is an important addition to your equipment. Some gilders use a breathing tube all the time to focus their moist breath on the gum. Treat breathing tubes with care because moisture from your breath can condense into liquid in the tube and drip on to your work. This is not good for the adhesive and a disaster for gesso!

Breathing tubes are simply made out of a piece of stiff paper, about 150 gsm in weight and probably no bigger than about 10 by 5 cm (4 by 2 inches). Roll it round to make a tube just over 1·5 cm (0·75 in) in diameter and secure with pieces of masking tape. Longer lasting and more robust are pieces of bamboo, again about 10 cm (4 in) in length in

Burnishers have long and short handles, and are shaped like a dog's tooth, a pencil, a lipstick or a small spade.

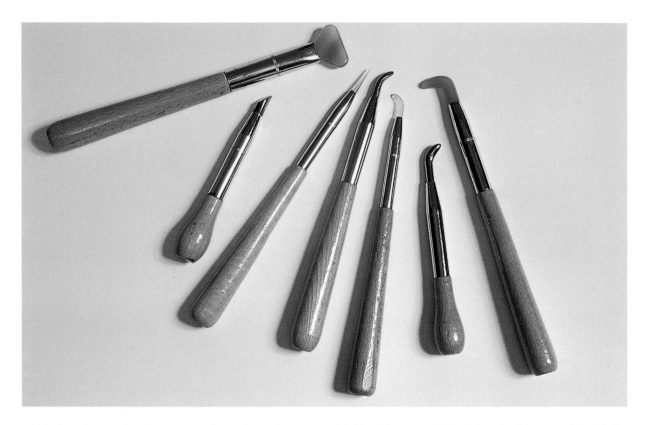

which the soft centre has been removed to make a tube.

Easiest to find are drinking straws. However plastic straws are useful only for the very vigilant. Moisture condenses so easily inside these, and always drips on the most important part of your work – if not on beautifully smooth gesso then on a wonderful free flourish on a difficult letter! Old fashioned wax straws are probably better.

Eraser

Gold is removed from the edges of gilding first with a soft brush – which may be all that is needed – then with a knife or a a sharpened pencil-shaped ink eraser. Care must be taken close to the gilding because the rough texture of an ink eraser may damage the gold, but the point is useful for getting into the awkward corners. A knife often leaves a rough surface when the gold has been scraped away.

Curved bladed knife

It is recommended that the gesso is scraped carefully before the leaf gold is laid. Scraping removes any bumps, lumps and irregularities in the gesso, which all show beneath the gold.

A knife with a curved blade is best for this, as a pointed blade can so easily catch in the gesso and ruin the surface.

Hygrometer, or humidity meter

Gilding is most successful when the humidity is between 63–73%. Although it is possible to determine this almost by sensing the dampness in the air when you have been gilding for some time, beginners may find a hygrometer a useful piece of equipment, if only to confirm that the problems they may be experiencing are due to a low level of humidity!

Gilding on a hard surface

A small sheet of plate glass about 30 cm (12 inches) square is an additional item. Gilding is most effective when the moisture from hot breath condenses against a cool surface. Taping your vellum or paper with masking tape (to prevent it from slipping around) on to such a sheet of glass, or perhaps a large smooth white glazed tile, will greatly aid this process.

Plate glass can be bought at reasonable cost from most glaziers or glass suppliers. Ask them to cut a piece which is about 30 cm (12 inches) square and then to grind the edges

Far left.
Gilder's tip, knife and cushion.

Left.
To flatten and open out a single gold leaf blow gently straight down after it has been placed on the cushion. This leaf of gold was quite crumpled; you can see the wavy pattern made to the surface by a gentle but constant stream of breath, which must be directly over the gold, as any sideways movement will blow the tissue-fine leaf away and crumple it again.

so that they are not sharp. Stick lengths of strong adhesive tape, such as that used by electricians or builders, along each edge to protect yourself when handling the glass.

Papers

For gilding use a good-quality paper such as a watercolour *hot press* paper. Paper which is smooth, with few or no surface bumps, is best because it then forms a good background for the shiny gold. Select a paper which is about 160 gsm or heavier. See page 292 for information about papers.

Vellum

Vellum, or calf skin, will always be the preferred surface on which to gild. The colour is sympathetic to gold and the brilliant hues of paint often used with it. The surface takes adhesives and gesso well, and it is so much easier to clean up gilding from the prepared surface of vellum than from the smoothest paper. However, vellum is expensive, it is also not that easy to obtain, and there is a growing number of people who choose not to use animal skin. For all these

reasons paper may be the best option for some.

However, there are few combinations which work better than gold, vellum and paint coloured like jewels. Although vellum is far costlier than the most expensive sheet of paper, a whole skin is not wasted because it is possible to use even the tiniest snippets and scraps of vellum for practice. A skin of any reasonable size, say about 6 square feet (many vellum manufacturers are old-fashioned in their measurements) or 0·5 square meters will be large enough for two rectangular panels; the larger side pieces can be cut into squares and rectangles which are about 8–10 cm (4–5 inches), smaller squares, about the size of a postage stamp can be used for tiny messages on greetings cards and the smallest scraps used to make vellum size for gesso. In this way one skin can be quite economical.

See pages 299–305 for more information on vellum and how to prepare it for use.

Adhesives

There is a variety of adhesives which can be used to attach leaf gold or metals to a surface. Some of these have been used for centuries and others have been in use only for the

last few years. All have advantages and disadvantages, and you should try to experiment with as many as you can to find out what works best for you in your circumstances. Some are easy to get hold of – even from your local super-market – others are available only from specialist suppliers.

Glair

Glair is very easy to use and easy to obtain. Most know that it is made from the white of an egg.

To make your own glair separate the white from the yolk of a fresh egg and put the white into a bowl. Whisk until the white is stiff (soft peaks) and then leave it overnight. In the morning a liquid will have separated from the froth, and it is this liquid that you use. Pour it into a small jar ready for use. Discard the froth.

Alternatively you can buy glair in a powder (as powdered egg-white) from most grocers and supermarkets and this has the advantage of being easy to handle.

Glair will not keep for long, so it should be used within a few days. Put a loose-fitting lid, perhaps an upturned saucer, over the palette with the glair. Do not make this airtight or the glair will go bad. Add drops of water if the glair dries out before you have time to use it.

Glair can be quite tricky to use and it is probably better to reserve glair for gold leaf rather than the other metals because it is not always the stickiest of glues when used for them.

Applying leaf to glair
If it is cold and damp glair can be used as it is, but if it is hot and dry you may need to add some water to the solution to dilute it. Because it is so dependent on variable weather conditions it is not possible to be exact about how many drops of water to use.

Glair can be painted with a brush on to paper or vellum or fed into a pen, however because of the gilding process, it is difficult to achieve any rhythm in writing. This is because a piece of loose gold leaf must be laid over the glair before it dries. Double gold leaf is best for this.

Paint a small part of the area which you wish to gild and, before the glair dries, drop a small piece of the gold on to the wet liquid. Continue this process until the whole area is covered. Place a piece of crystal parchment over the gold leaf and burnish very lightly. You can sometimes burnish directly on the gold after removing the crystal parchment and when the glair is completely dry, but do try this out on a test piece first. Very gently brush away the gold which has not stuck to the glair with a soft paint brush.

After a few days, try burnishing directly but very gently on the gold, and it should become even shinier.

Gelatin

Gelatin, used as a thickener and for setting juices and liquids into a jelly, is readily available from most grocers and super-markets. It usually comes as a powder or in leaves both of which can be used for gilding.

Making a solution
The powder or leaves should be dissolved in hot rather than boiling water in a ratio of 1:4, that is, one part gelatin to four parts water. It will not keep for long and so you should not make very much of this solution.

Dissolve the gelatin in hot water in a small heat proof container, such as a china egg cup. Add a tiny touch of food colouring if you need to although some types of gelatin are slightly yellow and you should be able to see this when used.

Applying leaf to gelatin
Gelatin should be used when it is still a liquid, which means that you should not allow it to cool and then harden. Apply the gelatin with a paint brush or feed it into a calligraphy dip pen using an old brush. Work quickly and in small areas. Before the liquid has cooled, cut a piece of double loose leaf gold large enough to cover the area of gelatin and lay it over the solution. Allow the gold to settle and the gelatin to dry. Then place a piece of crystal parchment over the gold and burnish *very* gently with a dog tooth burnisher.

Allow a couple of hours for the gelatin to cool and set with its gold topping. Then remove any surplus gold with a very soft brush, taking great care not to disturb the gum.

The gelatin will still be quite soft, so is best to use it for small pieces which will be framed quite soon. It is not advis-able to use gelatin in manuscript books where the heavy closing of the covers may cause damage.

Gum ammoniac

Gum ammoniac is available in two forms, either as a milky liquid in a bottle, or as lumps of resin. It is easier using the liquid but it does not retain its sticky properties for more than about a year, and, unless you are gilding vast amounts the gum will have deteriorated well before the bottle is even half empty.

Although it is a little more time-consuming, using the lumps of gum ammoniac is more economical as they last for many years.

Making a solution
The lumps must be made into a solution and the many imp-urities removed. To do this, take out the obvious pieces of wood and stones and put a three or four lumps of the gum into a small glass or china jar which has a screw top, breaking

any large lumps into smaller pieces if you can. Add sufficient distilled water to cover the lumps, stir a little, prop the jar up on a pencil or something which will mean that it is at an angle, cover with the lid and then leave overnight.

In the morning there should be no complete lumps of gum but a milky liquid, which must be strained to remove the impurities. Use a nylon tea strainer and pour the liquid through allowing it to drip through. Do not be tempted to stir or push the liquid through the mesh to speed up the process as this will force some of the sludge and impurities through and ruin the solution.

The milky liquid will dry to a clear gum when either painted on paper or vellum or used in a dip pen. This does make it difficult to see where it is so add a tiny drop of food colouring or a small amount of watercolour to the gum ammoniac solution so that it has a hint of colour and is then easier to see when gilding.

Storing gum ammoniac
The liquid will not retain its sticky properties for months on end, although it should still be reasonably sticky after as long as six months. Do experiment first though with an old solution, rather than spend much time using the gum only to discover that it is no longer sticky.

It is best to store the gum in a refrigerator when not used. Occasionally the gum will grow a mould. This does not affect its sticky properties and can easily be strained through a tea strainer as before.

Applying leaf to gum ammoniac
Gum ammoniac produces gilding which is shinier than powder gold, but not so shiny as gilding on gesso. It is not difficult to use. As a general principle it is better to gild first before any painting, as gum in the paint may also make the leaf gold stick to it. Transfer your design to the paper and then simply paint the gum where you want to gild, or use an old brush to feed the gum into a calligraphy dip pen, and use as ink to write letters.

Be warned – do not use a new or precious brush. Gum ammoniac can ruin brushes and they should be washed well in warm water after use and before the gum has dried and hardened. However, washing good-quality brushes in hot water is not to be recommended as it may damage the delicate hairs.

Allow the gum to dry, this may take an hour or so in damp weather. When it is completely dry, cut a piece of gold with its backing sheet – either single transfer leaf gold, if you are not sure about handling the gold, or double loose leaf gold for a better burnish – which is no larger than about 2 cm (1 inch) square. Always gild in small areas when you first start. If you are gilding very much smaller shapes or letters then reduce the size of pieces of gold leaf to be cut.

Mask any areas which are not to be gilded with pieces of crystal parchment. With the piece of gold ready to use in your hand or on a gilder's tip breathe on the gum ammoniac. Use one or two really long deep breaths rather than many shallow huffs. It is the moisture from the bottom of your lungs which reactivates the stickiness in the gum. See breathing for gilding, page 184.

Immediately place the gold face down, with its backing sheet, over the area where the gum has been re-activated and press firmly. Then remove the backing sheet carefully. Cover the gold with a piece of crystal parchment and, using a dog tooth burnisher, gently rub over the gold. If you burnish too vigorously the heat will soften the gum and ruin your gilding.

Remove the crystal parchment and check to make sure that all the areas you want gilded have gold on them. If some places are ungilded, cover as much of the areas where the gold has stuck as you can with pieces of crystal parchment to protect them, or cut a small hole in a piece of crystal parchment which just reveals the ungilded spot, and use a breathing tube (see page 169) to breathe on that area only.

Immediately place a piece of gold over the gum, and gently burnish through crystal parchment as before.

When you have finished use a very soft paint brush to remove the pieces of gold which have not stuck to the gum ammoniac. Take great care in doing this as you could damage the gilding.

What to do if there are problems
Occasionally the gold will not stick to the gum no matter how well you breathe. This could be because the gum has been painted too thinly at that point. Adding more gum to make a slightly thicker layer using a brush is best, although avoid heaviness, and making too thick a layer.

Very fine hair lines in letters may simply not have enough gum to fix the gold. The following process will need some experimentation, but it may help. Make sure that the pen is well charged with gum and then press the nib down on the paper *within* a previous thicker stroke before you write the narrowest part of the letter, or make a decorative flick. For example, in writing a letter **O** the first curve is to the left and downwards. Before you make the second stroke to the right, place the nib within the thickest part of first stroke, press the nib down to make sure that the gum is flowing well and then make the second stroke by pulling the gum round to the right.

Water gold size

At the end of the nineteenth century and earlier in the twentieth when gilding was far more popular as a genteel occupation, there were adhesives and sizes for attaching gold leaf readily available. This is not the case now. Some specialist suppliers do stock water gold size which is a bright

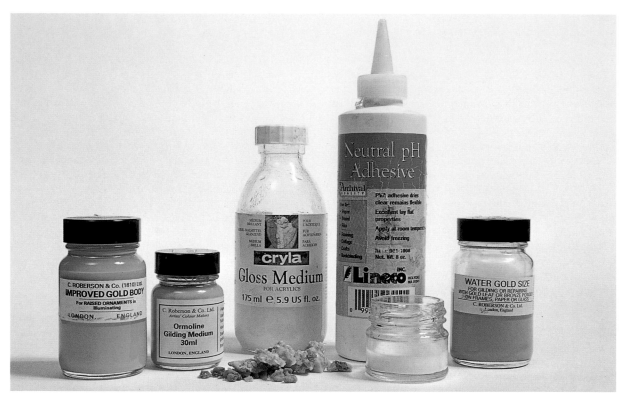

Applied adhesives – improved gold body, acrylic gilding medium, cryla gloss medium, PVA, water gold size and in front, lumps of gum ammoniac and a solution of gum ammoniac in the small jar.

yellow liquid; a small bottle of this will gild large areas.

Do not in any way confuse liquid water gold size with Japan gold size. The latter is used by picture framers and restorers, and it is oil based; this oil will spread on paper and vellum and completely ruin your work.

Applying leaf to water gold size

You may prefer to decant a little water gold size into a small palette for ease of use. Again it is better not to use a good quality brush with water gold size as the gum it contains needs to be washed out quickly in warm water before it dries hard. Gold size can be used with a pen or brush. Apply and then allow it to dry. Mask off all but a small area with pieces of crystal parchment and cut a piece of gold leaf (transfer or loose) with its backing sheet to cover the lettering or area painted. Now breathe on the gum to re-activate the stickiness and immediately place the gold over that area. Press down with your fingers and remove the backing sheet. Place a piece of crystal parchment over the gold and rub gently with a burnisher. Take away the crystal parchment and burnish very gently directly on the gold. Repeat this process until all the areas are gilded.

When you have finished all the gilding use a soft paintbrush to remove any excess gold which is not attached to the size.

Gilding medium, cryla gloss medium, acrylic medium and PVA

Modern adhesives such as these will certainly make gold stick to paper or vellum, and if you are finding gilding frustrating then a little time spent using them may restore your confidence. The only problem with them is that it is sometimes difficult to achieve a smooth surface which will show the gold leaf off to best effect.

Diluting these adhesives with water (up to 50:50) will result in a smoother surface, but this does obviously reduce the adhesive qualities. If you are gilding over an area then adding another coat or two of this dilute mix will not cause problems, but it is almost impossible to go over accurately with a pen letter-forms previously written.

Applying leaf to these adhesives

Gilding medium can be used straight from the bottle or decanted into a small palette for ease of use. The bright pink colour of the medium is easy to see when you apply it with a brush or pen, but the other adhesives may need a touch of colour added to them such as a pinch of Armenian bole or a little gouache. It is better to use old brushes for all these solutions and to wash them immediately after use.

Dilute PVA and cryla and acrylic gloss medium with

water so that the adhesive lies smoothly before you apply the gold. Use an ink dropper to count out the number of drops of adhesive and add the same number of drops of distilled water.

Use an old paintbrush or a calligraphy dip pen to apply these adhesives. The dilute solutions will sink into the paper at first, and you will need to apply several layers which can be built up a little to make a cushion. Allow the PVA and gilding medium to dry between each of these layers; this may take half an hour or so at a time.

When the adhesive has dried, mask off all but a small area with pieces of crystal parchment. Cut a piece of single transfer or double loose leaf gold with its backing sheet. Breathe on the area to be gilded with two long breaths. Immediately place the gold over the gum and press down hard with your fingers. Rub over with a burnisher. Remove the backing sheet and replace with crystal parchment. Rub over the back of the crystal parchment with a burnisher. Then burnish directly on the gold leaf after you have taken the crystal parchment away. Repeat this process over all the areas to be gilded.

Use a soft brush to remove the excess gold.

Improved gold body

Improved gold body is another yellow mixture, which is thick and sometimes difficult to handle. It does give a smooth surface and, with practice, can produce a pleasing raised gold effect on a surface. It does not always sit happily on vellum, though, and when used on paper can produce problems as some of the stickiness leaches out into the paper. The result is a gilded centre with a surround of ungilded yellow improved gold body. To avoid this, paint over the area where you are to gild with 50% dilute PVA which will act as a seal on the paper. Of course, this is not possible if you wish to use the improved gold body for lettering, but as it is very thick it is difficult to use this mixture in a pen, and when diluted it loses much of its adhesive properties.

Applying leaf to improved gold body
After painting over the area to be gilded with a 50:50 mix of PVA use an old brush to apply the improved gold body. Wash the brush out with water as soon as you have finished. Allow the improved gold body to dry.

Cut a small piece of double loose gold with its backing sheet. Breathe on the improved gold body and immediately place the gold over that area and press down firmly. Rub over with a burnisher; remove the backing sheet and replace it with crystal parchment. Rub over again with a burnisher and remove the crystal parchment. Now gently rub the burnisher directly over the area of gold. Repeat until all the improved gold body has been gilded.

Gilding with gesso

It is traditional gilding on a slightly raised 'cushion' of gesso which attracts many to learn the craft. Gesso is a compound of slaked plaster of Paris, lead carbonate (white lead), sugar and glue, which is applied to vellum or paper. When it dries it stays proud of the surface and gives a slightly raised effect. Gold leaf is applied to this cushion, and the result looks like solid gold, polished to a brilliant shine.

Gesso is notorious for being temperamental. It does take some practice to acquire the skill, but it is certainly not impossible, as long as the conditions are right. It is crucial to apply those conditions – humidity, breathing and speed. Once they are resolved then you are unlikely to have problems with gilding.

Traditional gilding with gesso

Graily Hewitt, an associate of Edward Johnston, did much research into the methods of mediæval gilding, and experimented with different recipes of gesso. (See page 177). It is from him and others that the methods and recipes which we use today have developed.

Although there are prepared compounds which are available from specialist suppliers for use in gilding sometimes called raised gilding medium, and it is also possible occasionally to buy 'gesso' it is really recommended that you make your own gesso. With any bought compound, where you are not completely sure of the ingredients, the proportions used and how well they have been ground, you may well be wasting leaves of gold in trying to apply them to a base which is not sound. In addition, sometimes these bought media have been found to be a little gritty, and this will scratch burnishers which will then affect the final look of your gold. Gold leaf is so expensive, and the process of gilding very time consuming, that not to have control over the gilding medium does seem to be leaving a lot to chance. Try to leave such compounds to the very last resort.

Making gesso
Powdered plaster of Paris is used to make moulds and models by mixing it with water. It has a specific property of setting hard before the water evaporates and so there is no shrinkage. For the same reason it is also used by dentists who may be able to supply you with it. Some of the molecules of water are removed in the process of making plaster of Paris and slaking it replaces that water. The powder generates heat when water is added and as it sets. The plaster needs to be slaked so that it sets hard and inert without generating this heat when applied to vellum.

It is possible to replace slaked plaster of Paris by gilder's

whiting. I have experimented with this and find the gesso not quite as satisfactory as that made with plaster of Paris; the gold does not adhere so readily nor give such a good shine and it is rather prone to cracking.

Slaking plaster

There are two methods to slaking plaster – one is traditional and lengthy, the other much quicker.

Slaking plaster of Paris is not difficult to do, nor is it particularly time-consuming in itself. What you are doing is washing away any dirt or impurities and also taking the heat from the plaster.

The traditional method takes a matter of weeks rather than minutes so you should plan for this before you are to gild.

You will need:
- *500 g (1 lb.) of fine dental plaster*
- *a large 7 litre (2 gallon) plastic bucket*
- *a plastic spoon or rod for stirring*
- *cold water, preferably distilled*
- *fine woven material, such as an old pillow case, for straining at the end of the process*

1 Fill the plastic bucket almost to the top with cold water. Shake in the dental plaster, stirring as you do so. It is important to add the powder to the liquid and not the other way round, otherwise the powder will set as a hard lump as soon as it touches the water.

2 Continue stirring for about an hour. It is important that the plaster does not settle at the bottom of the bucket otherwise again it will set hard into an unusable lump too early in the slaking process. The water will probably heat as you stir.

3 Loosely cover the bucket and put it somewhere out of the way. The following day carefully tip away the water, making sure that the sloppy plaster mix stays in the bucket.

4 Fill to the top again with cold water and stir, this time for ten minutes.

5 Repeat this process – tipping away water, replacing and stirring for ten minutes every day for a week, and then every other day for three more weeks. At the end of this time the plaster will be slaked.

6 Tip away as much of the water as you can. Now place a piece of fine woven material such as an old pillowcase or piece of sheeting in a large cooking sieve and place over the top of a mixing bowl. Gently ease the wet plaster in the bucket out on to this material. Use a plastic spatula to scrape the bucket clean if necessary.

7 Allow most of the water to drip away, and then squeeze the lump in the material. I usually pull small pieces of this damp plaster off and pat it into small cakes, then allow them to dry. If you prefer you could allow it almost to dry, and then cut it or break it into smaller chunks.

8 Put the lumps into a plastic bag and keep well away from anything containing iron, as this will create rust marks.

The slaked plaster, in an airtight container, will keep for years until it is required. This amount of slaked plaster will satisfy all your gilding needs for a very long time.

Slaking plaster quickly

The plaster which was used in the time of Cennino Cennini, whose treatise *Libro dell'Arte* is the main reference for gilding, would have contained many impurities and would probably have been not so finely ground. This is not so now, for our plaster is much more refined.

Plaster is in fact slaked as soon as the heat is removed – and this is done once it is mixed with water. As modern plaster is so much more refined, the repeated washings of the above process is not really necessary. Using only about 100 g (4 oz) of plaster and a large bucket of water simply carry out steps 1 and 2 above stirring for 20–30 minutes, making sure that the plaster is sprinkled slowly on to the water. Allow the plaster to settle and then pick up the process from steps 6–8 once the plaster has settled.

The ingredients of gesso

Plaster of Paris which has been slaked is one of the six ingredients for gesso. It is there to provide body to raise the gold from the surface, as well as strength; other compounds may crumble with vigorous burnishing.

You will also need powdered **lead carbonate** or white lead. ***Please note:*** this is highly poisonous and should be handled with great care. Store it away from children and pets, and not in the kitchen or near any food which it may contaminate. Lead carbonate acts as a filler between the particles of plaster and also adds body. I have tried titanium oxide but found lead carbonate much better.

The glue most used for gesso to bind the ingredients together is fish glue or **seccotine.** This is, importantly, liquid at room temperature and is the glue which is easiest to obtain from specialist suppliers.

Sugar is hygroscopic and so attracts moisture from the air which helps to reactivate the stickiness of the seccotine. It also should provide some flexibility in the gesso, essential when it was used in manuscript books. Some scribes use particular sugars such as lumps of sugar candy, or unbleached chunks of sugar often used with coffee, or preserving sugar. It seems to be important to use sugar which has a large crystalline structure rather than a finer textured sugar.

Powdered **Armenian bole** is used to colour, and you will need a tiny pinch only, just enough to give a pale pink colour so that you can see where you laid the gesso.

It is better to use **distilled water** rather than tap water as the gesso will keep for many years once made, and the adding of any impurity to the mix should be avoided.

Making gesso

Please note: if you suffer from allergies, are pregnant or have cuts or grazes on your hands it is advisable to wear both a mask over your nose and mouth and protective gloves when making gesso.

You will need:
- *a small spoon such as an old-fashioned salt spoon, or a small measuring spoon*
- *a blunt knife*
- *2 pieces of standard photocopying paper*
- *a rubber, metal or plastic pliable spatula*
- *a pestle and mortar* **or** *a ground glass slab and muller*
- *small pieces (5 by 5 cm, 2 by 2 inches) of thick polythene, cut from polythene bags*

The proportions of the ingredients for gesso are:
- *8 parts of slaked plaster of Paris*
- **3 parts of powdered lead carbonate (white lead)*
- *1 part of fish glue, seccotine*
- *1 part of sugar which has been ground to a powder*
- *a pinch of Armenian bole to colour the mix*
- *distilled water to mix*

***Remember to handle this carefully as lead carbonate is poisonous.**

How to make gesso ·

1 Scrape some powder from the block of plaster of Paris on to a clean piece of standard photocopying paper. Using the small spoon measure out eight flat spoonfuls of powder, levelling each one with the knife. Put the measured spoonfuls in separate heaps on the other piece of photocopying paper.
2 Measure one level spoonful of the ground sugar and put it on the paper.
3 Measure out three level spoonfuls of lead carbonate taking care not to breath in any dust, nor to touch it. Put these three spoonfuls on the paper.
4 It is always better to grind the dry ingredients first as powders so tip everything from the silicone paper into the pestle and mortar and add a tiny pinch of Armenian bole, just enough to make it a pale pink. Grind for about 15 minutes, scraping the powder down from the sides of the mortar with the spatula. *Or* grind these dry ingredients in the same way on a ground glass slab with a muller.
5 Now add the glue. Use the same spoon and squeeze enough seccotine out to fill the bowl then let it pour into the mortar and scrape the spoon so that there is none remaining.
6 Drip distilled water into the spoon to remove any last remaining glue and allow this water to fall into the mor-tar. You should not add too much water probably not more than about two spoonfuls, or just sufficient to make a wet sticky mix.
7 Continue grinding for another ten minutes with the wet ingredients now added. You may need to add more water, but do so drip by drip so that you have a thick creamy paste. You will also need to scrape the mix down from the sides of the mortar at frequent intervals.

Do remember that you want the ingredients to form a very fine powder. Grinding in a pestle and mortar is not stirring, you will need to use some energy, and the more you put in the better will be the final result.
8 By now the various constituents of gesso should be fully ground together. Using a spatula, make dabs of gesso on the small pieces of polythene which are no more than about 1 cm (0·5 in) in diameter. Scrape out all the gesso from the mortar and add to the dabs. Put this to one side without covering, to dry naturally in a dust-free area such as a drawer.

The traditional way of drying gesso is to make a 'cake' of gesso, by scraping out all the gesso into one round, and then dividing it as you would divide a round cake. This means that, as the gesso dries and the various ingredients separate slightly, each slice of the cake has the same proportion of plaster, filler and glues. In my experience it is not all that easy to break off these slices of the gesso cake, and by making smaller dabs or rounds, each of which can all be used at the same time, you are still ensuring that each small round contains the same proportions of the ingredients.

The usual instructions are for the gesso to be left to dry for a few weeks, by which time all the ingredients should be well set with each other. As this is a solid, when dry there will be little movement between the molecules, and the gesso can be reconstituted as soon as it has dried out. There have been occasions when I have had to use gesso straight away without allowing it to dry, and apart from the burnish not being so good, this seemed to work all right.

Different mixes of gesso

When you make your own gesso you can vary the ingredients for different purposes.

Gesso for hot, dry weather – If you find it difficult to get the gold to stick and it is hot weather, then increase the amount of glues in the mix, the burnish may not be quite so bright, but it will not be so frustrating.

These are the proportions of the ingredients which you should grind together as before:
- *8 parts of plaster of Paris*
- *3 parts of lead carbonate*
- *1·5 parts of ground sugar*
- *1·5 parts of fish glue, seccotine*
- *a pinch of Armenian bole to colour*
- *distilled water to mix*

This is a useful mix of gesso for using with platinum, palladium and aluminium.

Laying gesso. Gesso should be plastic enough to flow well, but not so runny that when it dries it does not stand proud from the writing surface.

Problems with gesso occur when it is too thick (centre) so that the individual pen marks can be seen and the gesso does not flow well, or when it there is simply not enough gesso on the area (far right) so that the pen marks show again, and the gesso does not cover evenly the area to be gilded.

Gesso for a high burnish – Alternatively, if you are gilding well and successfully and want a really bright burnish, decrease the amount of glues in the mix.

These are the proportions of the ingredients in this mix which you should grind together as before:
- *9 parts of plaster of Paris*
- *3 parts of lead carbonate*
- *1 part of ground sugar*
- *1 part of fish glue, seccotine*
- *a pinch of Armenian bole to colour*
- *distilled water to mix*

As gesso keeps for a very long time without losing its properties it is a good idea to make different sorts of gesso for these various occasions, label them carefully, and then reconstitute the gesso you want.

Reconstituting gesso

Take one of the small dabs or rounds and place it in a small glass jam jar or palette. Prop the jar on a pencil or side of a palette so that it is tilted and add just two or three drops of distilled water to it. Leave it for some hours, or overnight if you can. You are softening the gesso so it is easier to make into a solution. Then add a few more drops of water and stir very gently with the end of a paintbrush or something similar to make a smooth liquid, about the consistency of thin, runny cream. Whatever you do, be very careful at this stage. You should simply move the gesso around so that it is mixed with the water. Gesso is notorious for having bubbles and you do not want to introduce them yourself by over-enthusiastic stirring.

Some scribes use other liquids for reconstituting gesso. Try with distilled water first. If you have any difficulty getting the gold to stick then replace half the drops of water with vellum size (to make vellum size see page 305). Or you could replace half the water with glair. Glair is the liquid from beaten egg white, and instructions for making this are on page 172. Adding glair does get the gold to stick but it

also gives a very brittle mix, which sometimes cracks with hard burnishing. As well as this, glair is waterproof, so you should not leave the gesso for more than a day before you gild, otherwise no amount of breathing on the gesso will reactivate the glue. Two or three drops of gum ammoniac or PVA will increase the stickiness of the gesso but will reduce the burnish. Try it without these additional adhesives first, and then experiment with the quantities of adhesives and use the one which works best for you.

Removing bubbles in gesso

Without obvious reason some mixes of gesso are far more bubbly than others. When the gesso is laid, any large air bubbles will burst and make a hole. This will prevent the gold from attaching itself to that place. Small bubbles also do not give a smooth finish.

You can prick larger bubbles with a needle, held in a cork if it is easier.

Smaller bubbles can be removed in one of two ways. Traditionally scribes have removed them using ear wax, although I would not recommend this because the ear wax is usually stirred round in the gesso with a finger; it is not actually mixed with the gesso. Because of the lead content in gesso it is advisable not to put your fingers in the mix. I prefer to use a tiny drop of oil of cloves, available from a chemist or pharmacy. This disperses most of the bubbles, slightly aids the stickiness and also acts as a preservative. It was used by some illuminators early in this century when they wanted to keep liquid gesso for use on another day. Ideally, however, the gesso will be smooth and so neither of these processes to remove bubbles is necessary.

Laying gesso on Paper or Vellum

Gesso is a liquid, and covering an area such as in a mediæval manuscript painting with gesso could dampen paper such that

it stretched and then dried unevenly. The surface of paper is also porous, so some of the stickiness can leech around the edges of the gesso into the paper. To counteract both of these problems cover the area to be gilded only with a solution of PVA diluted 50:50 with water.

Neither of these problems occur with vellum which is non-porous and much the preferred surface. In addition, it is easier to clean up the gold from vellum, as the surface can be scraped with a sharp knife, or a hard ink eraser without harming the skin. However, vellum is very much more expensive than paper although it is possible to buy off-cuts of vellum from the manufacturer or from specialist suppliers quite economically, and these are certainly ideal for practice and sometimes large enough to gild and paint whole miniatures.

Vellum should be prepared for use by pouncing to remove the grease, and raising the nap if you are to write on it. See page 301 for this.

Attach the paper or vellum to a piece of plate glass with strips of masking tape before you start. The plate glass is cool, this will help to condense moisture from hot breath and so help the gold to stick.

Laying gesso

Working with gesso involves a technique which needs a degree of practice. To ensure that there is always an even mix, stir the gesso thoroughly but gently each time you fill a brush or a pen. Always be careful about introducing air bubbles.

Unlike calligraphy, it is better to work flat when laying gesso. This alleviates the problem of the gesso, in large letters or large areas, gradually sliding to the bottom, and creating a thicker area here than towards the top of the work.

Working flat when lettering may cause you problems if you are used to writing with the board at an angle. You may find the gesso flows more easily, nevertheless, if you raise the angle of your writing board to about 20° rather than 45°. Add a little more water to the mix if it gets too thick, remembering to stir gently but thoroughly.

Because you are usually working flat it is important to ease the muscles in your back and shoulders at regular intervals. If you lay gesso and gild in the same position for hours on end without getting up and walking round the room, shrugging your shoulders, flexing your fingers and stretching, then the muscles will be tense and this will cause pain, and perhaps lead to greater problems. (See page 36.)

It is better to lay gesso with a quill which has a longer slit, about 1 cm (0·4 in), as the action of gesso passing through a quill helps the problem of air bubbles. However, if you do not have a quill then gesso can be laid with a paintbrush or calligraphy dip pen. When using a brush to lay gesso wash it in water and dry carefully, squeezing out any air between the hairs so that this does not introduce air bubbles to the gesso.

Before you start it is a good idea to look carefully at your design and work out the best route around it so that the gesso is always wet where you are working. Gesso clogs a quill or pen so have a small jar of clean water ready to hand, and wash whenever necessary. Before you dip the quill/pen back into the gesso, dry it on a clean tissue or kitchen towel. Remember to keep stirring the gesso gently to maintain the mix.

When you have transferred the design on to the paper or vellum dip a clean quill or pen into gesso and 'scoop' some of the liquid up. Wipe the top of the nib on a piece of clean tissue or paper kitchen towel. Start at the top of the letter or the area where you are to gild. Press down slightly to release the flow and then move the pen in a narrow initial stroke. This should start the gesso flowing freely. Write with gesso as you would with gouache, realising that it is a stickier and slightly thicker mix, so that occasionally it will need to be 'encouraged' to flow. You may prefer to write with gesso on a very gently sloping board if you are used to this.

To gild an area start at one corner and pull the gesso down over a small patch, trying to avoid pen marks. A small amount of gesso will go a long way, further than you may think. Remember to work so that the edge of gesso never dries out. If you add wet gesso to a dry edge there will be a line which will be difficult to remove.

Once it has been laid allow the gesso to dry in a dust-free area. In good conditions it is possible to lay gesso in the morning and gild in the afternoon, but it is better to allow twenty-four hours at least for the gesso to dry. It may look dry and solid on the surface but be quite soft underneath, so when you start to lay the gold the action of the burnisher makes the gesso crumble.

Lay a couple of small areas of gesso on a scrap of vellum, which you have treated in the same way as the main piece. Test gild these areas of gesso first so that you know how many breaths are required to reactivate the stickiness, how well the gold will stick and so on.

What to do if there are problems with gesso

If your gesso shows pen marks where you have tried to lay it smoothly then this will usually be for two reasons – either the gesso is too thick or these is not enough gesso in the pen. If the gesso is too thick, it will not flow smoothly from one pen stroke to the next, and there may even be individual pen strokes with a gap in the middle. Scrape off the gesso and add a drop or two more to the reconstituted gesso in the jar. Make a few test strokes to ensure that the gesso is not now too dilute. It should be thick enough to stay a little proud of the writing surface. If you think the gesso is of the correct consistency then the marks may be that you did not have sufficient gesso when working over the area or letter. Again you will need to scrape the gesso off and start again,

remembering this time that the first and second stroke will make an outline, and a little of the 'filling in', but it is successive 'scoops' of gesso which provide the main body. When the gesso is of the correct consistency then it will flow easily into itself.

Although it will delay laying the gold, it is possible to repair problem gesso. If the gesso dries with a dip down the centre of strokes and it is too thin to scrape down smoothly then dampen the gesso with water applied with a brush and apply a thin layer of gesso to that area. In the same way, add dots of gesso to any large air bubbles to fill in the holes. Of course, it is best to avoid this by laying the gesso as well as you can, but occasionally problems like these occur even for the most experienced gilders.

Before gilding

Some scribes prefer to lay gold leaf straightaway, scraping gesso only if absolutely necessary. I much prefer always to scrape and also thoroughly burnish gesso before gilding so that the surface is as smooth as I can make it.

Use a knife with a curved blade to scrape down the gesso. A sharp point may stick into the gesso and ruin the surface. The knife blade should also be free from any nicks or damage. The slightest dent or jagged edge in the blade will result in the gesso having a similar groove or thin line standing proud.

Scrape the surface of the gesso so that it is smooth, free of all bumps and level. Do watch what you are doing, though, as too energetic scraping could take off all the gesso in one place. If you remove much gesso do avoid breathing in the powder, because of the lead content.

Avoid also a plateau effect on the gesso – with steep sides and a flat top – as this will cause difficulties in the gold sticking to the edges. Gesso should have smooth rounded sides.

When the gesso is as smooth as you can make it, carefully remove the powder with a soft brush on to a piece of scrap paper which is then folded and placed in a bin. Do not blow the dust away because you may inadvertently inhale some of the powder.

Now rub an agate burnisher quite hard over the gesso to give an extra smoothness to the surface. The gesso will become quite shiny which adds to the smoothness of the surface before gilding. This will also increase the effect of your breathing to reactivate the stickiness, as a shiny surface on the gesso helps to prevent the moisture from soaking in.

Laying gold

A single layer of gold will cover the gesso adequately, but for a depth of burnish it is better to add more layers of gold.

Gilding needs a calm mind and a quiet nature. It is a little like Chinese calligraphers who prepare themselves mentally for their work. Gilding is best done when you can be sure of no interruptions, as a door opening without warning may cause a whole leaf of gold to fly away and crumple in the draught. Alert the family to what you are doing, and try to work somewhere away from the telephone!

The written works of illuminators early in the twentieth century suggest that the weather and even a particular wind direction affects gilding. This has not been my experience, but I do find that a degree of humidity is essential. Long, hot dry days are not the best for illuminators, although when gilding is necessary on these days I find that very early in the morning – around dawn – is the best time. The additional advantage of this is that others are unlikely to be around this early and so you can gild uninterrupted.

The ideal humidity is between 63% and 73%. It is not absolutely necessary to have a hygrometer to determine this although for beginning gilding it may help. Do some test gilding on the small areas of gesso which you laid for this purpose. If the gold sticks well then the humidity is adequate. If it does not stick then you may need to increase the humidity. This is easily done by having bowls of boiling water near to where you are gilding. The steam will increase the local humidity, but the water may need to be replaced when it has cooled. Do not be tempted to place the bowls on the work surface itself; one tiny splash will ruin the gesso and gold. Once the humidity is sufficient, the water can be removed.

It helps to keep the vellum or paper, taped to its sheet of plate glass, in a cool place for some hours before you gild, preferably overnight. This allows the gesso to become quite cold, and the humidity in your breath will then condense better, reactivating the stickiness in the gesso. It is not recommended that you use a refrigerator because of the proximity of food to the poisonous lead carbonate in the gesso.

Unless you are used to handling gold, it is easier for a beginner to the craft to work with single transfer gold as well as double loose gold. (In the USA transfer gold is patent gold, and loose gold transfer gold.) The transfer gold, being easier to handle, should stick to the gesso initially, and, once attached, the following layers of gold will stick to it. However, too many layers of gold will peel off, so until you are used to gilding perhaps it is better to lay two layers of single and two or three of double. This is not as extravagant as it sounds as the layers of double gold can be folded back on themselves. Trimmings can also be saved to use for patching and other small areas of gilding.

Arrange everything you need so that it is to hand. Have the burnishers, silk, breathing tube, crystal parchment on the right hand side if you are right-handed. Books of gold should be away from your work. You do not want to catch them with your sleeve, or knock them to the floor by mistake.

The process

This is the process for gilding. Read this through first a few times, and then try it for yourself. You will find that you will be too slow if you read at the same time as gilding, and you will probably lose the stickiness in the gesso.

1 Breathe on the burnisher and polish it with the silk. There should be no pieces of gold or tiny bits of old gesso sticking to it. Anything on the burnisher will affect the gilding.

2 Plan the gilding carefully. Start with small areas at first. When you are gilding well you can tackle larger areas. Gold will overlap, and burnishing will push one piece of gold into the next, so it is not necessary to be as careful about overlapping the areas of gold as it is about laying gesso.

Mask all the areas which are not to be gilded with pieces of crystal parchment as a mask.

3 Take one of the sheets of single leaf gold from the back of the book. Using your clean, new scissors, cut a small piece of gold which will easily cover the area you are to gild.

4 This is the part of the process where you need to act quickly, so check that your burnisher and a piece of crystal parchment are within easy reach.

Lean over you work; your mouth should be no more than 5 cm (2 in) away. Breathe twice and long on the gesso. See page 183 for breathing for gilding.

5 You have about 3 seconds for the stickiness to remain active so immediately you have finished breathing place the gold face down on the gesso, and press firmly with your fingers. Then run over with a burnisher, paying particular attention to the edges where the gold is least likely to want to stick.

6 Now remove the backing sheet from the transfer gold. It should act like a transfer, in that most of the gold should be attached to the gesso, and there should be a matching blank space on the backing sheet. Place a piece of glassine over the gilding and rub over with a burnisher.

7 Check the gilding. Most of the gesso should be covered with gold. If it is working well all will be covered and you can continue with the next layers of gold. However, there may be one or two spots which do not have any gold – this will be particularly where there have been air bubbles, or around the edges of the gesso.

8 Mask the areas where the gold is already attached with pieces of crystal parchment. Or make a small hole in a piece of crystal parchment which is a little larger than the area ungilded. With a small piece of single transfer gold in your hand – possibly the corner of the piece you were just using focus your breathing on one of these areas, and breathe twice more – long deep breaths.

9 Immediately place the gold face downwards on this spot and repeat points 5 and 6. It is important to get the gesso covered with gold at this early stage so that the following layers can stick on to something.

10 Now place another layer of single transfer gold over the whole area you are gilding as before, using the edges to patch up any spots without gold. It may help to breathe just a little on the gesso before you lay the gold; too much breath will make the gesso very soft and may even peel off the first layer.

11 Double loose gold needs very careful handling. (See page 166.) Cut a piece of gold which will easily cover the area you are to gild, and hold it by the backing sheet along the edge or corner with your thumbnail and forefinger. If your hands are damp the gold will stick to them, so wipe any moisture on to a cloth or rag.

12 Breathe once on the layers of single gold and immediately place the double gold face down on the gesso. Through the backing sheet press firmly all over with your fingers.

13 Remove the backing sheet and replace it with crystal parchment, and rub over again with the burnisher.

14 Now burnish directly on the gold. Rub over gently at first and you will see the shine developing.

15 There will probably be some pieces of double gold beyond the areas where you have gilded. With a sharp knife gently lift these from the paper or vellum and turn them back on themselves so that they are on the gesso. Place a piece of crystal parchment over this gold and burnish as before.

16 Already the gold will be developing a good deep burnish, but you may want an even deeper one by adding another layer or more of double loose gold.

17 When you are satisfied with the gold on that particular area of gesso, move the pieces of crystal parchment so that another area is revealed. However, do make absolutely certain that the gold already burnished is covered, as you do not want it to come in contact with any of your moist breath as it may lift the gold off.

Now repeat the gilding process over the whole area, working on small sections at a time.

18 Allow the gold to rest for at least 4 hours and preferably overnight; more importantly, choose a time when the air is dry and there is low humidity. When it is calm you can now burnish the gold directly and quite firmly. Rub your burnisher with silk to ensure that it is completely free from grease. Gently rub over one small area of gold with the burnisher feeling carefully all the time to make sure that the gesso is completely hard then gradually increase the pressure. If you are in any doubt, stop and leave the gesso for a few more hours.

High humidity may soften the gesso even though you have allowed it to settle down, and this hard burnishing could crack the gesso and even make it break away from the surface.

If it feels firm then gradually work your way all over the gesso until you have a brilliant mirror finish. Any problems that you had with gilding will now all be worthwhile as you will almost be able to see your face in the shine!

19 After burnishing there will probably be some pieces of gold sticking to the paper or vellum, creating an untidy edge. This can be removed with care. Use a soft brush to remove any loose gold and then an ink eraser, shaped like a pencil,

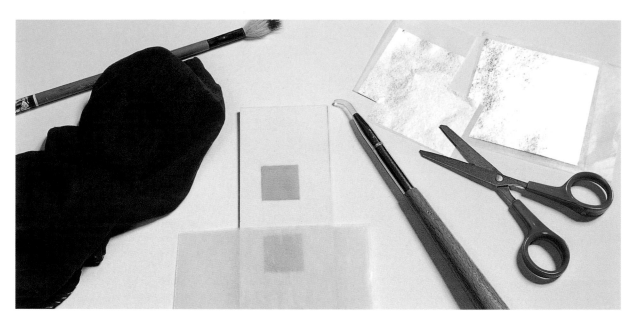

Everything should be to hand ready for gilding; the burnisher should be polished with the silk, and placed to your right-hand side (for right-handers). Areas not to be gilded at this time should be masked off with crystal parchment paper, and the gold placed ready to be cut. Everything else should be cleared from the surface.

with a sharpened tip to gently rub away the gold. Or you can use a sharp knife. This scratches away the gold which has attached itself to the paper or vellum. If you rub an ink eraser anywhere near the gold, it will damage your burnishing.

Do not blow away the rubbings or scrapings as they will then be blown over the areas you have spent so long in gilding. The remains of an abrasive eraser will damage the gold. As well as this any moisture in your breath may collect on the gold

and could cause problems. Use a very soft brush to gently guide the rubbings around the gesso and remove the waste.

To improve the shine of the gold, rub over with a burnisher twenty-four hours or so after the final hard burnish. Burnish again before you frame your gilding, too. Good gilding will result in gold which looks as if it is solid metal, with a mirror shine which reflects an image. It is a wonderful transformation from pink powdery gesso to this solid mirror finish.

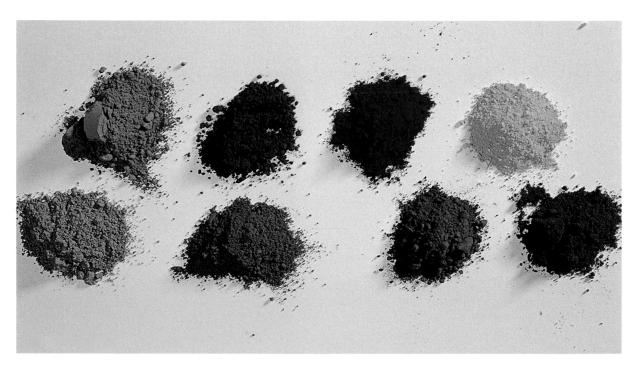

The colour of powdered pigments is much purer and more vibrant than any paint in a tube.

182

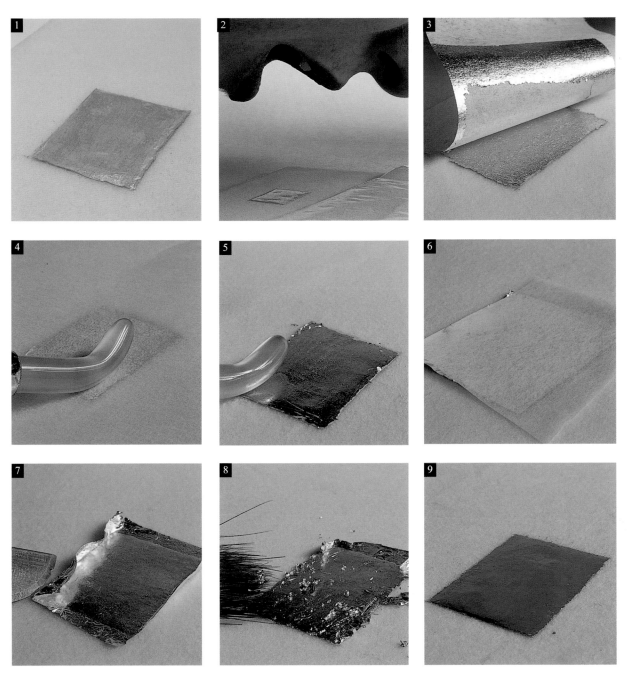

How to gild:

1 The gesso has been scraped with a knife to make the surface smooth, and it is then polished with a burnisher.

2 Breathing on the gesso to reactivate the stickiness.

3 The first layer of transfer gold is applied and the burnisher rubbed all over the ensure adhesion, with particular attention to the edges. The backing sheet is removed, leaving the gold attached to the gesso.

4 A burnisher is used to rub over the gold through crystal parchment paper.

5 Other layers of transfer gold are applied in a similar way and burnsihed.

6 Now layers of loose gold are applied by breathing gently first, quickly applying the leaf and then burnishing.

7 The edges of the loose gold, not attached to the gesso, can be lifted up carefully with a knife and burnished on to the gesso to add to the layers.

8 Using a soft brush to clean up the gold not attached to the gesso.

9 The gold burnished to a shiny finish and reflecting the light.

If you look at most illuminated manuscripts you will see that the gold area is outlined either in a colour, or with black. This tidies up the gold edge, and also makes a striking contrast between the shining gold and the flat paint or ink. A quill or brush can be used to paint or 'write' in this edging line. The quill bites into the edge of the gold very slightly and so ensures that the ink is where you want it to be, but may not always give the finest of lines.

What to do if it does not work

There will be occasions when gilding works as if by magic, the gold sticks to the gesso and burnishes to a brilliant shine.

On other occasions, even with the same mix of gesso, and seemingly similar conditions, the gold will not stick, or only stick in patches.

For small areas where the gold has not stuck use a breathing tube, and re-gild these spots as detailed in points 8 and 9 as on page 181.

If the areas are really unobtrusive, and the gold still does not stick, then you may choose to add a tiny amount of dilute PVA (50:50 with water) and then apply gold as before.

For larger areas which are troublesome, then it is best to scrape off any gold that is not really well attached using a curved-bladed knife. Brush this away with a soft headed brush.

Now check the conditions. The humidity could be too low. Place the vellum or paper to be gilded on a piece of plate glass somewhere cool. Pour some boiling water into a large mixing bowl, and put this on a stool or chair near to the work surface. Allow it to steam for five minutes, and then try re-gilding following the previous instructions. The contrast between the cool gesso and the increased humidity should improve the gilding.

If this does not work then it could be the stickiness in the gesso which is the problem. For a really rushed job, the only alternative would be to paint over the whole area with PVA or another gilding medium. The gold may not be a mirror finish nor will the depth of burnish be very good, but at least gold will be sticking to the gesso and it will be raised from the surface.

It is better, if you have the time, to scrape off all the gesso and start again, making sure that the gesso is well mixed each time before you charge your brush or pen.

The only foolproof way for getting gold to stick in these circumstances is to use a technique from the tempera painters, which is to use pure alcohol. Dip your brush into the alcohol and paint a small area to be gilded. Immediately cover with gold and proceed as before.

Breathing for gilding

One of the main reasons why people find gilding a problem is because they do not use the right sort of breath before applying gold or other metallic leaves. The reason for breathing on various adhesives and gesso is to reactivate the stickiness in the mixture. The moistest breath is that at the bottom of your lungs. A number of shallow huffs will not produce the required moisture, and the end result will only be exhaustion on your part and possibly hyperventilation!

If you breathe now into your hand you will see the difference in moistness of the air. Cup your hand over your mouth and breathe in and out quickly about five times. The palm of your hand will not be very moist. Again cup your hand over your mouth and make two very long breaths lasting

for 8 seconds or so, making sure that you take the air from the very bottom of your lungs. After just two of these breaths your palm will be quite moist.

Speed is also important. With gesso, you have about 3 seconds when the stickiness remains active. You should ensure that you have everything ready for gilding before you breathe. The gold should be already cut and in your hand or held on the gilder's tip. Your burnisher and the crystal parchment should also be within easy reach.

Egg tempera painting

English manuscript painting is often regarded as the best in the world, with the brilliant shine of layers of leaf gold providing the perfect foil for the jewel-like colours of egg tempera paints – colours which still sing out from the pages of books today after hundreds of years.

Egg tempera paints last, and their pigments have a depth of colour not found in other media.

Watercolour and gouache in pans and tubes are already mixed with gum so that the paint sticks to paper when it is used. Gouache also has a filler, usually chalk or blanc fixe (artificial barium sulphate), which makes it opaque. For egg tempera painting you will need pure powdered pigments; these are not powder paints which are already mixed with a gum. Artists' colourmen supply powdered pigments which are usually sold by weight. Lead red and Naples yellow, both containing lead, weigh very heavily, whereas some of the earth colours and lamp black, for example, are very light and fluffy, and you will have more than you know what to do with! These powdered pigments contain just the pigment, no adhesive.

The colours sold have the same names as watercolour and gouache. You may wish to start with a few basic colours and then expand your palette. These eight pigments will mean that you can mix almost any colour that you wish:

Black (jet black if possible, or mars black)
White (titanium or permanent)
Vermilion or **cadmium red** (red tending to yellow)
Alizarin crimson, or **madder lake deep** (red tending to blue)
Lemon yellow (yellow tending towards blue)
Cadmium yellow (yellow tending towards red)
Ultramarine blue (blue tending towards red)
Cerulean blue (blue tending towards yellow)

For pure secondary colours mix those which have a tendency towards one another. For example, lemon yellow and cerulean blue will make a clearer green than cadmium yellow and ultramarine.

This is explained fully on pages 307–308, and 310.

When you buy the pigments it is a good idea to transfer

them as soon as you can to an airtight container, such as a screw top glass jar, so that the pigments cannot be affected by damp. Label the jar carefully, including the date the pigment was purchased. Take great care with handling these powders as some of them contain poisonous substances. It is a good idea to wear thin plastic gloves and a mouth and nose mask.

Preparing the pigments for use

Some egg tempera artists use the powder pigments as they are, simply mixing them with egg yolk. Although this does save a little time it is rarely satisfactory. Many of the pigments do not mix easily in their powdered form, and much time will be spent trying to combine the sticky egg yolk with very fluffy pigment. As well as this it is difficult to mix colours together until they have been combined with some medium.

It is far better to combine the powder with water first. Mixed in this way the pigments last indefinitely and they are so much easier to handle.

Cennini (in his *Libro del'Arte*) recommends using porphyry for grinding the pigments. Granite is a good substitute for this, but both are not only difficult to obtain but also very expensive and heavy to use. Most artists use ground glass slab and muller instead.

You will need
- *a large ground glass slab*
- *a ground glass muller*
- *a flexible plastic or rubber spatula*
- *small airtight jars for storing the ground pigment*
- *distilled water*

You should buy the largest and best slab and muller that you can afford. Ideally the muller should be about 10 cm (4 in) in diameter, and the slab approximately 25 cm by 35 cm (10 by 12 in). It is better to use the glass slab supported by a wooden frame if possible. You will be exerting a lot of pressure when grinding on the glass and if the base is not completely flat and steady, the glass could crack under the strain.

Look carefully at the surface of both the slab and the muller before you buy. Make sure that there are no blemishes or air bubbles that you can see. The glass on both will need to be reground periodically, and if there are bubbles just below the surface, when reground these will appear as holes which will trap the pigment.

Before you use the slab and muller prepare the surfaces with medium-fine emery powder. Sprinkle the powder on the slab, add a little water until it is a thin paste and work over the slab methodically with the muller. Tip the muller slightly so that the parts of the sides which are ground are also rubbed into the emery paste. Wash the slab and muller carefully to remove all traces of the paste before you use them.

Using an old spoon place about a tea-spoonful of pigment on the glass slab. Pour about two spoonfuls of distilled water on the pigment and mix together with the flexible spatula. Some pigments will mix easily at this stage, others will float on the surface of the water.

The pigment and water should now be ground together. You should exert some pressure here as it is grinding rather than mixing. Use the spatula to pull the pigment back under the muller. Grind in a figure of eight and in doing so, work up a rhythm. You may need to add more water if the mix becomes a little sticky and the muller does not move easily over the slab. When the pigment is ready it should form a very fine paste and be totally mixed in with the water.

If you are grinding a few pigments you will probably notice that there is a difference between them. Some are already a very fine powder and mix well, others are rather gritty and need to be ground down to form a finer powder, still more are a little sticky and greasy and more water has to be added so that the muller moves more easily over the slab.

When you are sure that the pigment is fully ground scrape the resulting paste into a clean air tight jar with the spatula. Fill the jar to the top with distilled water and label each jar, noting also the date that the pigment was ground. The pigments will last almost indefinitely in this state, but you should check them periodically as the water should be topped up. If the paste is allowed to dry out then you will need to regrind again. Keep your pigments in a cupboard or away from sunlight.

Preparing the egg yolk

If you have ever left raw egg yolk by mistake on a plate or a work surface and then had to remove it when it has dried you will appreciate how effective yolk is as a glue! The liquid from the yolk sac is what is needed to attach the powdered pigment to paper or vellum.

It is better to use eggs as fresh as you can get them for egg tempera painting. These eggs usually have a stronger yolk sac, which makes them easier to handle.

You will need
- *a fresh egg*
- *two small clean containers, such as a cup and an egg cup*
- *a sharp knife*
- *four or five paper kitchen towels which have been folded in half to make a stack*

Crack the shell of the egg on the side of a cup and carefully break the shell into two over the cup. Tip the yolk sac from one part of the shell to another so that as much of the white as possible falls into the cup. Or use an egg separator. Break any long stringy pieces of white with the edge of the shell.

Now tip the egg yolk sac into the palm of your hand. Wipe the other hand on the stack of paper kitchen towels. Tip the yolk sac into this hand and wipe the other hand on the paper towels. Do this five or six times until all traces of egg white

Grind the pigments with water in a figure-of-eight movement.

Hold the yolk sac in your left hand and use a knife to prick it with your right. Allow the yellow liquid to fall into a container and discard the yolk sac.

Making egg tempera

The liquid yolk should now be combined with the powdered pigment paste to make the paint. The traditional proportions are egg yolk and water 50:50. Once the pigment has been combined to make a paste this proportion is not so easy to adhere to, however. Some pigments are heavy and will separate out, so it is not so much of a problem scooping up a little colour with a spoon and allowing the excess water to drain away. Others are light and will remain completely mixed with water in the jar – in fact the whole jar looks as if it is full of pigment; you will have to wait a very long time before the pigment and water separate!

In practice what is usually better is to use common sense. Use the tip of a small spoon to remove a small amount of pigment from the jar, taking the colour from the bottom of the jar and scraping it up the side so that as little water as possible is on the spoon. Tip away any water that you can see. Tap this into the well of a palette. Now add a few drops of egg yolk and mix well. To test, paint a narrow line of paint on a piece of glass and allow to dry. It should peel off in one continuous strip. Alternatively paint a small square on vellum or paper and allow to dry. Then rub over with your hand; it should not come off nor smudge.

Adjust the amount of egg yolk and water accordingly, so that the paint adheres to the surface but is the consistency of thin runny cream for painting.

If you wish to mix the paints to create new colours scoop up some of the pure ground pigment and place the colours into separate wells of a palette. Using an old brush add quantities of each colour into a third palette to mix. Always mix more than you need as you can keep this in a glass jar under water similar to the pure colours. When it is the colour you require, scoop a little into another palette and then add egg yolk so that it can be used as paint.

have been removed. This process not only removes all egg white but the warmth of your hands also slightly cooks the egg sac making it a little tougher and so easier to remove the yolk.

If you are right-handed put the yolk into your right palm (left-handers should use the opposite hands). With your left-hand pinch the yolk sac and lift it away from your hand. Holding the knife in your right hand, and with the yolk sac held over the egg cup, pierce the yolk sac and allow the liquid to fall into the egg cup. The yolk sac can be squeezed to remove all the liquid yolk.

The yolk on its own, and egg tempera when it has been mixed, will keep for a few days. Overnight loosely cover the palette and egg yolk container, but do not make it airtight otherwise it will go bad. When not using the egg yolk cover it with a damp paper kitchen towel so that it does not form a hard skin.

Illumination Projects

I t is surprising what a difference a touch of gold makes to any artwork. The gold can range from the layers of leaf gold on a raised cushion of gesso in a mediæval miniature which may also have highlights painted in shell gold, to a tiny spot of gold gouache decorating an initial or a monogram. This chapter gives you ideas of how to use gold in a variety of ways. Because using gold is so addictive it is tempting to over-use it. Remember that the impact of gold is always as a contrast to colour or background. If you use too much then that impact is diminished.

Cards and gift tags

You do not have to invest in an expensive book of gold to make your work come alive and impress other people. A tube of inexpensive metallic gouache and some metallic foil will serve your needs well until you feel ready to tackle projects using the real thing.

If you want to put your newly-found skills to use, but are not sure how proficient you are, then making a greetings card or a gift tag are good ways to begin. The reason for this is that they are small, do not involve a lot of effort, you can choose which of your designs to use, and they can look stunning for very little outlay!

For the basic idea you will need:
- *metallic gouache*
 or metallic powder (which already contains dextrin glue)
- *small pieces of good-quality different (in texture and/or colour) papers about 10 by 8 cm (4 by 3 inches)*
- *a piece of good-quality neutral tone paper for the card*
(A5 size, 8 by 6 inches) or gift tag (15 by 10 cm, 6 by 4 inches), at least 150 gsm in weight
- *a short length of matching narrow ribbon for a gift tag about 15–20 cm (6–8 inches) long and 2 mm (0·1 inch) wide*
- *hole punch for the gift tag*
- *a piece of cardboard (a rectangle cut from a cereal packet, trimmed with a knife to 10 by 1·5 cm, 4 by 0·5 inches (if you are left-handed, cut a left-oblique tip, see page 16)*
- *a narrow stick*
- *stick glue, PVA or cow gum*
- *layout or photocopying paper for practice*

1 Choose an initial as the design for your card; it will probably be the first letter of the recipient's name. Mix up the metallic gouache or powder until it is the consistency of thin, runny cream.

2 Dip the cardboard 'pen' into the paint and write the letter on the practice paper using different lettering styles and minuscule and majuscule letters.

3 When these are dry, dip the narrow stick into the paint and write over the letters in a free and flamboyant way, copying the lettering style in each case.

4 Choose which letter you prefer and write this with the cardboard pen on one of the good quality pieces of paper. When it is dry go over it again as before with the narrow stick. Try not to let your hand tense up when you do this, otherwise the letter will look stiff and tight.

5 Trim the paper if necessary so that the letter is centred.

6 Choose a piece of contrasting paper which is about 1 cm (0·5 inch) larger all round (trim if necessary) and paste the lettered paper on to this.

7 Now paste this on to a slightly larger piece of paper in another contrasting colour.

8 Decide whether your card or gift tag is going to be portrait shape (longer downwards) or landscape shape (longer widthways), and fold it carefully to make this shape. Go over this fold with a bookbinder's bone folder or the edge of a clean plastic ruler to make it sharp.

9 Paste the papers on to the front of this card, measuring centre points as guidelines if necessary.

Write your message inside the card or gift tag.

For the gift tag only make a single hole in the top left hand corner with the hole punch. Fold the narrow ribbon in half and push the loop through this hole. Thread the loose ends through the loop and gently pull them until the ribbon is snug. The tag can then be attached to the gift by these ribbons.

An A5 card will fit a standard sized envelope, but if you wish to make your own envelope to match, or you wish to put the gift tag in an envelope; see pages 115–116 for making simple envelopes.

Variations on a theme (see page 190 and end papers)

This basic idea can be changed slightly to make a range of different cards and tags.

A Gold metallic gouache written with a wide pen and a narrow ruling pen or stick.

B Gold metallic gouache written with a wide pen, silver gouache written with a ruling pen.

C Toning colours of gouache laid with a wide brush as a wash, with metallic gouache written with a wide automatic or coit pen. (See page 292 for information on papers. To avoid the paper cockling, either choose a heavyweight paper, such as 300 gsm, or stretch the paper before laying the wash.)

D Toning colours of gouache laid with a wide brush as a wash, with metallic gouache written with a ruling pen. (See note C about paper.)

E Letter written with resist (masking fluid), allowed to dry and then toning colours of gouache laid with a wide brush as a wash. (See note C about paper.) While the wash is still wet but just before it dries, drop in some metallic gouache. When completely dry use an eraser to remove the masking fluid.

F Letter written with resist (masking fluid), allowed to dry and then toning colours of gouache laid with a wide brush as a wash. (See note C about paper.) Just before the wash is dry, drop in some metallic gouache. When completely dry

use an eraser to remove the masking fluid. Use a ruling pen or stick to write a free letter with metallic gouache.

F Dropping some metallic powder into a wash before it dries.

Writing out names, for presentation or bookmarks

Having written out single letters you will see how easy it is to make something look impressive with a little bit of care and effort – and, of course, that glitter of gold!

Here are some ideas to take this a step further. You may want to make these projects into bookmarks, or perhaps place them in a mount so that the recipient can frame them to hang on the wall.

Using shell gold

Although shell gold is expensive, a few tiny dots of it cost very little and make the artwork look very impressive. For the first two ideas here you may even want to use a small piece of vellum to add to the expensive and luxury feel of the artwork.

Using a dark colour of gouache, write out a name on paper or vellum. Add a couple of drops of water to the tablet of shell gold to make it into the consistency of thin, runny cream. Using a small fine-haired paintbrush (00 or 000 in size, see page 306), paint two or three diamonds on the downstroke or the thickest stroke of the first letter of the name. When it is dry, place the point of a pencil burnisher in the centre of one of the diamonds. Hold the burnisher vertically, and rotate it carefully but firmly. The rest of the gold will be quite dull, but the centre will gleam like a jewel. Repeat this for the centres of the other diamonds.

If you would like to use more shell gold, then write the name in coloured gouache as before – this time it can be in any colour, and may even be in a light colour on a dark paper. In the same way, paint tiny dots of shell gold scattered around the name. Allow these to dry and then use the pencil burnisher to shine up just the centres of the dots to look like glistening specks of light.

Another idea, which uses a little more shell gold, is to write the name with the letters slightly spaced out again in a darker coloured gouache. Choose a hand which uses minuscules, rather than one which is majuscules only. When the paint is dry, write the name again in much smaller majuscules and in shell gold along a line which is just below the centre of the letters previously written.

A small amount of shell gold can also make the initial letter of a name look very grand. Try this out on a piece of rough paper beforehand using gold gouache. Write the name again using darker coloured gouache. Using shell gold (gold

gouache on the rough) and a fine-haired paintbrush paint a couple of sprigs of a plant coming out from the base line. Add leaves if you wish, but the effect should be delicate and not clumsy, so err on the side of caution here.

Using leaf gold

You can write out a person's name in gum ammoniac or another reliable adhesive; apply Dutch metal (schlag) or leaf gold to it and achieve a very pleasing result. But here are two ideas for taking the use of leaf gold just a little further.

Mix up a small quantity of darker coloured gouache and add 8 drops of PVA or acrylic gloss medium to it and stir round. Feed this paint into a calligraphy dip pen and write the name, ensuring that the letters are neither too large, nor too small. Allow the letters to dry.

When completely dry paint over the lettering with PVA or acrylic gloss medium which has been diluted only slightly with water – sufficient to give a smooth surface. Allow this to dry. The area that you paint can be left irregular, or you may wish to draw in fine pencil guidelines in a definite shape such as a rectangle and paint within this.

Cut a piece of double gold which will cover the area you have just painted. Have this, crystal parchment and a dog tooth burnisher ready to hand.

Breathe twice on the PVA/acrylic gloss medium, using long deep breaths (see page 184), and immediately place the leaf gold over and press down with your fingers. Rub over the backing sheet gently with the burnisher (the adhesive will still be quite soft). Replace the backing sheet with the crystal parchment and rub over again with the burnisher ensuring that the gold is completely attached.

Put this to one side for about 30 minutes to allow the gold and adhesive to become calm. Now use a sharp pointed knife and a metal straight-edge to gently score straight diagonal parallel lines which are very close together all over the gold. Turn the paper in the opposite direction and score lines again at an opposing angle. Gradually the name written beneath the gold will be revealed. If necessary, score vertical and possibly horizontal lines as well so the the name can be seen through the gold.

You can vary this idea by laying a wash of light coloured gouache before you write the name. For this you will need to add 8 drops of PVA or acrylic gloss medium to the gouache before you make the wash. Allow this to dry after it has been applied, and then write the name. This should be in a contrasting colour of gouache to which you have again added 8 drops of adhesive.

Allow this to dry and then paint over with slightly dilute PVA or acrylic gloss medium. Now repeat what you did before with the gold. Breathe on the adhesive after it has dried, apply the gold leaf, let it all settle and then score

lines which this time will reveal not only the name but also the coloured wash underneath.

Gilding a decorated initial letter

Once you have control of metal in a solution in the pen and brush and develop a steady hand for gilding and painting (and calligraphy), copying a mediæval decorated initial letter is not too difficult. To start, always choose an initial which has a few small areas of gold as these are easier to gild. Avoid, though, letters where the gold is in the form of very many small areas, as a pattern perhaps; gilding lots of tiny areas also presents a challenge.

The initial chosen, see page 194, is from the Salvin Hours, written in the diocese of Lincoln, possibly Oxford, about 1270. It is unusually lavishly decorated in a way which is more often reserved for psalters. The bold Gothic script, with prescissa (flat ended, cut-off) endings, holds its own against the gilding and blue and pink decoration.

Preparations for gilding a letter

First select a piece of good-quality smooth paper which is at least 150 gsm in weight and preferably more than 200 gsm (see page 293). You could also use a piece of vellum.

Using a sharpened 4H pencil and a piece of tracing paper go round the outline of the letter, not worrying about the minor decorations and shadings.

It is possible to transfer this tracing by going over the outline or scribbling with a soft pencil on the back of the tracing paper and then using this to make an outline on your best paper. However both of these methods take time, are rather messy and do not give a clear image. Far better is to make and use your own transfer paper. Armenian bole is an earth pigment which you now have in your stock, as it is used in making gesso. Use a sheet of newspaper to avoid mess. Place a sheet of ordinary photocopying paper on the newspaper and sprinkle a couple of pinches (no more) of Armenian bole powder over the paper. Use a cotton wool ball to rub this into the paper as much as you can; there should be no powder sitting on the surface. With a clean cotton wool ball rub over again to remove any surplus. This is now your 'carbon' paper, and should be used face down on the paper. (*Note*: Try to use as little Armenian bole powder as possible when making the paper as it can get very messy; it is a false economy to use as much as you may think sensible!)

Using masking tape attach your best paper or vellum to a piece of plate glass so that you have a firm base for gilding and painting. With a few tiny strips of masking or magic tape attach your tracing on two adjacent sides to the paper in the

Various simple greetings cards using metallic paints to write a single initial or a name, with colour.

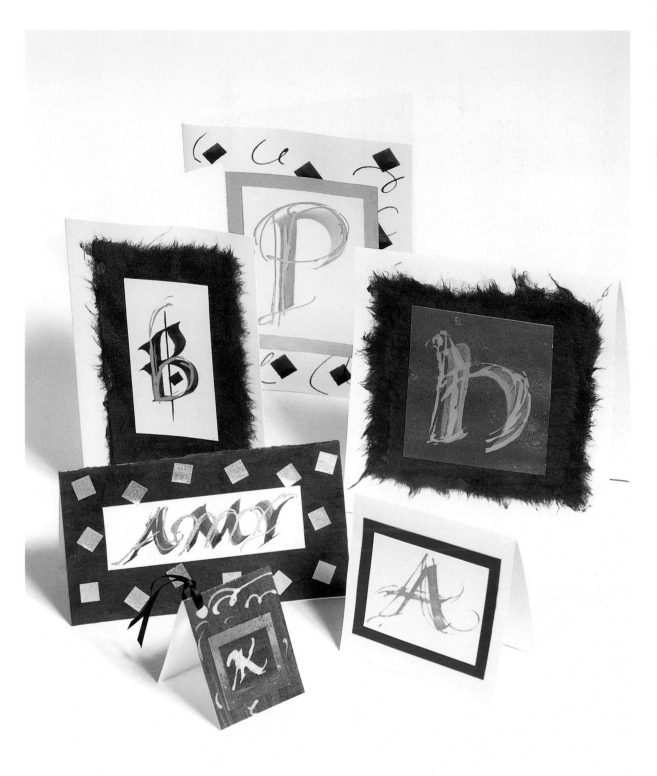

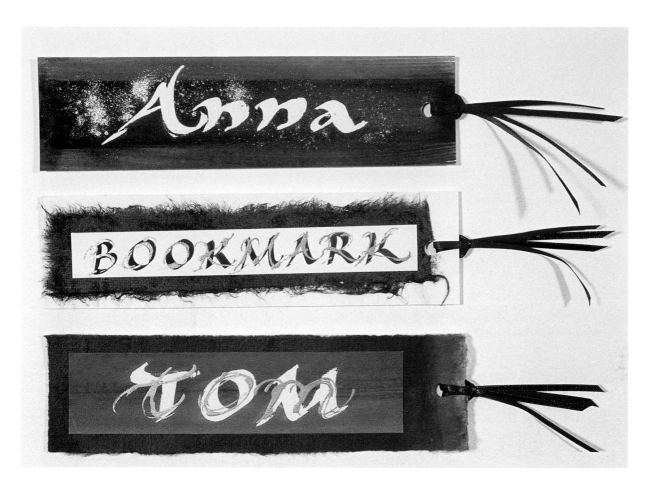

Writing out names for bookmarks. You could also write out names like these which can be framed and hung on the wall.

best position, probably centred. Slide the Armenian bole paper, face downwards, under the tracing but on top of the best paper. Now go over the tracing with a hard point; something like a fine ball-point pen which has run out works well. Try a couple of lines first to make sure that you are exerting sufficient pressure to make a mark you can see, but not too much so that there is an indentation in your paper.

When you have finished lift the tracing carefully but not completely. Remove the Armenian bole paper and check to ensure that all the lines have been traced through. Remove both the tracing and Armenian bole paper when complete.

Now mix up a very dilute solution of a red earth colour such as red ochre, or alizarin red mixed with a little yellow. With a very fine brush (size 00 or 000) go over the lines with this paint, which should have just enough colour for you to see. Make the lines as fine as you can. When the paint is dry, remove all the Armenian bole with an eraser. What you should be left with is the finest and lightest of outlines as a guide. This very pale red colour will not show through when you paint over, and if a small amount shows on an edge, the black outline will cover it.

Gilding the letter

Look closely at the original and identify which are the areas to be gilded. Mix up a solution of gold gouache or shell gold, ensuring that your mix is of the required consistency, neither too thick nor too thin.

Use a fine brush and the gouache or shell gold to paint over the areas which have been gilded. Ensure that you cover the areas well, either by dropping more paint from the brush into the wet gouache or shell gold, or by painting over the area twice. Insufficient metallic covering will give you a patchy and unsatisfactory finish which will mar the finished effect of all your hard work.

Allow the gold gouache or shell gold to dry completely. It may take as little as 20 minutes, or as long as half a day. Do not attempt to rush this as it is important for it to be dry otherwise the gold will lift off when burnishing.

Place a piece of crystal parchment (glassine) over the gold and rub gently with a burnisher to flatten the surface and give a slight shine. Increase the pressure and, when

191

you are sure that the gold is completely dry, remove the crystal parchment and burnish directly until there is a good shine.

Preparing to paint

Painting miniatures or illuminated initials is different from watercolour painting, as the painting surface is covered completely by colour, any white or lighter shades being made by the addition of white. Egg tempera paints would have been used in the originals, but gouache, being opaque, makes a good substitute. If you wish to use egg tempera, see page 184–186 for guidelines.

The palette used for this letter is restricted to pink, blue and a tiny spot of green, which may be omitted if you wish. Mix up sufficient colours so that you have enough for the whole letter, although you will be surprised at how far the paints will go.

It is sometimes difficult to get a good, smooth and flat coverage using gouache, so you may choose to use one of these methods.

Go all around the outline carefully first in the colour, and then flood the colour into the middle of the area working quickly and not allowing any edge to dry, otherwise there will be a line. You may need to work out your best route around the area to be painted to achieve this.

Or you may choose to mix up a more dilute mix of the base colour, and paint this first. Allow it to dry completely. Now paint in the more concentrated mix, again not allowing any part to dry to avoid a line.

A more time-consuming method, but one which is very effective is to use a brush which is almost dry and paint in many tiny strokes. Dip the tip of the brush into the edge of the paint and wipe most of the paint off with a paper kitchen towel. Apply the paint in tiny strokes which are parallel, gradually covering the area to be painted with colour. This third method does take time, but the end result will be flat paint if you make the strokes small enough.

Mixing the colours

A good deep ultramarine will give you a blue close to the colour in the original; add a little permanent white to it to tone it down a little if you wish. The unusual pink would have been made by adding white to red ochre. If you have restricted your tubes of gouache to those suggested on page 307 then you can mix this colour by adding a small amount of alizarin and a tiny amount of yellow to white. Add the smallest amounts of colour to the white as it is easier to add more colour than it is to add a lot of white. Mix up some white and black on their own. Then put some of the pink

and some of the blue into separate palettes. To mix up the slightly darker shade of blue add a tiny amount of its complementary colour – orange – to it, by mixing a little red with a little yellow. To darken the pink add a tiny amount of green to it by mixing a little blue with a little yellow. Now make an even darker blue and pink by adding a little more of their complementary colours. You now have the complete colour range needed, unless you wish to paint the green, in which case mix together cerulean blue with a little cadmium yellow, then add this mix to white.

Add sufficient water to all the paints so that they are the consistency of thin, runny cream. Do not leave any lumps of unmixed paint in your palette.

Painting

Cover most of the letter with a pad of folded paper kitchen towels to rest your hand and to prevent any of the gold being disturbed. Also have a few pieces of paper kitchen towel ready to wipe your brush. This paint is applied on quite a dry brush.

Use a very fine good-quality brush, sizes 0, 00 or 000 (very fine) depending on what you are used to. Dip the brush in the paint, wipe off most of it on a paper kitchen towel so that there is very little left on the brush. Apply the base colour first to the pink and blue areas. Allow this to dry completely (you can speed things up by using a hair dryer if the paint is not too wet).

Now add the lighter base colours, allow to dry, and then add the darker. You will need to look closely at the reproduction to determine where these are and how much of the twining lines they cover. Allow to dry.

The letter will probably not look very good at the moment, but do not get too despondent. The next two stages will really make a difference. Often the black outline is added last, but on this letter it has been painted before the white highlights. Dip the tip of your brush into the black paint. Wipe most of the colour off on to a paper kitchen towel. Start by outlining the curves of the decoration.

The straight lines here have been painted in with a straight edge. You may choose to do them freehand if you have a steady hand, or use a ruler. The ruler needs to be held carefully, see opposite. Place the edge of the ruler along the line to be painted. Keep the ruler in position and tip up that edge so that it is not actually touching the line. Place the brush so that the ferrule is against this edge of the ruler. Keep the third finger of the hand holding the brush against the edge of the ruler (it acts as a brake) and run the brush along the ruler to paint the line. It may take a little practice to perfect this, but it is a technique worth using.

Now the white highlights should be added. This is the part where you need to be very careful. Lines which are too

Painting a straight line along a ruler with a brush.

clumsy will spoil your careful painting so far. Dip the tip of the brush in white paint and again wipe off most of it. Try out the paint on a scrap of paper. There should be just enough paint to flow through the brush, but not so much that it makes an ugly blob at the beginning of the stroke.

Start by painting the v-shapes on the wider stroke on the right, treat each side of the *v* as a separate stroke, and note that each stroke starts with a small white dot. Then when you are more confident paint the white strokes on the thicker stroke on the left. Now tackle the strokes which curl

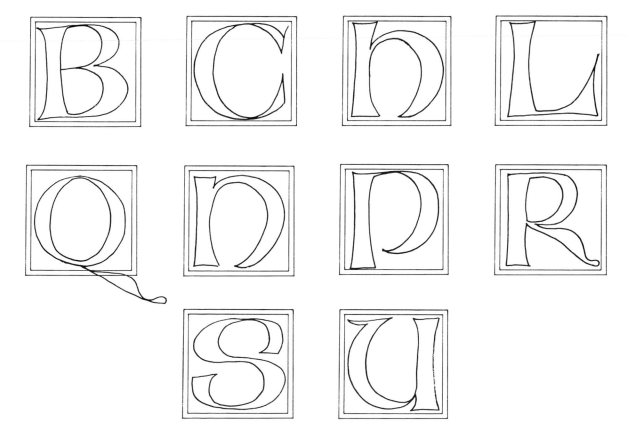

Outline letters to use within a square for making different interpretations of this style of decorated letters.

193

Gilding a decorated initial with gold gouache or shell gold.

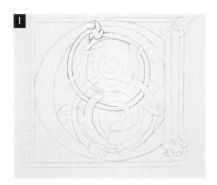

1 *The outline traced on to paper using home-made Armenian bole powder paper. A fine brush and a dilute solution of red earth paint was used to go over the outline; the Armenian bole lines were then erased.*

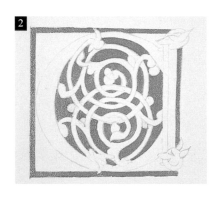

2 *The gold was painted using gold gouache (you could also use shell gold).*

3 *The body colour was painted using gouache paints.*

4 *Darker and lighter coloured areas were painted.*

5 *The finished letter.*

6 *The original letter from the Salvin Hours*

BL, Additional MS 48985, f.32b.

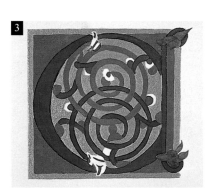

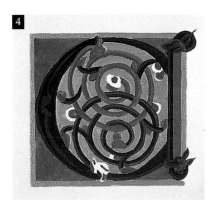

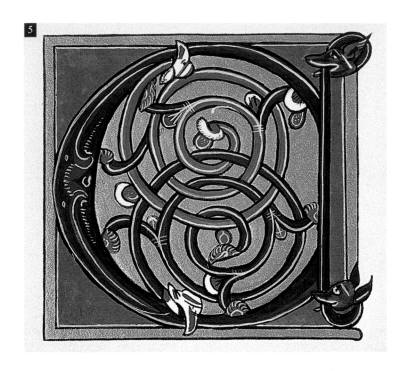

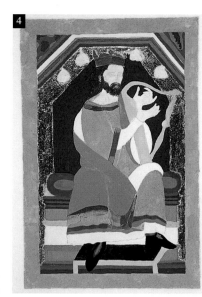

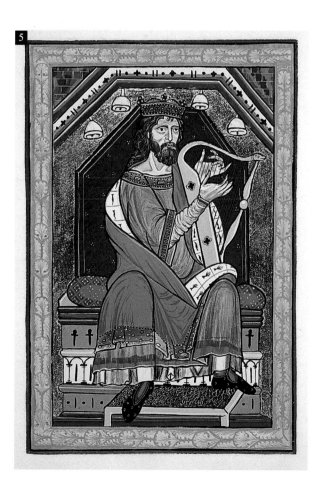

Painting a gilded miniature.

1 *The outline in dilute red paint.*

2 *Gold attached to cryla gloss medium with the loose gold waiting to be removed.*

3 *Body colours painted.*

4 *The finished miniature.*

5 *David as a musician from the Westminster Psalter.*

BL, Royal MS 2 A. xxii, f. 14b.

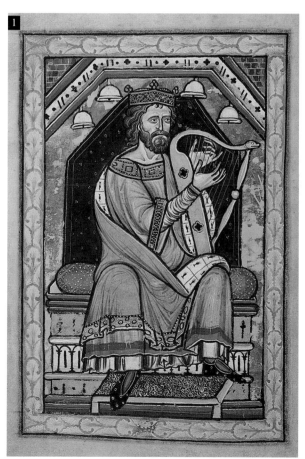

round with the decoration of the letter. Finally add the white decorations to the ends of the strokes and the tiny double lines within the decoration. The addition of this white will make your letter come to life, and if you have done it carefully it will be a good copy of the letter in the Salvin Hours.

Many mediæval letters were in this style of a pink and blue letter encased in a square, and it is not difficult to design your own letters so that you can paint your own initial or that of your friends.

Painting a gilded miniature

The beautiful gilded miniature shown on page 195 is of David as a musician. It is taken from the Westminster Psalter written possibly at St Albans or Winchester about 1200. David is shown here on a glorious cushioned throne with a blue backrest, playing his harp and dressed like a mediæval king. Sadly much of the gold has rubbed away, but a modern copy can restore him to his mediæval splendour.

Preparing to gild

First, trace around the outline using good quality tracing paper and a 4H sharpened pencil. Tape a piece of quality HP paper, which is at least 200 gsm, or vellum to a piece of plate glass to give a firm base for gilding and painting. Position the tracing on the paper/vellum and secure it on two sides with tiny pieces of masking tape. Slide a piece of Armenian bole paper face downwards underneath the tracing and on top of the paper/vellum. Go over the outline so that it transfers on to the paper.

Use very dilute red ochre paint and a fine brush and paint over the outline. When dry remove any smudges and the Armenian bole with an eraser.

Gilding

Using an ink dropper count out about 10 drops of PVA into a palette and add the same number of drops of water. Add a tiny amount of Armenian bole or some gouache to give just a little colour and stir round. Using a fine paintbrush paint the PVA over the areas to be gilded and allow to dry, remembering to keep washing your brush in clean water. Mix up a less dilute solution of PVA, about 80:20 of PVA and water, and paint this as before. You can apply more layers of PVA to gradually build up a slight cushion so that the layers of leaf gold are raised.

When the PVA is dry prepare your gilding materials as shown on page 182. Using crystal parchment paper mask

all but an area about 2 by 2 cm (1 by 1 inch), this can be increased if you are used to gilding. Cut a piece of single transfer leaf gold which easily covers this area and hold it in your hand. With your mouth about 5 cm (2 inches) from the paper make two long deep breaths over the unmasked PVA. Immediately place the gold over this area and press down with your fingers. Rub over with a dog tooth burnisher, replace the backing sheet with crystal parchment and rub over with the burnisher again. Check to see that all the PVA area is covered in gold; if not, repair as on page 183. Add another layer of single transfer gold and then two more layers of double gold. The depth of burnish will now be developing well.

Allow the PVA to become calm, it may take half a day depending on the weather. Rub over again gently with the burnisher to bring up the shine. Remove excess gold with a soft brush and a pencil-shaped ink eraser for any stubborn areas.

Painting the miniature

Now mix up your paints. Use gouache (or egg tempera, see page 184), and for this miniature you will need ultramarine, vermilion, cadmium yellow, lemon yellow, permanent white and jet black. The ultramarine and vermilion can be used as they are, although you may wish to add a little white to tone them down slightly. Also add white for the lighter shades of blue and red. Mix lemon yellow with ultramarine to get a viridian colour, and add white to tone it down to the hue that it is here (it would probably have been much stronger originally). The lighter red and grey of David's robes are made by mixing vermilion and ultramarine with white for the grey and more vermilion in the mix with white for the red. Use less white for the darker shadows.

Vermilion, lemon yellow and white will produce the light ochre colour for the harp, and a touch of ultramarine in the mix will make the rather pasty brown of David's face and hands. Less white in this will make the brown which trims his robes and the crown, and then a little more red will produce the colour of his hair. You can see from this how only a few tubes of paint will produce all the colours you need.

Paint as before, using a pad of paper kitchen towels under your hand to protect the gold. Start with the base colour, and work your way through the lighter and darker shades, then the white highlights and lastly the black outline.

Painting and gilding a mediæval decorated letter (see pages 198 and 199)

This letter is also taken from the Westminster Psalter and is in fact opposite the miniature of David. The letter *B* is the

Beatus initial which begins Psalm 1 and is often elaborately decorated. This initial includes animals, floral decorations and, on the left, scenes from David's life (wearing green stockings in each depiction) including him slaying Goliath.

Preparing to gild

The procedure is exactly the same for this as with the previous gilded works. Trace around the outline and transfer this using Armenian bole paper to good quality HP paper or vellum which is attached to a piece of plate glass. Go over the outline with dilute paint and erase the lines when dry.

Gilding

Mix up a solution of gesso, which should be the consistency of thin, runny cream, (see page 178). Apply the gesso to the areas to be gilded preferably using a quill, but a fine brush will do. Allow to dry thoroughly. Scrape over with a curved bladed knife to create a smooth surface – no bumps or corners. Carefully remove the scrapings. Rub over the gesso until it shines. Prepare your gilding materials (see page 182) and mask all but a small area of gesso for gilding. Cut a piece of single transfer leaf gold which will easily cover this area. With your mouth about 5 cm (2 inches) from the vellum, make two long, deep breaths and immediately place the gold in position, press firmly with your fingers and then rub over with a dog tooth burnisher. Replace the backing sheet with a piece of crystal parchment and rub over with the burnisher again. Check to ensure that the gold covers this area and if not repair any spots by breathing through a straw or breathing tube. Attach another layer of single transfer leaf and at least two more layers of double loose gold so that there is a depth of burnish.

Allow the gesso and gold to rest overnight. Make sure that it is not too humid the following morning (if so leave until the afternoon), then give the hard burnish on the gold before you start painting.

Painting the letter

The range of colours is the same as for the miniature of David, that is, vermilion, ultramarine, cadmium yellow, lemon yellow, permanent white and jet black.

Vermilion and ultramarine with varying additions of white will produce the body colour and lighter tones. The green of those wonderful stockings, the spirals and foliage in the letter itself is made by mixing lemon yellow, ultra-marine and a little white. The browns and beiges will be produced by mixing white with vermilion and lemon yellow – slightly more red than yellow. Mix ultramarine and vermilion to get the grey of Goliath's armour, David's sword and the lion's head in the middle of the letter, with a touch of yellow if it seems too purple.

The procedure is exactly the same as before. Use very little paint and cover the areas of body colour first. Follow this by painting the darker and lighter areas, then the white highlights, and finally outline in black.

Painting and gilding other artworks

These procedures show how to paint and gild simple medi-æval letters, miniatures and more complex decorated letters. Always apply the gold to an adhesive first as the gold will stick to everything you do not want it to, including the gum in paint. Outlining in paint also tidies up the edges of gold and a black line give a good contrast.

However this does not mean that you can only ever gild and paint by copying. What you are doing to learn the process and techniques is what apprentices did in producing these manuscript books. They watched a professional at work, initially helping by grinding pigments, preparing the vellum drawing lines and generally doing the more mundane tasks. Eventually the apprentice would be allowed to paint small sections, practising meanwhile on scraps. Then the day would come when they were allowed to paint the whole miniature perhaps. The same procedure worked with gilding – grinding gesso, preparing the gold leaf and so on, until at last the apprentice would be considered proficient enough to design (or copy) their own miniature, gild it and paint it.

Once you feel confident you can design your own works of art using gold and gouache paints. These tend not to be as spontaneous as, say, watercolour or oil paintings, as the areas of gold need to be planned carefully first. Consider your design on rough paper, work at it so that all the elements fit and balance. Make a rough of this using gold gouache and coloured paints to ensure that the colours and gold are in harmony. Then trace and transfer your design as before. This is how many artists in history have worked and indeed how many artists work today; the spontaneity comes in working things out in rough rather than on the best paper or vellum.

Being equipped with the techniques and method you can now tackle almost anything by applying gold and colour and take the traditional skills of the scribe and illuminator into the future by creating new and exciting artworks of your own.

Beatus initial from the Winchester Psalter. This is the opening to Psalm 1 showing David as king, as a musician and killing Goliath. The first letter of the word Beatus *('Blessed is the man…') was traditionally enlarged, painted, illuminated and decorated in an impressive way like this in many grand Psalters.*

BL Royal MS 2 A. xxii, f. 15.

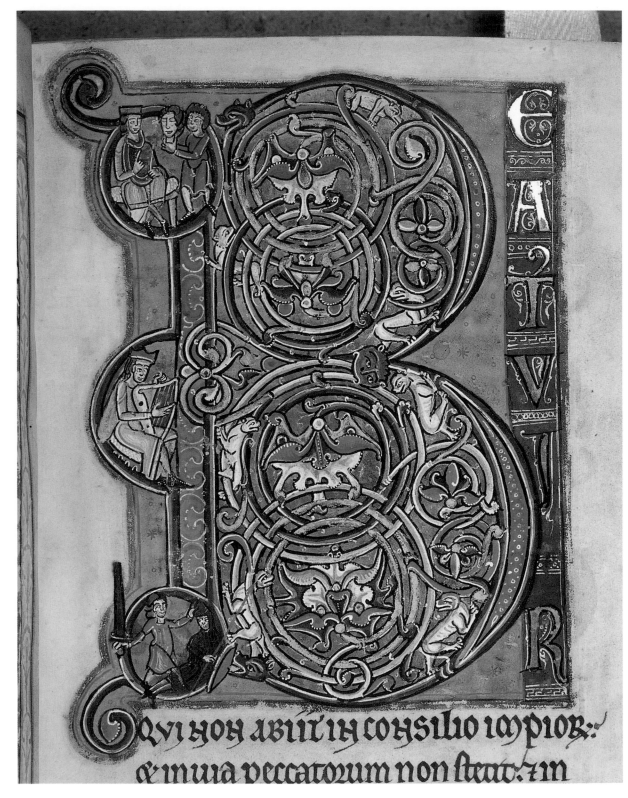

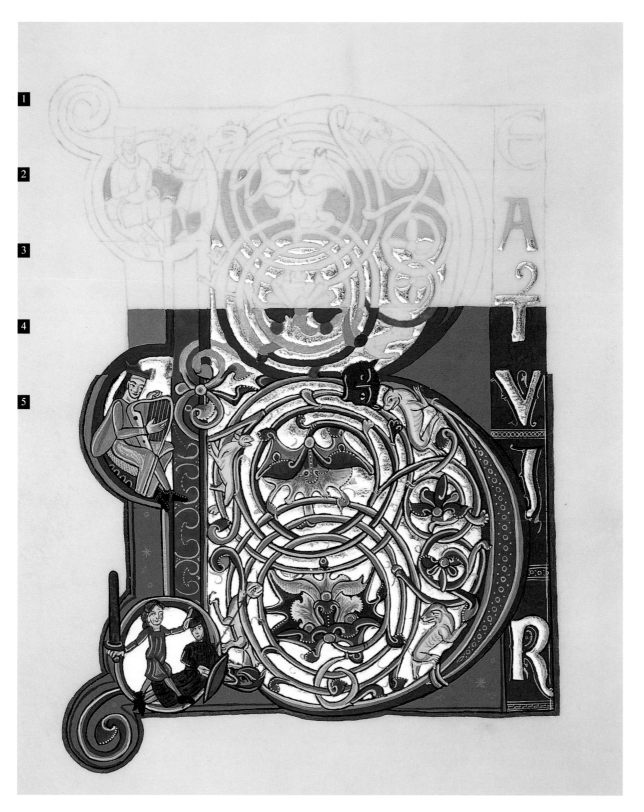

Painting a gilded and decorated letter.

1 *The outline in dilute red paint.*

2 *Gesso laid over the areas which are to be gilded.*

3 *Gesso gilded in layers of single and double gold, and burnished.*

4 *Base colours added.*

5 *Light and dark areas, black outline and white highlights finish the letter.*

Heraldry, and the heraldic tradition, can be still seen in many different places, here in Capetown, Edinburgh, Vienna, Hardwick, Salisbury, Lisbon, Delft, Toledo and on a bus shelter in Derbyshire.

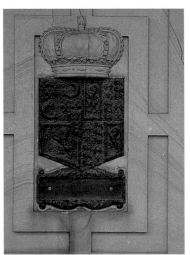
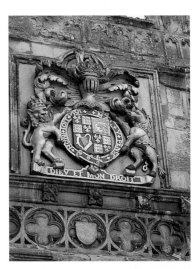
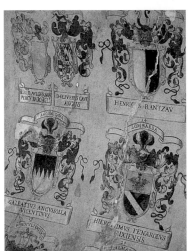
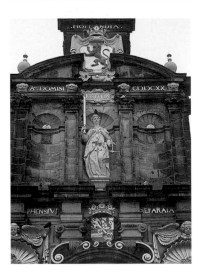
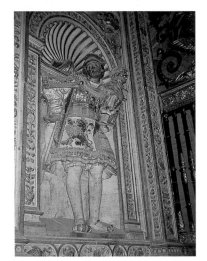

Heraldry

Introduction to Heraldry

The words and terms used in heraldry often cause some confusion. This is not altogether surprising. The word description of a person's coat of arms, the *blazon,* is usually a mixture of English and Old French, and can be almost unintelligible at first. The words used to describe the various parts of a full achievement of arms, or coat of arms, are not always clearly understood. *Crest* is sometimes used for the whole achievement of arms, for example, when in fact the crest is simply the decoration which sits on top of the helmet. Although a crest is often used on its own for someone's personal seal or as a decoration on stationery, it still remains only part of the whole achievement of arms.

At the beginning of this section on heraldry it is perhaps advisable to make sure that these words are clearly defined.

The **shield, helmet, crest, wreath, mantling, supporters, motto** and **compartment** all form parts of the **achievement** or **grant of arms,** although not every grant of arms has supporters, a motto or a compartment.

The SHIELD This can be of almost any shield shape, on which the pattern or devices awarded by the College of Arms are shown clearly. It forms the major part of a coat of arms.

The HELMET or HELM This sits on top of the shield. The helm shows the rank of the person who has been awarded the grant of arms.

The WREATH or TORSE This consists of six twists of material made up from the dominant colour from the shield and the dominant fur or metal. The six twists start with the metal or fur on the left, when looking at the shield.

The MANTLING This is the part of an achievement of arms where some movement can be introduced. It is material, again usually of the dominant colour and metal or fur from the shield, falling from the wreath, around the helm, to gather

at the sides of the shield.

The CREST The crest, which sits comfortably on top of the helm, is often taken from one of the patterns or devices from the shield, although it can be completely different.

The MOTTO Not all achievements have mottos, but if they do the motto usually sits on a scroll underneath or around the shield, although herald painters can be quite ingenious in incorporating a curling motto into their overall design.

SUPPORTERS and a COMPARTMENT Supporters are usually only awarded to peers of the realm and civic corporations. If supporters are part of the achievement they are traditionally placed one either side of the shield, and on a compartment, which is a little mound which relates to the supporters; a watery compartment for mermaids and an earthy compartment for more earthbound animals or people for example.

Medallion with the arms of the Cooks' Company. The complete coat of arms has been cast here as a medallion. The separate parts of the arms are clear – the shield shows a chevron engrailed between three columbine flowers, and the supporters are a buck and doe, each transfixed by an arrow. On a wreath sits the crest (with no helm to support it) and the motto is Vulnerat non victi.

British Museum, Montague Guest No. 917.

201

The Luttrell Psalter, early fourteenth century. Here Sir Geoffrey Luttrell is attended by his wife and daughter-in-law. Sir Geoffrey wears a surcoat showing his coat of arms, which also appears on the bardings of his horse – Azure a bend Or between six martlets Or. His wife holds a lance to which is attached a pennoncelle of his arms, and offers him a helmet where his arms appear again as a crest. Her richly decorated gown repeats the Luttrell arms but also impales that of Sutton (her family name) – Or a lion Vert double queued (forked tailed). His daughter-in-law holds out his shield, again with the Luttrell arms, and her gown impales Luttrell with Scrope (her family name) – Azure a bend Or.

BL Additional MS 42130. f. 202v.

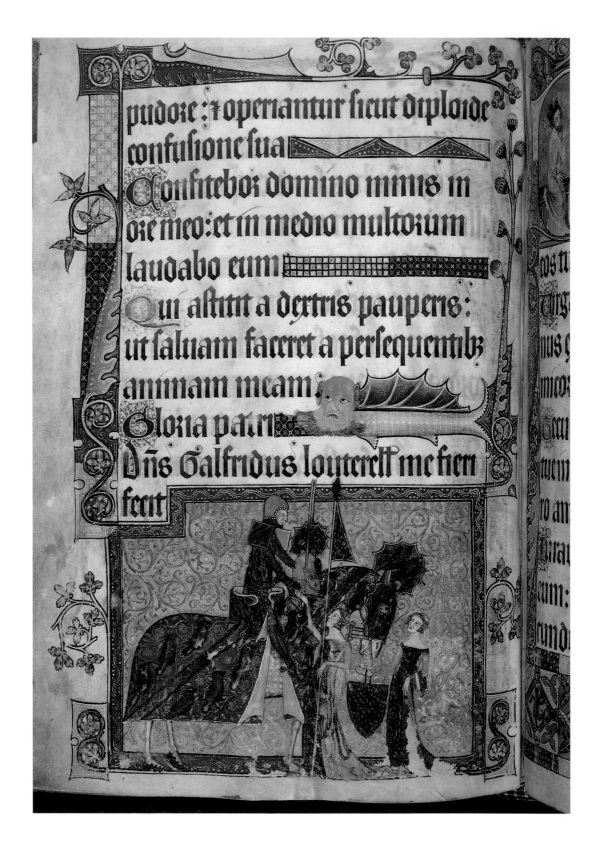

The History of Heraldry

The signs and symbols of heraldry are all around us. Those very same symbols and devices used by knights and lords in mediæval tournaments and sieges are still seen in the coats of arms of civic corporations and town councils, as emblems carved into wood and stone in our cities, towns and villages, in the badges used by regiments and the armed services, and in churches, stately homes and castles. They represent the constant values of honour, courtesy, courage, and honesty.

It may seem to the casual observer that heraldry has always been part of history, but this is not the case. There are two essential features of heraldry. First is that there is a limited number of colours, metals and furs used on shields, together with recognised devices or patterns. Secondly, and importantly, the coat of arms can be handed down from generation to generation.

The Greeks and Romans

In historical times patterns and various devices were used on shields. They may have been a simple circular pattern of metal studs or rivets used to attach the stretched leather cover of the shield to a wooden framework. The pattern may have been composed of strips and sections of coloured leather – decorative but also functional. Some very complicated patterns are evident on vases showing troops of Greek soldiers about to do battle. Contemporary texts do not suggest that the patterns were particularly significant. Similarly the Romans used emblems of eagles, for example, as symbols for their legions in the army. These symbols also decorated shields.

The Normans

The meticulous embroidery of the Bayeux Tapestry shows Norman and Saxon soldiers holding long pointed shields giving them great protection. These shields are decorated with animals, birds and patterns of various sorts. The embroidery was all worked in subtly dyed wool and stitched with the special 'Bayeux' stitch which gave a slight cushioning

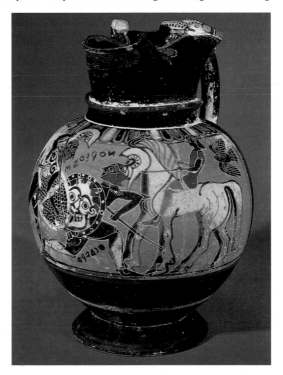

Patterns on the shields of soldiers on a Greek vase.

British Museum.

203

effect. There does not seem to be a great deal of difference between the patterns of shields of the opposing sides, nor is there a suggestion that the devices represented had any special qualities.

At one point during the battle at Hastings in 1066 the story goes that William had to raise his helmet to show his followers that he had not been killed; it was difficult for the Normans to recognise their leader wearing his helmet. Some easy form of identification was clearly needed.

When soldiers were dressed in chain mail with helmets covering not only their heads but most of their faces their followers could not be sure whether they were engaged in battle with the enemy or each other. This was even truer when chain mail was replaced by plate armour and sheets of metal covered the body with helmets protecting the head leaving only one small slit for sight.

Heraldry begins

It did not take long for a system of identification to be developed, and this was the beginning of heraldry. In England, in 1127, King Henry I knighted Geoffrey, son of the Count of Anjou, on the occasion of Geoffrey's marriage to Henry's only surviving daughter, the Empress Matilda; he also gave him

a blue shield on which were shown six gold lions. Geoffrey's grandson William Longespée also used the pattern on this shield, and this is shown on the effigy on his tomb which can still be seen in Salisbury Cathedral in Wiltshire today. The design, which remained the same, had been handed down through the male line in the family; it was hereditary. William's sons also used this shield design.

The bold gold lions stood out well against the blue background. As heraldry developed in response to the need for easy identification, small intricate patterns and a variety of colours were inappropriate. Contrast and boldness were the essence, and this is certainly so with this shield.

The hereditary nature of heraldry is also shown in seals. That of Waleran is possibly the earliest known example of an heraldic coat and an impression of it dated about 1136–1138 is attached to a charter (see illustration opposite). It is just possible to identify the checkered design on the saddle cloth of the horse, as well as on the surcoat of the knight and the lance flag that he is carrying. The coat of arms which has been borne by the Warenne family, Earls of Surrey, from this time is *or and azure checky* (gold and blue checks).

Another early seal is that of Robert Fitzwalter, and is early thirteenth century. On the seal matrix (see illustration opposite) it is easy to make out the arms on the knight's shield and the bardings of the horse – *a fess between two chevrons*. Around the seal is written '+ Sigillum: Roberti: Filii: Walteri:'. Interestingly, there is another shield on this seal which has been indentified as that of the Quincy family. Robert Fitzwalter and Saher de Quincy (who died in 1219) were cousins but that seems no reason to include this shield. It is thought, though, that the inclusion emphasises a political alliance between the two. Both were associated with the opposition to King John 1, which resulted in the signing of the Magna Carta at Runnymede, and were also joint governors of the Normandy castle, Vaudreuil. Saher de

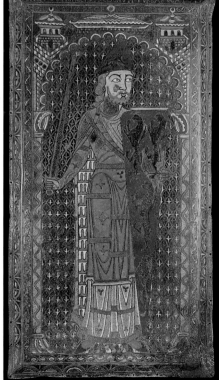

Right.
Funeral plaque of Geoffrey of Anjou, 1151–60.

Musée Tessé, Le Mans.

Far Right.
The tomb of William Longespée at Salisbury Cathedral which clearly shows his shield of six lions.

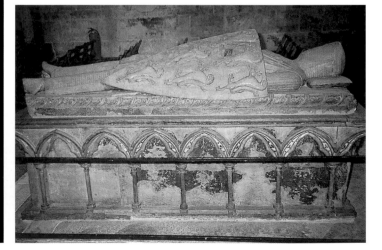

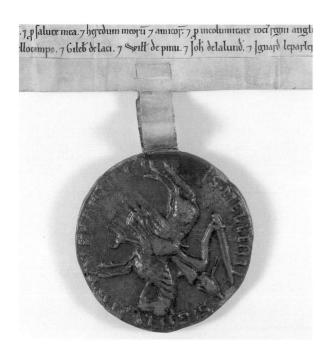

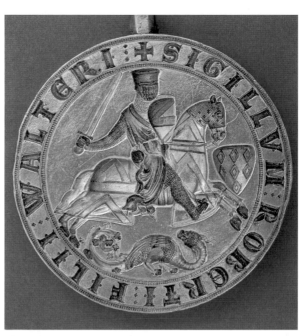

Far left.
The seal of Waleran,
Count of Meulan
and Earl of Worc-
ester, 1141–42.
(Diameter 90 mm,
3·5 inches)).

BL, Harley Charter 45
I 30.

Left.
Seal Matrix of Robert
Fitzwalter. early
thirteenth century.

British Museum,
M&LA 41, 6–24, I.

Heraldic rolls list
the names and often
also the coats of arms
of those taking part
in a tournament or
battle. Rolls were
usually written on
pieces of vellum or
parchment which
were pasted together
to make a long strip,
then rolled up for
safe keeping.
 The Caerlaverock
Roll contains the
blazons of those
taking part in the
siege of Caerlaverock
Castle, led by the
English King
Edward I in July,
1300.

BL, Cotton MS
Caligula A xviii, f. 17.

Rubbings of brasses showing heraldic devices.

1 *Rubbing of the brass of Sir John d'Aubernoun,* c. *1320–30.(2·08 by 0·62 m, 7·5 by 2 feet).*

Sir John's chain mail armour and surcoat can be seen easily, and his feet rest on a lion, symbol of strength. This is thought to be the earliest surviving English brass, and dated c. *1330.*

Both his shield and pennon show his arms of azure a chevron or. BL, Additional MS. 32490 B (1).

2 *Rubbing of the brass of a Trumpington knight. (2·05 by 0·68 m, 7·4 by 2·25 feet).*

The brass for Roger de Trumpington (d. 1289) or his son, Giles, or grandson, Roger. Here the figure rests his feet on a dog, a symbol of loyalty and trust. The Trumpington arms of crusilly two trumpets, *are canting (see page 218) arms on the name of the bearer.* BL, Additional MS 32490 B (2).

3 *Rubbing of the brass of Sir Robert de Bures,* c. *1330. (2·1 by 0·63 m, 7·4 by 2 feet). This figure shows the shield of* ermine on a chief indented three lions rampant *(although only two are shown).* BL, Additional MS 32490 B (3).

Quincy's seal shows also a shield of Fitzwalter.

The Crusades

Heraldry was certainly not confined to England. In Europe, too, shields were decorated in a set way, using a limited range of colours, metals and painted furs. There was considerable movement throughout Europe in this period. During the Crusades Christian countries were urged to free the Holy Land – now Israel and part of Jordan – from the Saracens. The First Crusade was from 1096–1099, and it was successful in that Jerusalem was captured by the Christians. However, other Crusades were less so, and a combination of bad planning, disease and lack of understanding of the nature of the

landscape resulted in disease, death, disorganisation and failure. The combining of forces from different countries must have led to an exchange of ideas, though. The Christians also learned a great deal from their Moslem enemies, not least the use of Arabic numerals instead of Roman, which speeded up the study of mathematics considerably.

Soldiers on the Crusades covered their metal body armour with a linen surcoat, which had slits at the sides for ease of movement. This may have been to try to keep the heat of the sun away from the metal of their armour and so protect their bodies from burning. The surcoat provided a natural canvas for decoration, and it must have seemed sensible to use the same patterns and devices as had already been painted on their shields. The European forces also noticed that their opponents wore a small piece of material attached

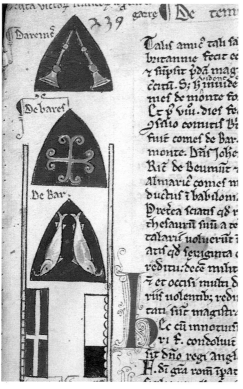

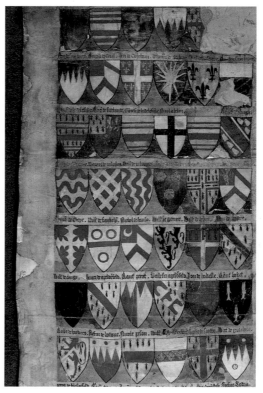

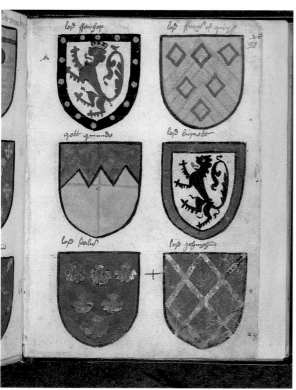

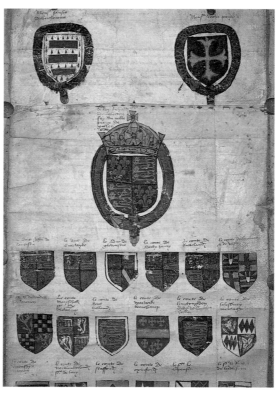

Heraldic Rolls.
Top far left.
Historia Anglorum
by Matthew Paris.
The text details the
history of the English
and shields are
drawn in the mar-
gins by the relevant
events. Upside down
shields indicate that
the bearer had died.
Vellum, 36 by 24 cm
(14 by 9·5 in).
c. 1250–59

BL, Royal MS 14 C.vii.

Top left.
The Dering Roll is
a fifteenth-century
copy of an earlier
roll of c. 1275, and
shows the shields of
Kentish and Sussex
families.
Vellum, 3·01 by 0·26 m
(about 10 feet by 10
in). c. 1500?

BL, Additional MS
38537.

Bottom far left.
The Portcullis' Book
contains three sep-
arate but contem-
porary rolls of arms
and is a collection
of shields. It is called
after the inscription
at the head of the
third roll.
Paper, 20 by 14 cm
(8 by 5·5 in), c. 1440.

BL, Harley MS 521.

Bottom left.
Willement's Roll is
named after its first
editor. It shows the
arms of the Founder-
Knights of the Order
of the Garter, and
of the nobility and
gentry in Richard
II's time.
Vellum, 9·1 by 0·29 m
(29 by 1 ft), early
16th century.

BL, Egerton MS 3713.

Rous Roll.
This roll was illu-
strateed by John
Rous who was the
chantry priest of
Guy's Cliffe in
Warwickshire. It
notes royal and
other benefactors of
Warwick, and also
celebrates Rous's
patrons.
The figures each
have a coat of arms
on a shield or a
banner and beneath
that a short biog-
raphy.
Vellum, 7 by 0·335
m (25·25 by 1 feet),
created during the
reign of King
Richard III
(1483–1485).

BL, Additional MS
48976.

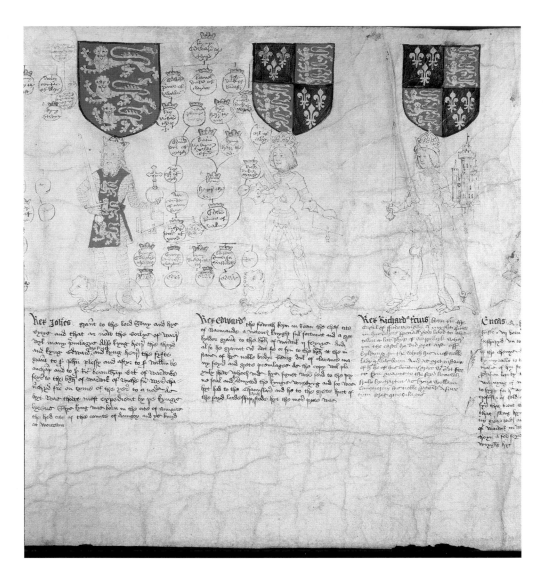

to their helmets which covered the back of their necks from the sun. It seems likely that this was the beginning of mantling.

Early heraldry

Designs on early shields were very simple. Some were only one colour or fur, others just one colour and a metal or fur in alternate stripes vertically or horizontally. There was a limit to the number of shields which could be treated in this way, though patterns began to get a little more complicated. At the same time it was necessary to make a record of the colours and pattern on an individual's shield, to ensure that there was no duplication. By the thirteenth century there were professional heralds who were specialists and knowledgeable in all matters relating to heraldry.

The first record of a herald at a battle is that at the Battle of Drincourt, Normandy, in July 1173. Some years later there is mention of a king of heralds in service to the King of England, and in 1290, Andrew was given the title of *Norroy,* North King or King of the North Men, a title still used by one of the three Kings of Arms today.

By 1300 heraldry was firmly established. In July of that year at the siege of the castle of Caerlaverock, near Dumfries in Scotland, a record was made of all those taking part. It was written in French in rhyming couplets and includes the *blazons* – or word descriptions – of all the supporters of the English King Edward I who led the siege. The manuscript of the Caerlaverock Roll is now in the British Library and is shown on page 205. It is written in a strong and efficient Gothic hand, with the names of those taking part underlined in red.

Heralds and Pursuivants, drawings by Sir Peter Lely (1618–1680).
The heralds on the right are shown in their tabards, but the pursuivant has his tabards twisted round slightly so that the longer sections are worn over the arms and the shorter sections over the body.

Far left. Victoria and Albert Museum (Dept of Prints and Drawings and Paintings no. PD. 140.)

Left. The Courtauld Institute of Art. (Witt Collection)

The work of the early heralds

The main job of the herald was to act as a messenger for his lord, who, in England, was often the king. It could mean that a herald would issue challenges to opponents, or perhaps negotiate a surrender, or even give warning of a siege. His job could be quite dangerous at times. The herald had to enter the enemy's camp to convey these messages without harm or hindrance. To help him do this the herald dressed in a distinctive way. He wore a linen surcoat which showed the arms of his lord, and, importantly, he carried no weapons but often a white stick. The duty of the herald was to convey the message, but not to report back on the enemy's plans and preparations, although this must have been very tempting.

The heralds in battle

Kings would often create new knights on the eve of a battle, and it was the job of the herald to note this. The heralds also had to record the last wishes of those who felt that they may not survive the ensuing conflict. During battle a herald would watch for any signs of cowardice or particular bravery, which would then be reported to the king.

At the end of the battle the heralds would record the deaths of knights and the nobility by identifying their coats of arms. The heralds on the victor's side would raise the standard of their lord, and the banners of the losers would be handed over.

As the heralds carried no weapons they could not take part in battle and so were unable to share in the spoils of war. Instead they received a fully equipped house or its equivalent in gold.

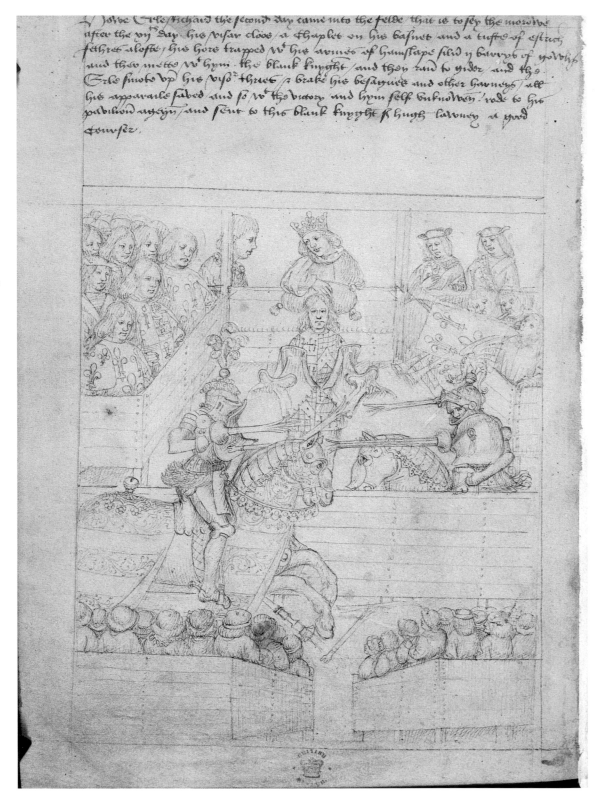

A Tournament in the Beauchamp Pageants showing Richard Beauchamp, Earl of Warwick jousting at Guines in 1414. The French king in his crown can be seen in the middle of the drawing. In front of him is the Warwick herald wearing a tabard showing the Warwick arms. In his hands are two saddles. The men wearing tabards on the right of the king could be heralds or princes; two show tabards of the arms of France and one wears the arms of England. Vellum, after 1483.

BL, Cotton MS Julius E. iv, art. 6, f.15v.

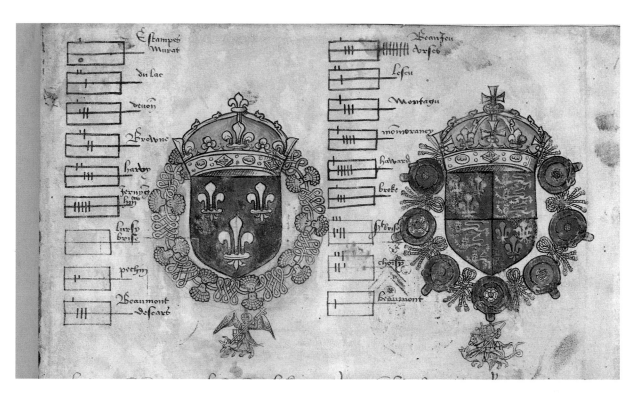

An armorial jousting cheque (see page 213) for the Field of the Cloth of Gold. This famous tournament took place between King Henry VIII of England and King Francis I of France. The arms of Francis, within a collar of the Order of St Michael, and Henry, within the Order of the Garter, are shown. Beside each can be seen the scores for one of the jousts.

Society of Antiquaries of London, MS 136, part 2, f.1.

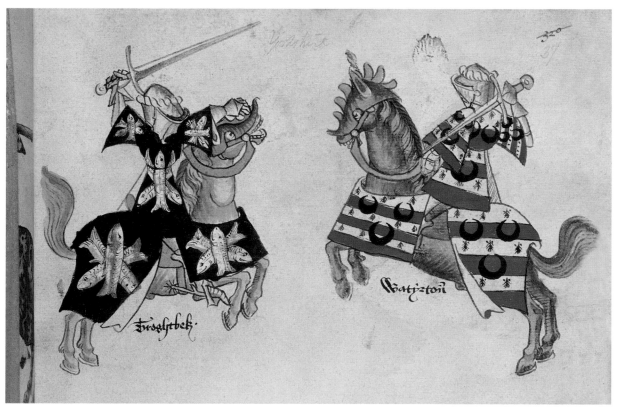

A Military Roll of Arms showing knights jousting. They show their arms on the shield, tabards and horse trappings.

Paper, 339 by 288 mm (13 by 11 inches), before 1448.

BL, Harley MS 4205.

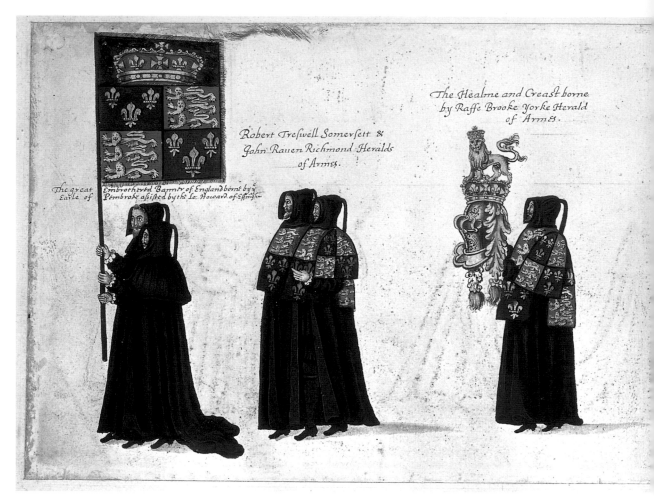

The funeral procession of Queen Elizabeth I of England. The heralds wear robes of mourning with hoods and tabards and process along the funeral route. The Royal Banner is held by the Earl of Pembroke, with Lord Howard followed by Somerset and Richmond heralds. York and Chester heralds hold the helm, crest and target of the Queen, and Norroy King of Arms (William Segar) holds the sword. Clarenceux, King of Arms (William Camden) holds the tabard which shows the Royal arms.

Paper, early seventeenth century.

BL, Additional MS 35324, f. 38.

Tournaments

Tournaments were an opportunity for knights to show their prowess and proficiency in the skills of battle. They were occasions of splendour and pageantry, where those who wished to take part could impress the ladies of the court by their bravery and, sometimes, foolhardiness. The bold colours and strikingly distinctive designs of banners, standards and coats of arms must have made an impressive spectacle.

The first tournaments were not very well planned; they seemed to be an occasion for young soldiers to be in teams and dash around on horse-back. The aim was to unseat members of the opposing team, but often the outcome was not just being unseated but death or serious injury.

In time tournaments became much more organised. Heralds would travel to different parts of the country announcing that a tournament was to take place. They would even go to other countries, stressing that safe passage through the host country was assured. However, not all those who wished to

take part were allowed to do so. A contender would need to show not only that he had four noble ancestors but that a member of the same family had taken part in another tournament in the past fifty years.

The tournament itself became a major event coupled with pageantry and ritual. This is well documented in the book written about the events which King René of Anjou-Sicily (1409–1480) had compiled and illustrated.

A challenge to a tournament was issued to an opponent through the King-of-Arms. The opponents selected the umpires who wore their coats of arms on badges fixed to the front of their hats. The helmets, mantling and crests of the participants were displayed, and the ladies of the court were led around these four times. Any knight who had been discourteous was identified by his helmet which was dashed to the ground, and he was then called to account for his behaviour. If an unsatisfactory answer was given, these knights were not allowed to take part in the feasting and celebrations.

During these early tournaments many participants were

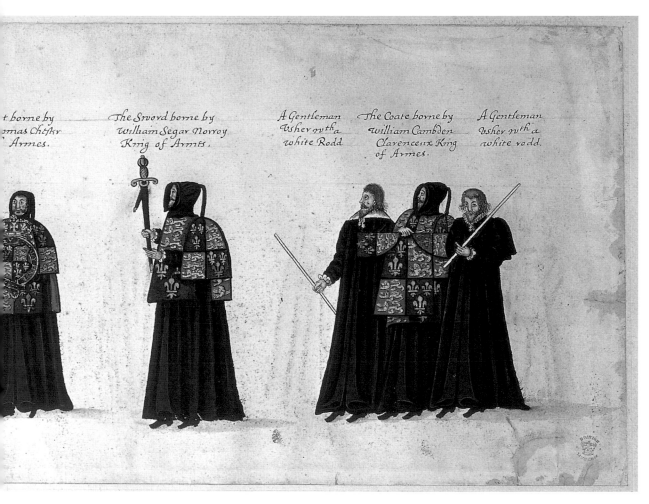

t borne by
_mas Chester
_ Armes.

The Sword borne by
william Segar Norroy
King of Armes.

A Gentleman
Usher with a
white Rodd

The Coate borne by
william Cambden
Clarenceux King
of Armes.

A Gentleman
Usher with a
white rodd.

killed or seriously injured, and it was soon realised that some safety measures would be needed. Rather than have a mêlée in which there was no order, later tournaments were more organised. Weapons were adapted so that the points on the lances were blunted or covered and so were less likely to maim severely. Plate armour and padding gave more protection to those taking part, and the use of the tilt made the tourney into an event of skill rather than good fortune. The tilt is familiar to most as the wooden barrier, usually covered with cloth, stretching along a rectangular field. Knights galloped on horses from opposing ends on either side of the tilt and tried to un-seat each other with their lances.

The role of the heralds at a tournament was to record the scores of those taking part, and to declare the winner if the outcome was inconclusive. Their notes were made on jousting cheques, where the location of the blows and their outcome were written down.

The costs to those taking part must have been considerable. They had to pay for protective armour, horses, attendants and accommodation for an event which often lasted several days. Only those who could afford such luxury and who could justify their place at the tournament due to their an-cestry would attend such occasions.

The number and hierarchy of heralds

In mediæval times heralds were part of a noble's household. There is evidence to suggest that some lords had many her-alds and used their skills in a variety of ways.

The exact number of heralds seems to have varied. After the battle of Crècy in 1346, five French heralds delivered a list of the French knights killed to Edward III of England. In 1396 it was recorded that the Duke of Bavaria had twenty-one heralds.

In England and in other countries, the monarch appointed Kings of Arms, Heralds and Pursuivants (originally

Hampshire seals collected on an heraldic visitation. These show the impressions of towns and families in Hampshire and the Isle of Wight in England which were collected by the Richmond herald (Robert Dale) in July and August of 1686. Robert Dale was assisting Clarenceux, King of Arms (Sir Henry St George the Younger). Each seal show the itinerary of the visitation.

BL, Additional MS 43872.

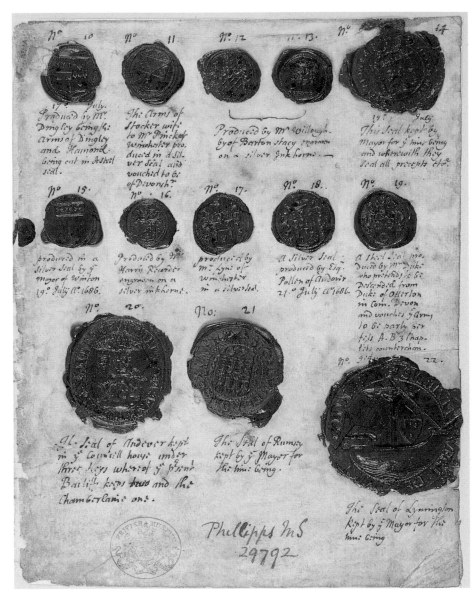

– north King or King of the North Men – the junior of the provincial Kings, is King of Arms of the northern province – north of the River Trent, but south of the border with Scotland. The office of Norroy was combined with that of Ulster in 1943.

At the time in which the Kings of Arms and Heralds were being established in England, Scotland was ruled by its own monarch. All matters pertaining to heraldry in Scotland was and is dealt with by the Lyon Court. Lord Lyon, King of Arms, is the Principal.

Visitations

The use of coats of arms spread amongst the nobility and gentry, and it became necessary for checks to be made on those who had the right to bear arms. Visitations were made by the heralds throughout England and Wales, particularly in the sixteenth century, although there is some evidence that there were visitations earlier, in the fifteenth century.

During a visitation local officials were made by law to assist the heralds who

apprentice heralds) to their court. They recorded any elevations to the peerage, granting of arms, changing of arms or any other linked heraldic matter. Today the three Kings of Arms can grant arms themselves, under licence from the sovereign.

Garter, King of Arms, became the principal of the heralds, pursuivants and Kings of Arms in 1415, when King Henry V of England created the highest order of chivalry, the Order of the Garter. Clarenceux, King of Arms, was referred to in a document of 1334, and was and is the King of Arms of the southern province, that is south of the River Trent. Norroy

summoned to them all those bearing arms. These people had to prove that they were entitled to so do. This could be by written pedigree, other documentation or a grant of arms issued by the College of Arms. A record was made by the herald who also sketched the arms. This was transferred into manuscript books at the College of Arms. If the individual holding the arms had no rights, then he was made to sign a disclaimer and his name along with others in a similar situation was made public.

There were visitations in Ireland and there were, and still are, visitations by Lord Lyon and his officers in Scotland.

A Coat of Arms

The *shield* is that part of a knight's armour which calls out for decoration and it has therefore become almost synonymous with heraldry. But it is only one aspect of the whole Grant of Arms made by the the College of Arms in London. As well as the shield there is the helmet – which usually signifies the rank of the applicant – the wreath, mantling and the crest. There may also be a motto, supporters and a compartment.

The achievement is often called a **coat of arms,** because in historical times the devices and patterns on the shield were painted on to a linen sur(over) coat, worn to cover body armour.

The shield

Almost all very early shields were round in shape. The battle scenes drawn on vases and carved into stone friezes in Greek times showed soldiers carrying round shields. Viking warriors, too, used round shields as a means of defence. In the Bayeux Tapestry the shields of both Saxons and Normans were elongated, tapering into a point from a slightly curved top. By the twelfth century this shield shape had been altered so that the top of the shield was straight. Over the years the shape of shields has changed, according to the needs and armour of the soldiers, an example being shields which were designed with a scoop cut into the right-hand side which were for use in tournaments. A lance rested on and was supported by this hollow shape. When designing a coat of arms the use of a shield shape appropriate to the period of the granting of arms is often a good way to start.

The essence of heraldry is that the design on the shield

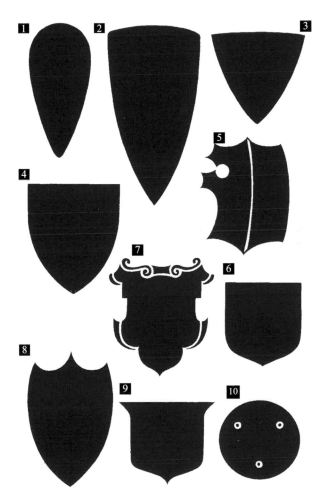

The shapes of shields mainly used in heraldry over the years.

 1 11th century, as on the Bayeux Tapestry.
 2 12th century.
 3 13th century.
 4 14th century – often used in heraldic designs now.
 5 15th century.
 6 16th century.
 7 17th century.
 8 18th century.
 9 19th century.
 10 20th-century British police riot defence.

Illustration by Timothy Noad.

215

should be clearly visible in the mêlée of battle. Designs were bold and colours were limited to those which were easy to replicate without problem. The colours, stains, furs and metals used in heraldry are called the **tinctures,** and the names used to describe them are from Old French, although they are usually pronounced in a decidedly English way!

Importantly, and to aid recognition, one of the heraldic rules is that two colours, two furs or two metals should not sit next to one another on a shield without some form of separation. In battle, it is not advisable for a soldier to be considering whether there is a bluey-green stripe on a greeny-blue shield or vice versa. During his thinking time he may have his head chopped off. However, a bold blue stripe on a yellow shield is instantly clear.

The Tinctures

An important point of heraldry is to make the elements obvious and beyond question at a time in history when exact shades and colours may not always have been available. Nowadays there are no hard and fast rules about the precise mix of pigments for these shades. It matters that red looks red, not what the name is on the tube of paint used.

Petra Sancta shading

There are many instances when heraldry is used as a design or decoration when colour is inappropriate – on stationery or a book-plate, perhaps, or when an heraldic device is engraved in silver or on glass. In the seventeenth century the Jesuit father Silvester Petra Sancta devised a system of shading or hatching to show the tinctures used in heraldry. It is an advantage to know the Petra Sancta system when trying to decipher a coat of arms which is not coloured, although perhaps it is worth noting that obviously this system was not used before the seventeenth century.

Lines and divisions of the field

The designs on early shields were very simple. A few were just one colour, but there was a limit to the number of shields which could be like this. Others were similarly uncomplicated, often divided horizontally, vertically or diagonally into two tinctures by lines with different patterns.

The **field** is the surface of the shield, and it can be divided by one line or more into two or various sections. These sections should have contrasting tinctures because of the rule that

two tinctures/furs/metals should not be contiguous as they are then not distinctive enough.

The shield for Waldegrave (illustrated opposite) is divided vertically, per pale, with a silver (or argent) section on the right and a red (or gules) section on the left. Using this as an example it is important also to point out that a shield is always regarded as being held by the bearer, so that the right-hand side, or **dexter,** is on the left when viewed, and the left-hand side, or **sinister,** is on the right. The top of the shield is called the **chief,** and the bottom the **base.**

The Ordinaries

Other broad bands of differing tinctures distinguished one shield from another. These are the **ordinaries** – broad horizontal, vertical and diagonal strips contrasting with the field. The names for the ordinaries are similar to those used to divide the field.

The Cross

Although the cross is an Ordinary, there are many variations. The edges of the cross may be straight or decorated in some way, according to the lines dividing a shield, shown below. The ends of the cross too may be decorated, or the bars shaped in different ways. Variations of the cross are some of the oldest decorations in heraldry.

The Sub-Ordinaries

Additional smaller patterns on the shield which are subordinate to the Ordinaries or the main decoration or divisions on the shield are called the Sub-Ordinaries.

The LABEL is a Sub-Ordinary but it can also have a particular purpose. It may indicate that a coat of arms rightly is borne by an eldest son during his father's lifetime. The label across the top of a shield shows that there is a difference between the father's shield, without the label, and the son's, which shows the label. When their father dies the label is removed. The Sovereign's children bear the Royal Arms with distinguishing labels.

The label is painted in a contrasting colour or metal to the shield's field, positioned towards the top of the shield, and is a narrow band or riband with shorter ribands hanging from it – usually three or five. These can be various shapes.

ROUNDELS are other Sub-Ordinaries. As their name suggests, these are round and coloured according to heraldic tinctures. (See page 222.)

Charges

One of the delights of heraldry is the weird and wonderful animals and objects which adorn the shield. They range from real and mythical animals, birds, flowers and plants, and from humans to all kinds of inanimate objects. It sometimes seems as if almost anything can be placed on a shield for decoration! Unicorns and dragons are well known, not so an opinicus – with the head, neck and wings of a griffin (thus the head, neck and wings of an eagle), the body and legs of a lion and the tail of a bear – or an enfield – the head and ears of a fox, the body, hind legs and tail of a wolf and the forelegs and talons of an eagle – or a sea lion, which is, of course, half fish and half lion, with the head, mane and shoulders of a lion, forelegs which end in fins, the tail of a fish and fins along its back.

Charges can be animals, humans and divine beings, fish and insects, monsters, the sun, moon, stars and clouds, trees, plants and flowers and inanimate objects. The charge can also be parts of all these diverse items – the leg of a lion, head of an eagle, a human hand or arm. All charges can be positioned at specific places on the shield, and these are described in the blazon, or word description.

The lion

The lion has always been regarded as the king of beasts and it is not surprising that it has been chosen as the emblem for kings and princes throughout the centuries. The lion has a reputation for ferocity, for protecting its young and its territory. Lions were also thought to have magical tails; they could make themselves and their foot-prints invisible by a swing of the tail, and the longer the tail, the better the magic. This makes the choice of a lion, with a very long tail, even more preferable for use in a coat of arms.

Early lions are not very lion-like to modern eyes. Seeing lions in their own habitat in photographs, on film or television or visiting zoos all mean that we are familiar with the lion's features. Not so the mediæval heraldic artist who had probably never seen a lion, and had to rely on paintings by others, who had also probably never seen a lion. However, the basic elements were there – the mane, tufted legs, paws and sharp claws, long tongue and teeth, and, of course, that tail, a long one, swishing above the lion's back.

Lions on early shields were shown in only one position, with one paw on the ground, and the remaining three raised; this original form is called **lion rampant.** Lions can be in many positions now and some of these are shown here.

Lions are usually painted with a long red tongue, and extended red claws, even though the lion itself is of a different tincture. (In the blazon, or word description, this is called *armed and langued* – claws and tongue.) This is to emphasise

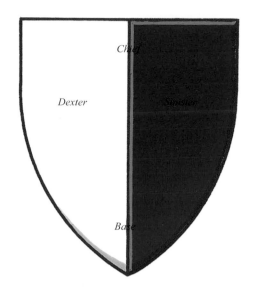

to their opponent the ferocity of the chosen emblem, which the bearer hoped to emulate. If the lion itself is red, or gules, or is on a red shield or field, then the tongue and claws are in a different tincture. Where more than four lions appear on a shield they are called lioncels – little lions.

The shield for Waldegrave. It is divided per pale, that is by a vertical line, and is half silver – argent – and half red – gules. The shield is always regarded as being held as though it were against the body, so the silver section is on the right, or dexter, and the red section on the left, or sinister, even though when viewed like this it looks the opposite.

A selection of crosses
1 *Bottony*
2 *Celtic*
3 *Cross-crosslet*
4 *Fleuretty*
5 *Flory*
6 *Fourché*
7 *Formy or paty*
8 *Fylfot or cramponned*
9 *Maltese*
10 *Moline*
11 *Patonce*
12 *Patriarchal*
13 *Potent*
14 *Recercely*
15 *Tau or St Anthony's*

Illustrations by Timothy Noad.

217

The colours, stains, metals and furs used in heraldry. Gold is often painted as yellow, and silver as white.

The Petra Sancta shadings (see page 216), using lines and dots are also shown.

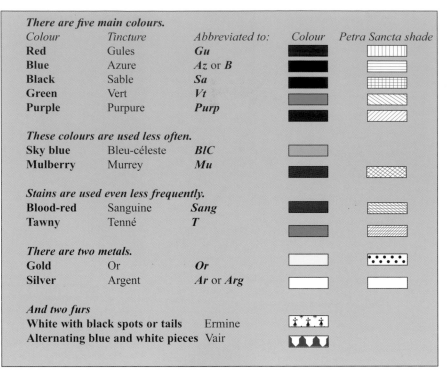

There are five main colours.				
Colour	Tincture	Abbreviated to:	Colour	Petra Sancta shade
Red	Gules	*Gu*		
Blue	Azure	*Az or B*		
Black	Sable	*Sa*		
Green	Vert	*Vt*		
Purple	Purpure	*Purp*		

These colours are used less often.				
Sky blue	Bleu-céleste	*BlC*		
Mulberry	Murrey	*Mu*		

Stains are used even less frequently.				
Blood-red	Sanguine	*Sang*		
Tawny	Tenné	*T*		

There are two metals.				
Gold	Or	*Or*		
Silver	Argent	*Ar or Arg*		

And two furs			
White with black spots or tails	Ermine		
Alternating blue and white pieces	Vair		

The Furs: these can be painted in a variety of ways, each one having its own word description.

*It is interesting to note the similarity in pronunciation between **vair**, which is squirrel fur, and **verre**, the French word for glass. Would Cinderella have won her prince wearing slippers of squirrel fur rather than glass? They would certainly have been very much more comfortable for her to dance the night away.*

Illustrations by Timothy Noad.

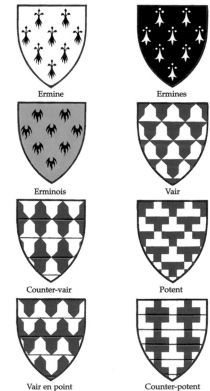

Ermine — Ermines
Erminois — Vair
Counter-vair — Potent
Vair en point — Counter-potent

Other animals

There are many different animals which appear in heraldry, sometimes on the shield itself, and sometimes in the crest. On occasion a particular animal may be chosen because of its special characteristics – a fox being cunning or stag fighting for its territory, for example. Often the animal is chosen because of the word play on a person's name. This is called **canting arms** or **arms parlant**. The cat or its head features in the coat of arms of *Catt, Catton* and *Tibbet*, the boar in that of *Bacon, Pigg, Hogg, Swinburn*, and the horse in *Horsby, Chevall* and *Trotter*.

In many cases only the head or a limb of an animal features in a coat of arms. When the head is shown as though cut with a straight line, it is called **couped,** but it is called **erased** when it looks as if it has been torn off. All of these emphasise the gory nature of heraldry which may have been designed to frighten an opponent.

The eagle and other birds

The eagle soaring to the highest heights with sharp talons and beak was chosen for these characteristics as an emblem for heraldry. It is usually drawn with wings outstretched and slightly stylised, and as such, makes a particularly pleasing shield-shape.

Many other birds occur in heraldry such as the falcon and hawk, the swan and crane. The pelican is usually shown standing on or above its nest feeding the young with its own blood. This is called **a pelican in its piety.** When on her own, pecking her breast with wings raised then the blazon is **a pelican vulning herself.**

The ostrich is often shown with a metal object in its beak, such as a horseshoe, which relates to its supposed incredible digestive powers. The swallow, called a **martlet,** is always shown without legs. This is because it was thought that the swallow, which feeds and sleeps without landing, could not do so because it did not have any legs to land on! All of these birds could be used for their supposed powers, or because they formed a word play on a person's surname and so were again canting arms.

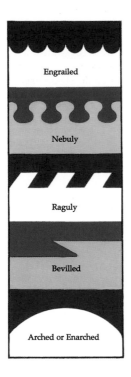
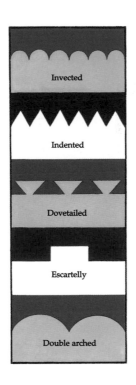
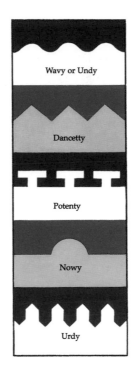

Lines dividing tinctures on a shield.

Engrailed

Invected

Wavy or Undy

Wavy crested

Nebuly

Indented

Dancetty

Embattled

Raguly

Dovetailed

Potenty

Angled

Bevilled

Escartelly

Nowy

Battled embattled or Embattled grady

Arched or Enarched

Double arched

Urdy

Radiant or Rayonny

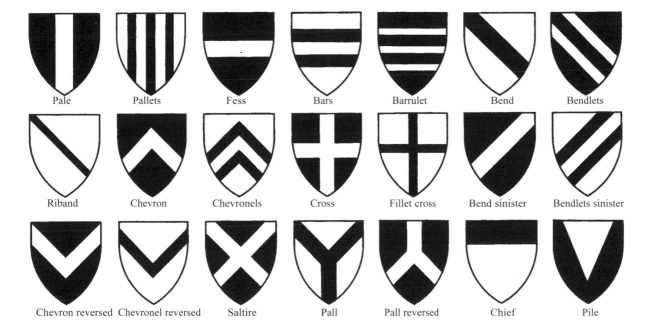

Pale | Pallets | Fess | Bars | Barrulet | Bend | Bendlets

Riband | Chevron | Chevronels | Cross | Fillet cross | Bend sinister | Bendlets sinister

Chevron reversed | Chevronel reversed | Saltire | Pall | Pall reversed | Chief | Pile

The Ordinaries and their diminutives.

Illustrations by Timothy Noad.

219

Lions with attitude.
1 *Passant guardant*
2 *Statant reguardant*
3 *Rampant*
4 *Sejant*
5 *Sejant affronty*
6 *Salient*
7 *Couchant*
8 *Dormant*

Illustrations by Timothy Noad.

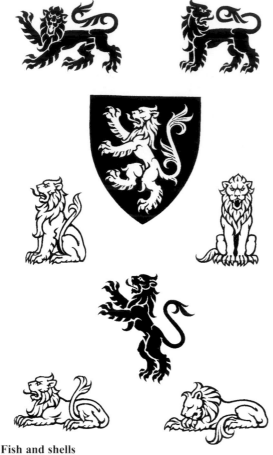

Fish and shells

The heraldic families of *Wilkinson, Shelley* and *Roche* all bear arms showing shells or fish. When fish swim horizontally the term used is **naiant,** when diving, head down – **uriant** and head up as though seeking air – **hauriant.**

Sun, moon and stars

Celestial charges occur frequently in coats of arms, both on the shield and as a crest. The sun is often referred to as being **in his splendour** or **in his glory**, and the rays can be straight, wavy or both, with the sun having a human face or not.

The moon, too, may have a human face, and when shown full is **in her complement** or **in plenitude.** When shown as a **crescent** moon the corners point upwards; **increscent** is when the corners point to the dexter (right) side of the shield and **decrescent** when they point to the sinister (left) side.

Heraldic stars are called **estoiles** and usually have six wavy points. The thunderbolt is the emblem of electric power, and has been used as the charge or crest on appropriate

modern coats of arms.

Monsters

Mediæval artists must have had great fun with the monsters they devised. Some were based on myth and legend, such as St. George and the dragon, others seem so strange that it is difficult to know why various parts of animals were chosen to make particular beasts.

When used in heraldry, monsters can be shown in any attitude, such as rampant, passant, statant and so on. They probably appear more as crests or supporters than on the shield itself (see page 223).

CAMELOPARD

This really is a strange creature in name, but not in depiction. The camelopard is simply a giraffe, but was thought by early heralds to be a cross between a camel and a leopard.

COCKATRICE

The cockatrice is similar to a wyvern in that it has a dragon's body and wings, but with the head, comb, wattles and feet of a cock.

The cockatrice was thought to be so evil that one look or its breath would be fatal. All animals were in fear of the cockatrice except the weasel.

DRAGON

This monster has a horny head and forked tongue, with armour-like rolls on its chest and belly. The dragon's four legs end in talons, and it has a pointed tail and bat-like wings.

A red dragon is the royal badge for Wales, and is found in many of the Welsh civic coats of arms. Dragons are also the supporters for the City of London, and are said to be the guardian of the City.

ENFIELD

This rather unusual mongrel has a fox's ears and head, a wolf's body, hind legs and tail, with an eagle's forelegs and talons.

It is the principal charge and a supporter in the arms granted to the London Borough of Enfield.

GRIFFIN or GRYPHON

A griffin has the head, breast, fore-claws and wings of an eagle, with the hindquarters and tail of a lion. It also has ears.

The combination of a lion and eagle makes the griffin a powerful emblem, as it combines the strength of the lion with the vigilance of an eagle – with the addition of ears for extra sensitive hearing!

HERALDIC ANTELOPE or IBEX

An heraldic antelope is similar to the tiger as it has the same

head and body with the downward horn and upward tusks. The difference is that the antelope has the legs and hoofs of a deer and also bears serrated horns.

HERALDIC PANTHER

This animal does resemble a panther which we would recognise, apart from two important features. First the animal is covered in spots which are of various colours, and secondly if it is incensed, flames come from its ears and mouth.

HERALDIC SEA-HORSE

Similarly the heraldic sea-horse has a horse's head and shoulders, with forelegs which end in fins. It is joined at the loins to a fish tail, and fins run down its spine.

HERALDIC SEA-LION

The heraldic sea-lion is part lion, part fish. It has the head, mane and shoulders of a lion, with its forelegs ending in fins, and the tail of a fish. The back of the sea-lion has fins.

The Corporation of Lloyd's in London and also the Port of London Authority both have supporters of sea-lions, to emphasise their connection with the water.

HERALDIC TIGER or TYGER

This does not resemble a tiger in the wild, but is similar to a lion though more tufted with a snouted face and pointed ears. It has a tusk or horn on its nose which curves downwards and also has tusks in its lower jaw; it is usually painted red.

MERMAID and MERMAN or TRITON

The mermaid, with the head and body of a woman and the tail of a fish, is always shown holding a comb and mirror. The merman, or triton, has the head and body of a man joined to a fish's tail.

OPINICUS

An opinicus also has a griffin's head, neck and wings, but it has a lion's body and four legs and a bear's tail.

It is particularly connected with medical matters. It is the crest of the Company of Barber Surgeons, and was granted to them in 1561. Since then it has not been used in many grants of arms, but it is part of the British Association of Oral Surgery arms, which were granted in 1962.

PEGASUS

The winged horse or pegasus is the symbol of fame, eloquence and contemplation.

In recent heraldry it has been awarded to individuals, companies or institutions who are associated with air transport.

PHOENIX

Another symbol associated with fire was the phoenix. This is an eagle with a tufted crest on its head, always drawn rising from flames. It is sometimes painted reddish-purple.

The phoenix is the symbol of resurrection and immortality in Christianity.

SALAMANDER

Usually a salamander appears in heraldry as a lizard-like creature surrounded by flames. On occasion it is drawn as a fire-breathing dog with a lion's tail.

The salamander could withstand any heat and even put out fires. If a fire burned for seven years without stopping a salamander would be born. It is the symbol of enduring faith.

Because of its fire-fighting qualities, it is used in the arms of some insurance companies.

UNICORN

The unicorn is well-known in mythology, however it is often wrongly drawn, as it is not simply a horse with a long pointed horn. It has a horse's body and head, with a long straight horn projecting from its forehead, but it also has a lion's tail, tufted hocks, a beard and cloven hoofs.

The unicorn is one of the supporters on the royal coat of arms and as such is taken from the Scottish royal supporters.

WYVERN

This is another type of dragon but with only two legs. It still has the horny head and forked tongue, wings and armoured front. Unless a particular tincture of wyvern is specified, the wyvern is painted green, with a red chest and belly.

There is a wyvern embroidered in the Bayeux Tapestry as the symbol for Wessex and it was the personal emblem of King Harold.

YALE

The main feature of the Yale is its long serrated horns, which were reputed to be able to swivel to any direction, both for protection and attack. It is usually drawn with one horn facing forward and the other back.

The Yale has the body of an antelope, or a goat, with the head of an antelope and the snout and tusks of a boar.

Trees, plants, flowers and fruit

Trees or just the leaves and perhaps the fruit are used in many coats of arms. It is difficult on such a small scale to distinguish between varieties, and so the leaves and fruit – if included – are exaggerated within the tree shape.

The planta genista, or broom, was the emblem chosen by and gave the name to the Plantagenet kings in English history (1154–1399). It appears on their badges in the form of pods, seeds and flowers.

Of the many flowers which have been used as charges in coats of arms the rose is one of the most common. An

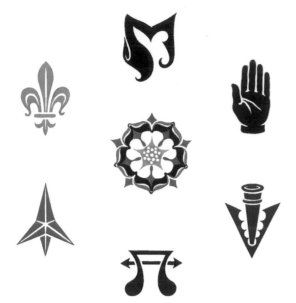

Right.
A variety of charges.
1 *Maunch.*
2 *Fleur-de-lis.*
3 *Left hand couped at wrist appaumé.*
4 *Tudor rose.*
5 *Caltrap.*
6 *Pheon.*
7 *Water bouget.*

Far right.
Birds and fish as charges.
1 *Martlett.*
2 *Dove, with dexter wing expanded and inverted.*
3 *Escallop (stylised).*
4 *Eagle displayed.*
5 *Hippocampus (seahorse).*
6 *Escallop (naturalistic).*
7 *Dolpin naiant embowed.*

Far right below.
Celestial charges.
1 *crescent*
2 *Sun in his splendour.*
3 *Etoile.*

Illustrations by Timothy Noad.

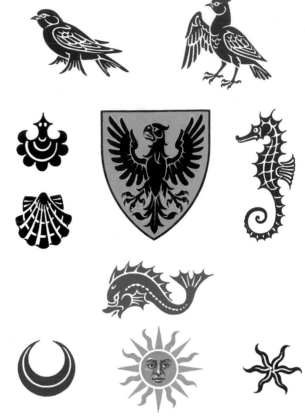

heraldic rose is a five-petalled dog rose which shows the tips of the sepals between the petals, and with seeds in the centre. If the flower is painted **proper,** or realistically, the sepals are green and the seeds yellow, but they can be of any tincture.

The Tudor rose of the English King Henry VII unites the white rose of York with the red rose of Lancaster.

The fleur-de-lis is a stylised form of iris, and was used in the

arms of the kings of France. Because of his claim on the French throne the English King Edward III combined the fleur-de-lis with the English arms of lions in 1340 and their inclusion in some form in the royal arms continued until as late as 1801.

Human and divine beings

There are instances of divine beings used in heraldry, but more often they are represented by their symbols – the rose or lily for the Virgin Mary, the eagle of St John, a sword for St Paul, keys for St Peter and a winged lion for St Mark.

Whole human beings are not often seen as charges on shields, though parts of the human body such as the head, arms or legs are shown. Humans are more frequently used as supporters.

Inanimate objects

The inanimate objects which appear on coats of arms often provide an interesting insight into history. A bouget, maunch or caltrap are not words which are familiar to us now, yet they were almost everyday objects in the past, being water

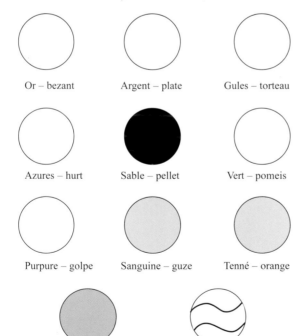

Or – bezant Argent – plate Gules – torteau

Azures – hurt Sable – pellet Vert – pomeis

Purpure – golpe Sanguine – guze Tenné – orange

Murrey – mulberry Barry wavy azure and argent – fountain

The sub-ordinaries – roundels.

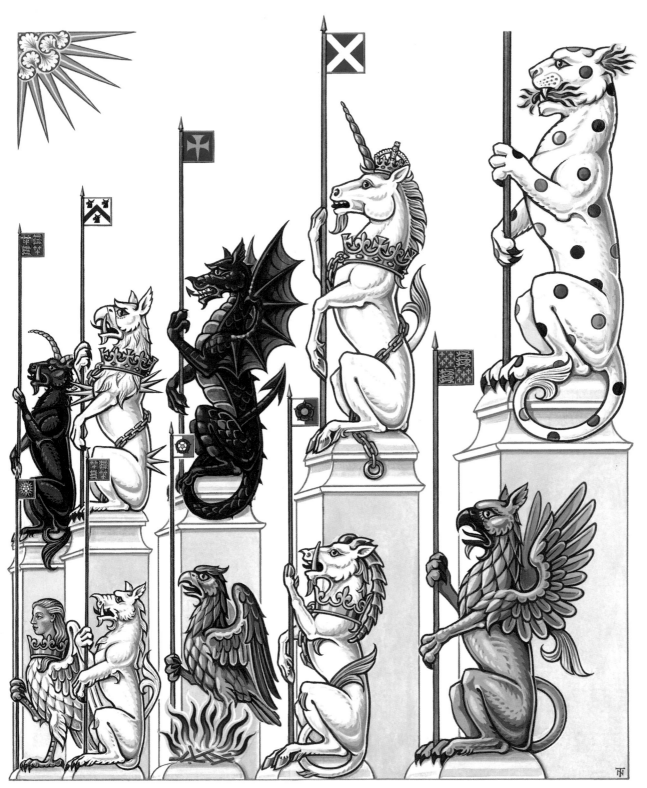

A variety of her-
aldic monsters
inspired by the
'Windsor Beasts' on
the parapet of St
George's Chapel,
Windsor Castle.

TOP ROW (from the
left):
1 Yale of Bedford.
2 Male Gryphon of
 Boleyn.
3 Dragon of
 Cadwalader.
4 Unicorn of
 Scotland.
5 Panther of Henry
 VI.

BOTTOM ROW:
1 Maiden-headed
 falcon for the
 House of York.
2 Tyger of Henry VI.
3 Phoenix of
 Elizabeth I.
4 Antelope of
 Henry VI.
5 Griffin of
 Edward III.

Illustration by Timothy
Noad.

buckets (two skins with a wooden cross piece between them), the long sleeve of a woman's dress and a means of maiming horses in battle.

More modern charges sometimes range from the bizarre to the almost impossible. The shield on the Worshipful Company of Framework Knitters has a large knitting frame, that for Sir William James Herschel a forty-foot reflecting telescope, and for Josiah Vavasseur a machine gun on a Vavasseur mounting.

The helm or helmet

Helmets have protected the heads of knights and soldiers from their opponents' blows throughout history. Sheets of metal were fashioned to provide protection which fitted the shape of the head and was strong enough to ward off blows from spears, arrows and the sword.

It was probably the development of a helmet which covered much of the face which partly gave rise to heraldry. The difficulty in recognising friend or foe meant that some form of easy identification was necessary, hence the bold patterns and devices on the bearer's shield and surcoat, and later, on the coverings or bardings of the horse. This conical shape, fitting over the head, with slits for eyes and breathing holes cut into the metal covering the cheeks must have been very uncomfortable for the wearer, even though it was padded. The advent of a visor, attached to the helmet by a hinge, which could be raised for breathing when the wearer was out of danger, must have been a tremendous relief!

During the Third Crusade, from 1189–1192, Kings Richard I of England and Philippe II of France launched an attack against Saladin in an attempt to free Jerusalem from the Saracens. The helmet Richard and his soldiers wore had a flat top, and looked rather like an upturned pot, with additional protection for the face. This 'improved' helmet had one problem, in that the flat top was not designed to deflect the blows of a sword, and this caused some often disastrous consequences.

In historical times there were laws which prevented the wearing of certain clothes by those who did not qualify – usually because of their status or class. These were called the **Sumptuary Laws** in England, and included such things as the wearing of purple silk, gold chains and crimson velvet. Only those whose rank warranted this could wear precious metals, furs and luxury fabrics.

In heraldry the rank of the bearer is also indicated by the helmet displayed on a coat of arms. The **sovereign's** helmet, and that borne by the royal family is of gold, with five or sometimes seven gold bars. It is shown facing to the front, or *affronty.*

That of **peers of the realm** is of silver, a mêlée helmet, with five gold bars shown and used to face to the dexter. **Knights** and **baronets** have a steel barriers helmet with the visor raised and used to face affronty. **Esquires, gentlemen** and **corpor-**

ations have a closed helm, often a tilting helm which used to face to the dexter.

In Scotland esquires and gentlemen do not show a tilting helm because in times past they would not have been of tournament rank.

The rules governing the exact positions of the helm used to be interpreted strictly. This sometimes made the juxtaposition of the helmet and what was on top of it somewhat ridiculous. The helmet would face dexter, and the crest would be affronty; or an affronty helmet with a lion rampant which is always drawn from the side. Nowadays, the heralds have relaxed this ruling so that the helmet can more comfortably follow the same alignment of the crest.

Mantling

In the hot sun of the Middle East the Crusaders must have looked enviously at the Saracens when they saw that the backs of their necks were protected from the intense heat by pieces of cloth. This not only meant that the sun's rays were prevented from getting to their exposed skin, but it also kept some of that heat from the metal of their helmets. The material was attached to the top part of their helmets and hung down on to their shoulders. This piece of material, called **mantling,** was adopted by the Crusaders and eventually became part of the coat of arms.

Mantling, also called **lambrequin,** flows from under the crest; it is often cut or slashed in a stylised form and sometimes ends in dancing tassels. It is the one part of the whole coat of arms where some life and movement can be introduced.

Early paintings show the mantling as very simple – as that original piece of material; later, in the exaggerated forms of Victorian heraldry it sometimes looks almost like seaweed!

Mantling is usually two-coloured – that of the predominant metal and colour on the shield, the colour on the outside being lined with the metal cloth. However, mantling can be more than just one colour plus one metal or fur, and the tinctures can be unrelated to those on the shield.

Sometimes the mantling continued the crest in the form of fur or feathers which look most attractive. In the second half of the sixteenth century the mantling in almost all grants of arms was *gules doubled* (lined with) *argent* (or with *ermine* in the case of peers), no matter what the colours on the shield. Perhaps this was because these are the colours on the English flag – a red cross on a white background.

Some mantling is decorated with a scattering of badges or knots; this is called **semy** or **powdered.** The devices appear on the mantling as if they were part of the material, rather than simply flat on the surface.

Mantling in the royal arms is always *gold doubled ermine* and that of British peers used to be *gules doubled ermine.*

Mantling is now part of the whole Grant of Arms and so the exact colours, metals and furs are carefully detailed in the blazon, or word description.

Wreath or torse

Sitting on the helmet is the **wreath** or **torse.** It is painted as six twists of material, and should appear as if it goes around the helm. Victorian styles of heraldic art showed the wreath as a straight pole, almost like a barber's pole, which suggests that the artists were not really clear what the wreath was.

The precise origin of the wreath is unclear. Perhaps it is from the 'favours' of ladies given to knights to represent them in tournaments; the favour would be in the form of a scarf or large handkerchief, made out of soft material. To show that he had that favour, the knight twisted it, wound it round his helmet and tied it at the back in a knot, for all to see. Alternatively, Crusaders, having already adopted the mantling of the Saracens, may have twisted that material around their helms to prevent it from getting in the way when they were not in battle. They continued to wear it as a twist when they returned home to show that they had been in the Crusades.

Whatever the origin the six twists sit as a wreath on the helm and below the crest. The first twist on the dexter (right) side is usually painted the principal metal from the shield, followed by the principal colour. If one of the principal tinctures is a fur, then the dominant colour of the fur is painted, so ermine will be painted in white and vair blue. However, as with many other aspects of heraldry, the principles may be applied differently, and the wreath can in fact be in whatever colour, metal or fur stated in the blazon, or word description.

Cap of maintenance

Occasionally the wreath will be replaced by a ceremonial hat or chapeau, usually of red velvet lined with ermine. This is also called **a cap of maintenance, a cap of justice, cap of dignity** or **cap of estate.** Although there is now no difference between these various caps, it is likely that there was some differentiation when they were first adopted. Nowadays grants of these ceremonial caps are rare and if in red and ermine are usually restricted to peers.

The Crest

The crest is the decoration which sits on top of the helm. It was made out of cloth or boiled leather which was then sewn and stretched over a wooden or wire frame or it was carved from lightweight wood.

Early helmets, made from pieces of shaped flat metal, were usually joined at the top of the head. This produced a groove or ridge to which feathers could be attached. Some crests which are in the form of feathers or plumes, such as the three white feathers of the Prince of Wales, as heir apparent, may well have started in this way. Vase paintings of Greek helmets with almost semi-circular tall fringes suggest that this practice started long before mediæval times. Changes in helmet design then resulted in the top of some helmets having a raised semi-circular piece of metal. It would seem natural to paint on this one of the devices taken from the shield. As time went on these devices became more elaborate, and the crest was detached from the design of the helmet to become a separate part of the arms.

The first coats of arms did not have crests; later crests became so elaborate as to be almost ridiculous. It is also unclear whether crests were ever worn into battle as, even made from the most lightweight material, they must have altered the wearer's centre of gravity and so affected his balance. There are contemporary paintings of crests fixed to helmets and worn by those taking part in tournaments, and it must have been a splendid sight to see knights in full armour with their shields, colourful mantling, wreaths and crests.

Crests were originally a mark of status, and so were not awarded to everyone. Now a crest is part of the usual grant of arms to a man, and the trend is to grant crests which could actually be worn, unlike some of those granted in the past where ships rested on clouds or were shown in distress on a rock. Attempting to wear a crest like this on top of a helmet would certainly have been a challenge!

Supporters

Animals, birds, human and divine bodies and monsters which stand either side of a shield are called supporters. Occasionally there is only one supporter standing behind the shield, but this is rare in English heraldry. It is thought that supporters could have derived from the badges worn by servants of the nobility. These may have been of fabric and sewn on to clothing to denote the household to which they belonged; or they were actual metal badges attached to clothing. These human or animal decorations were also used in the designs of seals. Animals and humans used on badges and seals in this way came in time to represent the individual, such as the white hart of King Richard II of England (1367–1400).

As with the devices on the shields themselves, supporters are many and varied. The choice is often quite intriguing – a Roman gladiator, a pirate, a carpenter, a salmon, a Matabele Zulu, a rhinoceros, Vulcan, along with monsters of all kinds.

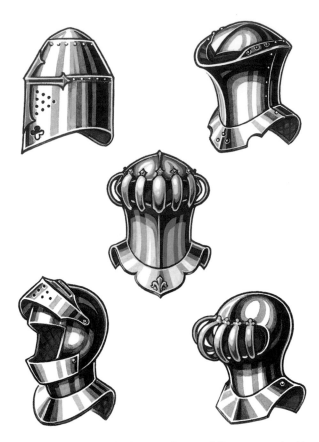

Helmets.
1 *14th century great helm for an esquire.*
2 *15th century 'frog-mouthed' tournament helm for an esquire.*
3 *Sovereign's helm.*
4 *Knight's helm.*
5 *Peer's helm .*

Right.
Women's heraldry. The armorial ensigns of Sarah Elizabeth Smith. *(Reproduced by kind permission)*

Below right.
1 *Paternal arms borne by a woman differenced by a small shield (escutcheon).*
2 *Husband's arms borne by a woman differenced by a small lozenge.*

Below right.
Diapering.
The arms for Stafford. *The yellow-gold field is diapered in a geometric pattern incorporating the Stafford knot badge. The red chevron is diapered with a floral motif.*

Illustrations by Timothy Noad.

Supporters are usually, but not always, different on each side of the shield.

Above all supporters must support. They should be painted with strength, an arm or leg outstretched, as naturally as possible, to support one side of the shield. Human and divine beings used as supporters are usually painted so that they face the front, but animals and birds are often shown in a rampant attitude, and therefore face into the shield. However, unless the blazon, or word description, indicates their attitude, this is at the discretion of the designer.

The College of Arms regards supporters as an indication of rank, and so they appear only on the arms of peers of the realm, Knights of the Garter, the Thistle and St Patrick, together with high-ranking knights of certain other orders, county, city, district and town councils, and certain corporations.

The Compartment

The supporters of a shield need in turn to have some support. This should be included in the grant of arms itself, but the interpretation of it is up to the designer. If not the choice may be to use a scroll-shape motto to support the legs of the supporters, or some floral scroll work, often called 'a gas bracket'; however unless the design is very good, this rarely looks substantial enough, and a small mound, or compartment, is the better solution. If it not blazoned then a simple grassy knoll can be used in a painting, although this is not allowed in the patent itself.

Far left.
Styles of mantling,
wreaths or torse
and caps of main-
tenance.
1 *Mediæval (15th*
century), based on
a Garter stall plate,
with cap of mainten-
ance and scalloped
mantling with ermine
lining; the shield is
'a couché'.
2 *Tudor (16th cen-*
tury) acanthus style
with twisted wreath,
from an heraldic
manuscript.
3 *17th century with*
'cloak' mantling and
a cap of maintenance,
from a bookplate.
4 *19th century with*
'seaweed' mantling
and a knight's helm,
from an engraving.

Left.
Two Crests.
Top – the crest for
Paul Brown, with a
magnificent owl
atop a circlet of
columbines.
Below – the crest
for Gibbs with a
menacing arm in a
gauntlet holding a
battle axe.

(Reproduced by kind
permission)

Illustrations by
Timothy Noad.

The Motto

Many people presume that mottoes, as part of heraldry, were originally war cries. Certainly some were, but not all. Usually mottoes were short phrases with a moral or religious message.

Occasionally they were a play on the name of the bearer – *Ne vile velis* for Neville (Form no vile wish). Or the motto referred to a device used in the shield and supporters – *Alte fert aquila* for Lord Monteagle, who bears eagles as supporters.

These two mottoes are in Latin, but they can be in any language, and the trend now is for a motto to be in English. The comedian Sir Harry Secombe starred in the long-running radio series 'The Goons'. Showing their sense of humour the heralds agreed that the motto *Go On* should be written under Sir Harry's shield.

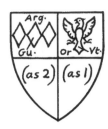

Two shields tricked, the blazons are:
1 *Per pale Azure and Gules, three lions rampant. Argent (for* Herbert*).*
2 *1 and 4 – Argent three lozenges conjoined in fess gules (for* Montague*).*
2 and 3 – Or, an eagle displayed Vert (for Monthermer*),*

Unusually, with all the rules concerning heraldry, those about mottoes are rather relaxed. In England the motto is not part of the grant of arms, and can be changed without problem. This is not the case in Scotland.

The motto can be placed on a curling scroll, or positioned in an appropriate place within the design. It can reflect the colours of the arms, or be a contrast. Essentially, it needs to be lettered clearly and carefully.

The Blazon

Reference has already been made to the *blazon,* which is the word description of a grant of arms. It is a condensed way of describing, without confusion, what is on the shield, wreath, crest and mantling, and what the supporters are, if any.

There is a pattern to describing the shield, which means that those who know the form and sequence can reproduce the essence of the tinctures and patterns on the shield without needing to refer to the original drawing. This is the order:

1 The surface or **field of the shield**, what tincture it is, whether it is more than one tincture, whether it is divided by a line, and whether it is scattered with small charges (semy).

2 The **principal charge** or **ordinary** of the shield, or groups of charges, which usually take the most prominent and central position.

3 The **secondary charges** on the surface of a shield.

4 Any **objects placed on one of the above charges.**

5 Important **objects on the surface of the shield** but not in a central position, such as a chief, canton and so on.

6 **Objects on the charges in 5**.

7 Marks of **cadency** (see page 232).

Blazons have few, if any, punctuation marks and to avoid clumsiness and repetition they employ a style which may seem rather confusing at first. For example, in the past the blazon for a gold shield with two blue roses separated by a broad vertical band in blue, on which are three gold roundels will not refer on each occasion to the gold and blue colours. The blazon would have been *Or a pale Azure between two roses of the second three bezants (roundels of the first* or *of the field).* As gold is mentioned first and is the colour of the field, this is referred to as 'the first' or 'the field'. Fortunately modern blazons are much more straightforward in their wording.

Even with more complicated shields the blazon can be understood if followed through carefully. When two shields are combined, the one on the right side, the dexter side, is always described first. If a shield is divided into quarters the one at the top right, the dexter chief, again is blazoned first, followed by the top left, bottom right and bottom left.

Crests, mantling and supporters are described as though they are charges on the shield, and again need to be followed through to be understood.

Tricking

It is not always necessary for the whole coat of arms to be drawn out in detail. Sketches of a shield, with the relevant colours can provide a picture aide-mémoire. The tinctures can be noted on the sketch as abbreviations (see above left), and if there are repeated charges only one need be drawn, a number being substituted in the relevant position. This is called **tricking**.

Diapering

Mediæval styles of painting often included much pattern and decoration. Large areas of colour on a shield were rarely left plain. A darker shade or lighter tint of the blazoned colour would be used to paint a free or ordered pattern over the surface, but care was taken that the pattern did not change the essence of the colour. If this was done then the shield would not be true to the blazon. The painting of such a decorative pattern is called **diapering.**

Women's heraldry

In the past women did not take part in fighting and battles, and so it was inappropriate for them to carry shields or wear helmets. A woman who has the right to bear arms displays this not on a shield but usually on a diamond-shaped lozenge. The difficulties of designing rampant lions and similar charges on such a shape can be easily seen! Tradition is for it to be

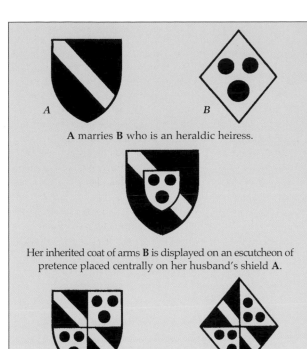

A marries **B** who is an heraldic heiress.

Her inherited coat of arms **B** is displayed on an escutcheon of pretence placed centrally on her husband's shield **A**.

Their sons inherit their parents' arms which are shown quartered – quarterly **A** and **B** on their shield. Their daughters inherit these arms displayed on a lozenge or roundel.

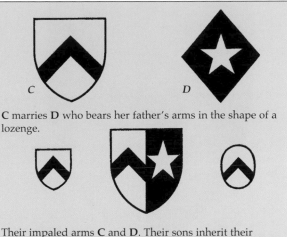

C marries **D** who bears her father's arms in the shape of a lozenge.

Their impaled arms **C** and **D**. Their sons inherit their father's arms only, shown on a shield, their daughters the same arms on a lozenge or roundel.

The children of quarterly **A** and **B** bear these quartered arms, with an inescutcheon of pretence if a son marries an heraldic heiress **E**.

Marshalling arms of an heraldic heiress with her husband's arms on the left and a woman who bears her father's arms on the right.

Illustrations by Timothy Noad.

this shape, although an oval or a roundel can also be used, which often lead to a more satisfactory overall design. Because she would not take part in fighting, there is no need for a helmet, and thus no wreath, crest or mantling. If she is a peeress, then the coronet of her rank (see page 235) and supporters are shown as well.

In the past a woman was not often granted arms in her own right; usually they were inherited from her father. Spinsters have a decorative bow with trailing ends above the lozenge, which is removed if she marries.

A woman who is a Mayor or Head of a College combines her arms with those of the office. The official arms are on the dexter, right, side of the lozenge and her own on the sinister side.

New rulings from the College of Arms allow for a woman who is awarded a coat of arms to display her father's arms on a shield with an escutcheon (small shield) for difference to show that she is married. The shield may be placed at the most appropriate position.

Marshalling

If a woman marries, her arms are combined with her husband's on a single shield. The combination of coats of arms on a single shield, not just those of married couples, is called MARSHALLING. There are different ways in which marshalling can take place.

If a woman is an **heraldic heiress** – which means that she inherits her father's coat of arms as she has no living brothers who, in turn, have no living sons or daughters – then her father's coat of arms is shown on a small shield – an escutcheon – placed centrally on her husband's shield showing his coat of arms. The small shield is called an INESCUTCHEON OF PRETENCE, because the husband pretends to the representation of the family, there being no male heirs.

If she has surviving brothers and so is not an heraldic heiress a woman would normally squeeze her coat of arms into half of the shield, and her husband's into the other half. This is called IMPALEMENT, and in this the husband's arms are shown in the dexter, right, side of the shield and the wife's in the sinister.

Coats of arms other than those of husband and wife can be impaled too. If the **holder of an office** is entitled to bear arms then the official arms are impaled with the office holder's personal arms. In this instance the arms of the office are placed in the dexter part of the shield and that of the bearer in the sinister.

Shield of Edward III of England, incorporating the French coat of arms in the first and fourth quarters – the most important.

Illustration by Timothy Noad.

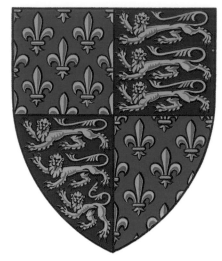

Historically, this combining of shields was achieved in a slightly different way. For a time the shields looked as if they were cut in half, and then simply stuck together, called DIMIDIATION. This created some very peculiar combinations! Perhaps the coat of arms of the Cinque Ports is the best known, where in dexter the leopards of England (three lions passant guardant) combine with three hulls of ships in sinister. This form of marshalling was abandoned because it caused confusion. If charges were on the sinister side of the shield only then they would not appear on the combined shield, and so it was unclear who was represented on it.

Two or more coats of arms can be combined on a shield in another way, called QUARTERING. Here the shield is divided into four, and a coat of arms placed in each section. The most important, usually the inherited coat of arms, is placed in the dexter chief, top right, section on the shield, or first quarter and repeated again in the sinister base, bottom left, or fourth quarter. The arms of an heraldic heiress are placed in the remaining quarters usually in the order in which they were acquired.

It was the custom for a time to trace back in history and for husbands who married women from important families to quarter their own arms with the prestigious arms of their wife's family. This indicated that the family of the person to whom this shield belonged had made good marital alliances in the past. Sometimes the quarterings became quite ridiculous as there were so many on a shield that it made the thing totally unreadable, and it was not possible to see what was what as the quarterings were so tiny.

Occasionally the quarterings indicated that the bearer had the title to land, in that his arms were impaled or quartered with that of an area. This was the case with King Edward III of England. His claim to the French throne was shown to all and sundry through his shield which proudly displayed the arms of France – *Azure, semé-de-lis Or* (which is France Ancient) quartered with that of England – *Gules, three lions*

passant guardant in pale Or (see left). In fact, the French arms were put in the most important quarters, the first and fourth, England being in the second and third. The French arms remained part of the coat of arms of the Kings and Queens of England right up until 1801.

Hatchments

In the seventeenth, eighteenth and nineteenth centuries, days before newspapers, radio and television, it was necessary to know when important people had died. This was effected by HATCHMENTS, (a corruption of the word 'achievement'), which are large diamond-shaped panels showing the coat of arms. After the funeral procession they were hung outside the house of the deceased for a year and a day, and then were usually taken to be hung in the local church, where they can be seen in many churches in Britain and Europe today.

The hatchment shows the shield, wreath, crest and supporters if any, of the person it represents. The motto, though, was often replaced by the word *Resurgam* (Rise again), or *In Coelo Quies* (Rest in Heaven).

It is the background colour which gives the clue to hatchments; that behind the deceased was painted black, and that behind the spouse still living was painted white. When both partners of a marriage had died then both sides were painted black, and the shape of a shield or lozenge indicates whether it is the husband or wife represented by the hatchment. Where a person died in office, and their arms were impaled with those of that office, the background to the official arms were painted white, as the office still remained. (See opposite page.)

Sometimes cherubs were painted above the shield or lozenge, and a skull was occasionally painted above the shield instead of the crest to show that the person was the last of his or her line.

Difference

Arms granted to a person in England can be inherited and displayed by that person's direct successors – however many there are. This could in times past lead to confusion, as the same design on a shield should not be borne by two or more people. There were ways of making the shields dissimilar for the various branches of a family. For example a red shield with a gold diagonal stripe – *Gules, a bend or*, could be changed to *Azure, a bend or; Gules, a bend argent; Gules, a bend vair*; and so on; all of these changes are for DIFFERENCE. Alternatively charges may be placed on the field or on the ordinary. So the same *Gules, a bend or* may now have two gold roundels either on the field or red roundels on the bend.

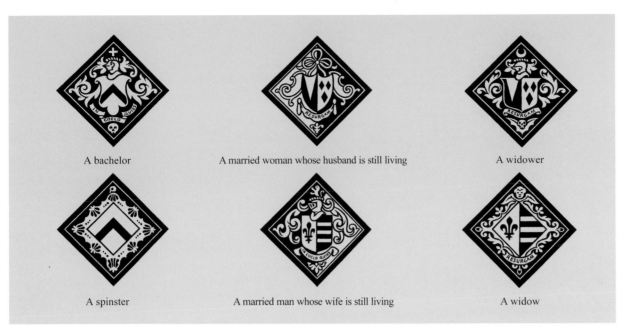

A bachelor

A married woman whose husband is still living

A widower

A spinster

A married man whose wife is still living

A widow

Hatchments based on examples from the 18th and 19th centuries.

Illustrations by Timothy Noad.

The colour and number of the roundels may vary and their position, or the charges, may be replaced by, for example, cinquefoils, keeping to the same colour scheme. These variations show that there is a link between the bearer of the original shield and these of the other shields which are related but different.

This method of difference also applied to those who were not necessarily linked by blood but had another connection. For example, those who were less exalted may have wished, in times past, to show that they owed allegiance to a person of higher rank, and so chose similar coats of arms, but with marks for difference. Others who followed a particular leader may also indicate their loyalty by displaying a shield with similar characteristics to their lord, but again with difference.

Cadency

Differences on the shield were made for blood relations by changes in tincture or by introducing charges which did not materially alter the basic design. A single mark for difference, which showed cadency – the descent of a younger branch of the family – was used from the beginnings of heraldry. From the early sixteenth century these marks used to show cadency were standardised, and a particular charge assigned to each son of a family to indicate his position. (See page 232.)

Cadency marks can be of any tincture, although the rule of no colour on colour or metal on metal still applies. They are usually displayed in the chief (top) of the shield. If a shield is quartered the mark is placed in the centre, overlapping all

four quarters.

These marks which indicate junior members of the same family may themselves have marks of cadency added to them. For example, the crescent of a second son may have a martlet added to it by that person's fourth son.

Apart from the label of the eldest son, which is removed when his father dies, other marks of cadency remain permanently on the shield as an indication of the relationship within the family.

There are no marks of cadency for women as all daughters use their father's coat of arms displayed on a lozenge, roundel or oval, although the daughter of a second son will obviously show a crescent as that is part of her father's shield.

Illegitimacy

Illegitimate sons often used their father's arms with some change, again for difference, or they used their father's charges or badges on their own shield.

In Royal and some other arms a small bend called a baton sinister shown going from sinister chief to dexter base (top left to bottom right), which is opposite to the usual bend, indicated illegitimacy when displayed on the arms.

On other coats of arms in England, Wales and Ireland a bordure wavy, and in Scotland a bordure compony, indicate illegitimacy. These marks are sometimes called abatements because they diminish the status of the arms, indicating that the owner is not in the legitimate line of succession. Refreshingly the word abatement in this context does not indicate

Marks of cadency.

Illustration by Timothy Noad.

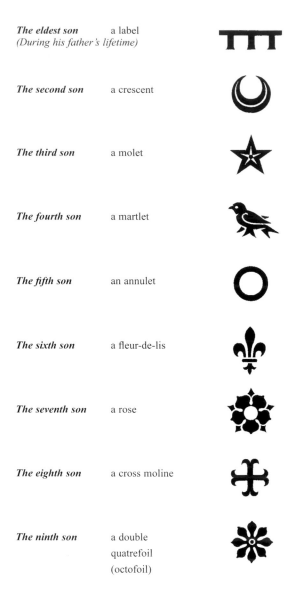

The eldest son (During his father's lifetime)	a label	
The second son	a crescent	
The third son	a molet	
The fourth son	a martlet	
The fifth son	an annulet	
The sixth son	a fleur-de-lis	
The seventh son	a rose	
The eighth son	a cross moline	
The ninth son	a double quatrefoil (octofoil)	

the arms, a complete coat of arms which is then quartered with the existing arms, or it can be an additional crest.

Augmentations marked, for example, the capture of certain illustrious individuals at battles in the form of charges from the defeated individual being added to the shield of the captor. The services of a previous Sir Winston Churchill to the English King Charles I resulted in him adding a canton (rectangle) showing the red cross of St George on a white background to his existing shield. Far more bizarre were the augmentations added to Horatio Nelson's shield. After the Battle of the Nile in 1798 the augmentation of a landscape consisting of a palm tree, a disabled ship and a battery in ruins was added in chief on his shield. Then, after his death, a blue horizontal stripe with undulating sides on which was written the word *Trafalgar* was also added. The result was an interesting mix! (See page 234.)

Other augmentations were in the gift of the sovereign, and were awarded by mere grace. King Richard II of England (1367–1400) granted the coat of arms of the earlier King Edward the Confessor to his relations. As his reign as King was rather a troubled one, this act no doubt helped to encourage his kinsmen to support him.

Badges

Badges were used in mediæval times to show loyalty to one person. However, they were not personal to the bearer, in the way that coats of arms were and are exclusive to one individual. The retainers in a household would wear the badge of their lord. Inns and taverns which were used by those retainers would also display that badge. Eventually the inn might have actually taken the name from the badge, and there are public houses in Britain today with names derived from these badges – *The Red Lion, The White Hart, The Bear, The Feathers,* and so on.

Badges pre-date shields and were used on seals and banners. Sometimes the design on the badge actually became part or all of the design on the shield and later the badge itself might have been used for the crest.

It is not always obvious why a particular device was chosen for a badge. Sometimes it was clearly a play on the name, favourite in heraldry. The white hart of English King Richard II (1367–1400), may have derived from the pronunciation of his name in French – *Richart*. The swan used as a badge by the Fitzswanne family is an obvious example; so is the mulberry tree used by the Mowbrays. The origin of other devices is more obscure.

A number of recent grants from the College of Arms have included badges which can be used for seals, stationery, and perhaps even for buttons. The granting of a badge as part of the full grant of arms to a town or city council is particularly

dishonour, as there is no mark of dishonour in English heraldry.

Nowadays those in this category have to prove their relationship to their father, and then petition for the arms to be granted to them. They may alternatively petition for a completely new coat of arms for themselves.

Augmentations

Augmentations are marks of honour, an addition to the achievement of arms, which were awarded to individuals as a mark of merit in recognition of a brave or generous act or deed. The augmentation may be a charge which is added to

useful. It means that the same badge can be used – perhaps even incorporated into their logo to show the location – by other organisations such as the fire service, interest clubs, societies and so on, whereas using the arms of the authority is not possible because in British law it is illegal for a person to display arms which are not granted to him or her.

Knots

Knots are often used as badges or may be shown as part of the design on a shield. The particular and different ways in which cords are linked or intertwined is significant, and often gives rise to the name. The Lacy knot, for example, resembles its name and appears on the counter-seal (the underneath of the seal) of Roger de Lasci, 1179–1211; the Bowen knot has four bows, again alluding to the name. Named knots have also been incorporated into the arms of associated authorities. The Stafford knot is now a charge in the arms of Stafford County Council, having been used as a badge by the Earls of Stafford and Dukes of Buckingham. The Wake or Ormonde knot similarly appears in the crest of the Isle of Ely County Council, relating to the association of that area with Hereward the Wake, a well-known historical English hero. See page 234.

Crowns and coronets

In heraldry there is a distinction between the crowns and coronets which may appear as part of the design on the shield or as part of the crest called *Crest Coronets*, and crowns and coronets which are worn on ceremonial occasions as part of a person's status, which are called *Coronets of Rank.*

Crest coronets

Rarely is the royal crown used on a shield, and when it does occur it is usually as a result of some associated act of bravery to the monarch. The English King Charles II's (1630–1685) escape after the battle of Worcester was assisted by Jane Lane, and consequently the crest of Lane of Bently incorporates the Crown.

A DUCAL CORONET or crest coronet is used if a specific crown is not named in the blazon, or word description. This is usually painted as gold, with four heraldic strawberry leaves standing proud, although only one and two halves are actually shown, and with jewels shown set into the rim, but not painted in any colours. Alternatively a crown with fleur-de-lis terminations (or *fleurons*), again in gold, may be drawn.

Occasionally heraldic creatures are blazoned *ducally crowned* or *ducally gorged*, where again the ducal coronet comes into play. In these two instances the crown is placed on the animal's head, or around its neck where it is *gorged.*

An ANCIENT CROWN is a gold rim with fleurs-de-lis extending upwards, usually one and two halves on the left and right showing. The simple SAXON CROWN has four tapering uprights ending in a round ball. This is how the Royal crown was shown on some Saxon coins.

MURAL, NAVAL and ASTRAL crowns are usually associated with army, navy or air force towns or personnel. A mural crown has battlements and stone work or masonry. It can be in different colours. Mural crowns were used extensively in Scotland to differentiate between different areas, for example, a police burgh had a crown azure, masoned argent – blue blocks and white cement, a burgh of barony, a crown gules masoned argent – red with white, and a royal burgh a crown of eight battlements proper masoned sable, that is, painted realistically of grey stone with black cement. Additionally Scottish County Councils did not have a mural crown but a circlet of gold with eight points and eight garbs, or wheatsheafs. This has now all changed in the UK as a result of local government reorganisation in 1973.

Naval crowns have sails and the sterns of ships shown alternately about the rim of a coronet. Horatio, Lord Nelson was granted a naval crown – so, too, the towns of Chatham and Plymouth because of their naval connections. Astral crowns have four stars between a pair of elevated wings, although only one star and two halves are visible.

A CELESTIAL CROWN has eight tall points, of which only five are shown, each one with a star as its point. It is similar to an EASTERN CROWN, but this does not have the stars.

A PALISADO CROWN and CROWN VALLARY are also similar, and both look like and are associated with fortifications. The palisado has seven visible palisades rivetted to the rim. It is likely that the crown vallary, with five projections showing, was a corruption of the palisado, and in fact the two are often interchangeable. For crest coronets see page 235.

Coronets of rank

These coronets indicate the rank of the wearer within the British peerage system. They were introduced during the fourteenth century when they were limited to dukes and marquesses. In 1444 earls were also allowed to wear them. Later, the English and Scottish King James I (James VI of Scotland) granted coronets to viscounts, and then in 1661 King Charles II granted them to barons to wear at his coronation.

The exact pattern does not seem to have been determined during these early periods, although that for barons was specified. Later the patterns and styles of the various coronets of ranks were standardised.

*Arms for Admiral
Nelson: Or, a cross
flory sable a bend
gules surmounted by
another engrailed of
the field, charged with
three bombs fired
proper on a chief (of
honourable augment-
ation) undulated
argent waves of the
sea, from which a
palm tree issuant
between a disabled
ship on the dexter, and
a battery in ruins on
the sinister all proper,
overall a fess azure
charged with the word
Trafalgar or. Crest –
on the dexter (as a
crest of honourable
augmentation), on a
naval crown or, the
chelengk or plume of
triumph presented to
Horatio, Viscount
Nelson, by the Grand
Signior or Sultan,
Selim III; and on the
sinister the family
crest – on a wreath of
the colours, upon
waves of the sea the
stern of a Spanish man
of war all proper,
thereon inscribed 'San
Joseff'. Supporters –
dexter, a sailor armed
with a cutlass and a
pair of pistols in his
belt proper the right
hand supporting a
staff, thereon hoisted a
commodore's flag and
in his left a palm
branch proper, sinister,
a lion rampant re-
guardant in his mouth
two broken flag-staffs
proper flowing from
one a Spanish flag or
and gules and from the
other a tri-coloured
flag, in his dexter paw
a palm branch proper.
Motto – Palmam qui
meruit ferat.*

*Based on his stallplate
as Knight of the Bath
in the Henry VII Chapel,
Westminster Abbey. (The
'Trafalgar' augmen-
tation is not shown.)*

*Illustration by Timothy
Noad.*

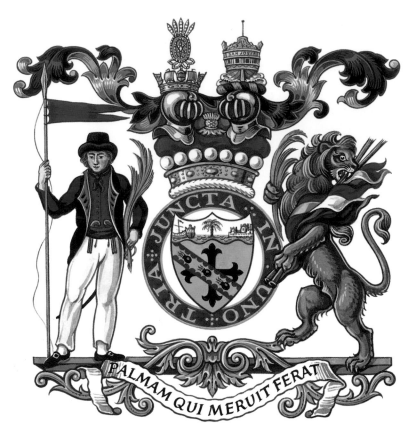

Coronets are usually shown with a red ceremonial cap of velvet, lined with ermine fur, and with a gold tassel, improbably shown elevated above the circlet – in fact the weight of a gold tassel if the cap was not padded would surely depress the velvet such that it sat directly resting on the wearer's head.

A DUKE's coronet has a silver-gilt rim (made of silver but plated with gold), which shows the form of jewels but they are not coloured as such. Eight heraldic strawberry leaves rise above this rim, of which five are shown.

The coronet of a MARQUESS is similar to the circlet of the duke, but has only four strawberry leaves which are alternated with four slightly raised points on which sit four silver balls.

Although these are sometimes painted as heraldic pearls, artificial or real pearls are not allowed in practice.

The most elegant of coronets is that of the EARL, which again has the same circlet but with eight strawberry leaves. Eight long stems extend above the rim, each topped with a silver ball, again sometimes painted as a pearl. Of these, four strawberry leaves and five stems are shown.

The much plainer VISCOUNT's coronet is a circlet as before, but with sixteen silver balls, all touching one another, with only nine showing.

Lastly, the BARON's coronet, the band of which is completely plain, with only four silver balls out of the six visible.

Peers and peeresses wear their coronets on state occasions, and coronets are also shown on their achievements of arms. The coronet is usually painted sitting on the shield just below the peer's helm of silver with gold bars. The proportions here are rarely correct as the coronet may stretch across the whole of the shield, with the helm sitting inside. However, if drawn in proportion, such that the coronet would fit on the head of the helm wearer, it again does not look right as the design of the achievement of arms narrows too much at that point.

Royal crowns and coronets

The design of crowns has changed over the years. Earliest crowns shown on coins were simple circlets with four uprights supporting a ball – similar to the Saxon crown. Later these were replaced by fleurs-de-lis, and with arches which met in the middle.

The heraldic crown which is now used is a gold circlet with rubies, emeralds and sapphires – often a rectangular or

lozenge-shaped ruby is shown in the centre, flanked by two oval emeralds which are in turn flanked by two rectangular or lozenge-shaped sapphires. Above the rim is a series of raised points supporting four fleurs-de-lis and four crosses paty, of which two fleurs-de-lis are shown and one and two half crosses. Above these stretch the golden arches of the crown, which are slightly depressed towards the centre. There are nine pearls on each of the side pieces of the arch and five pearls visible on the facing arch. Where the gold arches meet in the middle is a round ball, an orb, often shown green as an emerald, surmounted by a cross paty. The crown is lined with a cap of red velvet with ermine fur, which is painted to show just below the rim.

The coronet of the HEIR APPARENT (this is the male heir to the throne; a female heir to the throne is the HEIR PRESUMP-TIVE, as she presumes to the throne until an heir appears whose rights to the throne are more valid) is identical to the Royal crown apart from the fact that it has only one arch which is shown going across the crown from left to right.

Coronets of other relations to the monarch are without arches and coloured jewels, although the form of the jewels is shown, similar to that in the coronets of peers. SONS and DAUGHTERS, but not the Heir Apparent, have a circlet with four fleurs-de-lis and four crosses paty, of which two and

Page 234.
Knots.
From the left,
Stafford, Bourchier,
Lacy, Wake or
Ormonde, Bowen.

Left.
Crest Coronets.
1 *Ducal coronet*
2 *Anceinet coronet*
3 *Mural coronet*
4 *Naval coronet*
5 *Astral coronet*

Crowns and
coronets of rank.
1 *Baron*
2 *Viscount*
3 *Earl*
4 *Sovereign*
5 *Prince of Wales*
6 *Marquess*
7 *Duke*
8 *King of Arms*

Illustrations by
Timothy Noad.

one and two halves are shown respectively.

GRANDCHILDREN of the monarch, off-spring of the Heir Apparent, wear coronets with four fleurs-de-lis, two strawberry leaves and two crosses paty. Grandchildren of the monarch, sons and daughters of younger sons, replace the four fleurs-de-lis with four strawberry leaves, and their coronets are these four strawberry leaves with four crosses paty. Lastly, grandchildren of the monarch, sons and daughters of daughters wear coronets of four strawberry leaves and also four fleurs-de-lis.

The coronet of the Kings of Arms

One of the most attractive of all crowns and coronets is that of a King of Arms. A circlet of silver gilt bears the words *Miserere mei Deus secundum magnam misericordiam tuam* (Lord have mercy on me according to your great mercy) of which only the first three words are shown. Standing proud of the rim are sixteen leaves of oak or acanthus. Nine leaves are visible and they are of two heights. Similar to other crowns and coronets, this coronet is worn with a red velvet cap with a gold tassel and lined with ermine fur.

Pennons, banners and standards

Thousands of years before heraldry began soldiers used flags or painted devices held aloft on poles as rallying points in battle. A simple and clear design which could be recognised without confusion from a distance was essential. Similar plain devices were used to denote territory or family links throughout historical times. There are flags on the Bayeux Tapestry which depicts the defeat of the English, led by King Harold, by the Normans led by their leader, William, Duke of Normandy. The flags show simple devices of crosses and roundels, bars and a dragon. This was the standard of the English at the battle of Hastings, although it was a dragon with two legs rather than four, which we would call a wyvern.

National flags

Various types of flags were and are used at different events. The most familiar today are national flags. These are usually horizontal or vertical broad stripes of colour, square or oblong in shape. The flags of different countries are easily recognised despite the limited range of colours and designs. The best are those with clear and simple designs.

The national flag of the United Kingdom, the *Union Flag* (called the *Union Jack* only when it is flown from the Jack Staff on ships) compounds or combines the various elements of the national banners of England, Scotland and Ireland. The cross of St George, a red cross on a white background, was the symbol under which the English fought, as in early days battles were under the patronage of a particular saint. Scotland fought under the patronage of St Andrew, and used the symbol of a white saltire on a blue background. It would seem reasonable to suggest that the same is true of Ireland, but it is not clear whether there was a symbolic flag for Ireland before one was needed for the Union flag. In any case the combination of the red saltire of Ireland on a white background with the other two flags produced the Union Flag which is so familiar.

The white fimbriation, or narrow edge to the ordinary, of the red cross indicates the white field of the cross of St George. The blue background colour, or field, with the broad white stripes of the saltire represent the flag of St Andrew, and the narrow white stripes indicate the white field of St Patrick's saltire. As Scotland was joined to England well before Northern Ireland it has the senior rank and its symbol takes precedence over that of Ireland. Thus nearest the flag pole the broad white stripe of St Andrew should always be above the narrower stripe of St Patrick.

The United Kingdom is one of the few countries which uses different national flags for different situations. The Union Flag is flown on land, and ENSIGNS at sea. There are five ensigns in use today. The Royal Navy uses the White Ensign, which shows the red cross of St George on a white background, with the Union flag in the canton, that is a rectangular shape in the chief dexter – top right of the flag as it is held. The Blue Ensign is used on government vessels and is blue with a canton of the Union Flag. The Royal Air Force flies a flag of Royal Air Force blue, which is a light blue, showing the distinguishing red white and blue target of the RAF, with a canton of the Union Flag. The Red Ensign is similar to the White Ensign, apart from being red, and is the flag for all ships which are registered in the United Kingdom. Lastly the Civil Air Ensign is for aircraft registered in the United Kingdom and licensed aerodromes. It is Royal Air Force blue with a dark blue cross edged with white, and has again the Union Flag in the canton.

Pennons, penoncelles and pennants

Pennons were used by mediæval military commanders of a particular rank – that is below banneret, which was the rank of nobility between a knight bachelor and a baron – as their personal flags and were known to indicate their actual presence. They were about one metre (3 feet) in length and usually triangular or slit to make a swallow-tail effect. Interestingly, if someone was promoted on the field of battle, then the swallow-tails were simply cut off, to make a banner.

Pennoncelles, clearly, are smaller pennons, usually not longer than 45 cm (18 inches). Attached to a lance they were,

like their bigger partner, triangular or swallow-tailed.

Any flag which tapers and is used at sea is called a **pennant,** and can be of any length, blunt ended or swallow-tailed.

Banners, bannerets and banneroles

Banners are square or oblong flags showing the arms of an individual similar to how they would appear on a shield. As such they were personal and indicated their actual presence. Sometimes banners were fringed with the colours from the arms. They were taken into battle by the peerage and by knights banneret – a knight of renown and bravery – and showed the allegiance of the person whose arms were depicted. It was a very serious matter to lose a banner in the course of battle because as the banners were so personal the loss would indicate that the owner was in some difficulties. Banners were born by the nobility and were the responsibility of the lieutenant, which was also what a banner was called.

Small banners are called, naturally enough, **bannerets,** which is also the name given to the knight who carried a banner.

Banneroles are also small banners used at funerals to show the coats of arms of those associated with the deceased. They were often stiffened along their upper edge so that the arms could be clearly seen.

Standards

Standards are long tapering flags – sometimes very long indeed. Commentators at Royal occasions often talk about the Royal Standard flying from the bonnet of the sovereign's car. This would be a highly dangerous practice! A **Royal Standard** would be about 10 metres (33 feet) long, and not at all safe to be flying from a car. Of course the standard is confused here with a banner, which is rectangular.

Historically the standard formed a mustering or gathering point during military campaigns and for tournaments. Another name for this standard was the **ancient,** and it was the responsibility of the standard bearer to ensure its safety at all times.

Interestingly, standards were usually painted not in the tinctures associated with the coat of arms but in livery colours. The livery, as now, are the colours worn by retainers or employees as an indication of their allegiance to a particular individual or organisation. The colours do not necessarily relate to those on the coat of arms, nor do they obey the heraldic rules of no colour on colour or metal on metal, as they are chosen for different reasons. However, groups of retainers dressed in livery must have made a splendid sight at a tournament. In England blue and white were the livery colours worn by those supporting the Lancastrians (from 1267 to 1485, when the Battle of Bosworth united the Houses of York and Lancaster), blue and crimson the House

of York (from 1411 to 1485). In Tudor times, from 1485 to 1603, white and green were the colours for the monarch, and from 1603 to 1714 for the Stuarts, scarlet and gold.

The standard was either blunt-ended or swallow-tailed and displayed the livery colours, usually by division along the length of the flag, as well as badges. Later, mottos were painted on the standard, too, in narrow panels diagonally, or bendwise, across the flag. It was usually fringed with the colours used on the standard.

In Tudor times, standards showed the red cross of St George on a white background next to the flag pole, then the badge or crest of the person to whom the standard related, and the motto. There were no coats of arms on these early standards. This is different from today. Standards are still awarded by the Kings of Arms, which show now the coat of arms of the bearer nearest to the flag pole, then the badge or badges, sometimes with the crest and with the motto in diagonal strips. The actual standard may be of one colour or two, which may or may not be taken from the tinctures of the coat of arms. Many feel that it is a pity that banners and these standards granted to individuals and organisations are not flown from flag poles much more often.

Guidons and gonfannons

Guidons are small standards. Historically the red cross of St George on a white background was positioned closest to the flag pole and then the principal badge on the livery colours. There were no other badges and no motto. It was a conveniently sized flag compared with the standard, and often just as easily recognised. Today, if a guidon is granted, the cross of St George next to the flag pole is usually replaced by the bearer's coat of arms.

The sight of a forest of **gonfannons** held aloft nowadays at 'mediæval' festivals in Italy, such as the Palio in Siena, is truly spectacular, and gives some clue as to what a real tournament must have been like. Gonfannons are personal flags showing an individual's or a company's (or a guild's or church's) coat of arms, but are supported at the top, rather than at the side, and so are easier to identify, but more difficult to carry. Gonfannons are not often seen for the display of arms in Britain, but are used in churches for ceremonial purposes.

Orders and decorations

Most countries have some sort of awards system to recognise and honour those who, it is felt, have attained a certain status through good works, skill, their contribution to society or whatever. In Britain for those who bear arms, it is sometimes appropriate to indicate that they have received such

*Insignia of Office.
Insignia of the Earl
of Mar and Kellie –
Hereditary Keeper
of Stirling Castle.
The Royal Crown of
Scotland is shown
inescutcheon on the
centre of the shield.*

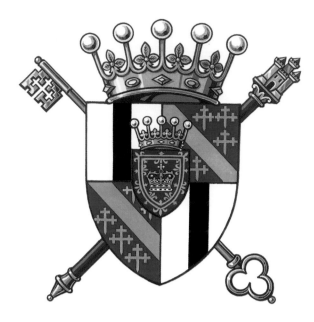

*Ecclesiastical
Heraldry.
 Ecclesiastical
hats as used above
shields and painted
in different styles.
Top – a Roman
Catholic bishop
with Patriarchal
Cross;* middle – *a
Church of England
dean;* bottom –
*Church of England
priest – the Tudor
rose denotes a
member of the
Royal Household.*

*Right.
Arms and Insignia
of the Bishop of
Durham, who bears
a sword crossed with
a crozier because of
his historical role as
Prince Bishop of the
area.*

*Illustrations by
Timothy Noad.*

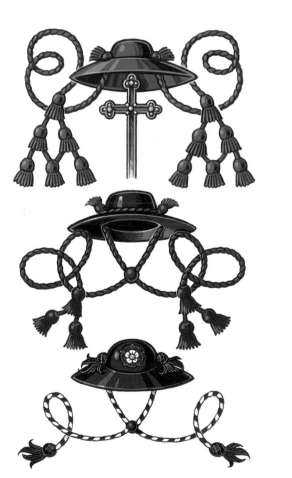

an award by displaying this with their coat of arms. For
some the badge of the order is suspended on its ribbon
below the shield and for higher grades their shield is surr-
ounded with the circlet of the order as well.

The Order of the Garter

The premier order of British chivalry is the **Most Noble
Order of the Garter.** It was founded in about 1348 by the
English King Edward III. The sovereign is head of the order
which meets at a Chapter of the Order in the Throne Room
at Windsor Castle when there are new knights. The limited
number of members receive any Knights or Ladies Elect
who are invested by the sovereign. Then they process to the
Chapel of St George at Windsor wearing the magnificent
dark blue velvet mantle with the eight-pointed badge of the
order embroidered on the left breast. They wear dark blue
velvet hats with a white ostrich feather plume. The dark
blue velvet garter is worn just below the left knee for
Knights of the Order, and below the left elbow for Ladies
at the Investiture only. It is embroidered in gold with the
motto *Honi soit qui mal y pense* (Shame on him who thinks
evil of it), traditionally being the response of King Edward
when Joan of Kent, who was later to become the Princess
of Wales, dropped her garter. As well as this they wear the

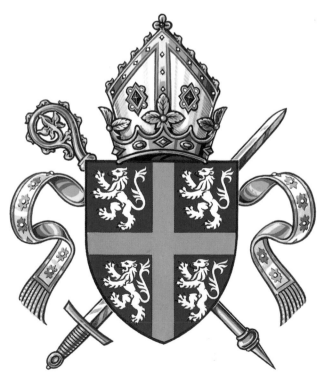

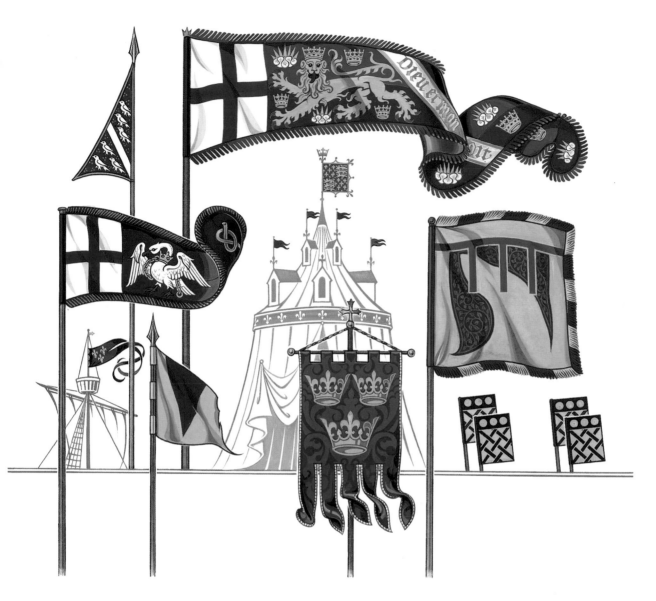

White ensign

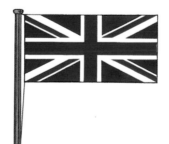

Union Flag

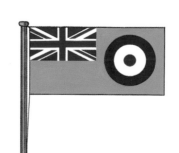

RAF ensign

Illustration by Timothy Noad.

Heraldic Flags, showing arms associated with King Edward III and his contemporaries.

1 Royal Standard of King Edward III with his badges and motto.

2 Royal Banner of King Edward III in the form of a weathervane on a tournament pavilion.

3 Guidon of Ralph, Lord Stafford (who is on the Hastings brass with King Edward III, St Amand); the principal badge is a chained swan and the subsidiary badge the Stafford knot.

4 Gonfannon of St Edmund King and Martyr, which are attributed arms as they occur on the tomb of King Edward III's son, Edmund of Langley.

5 Banner of Sir Hugh Hastings, (died 1347), as on his tomb brass at Elsing, Norfolk, showing arms of a maunch with a label for difference.

6 Banneret of Sir John Chandos, whose pennon tails were cut to promote him in 1367.

7 Banneroles of Lord St Amand in the form of a funeral procession.

8 Lance pennon or **pennoncelle** of Sir Geoffrey Luttrell as in the Luttrell Psalter.

9 Decorative swallowtail **pennoncelles.** on a tournament pavilion.

10 Ship pennant of King Charles V of France showing 'France modern'.

splendid collar of the Garter consisting of twenty six Garters encircling a red rose alternating with interlaced knots. The badge of the Order is suspended from the collar and shows St George on horseback killing the dragon. The badge itself is known as the *George.*

St George's Chapel at Windsor is fascinating for its heraldry. Members of the Order each have a specific stall, above which hangs their fringed silk banner, 150 cms (5 feet) square, showing their coat of arms. Their carved wood crests rest on metal helmets, with wooden swords and mantling of the correct tinctures. Their coat of arms is also displayed on an enamelled copper stall plate which remain *in situ* after their death. These stall plates form a wonderful record of heraldic design and custom. Interestingly, the early helmets on the stall plates face the altar, and so those on the left-hand side of the altar are unusual in that they face to the sinister.

The Garter is displayed around the shields of Knights or the lozenges of Ladies of the Order as part of their coat of arms.

The Orders of the Thistle and St Patrick

The Most Ancient and Most Noble Order of the Thistle has a special chapel for its use in St Giles Kirk, in Edinburgh, Scotland. It is not contemporary with the rest of the building, but interesting nevertheless. The Knights and Ladies of the Order display their arms on banners and stall plates which can be seen in the chapel. On their achievement of arms the collar of this Order encircles the shield and the badge of the Order hangs below it.

Although the **Most Illustrious Order of St Patrick** was instituted in 1783, later than the previous two, there are now no Knights of the Order. However the sovereign has not dissolved it and so it must still exist. The very attractive collar of harps and roses was displayed by the bearers around their shields, with the badge of a crowned harp hanging below.

Other Orders

There are other Orders of Honour where the collars and circlets are shown encircling a shield with the badge suspended below, such as **The Most Honourable Order of the Bath, The Royal Victorian Order,** and the higher categories of the **Most Excellent Order of the British Empire.** For members and Officers of the Most Excellent Order of the British Empire, for example, their badge is suspended from a ribbon of the colours below the shield.

Similarly decorations or medals, such as the **Victoria Cross, the George Cross** and the **Albert Medal,** awarded by the sovereign can be shown hanging from their appropriate ribbon below the shield.

Knights Bachelor

Knights Bachelor are not attached to any order but stem from the original system of knighthood which existed before these later orders were instituted. In 1926, King George V awarded a badge which knights can suspend on a ribbon below their arms. The badge refers back in time to knights winning their spurs as the vermilion and gold oval medallion shows not only spurs but a sword, belted and sheathed and a sword belt.

Baronets

Although the title is hereditary, **Baronets** are not members of the peerage. They were first created in 1611 by the English King James I in connection with the colonisation of Northern Ireland. The symbol for Ulster is a red right hand and to mark this fact, Baronets show an augmentation to their arms of an escutcheon or a canton which is *argent, a sinister hand erect, couped at the wrist and appaumé, gules* (white, an upright red left hand, palm facing outwards, which is cut off at the wrist).

In a similar way, the **Baronets of Nova Scotia,** created in 1625, mark the colonisation of Nova Scotia (Latin for 'New Scotland'), and on a canton or escutcheon show the arms of that province – *argent, on a saltire azure an escutcheon of the Royal Arms of Scotland* (white, with a blue diagonal cross on which is placed a small shield of the Royal Arms of Scotland).

The badges of Baronets of Great Britain and of Nova Scotia are suspended below the bearer's shield from an appropriately coloured ribbon.

Insignia of Office

There are six individuals or groups who may also indicate their office in various ways on their coats of arms. The Duke of Norfolk is the **Hereditary Earl Marshal,** which is indicated by his two gold batons, tipped with black. The Earl of Shrewsbury is the **Hereditary Lord High Steward of Ireland,** and shows this with a white wand behind his shield. Appropriately enough, a key and baton indicate the office of the **Hereditary Keeper of Stirling Castle,** who is the Earl of Mar and Kellie. **The Lord Chief Justice of England, Sergeants at Arms, Kings of Arms and Heralds** all display a collar of *SS* around their arms. That of the Kings of Arms is silver-gilt with a portcullis on each shoulder.

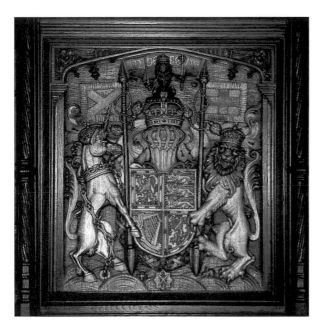

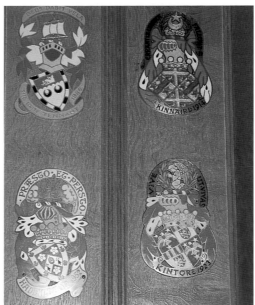

Far left.
The Royal Arms in the Chapel of the Most Ancient and Most Noble Order of the Thistle, St Giles' Cathedral, Edinburgh. Note the position of the Scottish arms in the first and fourth quarters.
 The Chapel was built for the knights between 1909 and 1911 by the Earl of Leven and his brothers, and was designed by Sir Robert Lorimer. The knights attend a service in the chapel each year on the Sunday on or following St Andrews Day, 30th November. They wear their robes of green velvet with the star of the order on the left shoulder and a plumed hat of black velvet. They have two medals which show St Andrew – one is worn on a green ribbon and the other is suspended from a collar of gold thistles.

Left.
Coats of arms in the Thistle Chapel.

Ecclesiastical heraldry (see page 238)

The Church has a very long history, longer than that of heraldry, and seals with a variety of Christian symbols were used by those in authority to give veracity to documents. With the beginnings of heraldry many of the Christian symbols were used as charges on shields, and the devices on seals were often simply transferred to become part of the coat of arms. Some of these symbols used on shields are obvious – keys for St Peter, birds for St Frances of Assisi, a money bag for St Matthew and a spiked wheel for St Catherine.

Others are more obscure as the story behind their origin is not as well known – a basket of fruit or flowers for St Dorothea, a candle and the devil for St Genevieve, a cow for St Bridget and eyes in a dish for St Lucy. At the time these devices were used, their symbolic nature would have been clear.

These symbols of the saints used on seals were repeated in the arms of some Sees, such as the keys of St Peter for the See of Peterborough. As well as these the the mitre of the bishop and the crosier – the pastoral staff – feature on shields and crests.

To signify their rank **Archbishops** and **Diocesan Bishops** impale or combine their personal arms with that of the See. Their office is deemed to be the more important and so is on the dexter, or right hand side of the shield, with their own arms on the sinister side. Other **Bishops** do not combine their own arms with that of office and use only their personal shield. However, on the achievement of arms of all Bishops, the helmet, wreath, crest and mantling are replaced with the Bishop's hat or mitre, and two crosiers may be placed behind

the shield, crossed diagonally. The mitre, positioned above the shield, is usually painted gold, and can be shown with jewels painted in colour or in gold. The fringed ribbons or infulae, on the back of a bishop's hat flow around it. Additionally, the **Bishop of Durham** has a ducal coronet surrounding his mitre, at the top of his shield. He may also cross diagonally the pastoral staff with a sword behind his shield. This refers to the special position of Durham as a Palatinate.

Other Anglican clergy, not bishops, often display their arms with shields, helmets, wreaths and mantling and crests. However, some feel that the aggressive nature of these items is not compatible with their pastoral role, and prefer to use ecclesiastical hats. It is a matter of choice for the individual and a Warrant was issued by the Earl Marshal in 1976 to certify this.

Roman Catholic clergy do not use a helmet, wreath and mantling, crest, nor indeed a motto. Instead, an ecclesiastical hat of a particular colour with a set number of coloured tassels indicate the rank of the bearer. The significance of these differently coloured hats varies from country to country, and it was felt that some form of standardisation was necessary for the granting of arms in England. In 1967 the Earl Marshal issued a Warrant indicating the insignia to be used, after having consulted with the appropriate authorities. Even though an individual may be of the peerage and entitled to include a crest or coronet in the coat of arms, this is not possible due to Papal decree.

In England the arms are usually displayed on a shield, however in Europe, the arms of those who serve the church are often shown perhaps more attractively in an oval or a cartouche.

Orders and Decorations.

Centre: Insignia of Office of Garter King of Arms with coronet, crossed sceptres and collar of ss encircled by the Garter.

From the top clockwise: Sash Badge of a Knight of the Thistle; Order of the Bath (Military) Badge as worn by Knight Commander and Companion; Royal Victorian Order Badge as worn by Knight Commander and Companion; Badge of a Knight Bachelor; Order of the British Empire Badge as worn by Knight Commander and Commander (riband of the Military Division to the right); Order of St Michael and St George Badge as worn by Knight Commander and Companion; Order of the Bath (Civil) Badge as worn by Knight Commander and Companion.

Illustration by Timothy Noad.

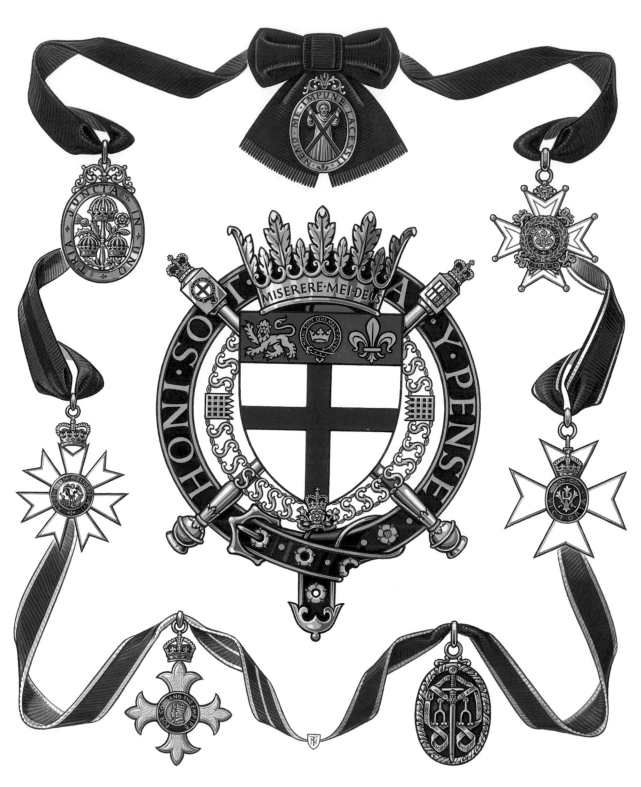

Designing and Painting a Coat of Arms

In historical times people who bore coats of arms displayed them in many different ways. These designs would appear not only on a shield, but on standards and banners, on pennants and guidons, on the clothing or badges worn by retainers, the coverings or bardings of horses, on tapestries and gonfannons hung in castles and great houses and even on the dresses and cloaks worn by ladies of the house. It must have been a splendid sight arriving at a castle to be met with all these wonderful colours and designs, and in those times people were certainly not reticent about showing in as many different ways as possible that they were legally entitled to display their arms.

Nowadays, there is rather a reluctance to be so outwardly flamboyant, and apart from perhaps a discreet use of a crest on letter headings or a ring with the coat of arms engraved as a seal, people do not display their arms in public to any great extent.

Despite this apparent reluctance in those legally entitled to display arms, there are many places in Europe and America which advertise for sale items associated with heraldry. From their sales pitch it seems that just about anyone can display as their own a coat of arms connected in some way with their name – on a 'parchment' scroll, or a paper-weight, even a key ring or a small shield. This is, in fact, not the case, and there is an element of deception on the part of these companies in so doing. In England, Wales and Northern Ireland Grants of Arms are granted by the Kings of Arms to individuals and there are strict rules and regulations about the displaying of a coat of arms to which an individual is not entitled. For the College of Arms it is necessary to prove an inheritance through a direct male line; in Scotland, under the jurisdiction of the Lyon Court this can be through a male or female line. One of the tasks of the present-day heralds is to trace a genealogical connection to verify a rightful succession to arms. Displaying a coat of arms to which an individual is not entitled is illegal, and the Earl Marshall's Court at the College of Arms was built for the purpose of hearing such cases.

However, a new grant of arms can always be applied for and made. This is not quite so elitist as it may seem to an outsider. Grants of arms are made to eminent men and women,

Coat of Arms for Black.
The blazon is:
Or on a Chevron Azure three Roundels Argent each charged with an Annulet Sable therein a Roundel Or on a Chief Sable a Balance Or and for the crest upon a Helm with a Wreath Or Sable and Azure an Arm embowed the hand proper habited Sable holding three Roses Gules slipped and leaved proper Mantled Sable and Azure doubled Or.

Illustration by Timothy Noad.

but there are no set guidelines. The applicant may have been honoured or decorated by the crown, have a university degree, contributed to national or local charities, good causes or government, or perhaps have held a commissioned rank in the armed forces. Essentially the person has to have some standing and a name in the community so that the awarding of such an honour in granting the right to bear arms is not in any way brought into disrepute. Arms can also be granted to schools, professional institutions, businesses and companies. For the last, commercial enterprises should have been established for a reasonable length of time, have a good reputation, be financially sound and be of some value to the community.

Of course, nothing is without cost. That for a grant of arms has to cover not only the actual work involved in designing, painting and writing the vellum scroll – the duties of the herald painter and the scrivener respectively, but also the herald's work, and an element of the fees has in addition to go towards maintaining the building of the College of Arms itself. Unlike some other institutions there are no subsidies to the College of Arms' building, which, because of its age needs a degree of regular care and maintenance. Despite all these financial factors, having a beautifully painted and hand-written vellum scroll to keep and display, and the use of an exclusive design for an individual and his or her successors to use seems remarkably good value for the sum involved.

Once an application to the College of Arms has been made by an individual or organisation, and steps have been taken to ensure their eligibility, a formal approach is made to the Earl Marshal, the Duke of Norfolk, who has jurisdiction over the officers of arms. The formal petition is called a **memorial** and is prepared by the herald at the College who is dealing with the grant. When it has been signed by the applicant, and the appropriate grant fee enclosed, the Earl Marshal should, in due course, issue his Warrant instructing the Kings of Arms to proceed.

Then the interesting part of designing a coat of arms begins. Various elements of that person's background will usually be considered – his or her school, university and occupation may well feature. Certain aspects may be taken from these coats of arms of school or university – perhaps the colours may be a key factor, or a charge from a related professional society may be used. Sometimes the applicant may be related to a family which already has a coat of arms, and one part of that design may be incorporated. There are so many factors which contribute to a lively design, and which make the granting of arms so personal. Often the heralds try to work out a play on the applicant's name, such as bows on the shield of the Bowes family, rams on the shield of Ramsey and wings on Wingfield's shield. This is canting arms. (See page 218).

Perhaps the choosing of designs and charges on a shield and for a crest may be easier to understand if a fictitious grant of arms is designed. This is for an individual who wishes to be granted a coat of arms to pass on to his children. The person's name is Black, and he is a graduate of Christ Church, University of Oxford. He was born in Lancashire and he now works as a chartered accountant, spending much of his time working with computers. After discussion with the heralds at the College of Arms, and searches to ensure that there is no other coat which is similar, his blazon could be something like this:

Or on a Chevron Azure three Roundels Argent each charged with an Annulet Sable therein a Roundel Or on a Chief Sable a Balance Or; and for the crest upon a Helm with a Wreath Or Sable and Azure an Arm embowed the hand proper habited Sable holding three Roses Gules slipped and leaved proper Mantled Sable and Azure doubled Or. (See page 243.)

The gold of the field represents the building stone of Oxford, and the blue of the chevron, Oxford University. The black chief clearly alludes to his name. The balance indicates the fact that he is a chartered accountant as it is taken from the arms of The Institute of Chartered Accountants in England and Wales. The heralds are often able to link a modern invention with an ancient heraldic device and ingeniously the roundels on the chevron represent a very up-to-date charge on a shield – computer disks. His crest shows a bent arm, dressed with a black sleeve, holding three red roses, indicating his origins from Lancashire. Where the word 'proper' is used in heraldic terms it means that the charge is shown in natural realistic colours, so the rose has a green stalk and leaves. The wreath and mantling combine the colours of the shield – gold, black and blue. The full coat of arms then is in some way a brief biography of that person's achievement and connections.

A grant of arms, which is unusual in that it is the first of its kind, was made to the Right Honourable Betty Boothroyd, MP, Speaker of the House of Commons. She is the first woman to hold the post, which, as the person who is there to keep the lower chamber of the Houses of Parliament in order, is no easy task! The blazon for her arms is: *Gules a representation of the Mace of the Speaker of the House of Commons palewise surmounted in base by a rose Argent barbed and seeded proper over all a fess Gold and owl guardant proper between two millrinds Sable. Motto: I speak to serve.*

The background to the chosen devices is very interesting and again is a biography of sorts. Betty Boothroyd has been a staunch Labour Member of Parliament for many years, and the colour red, being the colour of the political party, was a natural choice for her coat of arms. The Speaker's Mace is obvious as it is the symbol of her office. Betty Boothroyd was born and grew up in the town of Dewsbury, Yorkshire. The town itself and the Technical College both have an owl on their coats of arms. This appears on her coat of arms, as does the white rose of Yorkshire – the emblem of the county. She is Member of Parliament for West Bromwich West, which

has a history of metal working, and the historical device of millrinds represent the iron and brass foundries which were the principal industries of the town.

Betty Boothroyd is unmarried, and thus her arms are shown on a lozenge with a bow at the top painted in House of Commons green. The carved and painted hardwood panel is displayed alongside the arms of previous Speakers in the state rooms at the Palace of Westminster. Her arms were also used as a design to decorate bottle labels, and this is shown on page 267.

Painting a coat of arms

Painting coats of arms is both interesting and fun. It can also provide quite a challenge! It combines the skills of an artist, a miniaturist, an illuminator and a scribe with technical drawing. Animals and other charges are often less than a centimetre (0·4 inch) in size, yet have to be clearly and without doubt the animal in question. This is not always an easy task. Interpreting the blazon reinforces a technical knowledge of heraldry, and designing a complete coat of arms so that it balances and is in harmony needs a good eye.

Having been granted a coat of arms, the herald painter will have drawn and painted a full colour representation of the blazon on the actual grant of arms which is signed by the kings of arms and presented to the applicant. However, the more important aspect of the grant of arms is not this painting but the wording of the blazon. The style of the painting may vary considerably from artist to artist and from age to age, but as long as it is true to the words in the blazon then it is heraldically correct.

John Brooke-Little, previously Clarenceux King of Arms, has written '...the blazon or a lion rampant gules is capable of many artistic interpretations. The lion may be large or small, have three, four or five claws on each paw and may be thin, fat, smooth, hairy, angry, placid, highly symbolic or alarmingly zoological, but he must be a lion and he must ramp and he must be clearly visible. The field may be either painted in gold, imitation gold, or any shade of yellow which clearly represents gold. Likewise, the red of the lion, as long as it is unmistakably red, does not have to conform to a British Standard colour and whether or not the lion is shaded is a matter for the artist to decide. The actual shape and type of shield, provided it looks like some sort of possible or impossible shield, is also a matter of design. In late Victorian grants of arms the shield was often an impossible, curvaceous thing with a heavy gilt frame, but as the heralds of the day were happy with it who are we to condemn it on any grounds other than aesthetic?' (from Boutell's Heraldry)

Occasionally when clients ask for a coat of arms they expect an exact copy of a not very heraldic, and perhaps not very well done original. In these circumstances it is better to quote John Brooke-Little, and paint an improvement.

Fashions in drawing and painting heraldry have changed considerably over the years. In Victorian times the wreath, twists of material sitting on the helm, were usually drawn as a rigid horizontal pole – similar to a barber's pole. This would have been physically impossible unless the material was stiffened or starched considerably, which was not very likely. In a slightly earlier period, the mantling was so free flowing and flourished, that it almost overwhelmed the shield itself. Now there has been a return to the clear and bold mediæval style of painting, which is truer to the roots of the art of heraldic painting than more affected styles.

To begin to design and paint a coat of arms you should always start with the blazon; this is the key. You may need a reference book to interpret some of the more obscure terminology, but it is important to have a sound picture of what are the various elements which will make up the design.

Drawing the shield

Determining what is to go on the shield will help to decide on the shape of it. Some charges look better on a triangular shield with a point, whereas others sit more comfortably on a squarer-shaped shield. An eagle displayed looks magnificent on a triangular-shaped shield, for example, but the claws and lower feathers have to be a little contrived to fit on to a square shape. On the other hand the four limbs of a lion rampant can be pulled out to sit very comfortably on a squarer-shaped shield. If a shield is quartered, it is certainly better to choose a shield which has straighter, rather than tapering sides. If the charges would seem to fit equally well on almost any shape of shield, then it is a good idea to research into the period when the grant of arms was made and design a shield from those times. If this is not possible, then the best advice is to draw the shape of the shield which you find to be the most attractive, or simply one which is the easiest to draw.

As in any other form of art or craft, when drawing and painting coats of arms you should use the best equipment. This is not necessarily the most expensive. Choose pencils which have a hard point, rather than soft pencils which smudge. You can sharpen 2H to 4H pencils so that the points stay sharp for some time. A ruler with a metal edge is an advantage because it is unlikely to have any nicks or dents along the edge, although a new plastic ruler, which is looked after, is perfectly adequate. Choose compasses which have a screw device for fixing the distance between the two arms, so when making identical curves time is not wasted on repeat measuring. Set squares and protractors are also useful for ensuring that lines are horizontal or vertical and angles are sharp and accurate.

Drawing shields

a. A heater-shaped shield*

One of the easiest of shields to construct uses a ruler and a set of compasses, and needs very little artistic skill. Use a ruling pen, which can be filled with coloured paint to draw the straight lines, and fit this also into one end of a set of compasses when drawing the curves. It is a good idea to practise using a ruling pen if you are not experienced.

(*So called because it resembles the base of a flat iron.)

With a pencil and ruler on your rough, or with a ruling pen on your neat copy, draw a straight horizontal line which is any length, as long as it is easily divisible by 3.

Now draw two vertical lines at right angles (90°) to the horizontal line. These should be one-third of the length of the horizontal line, and end at points A and B.

Place a compass point at point A, and stretch the arms of the compasses until the pencil or ruling pen part is exactly at point B. Draw a curve. Now place the compass point at B, and stretch the arm to point A. Draw a curve from this point and you will find that the shield is a pleasing heater-shaped shield, ready for your design.

b. A narrow shield

John Ruskin gave the guidelines for drawing a narrower, perhaps more elegant shield. This shield is based on a square, which can be of any size.

Decide on the width of shield you want and make the top line into one side of a square. Mark on the diagonals of the square and a vertical line indicating the mid-point.

Divide this vertical line in three, and mark on the half way point of the top third. Use this mid point to draw a horizontal line extending beyond the sides of the original square and cutting it at points A and B.

Place a compass point at A, extend the other arm until it reaches the half way line of the original square and make a semi-circle, so that it cuts the horizontal line at C. Repeat this with the compass point at B, making a semi-circle which extends to the right, cutting the horizontal line at D. Now place a compass point at C, extend the compasses until the other point touches B, and draw a curve from this point to the vertical mid point line. Repeat this process with the compass point at D stretching to A. You may like to ink in, or make darker the top straight line of the square and the parts of the sides which are straight to complete the shield.

c. A squarer shield

The two shields so far use only mathematical instruments for construction, and so are useful if you are not sure of your painting skills. Some other shields are drawn either completely or partially freehand. A square-shaped shield which is the preferred choice for a quartered shield, or one with charges which fit best into this shape is constructed mainly by straight lines, with only a little free hand drawing at its base.

Draw the top and side lines of a shield the size you have planned it to be. Mark on the mid point of the top of the shield with a vertical line. Sketch in a curving shield shape on one side. When you are happy with this shape, go over the sketched lines with a solid pencil line. Draw a straight vertical line on a piece of tracing paper with a ruler. Place the tracing paper over your drawing, matching this vertical line with the one on the paper. With a pencil draw over the solid curved line at the bottom of the shield. Turn the tracing paper over, match up the vertical lines again and draw over the back of the curved line. There should now be matching curved lines at the bottom of this shield which simply need to be inked in.

d. A round-based shield

This very simply constructed shield does not use any freehand drawing either, and may suit particular designs which you have to put into a shield-shape.

Draw three straight lines – the top and sides of the shield, the sides being longer than the top. Then draw a line showing the mid-point of the top of the shield. The bottom curve of the shield is made of a semi-circle drawn using a set of compasses. Place the point of the compasses on the mid-point line and extend the other arm until it touches the side of the shield. Then draw a semi-circle from this side until it reaches the other side.

When drawing shields using compasses you may not want the points to show on your neat version. To avoid this use pieces of masking tape. When you have drawn the lines and know where you will be placing the compass points, continue the vertical line for another centimetre (0·4 inch). Now draw a short horizontal line so that it crosses the vertical line at the point of your measurement. Cut off a tiny piece of masking tape, about 2 mm (0·1 inch) wide. Fold this until it makes a small cushion. Stick this carefully on to your paper at the spot where the compass point will go. Using the pencil lines just drawn as guides carefully make a pencil mark where the compass point should be. The masking tape will take the compass point and there should be no pin-prick on the paper when it is removed. You may have to practise this once or twice to ensure that your markings are accurate and the compass point is not pressed too hard into the masking tape.

Designing the ordinaries and charges

Painting heraldry is not always straightforward; it often means that historical, botanical, zoological and other studies are necessary. It is important that a wolf is drawn and looks like a wolf, rather than a fox, if that is the blazon; that a particular type of flower is correctly depicted if specified; that a carriage clock rather than a wall clock or bracket clock is drawn on the shield if the wording in the blazon states this.

Charges are often used on shields which are non-existent in real life now – bosons and gurges, molets and clarions, for example. However, once you are interested in heraldry, these obscure terms soon become familiar.

The shield itself may take up about half the area of the design of a full achievement of arms, which should be balanced to work well. Having got the basic shield shape the ordinaries and charges should be designed to sit well within it. When drawing these always remember that the essence of heraldry is that what is on the shield should be seen easily and clearly, particularly at the height of battle, when there was not a lot of time to consider what exactly was on a particular shield. When you have finished always place your colour rough some distance away to see if what you have done matches this ideal. Of course, some later shields are very much more complicated than the early mediæval ones, but the charges and ordinaries should still be clear.

As a matter of principle, ordinaries should take up visually about one-third of the space on the shield if it is not charged, and slightly less if there are charges. However, the aim is for an harmonious whole, so the designer has to ensure that the shield looks balanced.

Charges on the ordinaries are drawn so that they are vertical unless they are on a bend or saltire, when they slope with the direction of the charge.

On the shield itself the charges should be bold, fit well into the space – be neither too small or cramped, nor too large and squashed. When drawing animals, start with the skeleton form so that they remain functioning as far as possible. This means that the limbs on an animal such as a lion or horse should look as though they are attached at the right places, even though the extremities may have to be slightly manipulated such that they fit the available space. Sometimes charges on small shields may be tiny – a matter of only a few millimetres (tenths of an inch) in height. Having drawn the skeleton form it is then easy to build up the shape from this.

It is better to use mathematical drawing instruments rather than relying on a shaky hand and a not very experienced eye. If there are three roundels on a chief, they should all look the same and have the same dimensions. Use a set of compasses for this, or a special stencil with outlines of circles of various sizes. However, charges on various places on a shield do not necessarily always have to be the same size. A shield showing a chevron with two roses in chief with one in base, may well look much better if the top two roses are slightly smaller, and the lower rose larger, especially if this fits the available space better. Similarly, it is often an improvement to paint charges with very slight differences. Three boars' heads couped may all look the same at first glance, but have very small changes, such as one having more pointed ears, another having more teeth, and a third having a meaner look to its eye. This is the exciting part of interpreting a blazon – adding your own personal stamp to the painting.

It is a matter of personal taste whether the charges and ordinaries on the shield are modelled so that they look three-dimensional. Whether they ever were is debatable, although the shield of the Black Prince (1330–1376) which is still displayed at Canterbury Cathedral in Kent shows lions which are modelled and stand proud from the shield. Perhaps a few lines of shadow and highlight are sufficient to give the impression that the shield is not completely flat and then even fewer indications, if wanted, for the charges and ordinaries.

The helm, wreath, crest and mantling

The helmet, wreath and crest should take up the remaining half of a coat of arms design.

The helm

The relaxing of rules by the College of Arms now means that a helmet can face the same way as the crest. In the past anomalies occurred where a helm was shown affronty, or facing to the front, with a crest in profile. The helmet should take up just under half of the remaining space and be so designed that it looks as if it is sitting comfortably on the top

of the shield, rather than balancing precariously on the edge. In real life it would be very difficult for the helm, which fits over the wearer's head, to balance on the narrow edge of a curving shield, however it is the job of the artist to make the impossible sometimes possible!

Some early designs of helms would have been almost impossible to wear as the neck appeared to be so narrow. Helms should look as though they could be worn, and should also be clearly three-dimensional.

Visits to local museums or collections of armour are invaluable in that you can make studies of the way in which helms work – how they are bolted together, where the rivets are, what decorations they have and so on. However, sadly most of the very old helms are lost to us now in that the originals were melted down to provide the metal for a newer design of helm.

I always use watercolour when painting helms, rather than gouache. Watercolour sits well on vellum requiring very little paint, and it is possible to paint a three-dimensional effect by gently moving the paint to create shadows and denser colour. Remember always to include a little of the colour for the mantling in the shadows of the helm. It is metal and would reflect any colour close to it. *Neutral tint* is a good choice of watercolour for the steel helm of a gentleman and esquire, while *Payne's grey* represents silver well for a peer's helm. However the best mix for grey in my opinion is burnt sienna and ultramarine, and different proportions of these two colours will serve you well. (See page 310) for more information on colour. Interest can be added with bolts and rivets. There could be gold additions and patterns on the helm of a peer to make this more interesting.

The wreath

The six twists of material which form the wreath should also be painted realistically, as if it is soft material which sits on the helm. The temptation may be to paint these as a straight line, which would be an inaccurate representation. Use modelling colours here so that the wreath actually looks like strips of differently coloured material twisted round.

It often helps to practise painting the wreath from real life, and is not too difficult to do. It does not matter that the colours are exact, simply twist some plain coloured long scarves, or strips of plain material round one another and curve them into a circlet. It may sound a little bizarre, but the best effect is to drape this circlet of scarves over an upturned glass pudding basin or mixing bowl. If the fabric is simply placed on a table to paint you will not get the full effect of the material sitting on the head-shape of a helm. Notice where the light falls and where the shadows are. Of course, heraldry wreaths are very often stylised but you will at least be painting them having had the experience of seeing what they look like in real life.

The crest

The crest should take up just over half the space for the helm and crest together. Sometimes the crest is simply a charge from the shield, at other times it is something completely different. Again some research may be needed here to ensure that your painting of the crest is true to the blazon.

The mantling

Mantling was originally a piece of cloth which protected the helm. Mediæval styles show this well. A little later this cloth twisted and turned a little, perhaps with tassels, as though it had been cut by an opponent's sword. Even later still the design became so convoluted that it resembled seaweed hanging either side of the helm. This style is not to be recommended unless designing a period piece.

The mantling is usually drawn and painted today in a realistic style with twists and turns of cloth surrounding the crest and shield and forming a frame. It is one of the parts of an achievement of arms where life and vigour can be introduced as the material swirls and curls about itself.

It is worth taking the constituent material into account when designing mantling. If one of the tinctures is a fur, for example, this would be heavy and the cloth would hang in a different way to lighter material.

To add richness to your design it is often a good idea to paint the gold and silver of mantling in gold or silver gouache or in real gold. (Real silver tarnishes within a few years even when the work is framed and so using this is not advisable.)

Occasionally the mantling is charged – semy – with various devices, roundels, buckles, knots. These should be painted as though they were part of the material itself and so twist and turn with the design, rather than be simply painted on flat afterwards.

It is worthwhile again to practise painting actual pieces of material to notice where shadows and highlights lie. This gives a very good grounding to painting mantling.

Supporters, the compartment and motto

Supporters should be designed and painted so that they look realistic. They should support the shield, usually with one limb, rather than the shield supporting them. They should be larger than the shield, but not than the whole achievement of arms otherwise the balance is wrong. Any escutcheon or collar in the blazon should hang or circle supporters in a natural way, and not look as if it has been added flat, as an afterthought. Heraldic supporters are strong and proud so design them with this in mind.

Skeleton forms of a lions, a stag, a horse and an eagle.

Illustration by Timothy Noad.

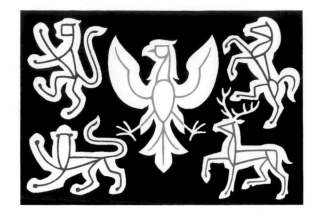

The compartment

This is not always blazoned, but for supporters to support the sometimes this can be by the ribbon containing the motto, or a scrolled decoration often referred to as a 'gas bracket', at other times a mound of some sort is appropriate. If the compartment is not blazoned then it is acceptable to paint a grassy mound.

Painting heraldic roses based on a circle.
Divide the circle into five sections, with a yellow centre. Add a central line to each red segment, and green 'leaves'. finish with modelling colours.

Painting a fleur-de-lis from a lozenge-shape.
Paint a lozenge, with the basic fleur-de-lis shape marked. Paint in the detail; add the modelling colours and paint in the background (which here is white).

Painting a row of tiny lions.
Establish the size and shape in outline. Paint in the detail and add the modelling colours. Tidy up the background.

Illustrations by Timothy Noad.

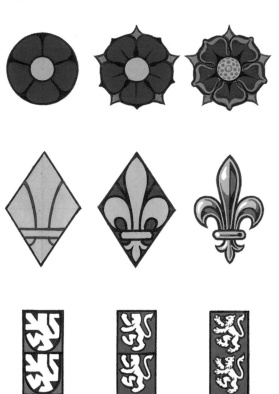

The motto

The scroll or device on which the motto is to be lettered can form an important part of the overall design. Although it is commonly found at the bottom of the shield, it does not have to be there and some excellent designers have used the scroll at one side of the shield or towards the top to balance an unusual arrangement as on certain Garter stallplates.

If you decide to paint the scroll then use a very dilute paint where the writing will be. Dab some powdered gum sandarac at this point (see page 297) to make writing on the paint easier, otherwise the ink or paint used for writing will bleed into that for the background and the effect will not be sharp.

Practise writing out the words of the motto on a separate piece of paper until they are the size which will fit in the scroll and they look balanced and even. Place this paper a little above where you are to write on your rough and copy in the motto.

Paints for heraldry

Bearing in mind John Brooke-Little's comments about colours in heraldry (see page 245), it should be emphasised that there are no specific set colours to use. There are guidelines, however, but the more important point is that the colours should balance, and that one colour does not dominate all the others. The best paints to use are artists' gouache as they are opaque.

Using the paint

Very often the charges on shields will be slightly modelled to a three-dimensional form. Mantling, the wreath and the crest should also be painted so that they look realistic rather than flat. For this, modelling colours for the main heraldic tinctures will be needed in addition to the basic paints.

Shields can be outlined in different colours, but often red ochre is used as it complements the colours in heraldry. In fact it is an interesting exercise to paint the same shield a number of times, but with a different colour for the outline, and compare the effect. For balance, it is probably better to choose a more sober colour for outlining, which may be a darker shade of the principal colour of the shield, or possibly something like Burnt Sienna mixed with a little Jet Black.

Paints and Surfaces

See the Reference section which starts on page 291 for more information on handling and mixing paints, selection, use and care of brushes, paper and vellum.

Tinctures and their suggested modelling colours.

Tincture		Gouache colour	Modelling colours
Or		Gold, real gold or artificial, or brilliant yellow mixed with yellow ochre	Burnt sienna and vandyke brown
Argent		Silver metallic gouache, real silver, or white	Dark and light grey
Gules		Scarlet lake, with a little orange lake light, and a touch of white	Havannah lake and alizarin crimson
Sable		Jet black or lamp black with white to make dark gray	Jet black and shades of grey, with white for highlights
Azure		Cerulean blue with a little ultramarine and a touch of white	Cobalt and indigo
Purpure		Light purple and a touch of white	Indigo mixed with light purple, alizarin crimson
Vert		Winsor emerald or permanent green deep with a little white	Permanent green deep mixed with a little indigo,
Tenné		Burnt umber and a little white	Burnt ochre
Sanguine		Alizarin crimson	Havannah lake
Murrey		Magenta and white	Alizarin crimson
Vair		Prussian blue and white	Prussian blue/black, greys
Ermine		White (or paper surface unpainted), jet black for tails	Shades of dark and light grey

251

Painting the achievement of arms

If you decide to use gold or silver in your heraldic painting then these should be painted and burnished first. Otherwise it is better to paint the shield first. For an achievement of arms the light is usually considered to be falling from the top left hand corner, so the shadows and highlights should reflect this.

Paint the background or colour of the field, remembering to mix sufficient paint. Sometimes it is difficult to ensure that the paint lies flat and smooth – blue and red seem particularly unco-operative here. It may help to paint the field as two washes. Dilute a little of the paint with water, then go round the outline of the shield, the ordinary and all the charges. Then, working from one corner, fill in the field.

It is important that the edge of the paint is not allowed to dry before the next area of paint is laid down, so a degree of speed is needed as well as working out the best course the painting should take. If the paint does dry, there will be a line which may show. When this first layer is dry paint the second coat, and the result should be smooth.

When the field has been painted, then the background and details of the ordinaries and charges should be completed. Usually they are outlined perhaps in a modelling colour, to separate them clearly from the background. Some tidying up may be necessary, as it is very easy for the paintbrush to slip and a line be slightly longer than it should be. One of the advantages of gouache is that colour can be laid on colour.

Reserve some of the paint used for the field, ordinaries and charges for painting the mantling and wreath, so that the colours are consistent.

Cover the shield with a pad of folded kitchen towels attached with tiny pieces of masking tape. This will protect your painting from splashes and should also avoid any of the paint becoming shiny, as sometimes happens if it is rubbed by the hand or arm.

Mix up watercolours to the correct shade for the helm, remembering to consider the fall of the light and that some of the colour of the mantling and wreath will appear in the shadows.

Now complete the painting of the mantling and wreath, using the colours saved from painting the shield, if appropriate. Add highlights and shadows, and then paint gold tassels and any decoration on the mantling. Outline the wreath and mantling in a suitable colour to tidy the edges.

Enlarge the pad of kitchen towel to cover all the parts of the achievement which have now been painted. Then paint the crest, supporters and compartment, if any.

Last of all paint the scroll or device to encompass the motto. Dilute the paint where you are to write so that it is very thin. Dab this area with some gum sandarac (see page 297) if you are writing with a pen, otherwise the ink may bleed into the paint. This is not necessary of you are painting the letters of the motto with a brush.

After all this hard work and effort, tidy up any stray lines or blemishes and then you can frame your work.

If there is any gold on your achievement of arms, or if you have used vellum, it is better to place a small 'slip' between the glass and the work itself, so that there is a very small gap and the glass does not touch the surface of the work. The slip may be a tiny strip of gold moulding, or even the thickness of a good quality acid-free mounting board.

Vellum which has been stretched over a board should not move, especially when framed. Vellum which has not been stretched may buckle and cockle, so it is better to keep it in a constant temperature and atmosphere. In any case, no matter what the permanence of the paint according to the description on the tube, it is better to keep your painting out of the harmful effects of the sun's rays. Red is particularly fugitive, and it would be a pity for those vibrant colours you have chosen to fade into pastels within a few years. Place your heraldry on a north-facing wall or one where it is out of the sun to preserve the colours for as long as possible.

The College of Arms

The College of Arms is situated in a splendid seventeenth-century building in Queen Victoria Street in London. It is close to the heart of the City of London, with the Mansion House – the home of the Lord Mayor of London – a few streets away, and the dome of St Paul's Cathedral visible beyond the roof. However, the kings of arms and heralds did not always have such impressive accommodation.

In early mediæval times there was no need for a special building for heralds. They were part of the sovereign's household or attached to that of a noble lord. Their main role was as part of tournaments and jousts, to announce that an event was taking place, to recognise and record the combatants, and to adjudicate and decide on the winner if there was any doubt. They also acted as messengers.

Although there is evidence to suggest that by 1285 there were already two kings of arms with jurisdiction over the north and south of England it was not until the creation of William Bruges as Garter in 1415, and as Principal King of Arms in 1417 that it was thought that there should be some charter of incorporation and a building from which the kings of arms, heralds and pursuivants could operate.

It was later even than this, in 1484, when King Richard III of England founded the College of Arms. The King originally gave them a house called Coldharbour in Upper Thames Street, but unfortunately his untimely defeat and death at the Battle of Bosworth field a year later resulted in his successor, King Henry VII, cancelling all such grants.

Finally, in 1555, on the 18th March, King Philip (of Spain) and Queen Mary I of England gave Derby House to 'The Corporation of Kings, Heralds, and Pursuivants of Arms', of which they then took possession in 1565. Just over 100 years later Derby House was destroyed by the Great Fire of London in 1666, although all the records, books and collections were saved.

At last, five years after this in 1671 the present building of the College of Arms was erected on the same site, and has been home to the kings of arms, heralds and pursuivants to this day. Changes have been made to the original structure over the years, the house next door was added to the main building in 1819 and the building of Queen Victoria Street necessitated other alterations. Despite this the building remains as elegant and graceful as ever, providing fitting surroundings for the chambers of the officers of the College.

The College contains not only rooms for the officers but also a beautiful wood panelled library storing, amongst many other books, over 158 volumes containing the grants of arms. These records mean that the officers are able to check that new grants of arms do not duplicate one which has already been formed.

Just inside the entrance to the College of Arms is the court. This too is wood panelled, with a magnificent raised throne-like seat. Here disputes connected with heraldry can be heard and judgements made. In fact the last time there was such a dispute was in 1954 when the Manchester Palace of Varieties, a theatre, used the coat of arms belonging to Manchester Corporation on its proscenium arch. The court found for the Corporation, but in fact the case was held at the Law Courts and not the College of Arms. Before that the previous time the court sat was about 250 years earlier.

The building is actually owned and maintained by the three kings of arms, six heralds and four pursuivants who form the Chapter. They meet each month to decide on matters of business.

The officers of the College are members of the

The College of Arms in Queen Victoria Street, London. The dome of St Paul's Cathedral is just visible beyond the roof. The magnificent gates were presented to the College in 1956 by an American benefactor, Blevin Davies, who brought them from Goodrich Court in Hertfordshire; the house has since been demolished.

Royal Household and receive a salary from the crown which was set in 1831, pursuivants receiving £13·95p, heralds £17·80p, provincial kings of arms £20·25p and Garter £49·07p. Perhaps it should be pointed out that this is an *annual* salary! From this it can be seen that the officers do need to work privately as heraldic, ceremonial and genealogical consultants as well as granting arms. Payment for such granting of arms has, therefore, to cover not only the fees of those involved – the painter, scrivener, recorder and so on – but also those of the officers and for the costs of maintaining the building.

The Earl Marshal – an hereditary post held by the Dukes of Norfolk since 1672 – has jurisdiction over the officers of the College, and grants of arms can only be made by Warrant from him. However, he is not a member of the College of Arms as such, having only visitorial powers.

It is the Earl Marshal's responsibility to organise all state ceremonies such as the Opening of Parliament, royal and state funerals and, of course, the Coronations. Occasions such as royal weddings are royal, but not state, and so the Earl Marshal is not involved in their organisation. He is responsible to the sovereign for all matters relating to heraldry, honour and precedence and is the hereditary judge in the Court of Chivalry. Originally

the job of the Marshal was to supervise the royal stables, but over the years this has changed to a much more dignified role.

The Kings of Arms

There are three kings of arms; the principal is **Garter**, and the provincial kings are **Clarenceux** and **Norroy and Ulster**, of whom Norroy and Ulster is the junior.

Norroy and Ulster

The earliest reference to a king of arms is that to Peter, King of Heralds, beyond Trent in the north in 1276. In 1338 Andrew Norreys or Norrois received payment, and in 1386 John Lake or March was called Norroy King of Arms, Norroy possibly being a diminution of *north* and *roi,* the French for *King.* It could also mean *king of the north men.*

Although there was a herald of Ireland, this title was not used after 1487, and in 1552 King Edward VI of England instituted the title of Ulster as the principal herald of Ireland.

Initially it is probable that the Ulster heralds were part of the College of Arms, but this link was broken and it was when Eire became a republic in 1937 that thought was given to combining the office of Ulster king of arms with that of Norroy, which indeed took place in 1943.

Norroy and Ulster, the junior of the kings of arms, has jurisdiction over England to the north of the River Trent and the six counties of Northern Ireland.

Clarenceux

England and Wales south of the River Trent is the province of Clarenceux, who is the senior of the provincial kings of arms. The first firm reference to Clarenceux was in 1420, and it is thought that the title came from the Dukedom of Clarence. There is some evidence to suggest that a payment made to Andrew Clarencell in 1334 was for his duties as a king of arms, but this is not certain.

Garter

The office of Garter, who is the principal king of arms was made by King Henry V, to serve the highest order of chivalry in the land, that of the Order of the Garter, (see page 238). All grants of arms are signed by Garter, as well as by the appropriate provincial king of arms.

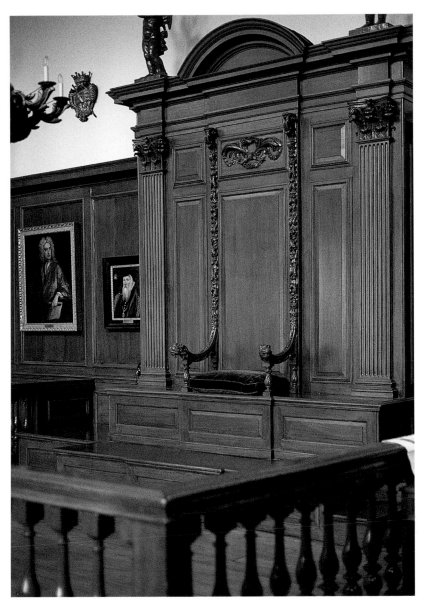

The Earl Marshal's Court at the College of Arms.

The Heralds

There are six heralds who are Officers of Arms attached to the College – **Chester, Lancaster, Richmond, Somerset, Windsor** and **York.** It is difficult to determine which one was instituted first as records are patchy. As well as this, it seems that heralds with these titles were both private heralds – perhaps to a Duke or an Earl, such as Richmond or Somerset – as well as heralds to the sovereign. It seems that most became Heralds in Ordinary – that is, part of the Royal Household and attached to the College – in the fifteenth and sixteenth centuries.

Pursuivants

There are four pursuivants – **Bluemantle, Portcullis, Rouge Croix** and **Rouge Dragon.** These were originally apprentice heralds, and it is difficult to find precise dates when they became part of the College of Arms. By tradition Rouge Croix, taking his name from the cross of St George, is the oldest.

The banner of the Officer-in-waiting who is on duty each week day is flown from a flagpole at the top of the steps to the entrance of the College of Arms. This is the banner of Hubert Chesshyre, Clarenceux King of Arms, when he was Chester herald.

Officers of Arms Extraordinary

There are also Officers of Arms Extraordinary; at present these are **Arundel, Beaumont, Fitzalan, Maltravers, Norfolk, New Zealand, Surrey** and **Wales.** These are heralds who are ex officio members of the Royal Household and assist the Officers of the College in their ceremonial duties often for a particular purpose such as a Coronation. Beaumont herald was first appointed in 1982, whereas there are records which verify that Arundel herald was carrying out duties in 1413.

The appointment of New Zealand herald is an interesting one. He is known as the Antipodean herald and was created by Queen Elizabeth in 1978 on Waitangi Day. He represents the College of Arms in New Zealand and is deputy to Garter King of Arms, but only in that country.

The duties of the modern-day herald are described by Hubert Chesshyre, Clarenceux King of Arms, in the next chapter.

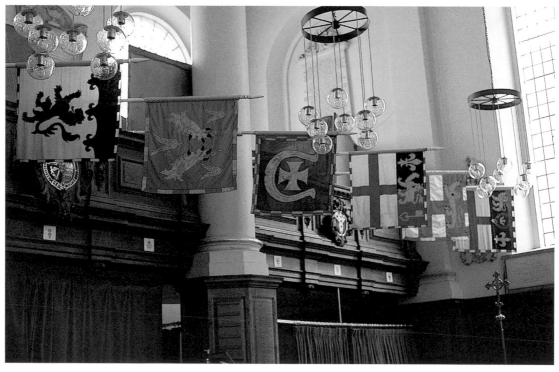

When the banners are not in use they make a magnificent display at the Heralds' Church, St Benet, Paul's Wharf opposite the College of Arms. The banners of the kings of arms are displayed closer to the altar.

The work of the modern herald
Hubert Chesshyre, Clarenceux King of Arms

I have been asked to contribute a chapter on the activities of a present-day Officer of Arms, which is not as easy as it may seem, since each herald runs his own practice and to some extent pursues his own interests. I shall therefore write mainly about my own work which will, of course, in many respects coincide with that of my colleagues.

State Ceremonies

The two Great Officers of State responsible for the ceremonial activities of the Sovereign are the **Lord Chamberlain** and the **Earl Marshal.** The former (through his Comptroller) arranges garden parties, investitures, state visits, royal weddings and funerals and so on. State occasions (other than state visits) are the responsibility of the Earl Marshal who works of course in close conjunction with the Lord Chamberlain and his staff. State occasions include (or have included) the Funeral of Sir Winston Churchill in 1965, the Investiture of the Prince of Wales in 1969, the State Opening of Parliament and the Coronation and Funeral of the Sovereign. All the Officers of Arms participate, wearing their tabards in those ceremonies organised by the Earl Marshal, and most are involved in the preparations beforehand which, in the case of a Coronation, can take up to a year. The heralds are also asked occasionally to take part in 'semi-state' events such as the service in St Paul's Cathedral in 1977 marking the twenty-fifth anniversary of the Queen's Accession to the throne.

At the time of the Investiture of the Prince of Wales I was a probationer at the College of Arms, training under Sir Anthony Wagner to become a Pursuivant. I was asked

D H B Chesshyre, Rouge Croix, as Garter's deputy, introducing Baroness Vickers to the House of Lords in 1975.

Universal Pictorial Press.

to take part in the ceremony as a Green Staff Officer and my duties included leading the procession of Welsh Sheriffs through the streets of Caernarvon into the Castle.

A more regular ceremony in which the Officers of Arms participate is the State Opening of Parliament when the Sovereign wears the Imperial State Crown, and historic

257

The stall plate of HRH The Duke of Kent (KG 1985) by John Bainbridge.

Illustration supplied by Hubert Chesshyre.

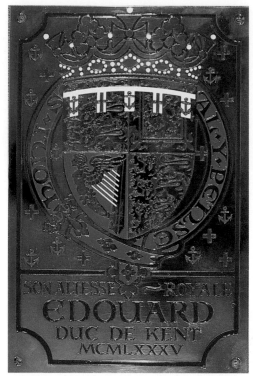

items such as the Sword of State and Cap of Maintenance are carried in solemn procession. The heralds line the steps leading up from the Norman Porch and once the Sovereign has gone up to the Robing Room they move into the Royal Gallery where they wait with the Sovereign's Body Guard of the Yeoman of the Guard and various dignitories from Government and the Royal Household. When the Sovereign emerges from the Robing Room to the accompaniment of a fanfare of trumpets the heralds lead the whole procession through the Prince's Chamber and into the House of Lords for the Speech from the Throne.

The Introduction of new Peers

Garter has special duties in the House of Lords as he settles the titles of new peers and carries out their ceremonial introduction into the House. Garter (or his deputy) carries the patent creating the peerage and the new peer carries his or her Writ of Summons to the Palace of Westminster. The new peer is accompanied by two others of the same degree and under Garter's direction they enter an appropriate bench where they doff their hats and bow low three times to the Lord Chancellor who sits on the Woolsack. Women peers are spared the hat doffing and simply bow their heads. The late Harold Wilson (Lord Wilson of Rievaulx) created so many

peers when he was Prime Minister that Sir Anthony Wagner, who was then Garter, could not spare the time to introduce them all and I had the pleasure of performing twenty introductions and of lunching with most of the new peers beforehand. Garter always holds a short rehearsal after lunch and I enjoyed the sense of power when, as a mere Pursuivant, I conducted such rehearsals and ordered mighty men to sit down, stand up, put on their hats and take them off again! Sadly the ceremony was modified in 1998 and hats are no longer doffed.

The uniform

The uniform of an Officer of Arms, worn on State and similar occasions, often in the presence of the Sovereign, includes the following:

1 The **tabard,** a garment of mediæval origin embroidered with the Royal Arms. The tabards worn by the Kings, Heralds and Pursuivants are embroidered respectively on velvet, satin and damask. The tabard worn by Chaucer's ploughman in *The Canterbury Tales (Prologue)* was a humbler version but presumably of similar shape.

2 A **scarlet coatee** or tailcoat embellished on collar, cuffs, breast and pocket flaps with gold wire decoration in the form of foliage. The width of the breast embroidery increases on promotion from Pursuivant to Herald and from Herald to King of Arms.

3 Black barathea **breeches.**

4 Two pairs of black **stockings** or tights.

5 Black court **shoes** with gold buckles.

6 Court **sword** with gold knot.

7 **Collar** of SS (Kings and Heralds only).

The tabards are kept at the Central Chancery of the Orders of Knighthood in St James's Palace, which is responsible for the robes, insignia and administration of most of the British Orders of Chivalry.

When I became a Pursuivant in 1970 an Officer had to buy all his own uniform apart from the tabard. However as the coatees in particular became so expensive the Earl Marshal set up a Uniform Fund in conjunction with the Treasury and I became its Founder Secretary in 1980.

Orders of Chivalry

Another duty of the Officers of Arms is to attend the Sovereign during the ceremonies connected with the Most Noble Order of the Garter. These usually take place on the Monday of Ascot week in mid-June at Windsor Castle. It has become customary for the heralds to have a picnic lunch

beside the river at Runnymede whilst the Queen and the Duke of Edinburgh entertain the Knights and Ladies of the Garter and their respective wives and husbands and the Officers of the Order to a magnificent luncheon in the Waterloo Chamber.

Being Secretary of the Order I no longer take part as a herald but as one of the five Officers of the Order (Prelate, Chancellor, Garter, Black Rod and Secretary). My task is to undertake on Garter's behalf the detailed preparations for the investiture and installation of new Companions, the procession and the seating in the quire of St George's Chapel, the drafting and distribution of leaflets and printed ceremonials (with valuable help from the Central Chancery) and the allocation of tickets for the Companions and others. Throughout the year I also commission the banners, crowns, coronets, crests and stall plates required for each Companion. These insignia are removed when a Companion dies apart from the stall plate, which remains in place, and this series of copper and enamel plates going right back to the early 15th century is undoubtedly one of the finest collections of heraldic art in the world.

Recent stall plates have been made by Henry Gray MVO, John Bainbridge (died 1996) and Timothy Noad, all well established Herald Painters at the College of Arms. The first step is to make a pencil drawing for approval by Garter and the Secretary of the Order. Then an accurate black and white drawing is prepared and sent to the engravers who select a plate and produce a photographic negative of the artwork. This is used to etch the design into the copper plate after which the artist fills the cavities with coloured enamels on which he or she paints the finer details. A few decades ago the stall plates made by Harold Soper were properly enamelled (fired in a kiln) but this is an expensive process which the Order can no longer afford.

The Warrant appointing a Knight or Lady Companion is prepared on a piece of vellum measuring approximately 42 by 57·5 cm (17 by 23 inches) with an illuminated border by Fred Booth or Dennis Field, both Herald Painters at the College of Arms, or by the miniaturist Helen White, and the text is added by Keith Evans, Clerk of the Records and Head Scrivener at the College. It is then sent to HM The Queen for her signature as Sovereign of the Order and countersigned by the Chancellor. Finally I arrange for the document to be sealed with the Great Seal of the Order by the Crown Office at the House of Lords who keep an electrotype matrix for the purpose. The original silver matrix dating from 1716 cannot now safely be used as it has developed a crack. The document is then loosely rolled, tied with a blue ribbon, put into a handsome blue box with a copy of the Statutes and given to the new Companion. The practice of presenting a copy of the Statutes with the Warrant dates back to the Middle Ages and some finely engrossed and illuminated copies have survived.

In my early years at the College the banners, crests and

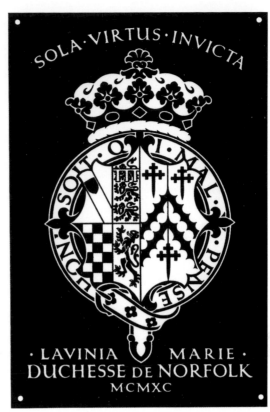

The Garter stall plate design by Henry Gray for Lavinia, Duchess of Norfolk, who became the first Lady Companion (non-royal lady) of the Order in 1990 in accordance with a statute of 1987. Her arms are shown on a widow's lozenge which the artist has cleverly broadened by means of a series of curves to accommodate the impaled arms.

Illustration supplied by Hubert Chesshyre.

stall plates were all produced by Frank Berry of Dorking, but soon after he died in 1985 we began to commission Perretts of Enfield through the agency of Major Tony Gardner. Perretts closed down in 1993 and the banners are currently made by Porter Bros of Liverpool, again via Major Gardner. The banners are five feet square and painted on both sides with oil paint and gold leaf. In Frank Berry's day they were made of silk but nowadays a man-made material called raycot is used.

After Mr Berry's death I was anxious to find a woodcarver willing to produce crests at reasonable rates. I spotted a photograph in *The Times* of a young craftsman called Ian Brennan who had lost his studio in a fire in 1984. I contacted him immediately and within a few days he had visited the College and agreed to carve and paint crests for the Order of the Garter.

In recent decades the procession on Garter Day has formed up in St George's Hall whose walls are mediæval, but whose interior was last refurbished for King George IV by Wyattville in the 1820s. The roof was decorated with the shields of all the Knights of the Garter from 1348 to the present day, which were a talking point at State Banquets. The Hall was gutted in the fire of 1992 but after much deliberation by two committees headed respectively by the Duke of Edinburgh and the Prince of Wales, proposals by the architects Sidell Gibson

Grant of arms to Kingston University in 1993 with a decorated border by Jacqueline Rose and text by Keith Evans.

Illustration supplied by Hubert Chesshyre.

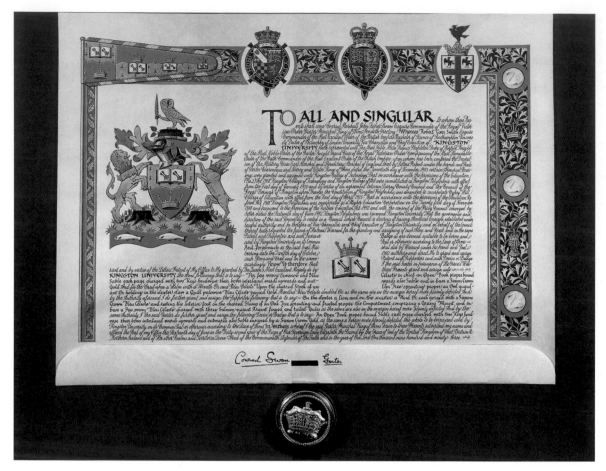

were accepted and these included the replacement of the shields which number about 1,000.

As Honorary Genealogist of the Royal Victorian Order I am asked to write to newly appointed Knights and Dames Grand Cross to offer them a stall plate in the Queen's Chapel of the Savoy. The plates are similar to the Garter plates but a little larger which allows space for Supporters to be included. When I succeeded Sir Walter Verco as genealogist he told me that the plates were not to be gilded, like the Garter plates, but left to darken 'like an old penny'.

There is a long tradition of using French for the inscriptions on the Garter plates. In the case of Matthew White, Viscount Ridley (KG 1992), *Matthieu* and *Vicomte* seemed appropriate but it was decided not to change *White* to *Blanc*!

Space does not permit me to write about all the bodies with which the heralds are professionally involved but apart from the Garter and the Royal Victorian Order they include the Orders of the Bath, St Michael and St George, the British Empire, Malta and St John; the Society of Antiquaries, Society of Genealogists, Heraldry Society, Westminster Abbey Fabric Commission, Royal Mint Advisory Committee, the

City Livery Companies, committees on Naval Badges, Regimental Colours, RAF Badges and many more.

Grants of Arms

Turning now to more typical work of a modern Officer of Arms I will start with Grants of Arms as these are the principal means by which the College is financed. Contrary to popular opinion arms are not granted by the College of Arms or by the heralds but by the Kings of Arms. Garter's patent of appointment from the Sovereign empowers him to grant Arms to 'eminent men' which nowadays is interpreted to include women and corporations, and the patents of Clarenceux and of Norroy and Ulster are similarly worded.

'Eminence' is interpreted quite liberally nowadays. If an applicant has received an honour from the Crown, held commissioned rank in the armed forces, obtained a university degree, a professional diploma and so on, there is usually

no problem. Others who may not have had the opportunities to acquire such qualifications may nevertheless be eligible.

If they have served their local community in some way, supported charities, taken an interest in heraldry and genealogy and kept themselves out of prison, testimonials from two friends or acquaintances of some standing will probably satisfy the Earl Marshal. Ever since the Middle Ages arms have also been granted to corporations including abbeys, universities, colleges, schools, civic boroughs, livery companies, bishoprics and in more recent times, local authorities and commercial companies. The latter must demonstrate that they are reasonably long established, and leaders in their field and that their work is of benefit to the community.

The first step in applying for a grant of arms is to ask one of the Officers of Arms to act as agent. He will then prepare a typescript memorial (or formal petition) addressed to the Earl Marshal in the applicant's name. The latter will be asked to check and sign the memorial and send it with the fees to his agent who will forward it (via Garter) to the Earl Marshal. He in turn will, if he is satisfied as to the applicant's eligibility, address a warrant to the Kings of Arms instructing them to proceed with the grant. The agent will then set to work on the design of the arms and eventually order a coloured sketch for consideration by the prospective grantee.

Arms do not have to be symbolic but they usually are, though the symbolism is seldom recited in the blazon or the text of the grant. Such recitations have occasionally been allowed in the past and examples include the grants to Zephaniah Holwell in 1762 who survived the Black Hole of Calcutta, the Revd John Hockin in 1764 who repelled some French pirates off the coast of Cornwall and Mr Noel Phillips in 1928 whose great grandfather was rescued from drowning in the sea at Portsmouth by a passing dog! All three coats include emblems relating to these episodes, a skull for Mr Holwell, the lilies from the arms of France 'confusedly dispersed' for Mr Hockin and the dog itself for Mr Phillips. (A portrait of the dog by George Morland came up for sale at Christies in 1991.) Such patents are interesting as historical documents but some of the texts concerning events in the Napoleonic wars are long and tedious and grantees are not permitted to tell such tales in their patents today.

In my own practice I usually invite prospective grantees at the outset not to submit designs of their own but to list five or ten items to which reference might be made in the design. Such items could include places of birth, education and residence, occupations or interests of the client's wife, husband, children or ancestors, the grantee's own career and hobbies, and any favourite emblems, shapes or colours. I then work out a rough design and blazon and ask an artist to prepare an approval sketch which I send to my client together with a summary of the symbolism. My own approval sketches are normally painted by Jacqueline Rose of Hastings using printed proformas which I supply. These include the

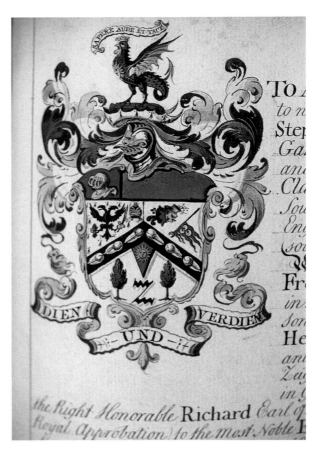

The sort of cluttered and asymmetrical design one should try to avoid! Grant of arms to J A F Hesse in 1772.

Illustration supplied by Hubert Chesshyre.

outlines of the shield, helm, mantling and motto scroll, thus saving the artist a good deal of time and trouble.

If the client approves of the design he or she initials the sketch and returns it to me so that searches can be made in our official records to ensure that the design is distinctive. A pictorial or visual index known as an **Ordinary** is used for such searches, an Ordinary being a collection of arms, crests, badges or supporters arranged (usually alphabetically) according to their design, whilst an **Armory** is a collection of coats of arms arranged alphabetically by family. Thus an Ordinary might begin with *Abacus* or *Acorn* and an Armory with *Aaron* or *Adams*.

The College Ordinaries are essential tools not only for checking the distinctiveness of new designs but also for identifying heraldic devices on rings, porcelain, seals, silver plate and other such items sent or brought in to the College by members of the public. An Ordinary is in effect a primitive form of computer and undoubtedly the College Ordinaries will be computerised within a few years, thus enabling much more rapid and sophisticated searches to be made.

For twenty years I was editor, with Thomas Woodcock, of the *Dictionary of British Arms* which was started under the

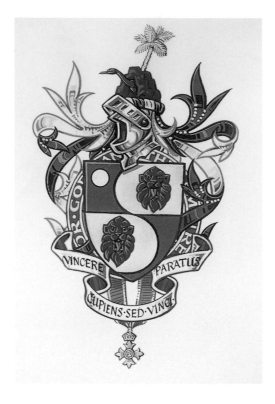

The arms of Hon. Sir John Swan, Premier of Bermuda 1982–1995.

Illustration supplied by Hubert Chesshyre.

of the agent and even a portrait of the granting King in the initial letter.

Once the painted sections are complete the lengthy text is drafted and then copied on to the vellum by a scrivener using a formal hand such as Italic or Copperplate. Having been carefully checked the document is signed by the Kings of Arms and the achievement (minus helm and mantling which follow standard models), together with the full text, is copied into the College's official registers by the recording artist and record scrivener respectively.

The Registrar having checked the record entry endorses the patent and hands it over to be sealed. This involves attaching the Seal of Garter and usually one or both of the provincial Kings by means of a blue ribbon threaded through slits in the folded bottom edge of the vellum. The ends of the ribbon pass through the base of a circular metal skippet which is filled with red beeswax. Whilst the wax is still soft the seal of the appropriate King is impressed in it and the skippet is covered with a metal lid embossed with the distinctive crown of a King of Arms.

The document is finally rolled up, secured with two silk rings and placed in a red box stamped with the Royal Cipher in gold. It is then ready for collection or despatch to the grantee. In the case of a grant of arms to a corporate body the patent is sometimes presented by one of the Kings of Arms or by the agent acting as his deputy. On such occasions the Officer of Arms will frequently wear uniform (scarlet coatee, black trousers or overalls with side stripe but not tabard) and the presentation is often attended by the Lord Lieutenant of the county.

The Hesse arms on page 261 provide a classic example of a bad design, incorporating far too many objects. Despite the thousands of arms already on record it is often possible to achieve simplicity in a new design by introducing novel charges or by the imaginative use of traditional emblems in unusual forms or combinations, an area in which the present Garter, Peter Gwynn-Jones, has done useful work.

For my client the Hon. Sir John Swan, lately Premier of Bermuda, I used a wavy division of the shield in a form not often encountered, and for Surrey Institute of Art and Design (see page 265) I employed the fairly uncommon device of placing charges partially outside the shield. The Badge, which reflects the design of the arms, shows how one can invent a simple 'modern' emblem which could be used as a logo without anyone realising it was part of a coat of arms.

In the arms of Vincent D'Aguilar of Nassau, Bahamas (descended from Baron D'Aguilar who lent money to Maria Theresa (1717–1780) to remodel Schönbrunn Palace) the winged pear tree is unique in combination with an orle, and in the shield of Richard Chartres, Bishop of London (see page 265), the simple coat of two bars used by his Irish and French ancestors is made distinctive by superimposing an ecclesiastical labyrinth.

auspices of the Society of Antiquaries in 1926 and of which the first volume *(Mediæval Ordinary, volume 1)* finally saw the light of day in 1992. Had it not been for the computerisation of the data it would probably have taken a great deal longer.

Returning to Grants of Arms, once Garter (and if necessary the Provincial Kings) have approved the design and blazon of the arms, the production of the patent itself can commence. This consists basically of a piece of vellum measuring about 53 by 43 cm (21 inches wide by 17 inches high), though larger skins are used to accommodate decorated borders.

The heading of the patent consist of the Royal Arms flanked by those of the Earl Marshal and the College. The basic grant fee covers the cost of a so-called 'printed' heading where the outlines of the three coats of arms are printed in sepia and coloured in by a jobbing artist. For a more sumptuous effect with bolder outlines and burnished gold the grantee has the option of paying a little extra to have the heading drawn and painted entirely by hand by the same artist who paints the new arms in the top left hand corner of the document.

Another option is to have an illuminated or decorated border to the patent, a tradition going right back to the chronicles, psalters, books of hours and other illuminated manuscripts of the Middle Ages. Modern borders can include birds, flowers, foliage, insects, swags, strapwork, the arms of the Kings making the grant, the arms and/or the official badge

Badges

The use of heraldic badges was revived earlier this century. These are free-standing emblems (like a modern logo) intended for use independently of the main arms. The Tudor Rose, the Beaufort Portcullis and the Bear and Ragged Staff of the Earls of Warwick are familiar examples from a previous age. Badges are particularly useful for corporate bodies, whether commercial, professional, charitable or academic. Such corporations should reserve the main arms for their common seal, banners, stationery, degree and diploma certificates, depiction in windows and other architectural contexts and generally for use at headquarters.

The badge on the other hand may be used on the ties of members, associates or employees, as 'colours' and on trophies for sports and social clubs, on vehicles, crockery and in many other situations. Individuals may work the badge into a bookplate design, give it in the form of brooches to female relations and friends, as has long been the practice with regimental badges, and generally use it as an additional mark of their own identity.

Heraldic history was made in the Diocese of Southwark in connection with the three Suffragan or Area Bishops (Kingston, Woolwich and Croydon). Badges were granted to the Bishop of Southwark for use by the three Suffragans and this must be the first time in English history that

Suffragan, or Area Bishops, have borne heraldic emblems relating to their offices.

Corporate arms

Although arms are widely used by corporate bodies today it is a pity that more commercial companies do not apply for them, preferring logos formed from shapes or letters or else curious feathery designs looking like fragments reassembled after an explosion.

A well designed coat of arms can convey an air of authority based on firm foundations. The fact that a heraldic emblem (usually called a *crest!*) can create a desirable aura of prestige in certain areas of the market is evidenced by the number of bogus coats of arms used to promote sales of a wide range of goods and services.

A passing representation of a coat of arms was commissioned by Gallaher Ltd some years ago, which they wished to 'register' at the College of Arms. Having told them that this was not possible I was able to persuade them that all the desired allusions could be made much more subtly in a genuine coat of arms which was duly granted.

Companies who hold a Royal Warrant to supply the Sovereign or a senior member of the Royal Family derive prestige from displaying a royal coat of arms, and if this is

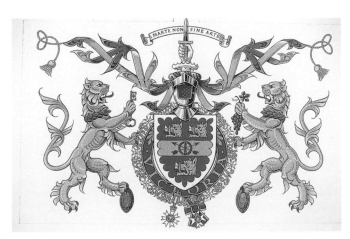

Left above, Badges granted to the Bishop of Southwark in 1996 for use by the Suffragan Bishops of Kingston, Woolwich and Croydon (artist J. Rose).

Left below, Table mat design by Timothy Noad for Sir Ewen Fergusson (see page 264)

Illustrations supplied by Hubert Chesshyre.

the kind of image they value they should consider applying also for a grant of company arms, so that if they ever lose the Royal Warrant they will have another string to their bow. This was the course followed by my former employers John Harvey and Sons Ltd, the wine merchants. Those who think a coat of arms is 'old-fashioned' should remember that a shield or badge of simple design can be used on its own in just the same way as any modern trade or service mark.

Designs for special purposes

One of the attractions of heraldry is that it can be adapted for use in a wide variety of media and contexts. I was one asked to design banners for the front of a new Norman Foster building in Hong Kong. This was a daunting prospect as it was a skyscraper and the banners were to be many meters (yards) high but only a few centimetres (inches) wide. The eventual solution was to place rectangular depictions of appropriate coats of arms at intervals along the banners and to link

them with vertical stripes of suitable colours.

More recently I was asked to arrange for the replacement of some decaying banners hanging in the hall of the Worshipful Company of Stationers near St Paul's Cathedral. Most of them commemorated former Masters of the Company who had also been Lord Mayor of London and they showed the entire coats of arms including supporters, crest and motto, against a coloured background. I had to persuade the Company that the most effective form of heraldic banner shows the arms (in this context the shield alone), expanded to cover the entire surface of the rectangular banner. Luckily one of their banners (that of the late Duke of Windsor as Prince of Wales) was already in this correct form.

I commissioned Henry Gray to produce coloured working drawings of the banners and they were made by a Scottish veterinary surgeon Patrick Barden, who has transformed himself rather surprisingly into a successful flagmaker. The illustrations on page 266 show two of Henry Gray's designs. A good heraldic artist will adapt the charges to fill, but not overfill, the available space, unlike some Georgian and Victorian artists who depicted tiny emblems floating in a sea of colour.

The Stationers' banners (contrary to the normal shield) are slightly greater in length than height and this is a popular shape for a flag. However it does not always produce the most satisfactory design, and whilst the arms of the Prince of Wales fill the surface quite comfortably there was a limit to the extent to which the Waterlow bones and lion could be stretched without distortion. The Garter banners being square approximate more closely to a shield with corners added at the bottom.

Perhaps more of a challenge than the Stationers' banners was the elongated tablemat design for Sir Ewen Fergusson, former British Ambassador in Paris and chairman of Coutts and Co. Incidentally it is not often that one sees around the same shield the collar of one Order and the circlet of another, Sir Ewen being both a GCMG and a GCVO.

The normal diet of a herald painter at the College of Arms consists of library paintings (on stretched vellum), certificate paintings, coloured working drawings and black and white designs for signet rings and letterheads, but I am concentrating in this section on the less usual commissions. One of these is for a bookplate design which clients require from time to time. Nowadays these are more often for reproduction by photo-lithography or computer than an engraved copper-plate so the artwork need not be quite so finely executed. One of the illustrations on page 267 shows Dennis Field's design for my client Christopher Robson in whose punning coat the moon robs the sun of its lower half.

An important year for Westminster Abbey was 1995 when the Queen and the Duke of Edinburgh attended a grand service on 19th October to celebrate the completion of a lengthy restoration programme which included the addition of a

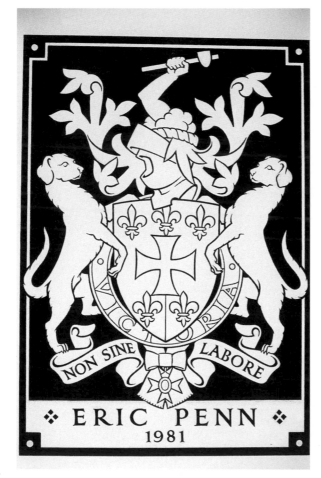

Henry Gray's artwork for the stall plate of Sir Eric Penn, Comptroller of the Lord Chamberlain's Office, as a GCVO (Knight Grand Cross of the Royal Victorian Order).

Illustration supplied by Hubert Chesshyre.

NON SINE LABORE

❖ ERIC PENN ❖
1981

new heraldic window in the Henry VII (or Lady) Chapel. I was appointed heraldic consultant for this window which enabled me to act as agent for grants of arms to several people and organisations involved with the work of restoration. One of these was Rattee and Kett, the long-established Cambridge firm of builders and restorers of historic buildings. They are a subsidiary of Mowlem, so arms including a mole and a dancetty division of the shield to resemble the letter **M,** were granted to the parent company together with two badges, one for Mowlem and one for Rattee and Kett.

The window was designed by John Lawson in conjunction with Donald Buttress, Surveyor of the Fabric at the Abbey, and myself. John Lawson's company, Goddard and Gibbs, actually made the window at their studios in east London. The arms of an American benefactor and Trustee of Westminster Abbey, Helen Walton, widow of Sam Walton, founder of Walmart Stores, are shown on page 267.

Mrs Walton's arms are depicted on a lozenge which is still the traditional form for the arms of a widow or maiden lady. My design was interpreted by John Lawson and topped by a 'true lovers' knot'. The lozenge designed by Dennis Field for my mother's memorial service in Canterbury Cathedral in 1995 is also shown. He has skilfully modified the outline of the lozenge to create a little more space, and introduced some diaper pattern into the simple Boothby coat to balance the dark field of the Chesshyre arms. This is also a good example of modifying the charges (principally the three lures) to fit into somewhat cramped quarters. Another lozenge, with a generous true lovers' knot for Miss Betty Boothroyd, first woman Speaker of the House of Commons, completes the quartet on page 267 and is shown on her own whisky label.

The lozenge shape is also used for funeral hatchments which are still occasionally commissioned nowadays. The hatchment made by Robert Parsons in 1991 for the late John Langton of Langton in Lincolnshire was so large it had to be hinged for ease of transport. A somewhat similar commission was a large painting on an oak panel of the Stuart Royal Arms for the church of King Charles the Martyr in Tunbridge Wells. The panel was made and painted by David Truzzi-Franconi to a design by Henry Gray.

In 1988 I was asked to design fictitious eighteenth century arms for the principal characters in the film *Dangerous Liaisons*. The arms for the Marquise de Merteuil with artwork by Timothy Noad are shown on page 268.

The Waiting System

Each herald and pursuivant takes it in turns to be **Officer in Waiting** for a week at a time. Thus if there is a full

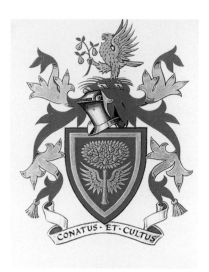

Library painting by Jacqueline Rose of the arms of the Surrey Institute of Art and Design. Note the simple badge.

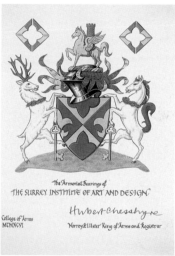

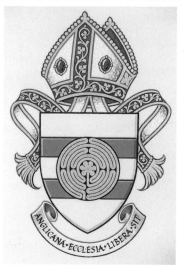

Two simple designs: – Vincent D'Aguilar and below, Richard Chartres, Bishop of London (see page 262).

Illustrations supplied by Hubert Chesshyre.

Henry Gray's designs for banners for Stationers' Hall above, the Prince of Wales, and below, Sir W A Waterlow (see page 264).

Illustration supplied by Hubert Chesshyre.

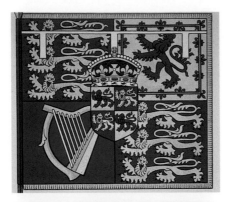

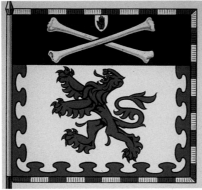

complement of six heralds and four pursuivants, an officer will be in waiting once every ten weeks. During that week his banner will fly from the front of the porch.

The Officer in Waiting deals with all letters addressed to the College rather than to an individual officer. He also answers telephone calls and e-mails from the public and interviews callers. His hope is that once the week is over he will end up with five or ten prospective clients who will pay him (preferably in advance) for a search in the records, a programme of genealogical research or even a grant of arms.

The waiting week is of considerable importance since Officers of Arms, as members of the Royal Household, receive only nominal salaries (£13·95p per annum for a Pursuivant) which do not begin to cover the costs of food, clothing and accommodation. Heralds are therefore in effect self-employed heraldic and genealogical consultants. As each runs his own practice, they compete with one another for business which imparts a healthy element of motivation not always to be found among salaried employees.

The Kings of Arms do not normally appear on the waiting rota as they receive fees for making grants of arms, but of course they can continue to run the heraldic and genealogical practices they have built up prior to their elevation.

The waiting callers usually include people who are hoping to establish a right to existing arms, which is done by proving and recording at the College a legitimate descent in the male line from someone to whom arms were previously granted or allowed. Others are gullible members of the public who have bought arms from heraldic 'bucket shops' thinking that arms go with a surname, which is only partly the case: they are normally granted to an individual and his descendants, and if you are not a descendant you have no business to use them. One only has to think of the absurdity of someone asking for 'the arms of Jones'. There are doubtless several hundred Jones families (mostly unrelated) entitled to different coats of arms granted at different periods, and several million Jones families who have never qualified for any arms at all.

Others bring in such items as portraits, watches, silver, porcelain, rings, textiles or glass adorned with arms or crests which they wish to have identified. As so many people have used arms without authority in the past, this is not always possible, though in many cases some likely surnames can be suggested. I once received a visit from a Maidstone policeman with a tie in a polythene bag which had been used to strangle someone the night before. He hoped that the identification of the shields on the tie might lead to the identity of the murderer but unfortunately the 'arms' were merely decorative devices on a tie sold by numerous branches of a well-known High Street retailer.

Some callers and correspondents are interested in straightforward genealogical research (see below) and there is always a small proportion of 'oddballs' who have written to the Queen or the Prime Minister about their heraldic or genealogical fantasies and been re-directed to the College.

If there is a topical story about a member of the Royal Family, a leading politician, a peer or a criminal which has any heraldic content, the Officer in Waiting must deal with urgent press enquiries and try to explain why he cannot produce instant copies of non-existent paintings of the appropriate arms.

Genealogy

It is probably fair to say that almost every Officer of Arms sets out on his path to the College of Arms by investigating his own ancestry. This is an excellent means of training for the genealogical work which forms a greater or lesser part of every herald's professional practice. Genealogy is an essential adjunct to heraldry since coats of arms descend from generation to generation.

The mechanics of genealogical research have changed dramatically during the last few decades. When Tom Woodard, a much revered College genealogist who died in 1995 aged 90 started work at the College as a youth, his employer bought him a motorcycle so that he could ride from parish to parish to consult the registers. Nowadays most of these registers have been deposited at County Record Offices and the contents of many of them computerised by the Mormon

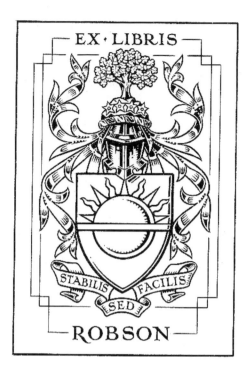

Far left.
Robson bookplate design by Dennis Field (see page 264).

Left.
Arms of Helen Walton in a window at Westminster Abbey (see page 265).

Far Left.
Arms of Miss Betty Boothroyd on her whisky label (see page 265).

Left.
Arms of Mrs Hugo Chesshyre as a widow, by Dennis Field (see page 265).

Illustrations supplied by Hubert Chesshyre.

The arms for the Marquise de Merteuil with artwork by Timothy Noad.

Illustration supplied by Hubert Chesshyre.

Church, whose International Genealogical Index on microfiche and now on the internet has made millions of baptismal and marriage entries available to the public worldwide.

Nevertheless, genealogical research retains an attractive element of detective work and a keen sense of satisfaction when a breakthrough is made. One of my genealogists had the good fortune to discover the true parentage of Henry Moore, the sculptor, by means of searches made at Henry Moore's own request in the confidential census returns less than 100 years old. Sometimes skeletons are found in the cupboard and tact is needed when breaking the news to one's client.

For over seventy-five years grants of Honorary Arms have been made to distinguished Americans descended in an unbroken male line from subjects of the British Crown. In 1964 the rules were tightened to allow such grants only when the petitioner had proved and registered a legitimate descent in the male line from a British or pre-Revolutionary ancestor. In 1995 this was relaxed to allow petitions from those who had registered at the College any British or pre-Revolutionary descent whether through male or female lines and regardless of legitimacy. Thus the Officers of Arms have to be expert in the assessment of American genealogical sources. Special considerations apply to Americans of Scottish origin to whom arms may be granted retrospectively in certain

cases by Lord Lyon King of Arms in Edinburgh.

Two of the most important classes of official records at the College are the series of grants of arms from the Middle Ages to the present day, and the heraldic Visitations. The latter were instituted by King Henry VIII in 1530 when he issued commissions to the Kings of Arms to visit their provinces and record the arms and pedigrees of the gentry, and they continued until the 1680s. Those who are fortunate may succeed in proving and recording a legitimate male line descent from a previous grantee or from an ancestor whose arms were recognised at the Visitations, and thereby establish their own entitlement to arms.

Pedigrees are also recorded in order to establish a right to a dignity such as a peerage or baronetcy, or else simply to create for posterity a permanent and official record of a programme of genealogical research.

As the College is the official registry of the arms and pedigrees of English, Welsh, Northern Irish and Commonwealth families, entries in the records enjoy a unique status. In the case of a pedigree the draft is submitted to two independent examiners, being Officers of Arms who have not been involved in its preparation. After due consideration they will underline in red only those items which they consider to be proved beyond reasonable doubt. It is therefore necessary to produce evidence for each and every item, in the form of wills, parish register entries, family Bibles, certificates of birth, death or marriage and so on. As far as possible the place of every event must be included and this is an element usually lacking in pedigrees published by such authorities as *Burke and Debrett*.

Publicity

Until recently the College did not publicise its activities by means of advertisements but more subtly through books, articles and lectures. Some former officers, for example, John Brooke-Little, Francis Jones, Wilfrid Scott-Giles, George Squibb and Sir Anthony Wagner have been prolific writers in recent decades. Others of us travel around the country giving lectures. John Brooke-Little has been active in this field also, both here and overseas and I myself lecture mostly in this country through the agency of NADFAS, Speaker Finders and formerly Foyles. The College, like Buckingham Palace, now has its own website.

There is insufficient space here to discuss peerage claims, Royal Licences to take additional or alternative names, arms or crests, Royal Warrants of Precedence, searches in the College Records and Collections and many other, sometimes complex, tasks which are undertaken by the heralds. Suffice it to say that a modern Officer of Arms must be a Jack of All Trades and, let us hope, master of two or three.

Heraldry Around Us

In Britain, as well as many places in Europe, it is difficult to walk down any street without seeing evidence of some aspect of heraldry. It may be in the form of the town coat of arms on a lamp-post or litter bin, the royal arms displayed in the local church, or the sign and name of the inn or public house on a street corner. Heraldry in its many aspects has been part of the fabric of life, and it is not surprising that there is still much evidence of it around us.

Churches

Many churches have examples of heraldry, sometimes as memorials, brasses on tombs, in the form of honours flags and rolls of honour for the armed forces and even royal coats of arms.

Memorials

The walls of older churches often have stone or brass memorials to past parishioners put there by their family or friends. Some of these include heraldry as part of the design or decoration if those they commemorate were entitled to bear a coat of arms.

It can be interesting to follow through the fashions in heraldic design on these plaques; however it should be noted that many memorials and monuments in churches were commissioned many years after a person's death, and so these fashions may not be contemporary to that person's life.

There are few wall memorials earlier than the late

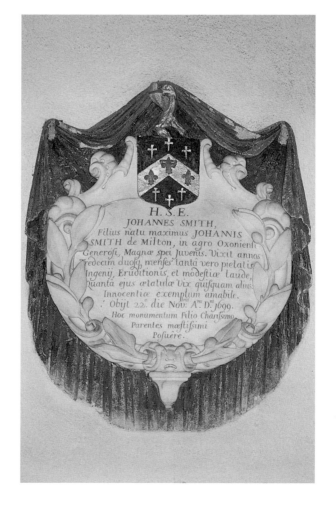

A restrained and dignified wall memorial to Johannes (John) Smith, from the church of Great Milton, Oxfordshire.

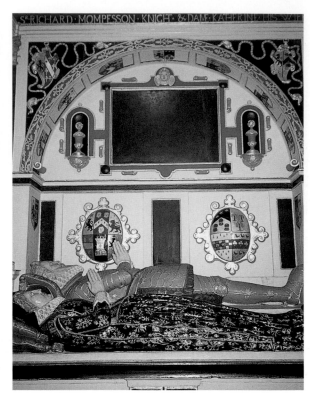

Right.
The magnificent monument erected by Sir Michael Dormer in 1618 to honour himself, his wife Dorothy and his father Ambrose (note the three effigies within the monument).
Far right.
The monument to Richard Mompesson, Knight, and his lady, Katherine. Both at St Mary's Church, Great Milton in Oxfordshire.

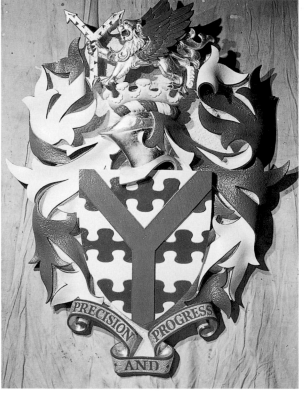

A wonderfully lively and vibrant heraldic coat of arms cut by David Kindersley in Portland stone for Pye. (Cambridge)

sixteenth century. This was when tomb chests which had previously stood separately in the church were moved towards the walls. These memorials were originally connected, and in some cases actually attached to a tomb chest. Eventually they were separated completely, and later plaques are not related to the tomb chests nearby in the church at all.

Sometimes the coat of arms is contained in a cartouche towards the top of the memorial, at other times the coat of arms is at the top of a pyramid shape. The coat of arms may simply be carved in relief in the stone or wood, or may be painted. If it is painted, it is usually the only part of the memorial where there is any colour.

Those who were connected in some way with the military, often being killed in action, may have their coat of arms with guns or flags on either side.

Those memorials which are carved and laid into the floor rather than on walls are rarely as well preserved, having been worn away by the tread of many years. However, even though the lettering of the name and other details may have been almost obliterated, the clear bold shapes used in heraldry usually remain and it is not too difficult to identify the person being remembered, given a knowledge of heraldry and local history.

All this suggests that such heraldic memorials are part of the past and therefore consigned to an historical context.

Far left.
A surprisingly well preserved floor memorial with a lively coat of arms and a wonderful scroll for the motto from the Old Church (De Oude Kerk) in Amsterdam, The Netherlands.

Left.
A flamboyant wall memorial with two delightfully chubby cherubs from the Old Church (De Oude Kerk) in Amsterdam, The Netherlands.

This is not the case. Many stonemasons and letter cutters at work today are asked to include heraldry as part of a modern memorial. Few do this so well as the Kindersley workshop in Cambridge. Set up by David Kindersley, who was trained by the eminent letter cutter and designer Eric Gill, the workshop thrives and is now run by Lida Lopes Cardozo Kindersley, David's widow. His inspiration continues as is evidenced in their most recent pieces.

Tomb chests

The large, free-standing tomb chests seen in many churches rarely contain coffins, but are simply monuments to the deceased. However, they often provide a marvellous opportunity for decoration, which is often heraldic.

Some of the earliest monuments and tomb chests show effigies or stylised images with husband and wife (or wives) placed side by side. For many years the male effigies would be carved as wearing armour, sometimes with shields, and surcoats decorated with related heraldic devices. This was, after all, what most of them would wear for important occasions such as tournaments, battles and sieges. Women would be dressed in the fashion of the time with mantles (cloaks) and kirtles (gowns) decorated with their husband's or father's coat of arms. In Worcester Cathedral Matilda, Countess of

Salisbury, who died in 1281, is shown wearing a cloak patterned with small shields which show her father's arms of *chequy or and azure a fess gules* (gold and blue checks with a broad horizontal red stripe).

Heraldry often forms a decorative element of these tombs, and as styles changed over the years, tomb chests became more elaborate. Some have richly decorated and painted canopies supported by marble or wooden columns, which may be also carved. Others have elaborate borders with a whole army of mourners kneeling with heads bowed around the sides.

Brasses

Brass Rubbing Centres, where replicas of brasses from local churches are collected together so that people can make rubbings using a suitably sized piece of paper and a special crayon, are a feature of many historic towns. Those who use them can easily make a good quality rubbing of an historic brass which can be hung on the wall or kept for future reference. An additional benefit is that the actual brass is preserved as it is not worn away by people making continual rubbings of it.

There are about 7,500 brasses in England – more than in any other European country. The brasses are not, however,

271

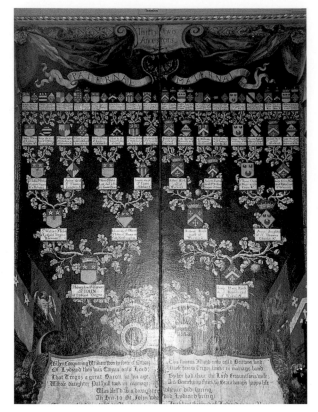

Right.
Part of the magnifi-cent heraldic memorial begun by Sir John St John in 1615 to commemorate his parents Sir John (died 1594) and Lucy Hungerford (died 1598) at St Mary's Church, Lydiard Tregoze, Wiltshire.

Far right.
Heraldic brass from the church at Great Milton, Oxfordshire.

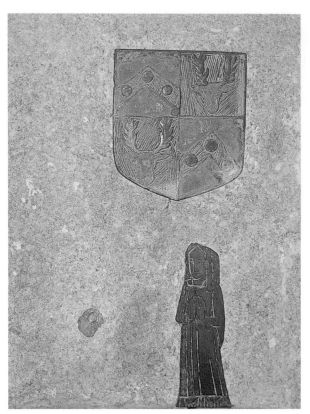

made of brass but of sheet latten which is a metal alloy similar to bronze, being a mixture of copper (75%), zinc (19%), lead (4%) and a little tin (2%). The design was drawn out and then copied on to the sheet of metal with paint or a metal point. This was then engraved using sharp metal chisels and a special hammer. When all had been engraved the hollows were filled with bitumen which made them black. The brass was then set into the stonework where an exact indentation had been made. They were originally fixed with bitumen but later metal rivets were used as well.

Most people, understandably, think that the brasses are an effigy of the person being remembered. This was probably the case early on but later what usually happened was that the most relevant would be selected from a number of stylised patterns produced by the engraver. Personal details such as the pattern on the shield or decoration of a mantle would be added by the workshop. Sadly it is often these very personal details which have been lost over the years.

The size of brasses ranged from almost life size to tiny brasses less than 20 cm (8 inches) high. Often there was an inscription and a decorative canopy as well.

Some brasses and other church monuments have had the faces defaced. This damage was usually done during the Reformation which began in 1533 when many of the monuments in what had been Roman Catholic churches were dis-

figured. These churches were either destroyed or taken over by the the Church of England. Further damage occurred in the 1640s during the English Civil War.

Stained glass windows

The brilliance and richness of light through stained glass adds much to the religious experience of visiting or worshipping in churches. Many windows include some heraldic reference, often as an acknowledgement to the original benefactor or as a plea for prayers and remembrance.

To make stained glass windows a life-size design of the actual window would be drawn out, and pieces of glass cut to fit.

Before the sophisticated glass cutters which are available now were used the glass was cut by drawing the line with a hot iron and then running cold water after it. The glass cracked at this point and it could then be trimmed to fit the shape required.

The colours were made by adding metallic oxides to clear glass – cobalt for blue, manganese for violet and copper for red. Details of faces, hands, folds in clothing and so on were painted on with brown enamel which was fired on. Strips of lead with a receiving groove would be bent around the pieces

glass simply as bold and striking patterns. They were some-times also there for symbolic reasons, showing allegiance and loyalty to a particular individual for example, or were indicative of the ownership of an area.

During the sixteenth century technology in stained glass developed such that a sheet of glass could be painted with enamel colours. Larger pieces of glass were used and de-signs became much more intricate.

Nowadays stained glass designers use their material in very exciting ways, and modern heraldic designers can make much of the play of light through the coloured glass.

Decorations on the building

Churches lend themselves to decoration. The sheer space within a church allows for elaborate carving which would be out of place in a smaller building. Wooden beams soaring upwards supporting the roof provide many suitable points for coats of arms or other linked heraldic devices. Similarly where those beams intersect in the ceiling there may be carved wooden bosses on which are shields or heraldic charges.

The sides of wooden pews may be decorated with the shield of the benefactor for that particular pew or for many. And pulpits and fonts too provide suitable spaces for deco-ration. These may show the coats of arms of those who have contributed to the church or offered it protection in trouble-some times, or they may be the attributed shield or symbol of the patron saint of the church. Other shields may show the arms of the diocese in which the church is located.

Misericords are often a source of humorous vernacular

of glass which would then be soldered together, and, with reinforcing bars, the whole window would be constructed.

The large bold designs used in heraldry were suited to these strong colours, but some of the charges on shields are small and intricate. It was often too complicated to cut tiny pieces of glass and surround them with lead. In these in-stances the piece of glass would be painted all over with brown enamel and the required design scratched away. Or the design would be surrounded by the enamel leaving the design in silhouette on the coloured plain glass.

Heraldic designs and emblems were also used in stained

Three mystical heraldic beasts, including a griffin and a salamander, carved in stone outside the San Juan de Los Reyes monastery, Toledo, Spain.

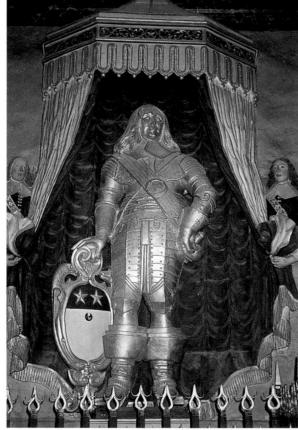

The Golden Cavalier from St Mary's Church at Lydiard Tregoze. A realistic carving of Edward St John in full battledress coming out from his tent, with his armour clearly shown and his right hand resting on his shield. Edward died from his wounds during the Civil War in Britain (1642–1649).

carvings. These 'mercy seats' provided a degree of rest for the choir and clergy during the long hours of service. When the seat is in use the carving is hidden, but when the seat is lifted the whole variety and delight of the carvings are revealed. These range from mythical and mystical beasts and monsters, biblical stories, domestic animals to scenes of mediæval life. Others show shields, coats of arms or charges. The charm of misericords is their variety of subject and the fact that this is hidden until the seat is lifted.

Hatchments

Large diamond-shaped heraldic panels with a black background showing the full coat of arms of the deceased are sometimes displayed in churches. They are called hatchments, which is a corruption of the word 'achievement'.

There are hatchments for men and women, indicated by a shield – for men – or a lozenge – for women. The background behind the shield or lozenge is painted black to indicate the deceased. If a partner is still living then their half of the combined, or impaled, shield or lozenge was painted white.

Usually the helm is omitted and there may be cherubs and skulls as decoration, which are not part of the actual achievement. The motto is also often replaced by *Resurgam* (Arise) or *In Coelo Quies* (Rest in Heaven)

It is thought that in the past hatchments were part of a funeral procession. They were hung outside the deceased's house for a year and a day until they were taken to the church. This announced to all passers-by that an important

person in the neighbourhood had died, which, in the days before newspapers, radio and television was a necessary and valuable service. (See also page 231.)

Military colours and banners

Many regimental and naval badges use traditional heraldic devices as part of their design, and the colours of flags reflect those same clear bold tinctures used on shields to distinguish knights in battle.

The flags showing the colours and honours awarded to sections of the armed forces are often hung in churches with which they have an association.

Rolls of Honour of the Armed Forces, which are the lists of names of those who have died in action, are also usually placed in associated churches, for consultation and for the prayers and remembrance of friends and relatives. These will often have the relevant badges and emblems of honour embossed on the front cover, or painted on the title page.

The Roll of Honour for the Battle of Britain pilots is a splendid gilded and decorated book which is on display at Westminster Abbey in London, while Aldershot also has Rolls of Honour for the army and Plymouth has the same for the navy.

The Royal Arms in churches

Many older churches have carvings, stained glass, or even paintings which have some heraldic device taken from the Royal Arms. Quite often there will be a full painting of the royal coat of arms from a particular period in history. This stems from the need for an outward display of obedience and loyalty to the sovereign as head of the Church. Because of this almost all paintings of the Royal Arms date from 1534 when the English King Henry VIII broke with the Roman Catholic Church, established the Church of England and replaced the Pope as the Supreme Head of the established church.

The paintings arc usually on canvas but are occasionally

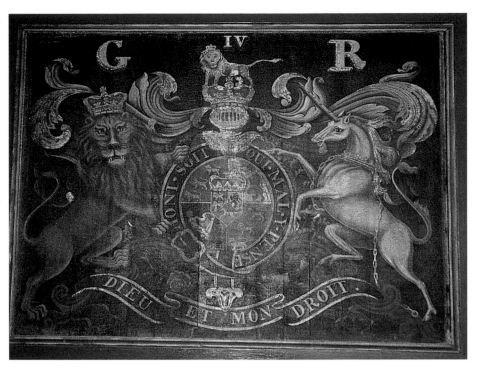

The royal arms of George IV at Andreas church on the Isle of Man.

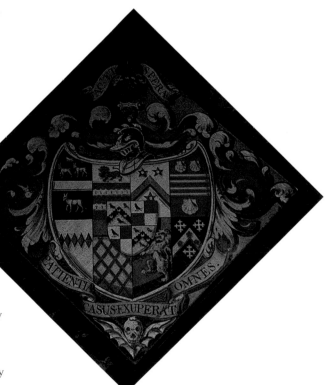

A hatchment for Askew (notice the asses 'skewed' – distorted) in the church of St Mary's on Holy Island, Northumberland.

275

Royal Warrant Holders in London.

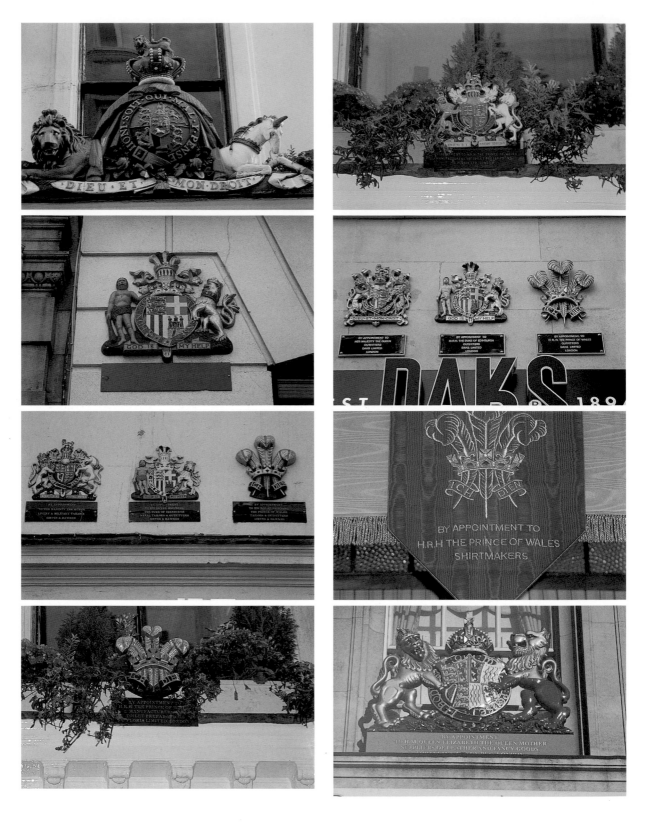

on plaster; some are carved or even cast in iron. In 1614, the then Archbishop of Canterbury instructed a painter stainer to survey and paint the Royal Arms in all the churches and chapels, so it is likely that there were many more examples than have come down to us now. They form an interesting insight into the changes in the Royal Arms over the years, although not many are actually dated, and where they are this may be the date of an alteration rather than the original.

The paintings are prominently displayed, often attached to the top of the chancel screen which is where the crucifix or rood is displayed in Roman Catholic churches.

The Royal Arms – other uses

The Royal Arms can be seen in many different locations, in a variety of media and in a whole host of forms throughout Britain.

Coins

In Britain you have only to reach into your pocket for change to see coins showing a number of ancient heraldic emblems. The three feathers of the Prince of Wales is used for the 2 pence piece, the Royal crown surmounting a thistle, for Scotland, on the 5 pence piece, the crest of a lion passant guardant on a 10 pence piece and the Tudor rose – the red and white roses of the houses of Lancaster and York combined – again surmounted by a royal crown on the 20 pence piece.

In the spirit of simplicity and to reflect a modern look, coins nowadays are rather stark and bare, and, apart from the 20 pence design, none seem to fit very happily in the space of the coin.

This contrasts with some of the coins of the past which,

although perhaps a little elaborate in design, seem more suited to the small circular area of coinage. The shield with a round base, reflecting the shape of the one shilling piece, and the pattern of national flowers – the rose, thistle, shamrock and leek – woven around the two shilling piece of Queen Elizabeth II's pre-decimal coinage are particularly good examples.

Royal Warrants

Walking round London, it is not difficult to find the sign of a Royal Warrant Holder. Within a small space of a few streets there will be badges and the royal arms indicating that the shop supplies goods or services to the royal family. However, Warrant Holders are not confined to London; there are holders throughout the country, although they do tend to be concentrated in towns with royal associations such as Edinburgh and Windsor.

It appears that the English King Henry II (1133–1189) granted the first Royal Warrant in recognition of personal service to the monarch. Nowadays there are about one thousand firms who are Warrant Holders and they are held not just for service but for the supply of goods, too.

Those who may qualify have to satisfy the Lord Chamberlain's office and the Royal Household Tradesmen's Warrants Committee that they have supplied goods or services to the royal family for a number of years and that their business is sound. They are then allowed to display the Royal Arms with wording that they supply specific goods or services to individual members of the royal family.

When that member of the royal family dies the Warrant lapses, although the words 'By appointment to His or Her Late Majesty' may continue to be used.

The Howard lion, with a tremendously long tail and his companion supporter the white horse, holding in his mouth a slip of oak 'fructed proper', that is, with leaves and acorns, standing guard outside the entrance to the inner castle (the keep on the motte) at Arundel Castle in Sussex, home of the Dukes of Norfolk, hereditary Earls Marshal.

Government offices

An accepted form of the royal coat of arms is displayed on some Government offices, embassies abroad and stationery. The design has changed over the years, and has to be approved by the crown office.

Sadly many government departments now display not the royal arms but a logo, often devised at great cost. Logos change with fashion, and those which may look smart and up-to-the-minute now will date within a decade. The royal coat of arms is familiar and a standard; it does not date, and it is a pity that it is not used more.

Old buildings and stately homes

On the outside of the Lion Tower marking the entrance to the Great Hall in mediæval times at Warkworth Castle in Northumberland there is a shield showing the Percy arms, with the Percy lion, and a helm with the lion crest. This outward display of ownership was a common sight in previous centuries. Castles and fortified houses were permanently marked by carvings in stone with the owner's coat of arms, and there would have been a banner or even a standard flying from the rooftops, and other outward signs of ownership, too.

There is still much evidence today of heraldry in old buildings – great and small. Many cottages, mills, barns and other buildings which belonged to landowners have the coat of arms or a badge of the landlord displayed on an outside wall. Usually this is carved, but occasionally it is moulded in plaster. However, it was not only walls which were so marked. The ostrich feathers which form the crest of the Cokes was actually embossed on the oven door of every cottage in Holkham in Norfolk.

Similar carvings in stone and wood adorn the insides of houses – beams, ceilings, fireplaces, lintels, window frames, all bristled with heraldic emblems. These were painted, too, on ceilings and walls. Coats of arms decorated china, silverware, glass and linen. In fact, there seem to be few places which it was not possible to decorate with a crest. There are even portraits with the full coat of arms or the crest incorporated into the design, either in an obvious position, perhaps in sidelines into a corner, or alluded to in an allegorical form.

Inn and public house signs

A number of inns and public houses in Britain are quite clearly related in some way to heraldry because of their name, being called the King's Arms, or the Bricklayer's Arms. Some are fortunate enough to have a good heraldic representation of that coat of arms as their sign, hanging outside above the door. Others are called after a royal badge perhaps. The Feathers or The Three Feathers clearly refer to the badge of the Prince of Wales; others, such as The Rising Sun, The White Hart, The Rose and Crown may not be quite so obvious to us now but are connected to the designs of royal badges as well. And inns or pubs with the name of The Red Lion, The Chequers, The Blue Boar and so on would have had some form of heraldic connection even though there is now no clear link.

Far right.
The White Hart Hotel in Salisbury, with a painting of a white hart and a magnificent carved animal atop the gabled roof.

Right.
The Cornish Arms outside the public house of that name, near St Ives, Cornwall.

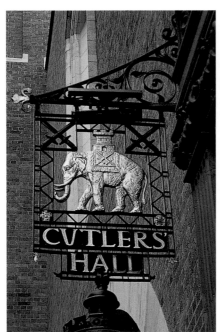

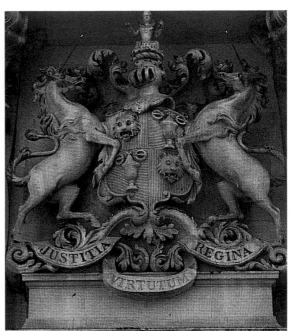

Guilds and Livery Companies are proud to display their coat of arms outside their halls – modern and historic. Notice the coat of arms of the Cutlers' Company shows an elephant as its crest, harking back to the days when ivory was used for knife handles. The gold lion's face of the Goldsmiths' is shown as a badge at the entrance gate to a pretty city garden which is maintained by the Company.

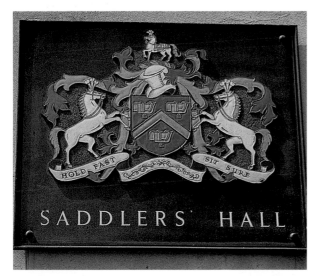

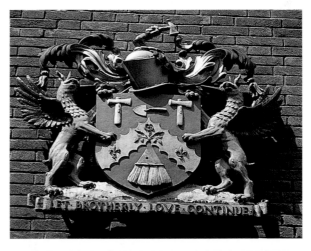

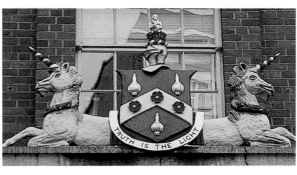

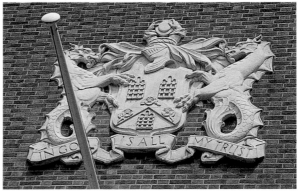

It is likely that in the past followers and retainers of a lord would have taken to drinking in one particular public house, in the same way that an amateur soccer team, or team in a general knowledge quiz would do today. In those days the owner might have put up a board showing the badge or specific aspects from the coat of arms to indicate to all the followers that this public house had loyalty to that person. In time the name of the inn or public house might have been changed to register this fact.

Sadly many public houses are changing names now as a result of being taken over by large breweries. Names showing such an allegiance over hundreds of years are forgotten on the whim of a marketing and design team. The name changes along with the character of the traditional public house, although not always without protest. It is surprising, and encouraging, to see how loyal people are to the name of their local pub.

Guilds and Livery Companies

There are few cities in the world which can rival the pageantry and mystique as the City of London with its Guilds and Livery Companies. Guilds originated as groups of people skilled in a particular craft who met – perhaps in a special hall – to discuss matters relating to their trade. There is a reference in Stow's *Survey of London* 'in the year 975 in the Ward of Farringdon, without the city walls, there are situated divers slaughter-houses and a Butchers' Hall where the craftsmen meet', which suggests that these guilds were in existence long before heraldry came about.

Guilds petitioned for a charter from the sovereign, but they were granted their livery from the Court of Aldermen, which was established in 1506. Before livery is granted, the Aldermen have to be assured that this particular guild is not engaged in the same or similar trade as any other, that they have been together for a sufficient length of time and that there is a future for that trade.

However, not all Guilds have livery; the Parish Clerks have never applied for livery, and the Watermen and Lightermen (lighters are a particular type of Thames boat) were incorporated by an Act of Parliament in 1555, which meant that they are not in the jurisdiction of the Lord Mayor of the City of London, cannot elect the Lord Mayor, and thus are not awarded livery by the Aldermen. Livery is simply the uniform, usually in distinctive colours, worn by liverymen and liverywomen in the same guild. It was originally the livery (living) of food and clothing given to the retainers of a great household.

Nowadays those who are already freemen or women of Companies and become liverymen and liverywomen at a special ceremony are clothed with the company's livery – a gown in livery colours, usually resembling an academic robe – which is then removed, as only the head and officials of the company wear their gowns when carrying out their Company duties.

Guilds and Livery Companies existed to uphold standards of trade, to train new members in that trade, to care for bereaved families of members and to preserve their own customs and traditions.

Most Guilds had a system of apprenticeship lasting a set number of years. Children would be apprenticed at an early age and would leave home to live with a master who would teach them the secrets of the craft. At the end of the given number of years apprentices became journeymen (worked and paid by the day, from the French *journée),* and could leave to study with other masters. Eventually they would produce their masterpiece, an example of their work which would be examined and scrutinised by masters before they were allowed full entry to the guild.

Refreshingly there were few barriers to entry for women, who were masters at their craft in the same way as men.

Nowadays Guilds and Livery Companies usually have a broad intake. A few, such as the Brewers, Solicitors, Scriveners and Master Mariners, admit only those directly involved in the craft. Some become members of a Company by serving an apprenticeship of a given number of years and become skilled in that craft. Children born after their father's admission to the company may become members after they reach the age of twenty-one, even if their own trade or profession is different. Queen Elizabeth II became a freewoman of the Drapers Company in this way as her father was a freeman of that Company. Or the Company may ask eminent individuals, who will bring honour to the Company, to become members. Lastly, people can become members by buying into the Company. This raises much needed funds and also broadens the intake of members.

Once people have been accepted as freemen and freewomen of a Livery Company they can receive the freedom of the City of London by attending the Chamberlain's Court in the Guildhall. The privileges of this include the rather doubtful honour of being allowed to drive a flock of sheep over London Bridge.

Election to the Livery of a Company is one stage beyond this. It is achieved by some, not all, after waiting a number of years – anything from two to over twenty.

The links between these companies and heraldry began with the granting of arms. The earliest surviving grant of arms – not only to a Livery Company but to anyone at all – was made to the Drapers Company on 10 March 1439 by William Bruges, the first Garter King of Arms. Despite some damage it is a magnificent scroll with colourful decorations and a shield supported by pink-robed angels with red and blue wings.

Nowadays there is plentiful evidence of heraldry in most companies. The coat of arms is prominently positioned on

the outside of the Fishmongers Hall in London, which is the third hall on this site, built in 1834. The shield with its distinctive arms of dolphins and stockfish with crossed keys in chief is supported in dexter by a merman and sinister by a mermaid. The dolphin from this coat of arms appears throughout the decoration inside the building – inset into marble floors, around pillars, on table legs and chair arms.

In a similar way the elephant, from their crest, decorates the Cutlers Hall built in 1887, which belongs to the Guild of Cutlers. The elephant was used as a crest by the Cutlers because of the ivory tusks which went to make knife handles.

Not all halls are old buildings. The extensive bombing during the Second World War destroyed many buildings, including some of the guild halls. The Haberdashers modern hall in Staining Lane, London is decorated with the coat of arms of the company, that of the City of London, those of the sovereigns who granted them charters and, in addition, those of over forty members of the Livery Company who have become Lord Mayors of London.

Precious objects of gold and silver plate, silverware, glasses, wall hangings, wood carvings on tables and chairs, staircases and even the Master's Crown of the Girdlers Company, dating from the sixteenth century, are all decorated with the coat of arms or crests of the company or notable individuals. They are a treasure house of heraldry.

Civic heraldry

Despite a number of area reorganisations and a trend for logos rather than a coat of arms, the use of coats of arms to denote a town, city, district or local government authority is still popular. In fact, a number of reorganised areas have reapplied for a grant of arms, so incorporating features on previous arms for the new shield. One such area is the London Borough of Greenwich, which combines the formerly separate areas of Woolwich and Greenwich. The new coat of arms shows symbols relating to both areas – guns indicating the importance to the area of the Royal Arsenal at Woolwich. This was a major employer in the area until after the First World War, when it was realised that siting an armaments factory in the middle of a densely populated area was not sensible. The other parts of the shield are connected with Greenwich, which is famed for the time line, or meridian, and the naval dockyard. The connection with water is shown by the blue and white wavy line.

Coats of arms may be used on stationery, painted or carved in the fabric of the Town Hall or civic centre, appear on treasures owned by the corporation, be painted on the side of vehicles used by the employees of that area, be represented in the form of a badge on litter bins, park seats, day centres and almost anywhere. Most importantly, perhaps,

it is usually enamelled and hung as a pendant from the mayoral, or the leader of the council's, chain of office.

Historical milestones giving distances from certain locations may display the town or city's coat of arms, which could appear also on marking posts, such as those at the entrances to the City of London.

However there are also instances of heraldry being used in a modern setting. The Whitgift Centre, a pedestrian shopping area, or shopping mall, in Croydon, south London, was built on the site of the old Whitgift School in the centre of the town. A large and colourful perspex panel of the Whitgift coat of arms is sited at one end of the shopping precinct, near to the entrance of the shop of Marks and Spencer. An interesting juxtaposition of old and new!

Schools, colleges and universities

In the past many schools and colleges were established as a result of one person's philanthropy; it may have been the king or queen or a local dignitary. Schools then take the name of their founder, and may use all or part of that person's coat of arms as their badge.

The individual need not be from a long line of wealthy nobility. Sevenoaks School was established in 1432 by William Sevenoke, who was a foundling, an abandoned orphan, and eventually made his way in life, becoming Lord Mayor of London and rich enough to establish a school as well as almshouses in his home town. This was originally for the poor boys of the parish, but is now a fee-paying public school. The coat of arms of William Sevenoke, *azure seven acorns argent (*seven silver acorns on a blue shield), has been adopted by the school in recognition of his generous gesture. Interestingly enough, in the late seventeenth century there was some doubt as to the actual configuration of the acorns, and there was no record of this at the College of Arms as apparently it had been destroyed in the Great Fire of London. One person remembered that there had been a painting of the shield in the upper end of the Grocers Hall of the Grocers Company in London, and was able to confirm that the acorns were positioned 2,3,2 on the shield.

Not too far away another fee-paying school was established in 1553, again originally as a free grammar school for the boys of Kent and adjoining counties. This school, Tonbridge School, was established by Sir Andrew Judd who was a Lord Mayor of London, too, and a member of the Skinners' Company.

His coat of arms was used by the school until 1923, when it was granted its own arms, based on that of Sir Andrew Judd. His impaled shield became quartered, and the new shield is *Quarterly Gules and Azure a cross fillet Or between in the first and fourth quarters a fess raguly between three boars'*

Right.
*The coat of arms of Earl Amherst, one of many displayed on buildings in Riverhead, Kent, close to Montreal Park, the home of the family before it was pulled down. The Earl's crown surmounts the design and the shield of three tilting spears erect are in front of the letter **A** for Amherst.*

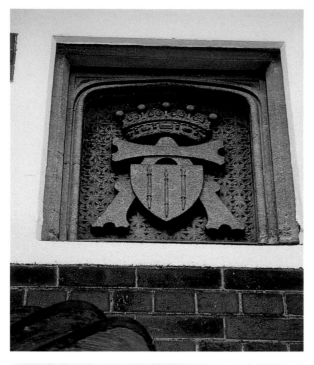

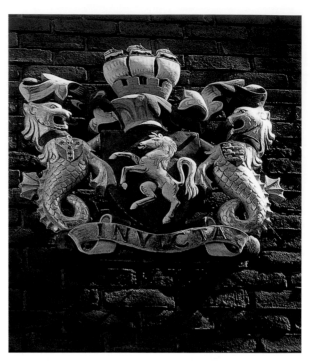

Far right.
The coat of arms of Kent outside the fire station in Sevenoaks, Kent, with the white horse of Joan of Kent as the main charge on the shield and sea lions as supporters – indicating Kent's long association with the sea.

The coat of arms of Tonbridge School, Tonbridge, Kent.

Quarterly Gules and Azure a cross fillet Or between in the first and fourth quarters a fess raguly between three boars' heads couped Argent armed and langued Azure and in the second and third quarters three lions rampant Or.

The red and blue colours of the shield are reflected in the couped boar's head which shows both.

Reproduced by kind permission.

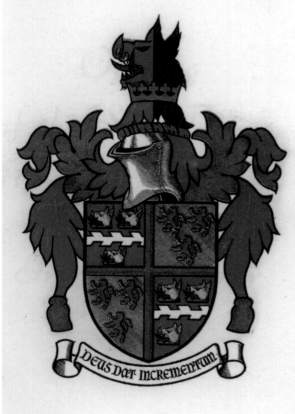

heads couped argent armed and langued Azure and in the second and third quarters three lions rampant Or. The red quarters of the shield are divided by a white horizontal stripe with a raguly edge, with two silver or white boars' heads above and one below. The heads are cut straight across. Because of the red background the tusks and tongues are painted blue. This is the arms for Sir Andrew Judd. His wife's arms are three gold lions, rampant, on a blue background, from the Chichele family. Over the whole of the shield is a narrow gold cross.

Different Heraldic Traditions

Most countries in Europe have an heraldic tradition. In some this is still very strong, in others it remains part of their history and, if not actually discouraged, is certainly not to the fore. Yet heraldry is not confined to Europe. Many countries throughout the world have their own heraldic traditions, or have groups or societies of individuals who are interested in heraldry in all its forms. It is not possible here to give a complete overview of heraldry throughout the world but a few areas have been selected for special consideration.

Scotland

Heraldry is certainly alive and well in Scotland. Lord Lyon King of Arms has jurisdiction over all heraldic matters in the country and is judge in his own court. His powers, granted by the Crown of Scotland, allow him both to fine and to use imprisonment as punishments. Although there is a court at the College of Arms in London, it was last used in 1954, and so the Lyon Court is, to all intents and purposes, the last remaining court in Europe to hear heraldic matters. Apart from Lord Lyon there are three heralds – **Marchmont, Rothesay** and **Albany** and three Pursuivants – **Ormond, Unicorn** and **Carrick.**

Although similar in many ways to English heraldry, that in Scotland does have distinctive and important differences. The civic coronets used in the coats of arms for councils and burghs have already been considered (see page 233) and are only one feature of difference. Mottoes are placed above the crest in a full achievement of arms, whereas in England they are traditionally positioned below. In addition, a significant factor is that there is no family coat of arms. The heir – male, female or tailzie (that is, an heir who is nominated within the blood relationship) inherits the achievement of arms. Junior members of the family are assigned coats of arms with differences determined by Lord Lyon, not simply marks of cadency on the paternal coat.

The clan is also a most important feature in Scotland, with badges and specific tartans assigned to those with the same family name or who are members of the clan. Clansmen and clanswomen can and do wear the clan badge. This is the crest of the chief depicted within a strap and buckle showing the chief's motto. Badges are, however, in a grant of arms, restricted to the chief of a clan. In England badges can be awarded to anyone as part of their grant.

Wales

The Welsh have a great sense of tradition and family history. Many of those who were originally awarded coats of arms were descended from the great royal and almost royal families. These were led by, amongst others, the **King of Gwynedd, the King of Powys** and the **King of Rhyng Gwy ag Hafren.**

The kings of arms and the College of Arms have jurisdiction over the principality and the same rules which govern English heraldry apply to Wales.

Prince Charles is addressed as the Prince of Wales, although not all male heirs to the throne (heirs apparent) held this title. The badge of the Prince of Wales is the Welsh red dragon wearing a white label of three points and

The birthbrief of Sir Malcolm Innes of Edingight drawn up when he was Marchmont Herald (he is now Lord Lyon at the Court of Lord Lyon, Edinburgh).

Notice the mottoes above the coats of arms rather than below, as is usual with heraldry south of the border.

Reproduced by kind permission of the Lord Lyon.

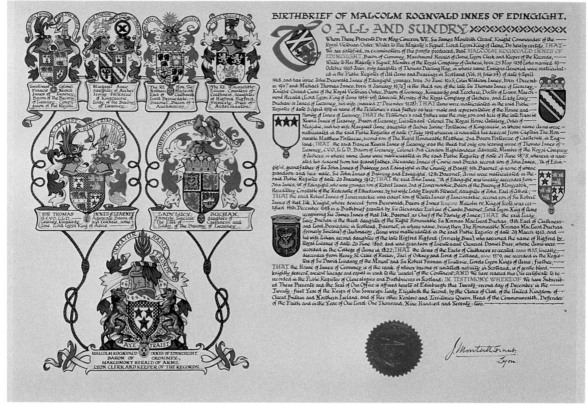

standing on a green mound – *y ddraig goch*. The badge of the heir to the throne is the three white ostrich feathers encircled by a gold coronet of fleur-de-lis and crosses paty, with the words *Ich Dien* on a blue scroll. There is the possibility that these words are not from the German, meaning 'I serve', but from the Welsh *Eich Dyn,* which is translated as 'Your man'.

Ireland

It is in those countries which have or have had close links with England where, naturally enough, the heraldic system is most similar. For many years Eire or Ireland was part of the Union, and the rules and regulations pertaining to heraldry in England and Wales were applied.

The first Ireland king of arms, Chandos, was created in 1392 by King Richard II of England. It was part of the sovereign's policy to bring order to the country. There were other Ireland kings of arms but they appeared to have little to do with the Irish or with the granting of arms. It was in 1552 that the English King Edward VI replaced the Ireland king of arms with the Ulster King of Arms (and principal herald of Ireland).

With the establishment of the Irish Free State in 1922 an anomaly occurred. The British Crown continued to appoint personnel to the Office of Arms at Dublin Castle. This was resolved in 1943 with the creation of the Chief Herald of Ireland who has heraldic authority over everyone of Irish descent no matter where they currently live. The Chief Herald grants coats of arms to those with a certain standing in society. He also confirms the arms to people who can prove that their family has borne arms for over one hundred years. In both instances it is considered a form of honour to be awarded or have confirmed a grant of arms.

The United States of America

It is written in the American Constitution that citizens of the United States cannot bear any title. Even if a title is awarded by another country this is still not recognised in America, although it may be acknowledged at the end of that person's name as, perhaps, *Hon KBE* (an Honorary Knight of the British Empire). The original Pilgrim Fathers were trying to get away from, amongst other things, the rigid class system, of which titles and related honours are clearly part, and therefore clauses to this effect were eventually written into their Constitution by their successors.

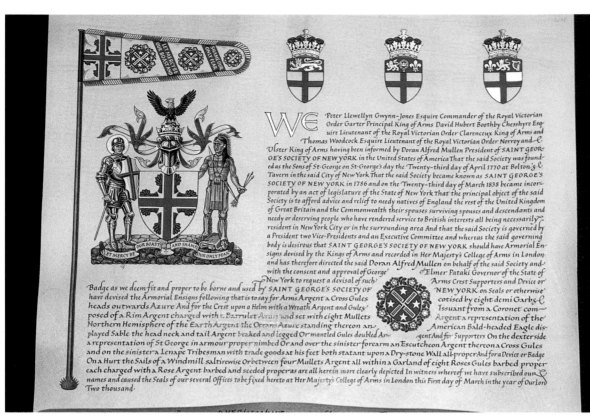

A devisal of arms for the St George's Society of New York, with, of course, an eye-catching cross of St George as part of the arms, and St George as its dexter (most important) supporter. Devisals show the coats of arms of the three kings of arms, but not the Royal Arms nor that of the Earl Marshal. However, with a badge and a standard and when magnificently painted and written by heraldic painter, Timothy Noad, devisals are as impressive as any grant of arms.

Reproduced by kind permission.

Citizens of the United States can, however, bear arms, although this right is not recognised by law in any US state. If a person can prove that there is a direct male line, legitimate or illegitimate, to an individual who was awarded arms, then they may apply to the College of Arms in London for Honorary Armorial Bearings. Prior to this their pedigree has to be placed with the College of Arms. Honorary Armorial Bearings can also be given to those who are honoured by the British Crown, (such as by membership of the Order of the British Empire), usually for services to the United Kingdom or of an international nature.

In 1960 the Earl Marshal issued a warrant such that the College of Arms could design and record coats of arms for towns in the United States, and later, in 1962, this was extended so that businesses and corporations could also receive a coat of arms. These are called **Devisals of Arms**, and before they are made consent and approval must be gained from the Governor of that state.

A Devisal is similar to a grant of arms made to a British subject. The design must not have been granted to anyone else before, it usually incorporates various elements relating to the applicant, and is written and painted on vellum. However, the wording is different, and so is the decoration. The Royal Arms and that of the Earl Marshal are omitted, replaced instead by either the full coats of arms of Garter,

Clarenceux and Norroy and Ulster – the kings of arms – or simply their crowns. It is signed by all three kings of arms.

In the United States, as elsewhere, there are businesses which will issue an applicant with a coat of arms connected in some way with their surname, and there are even organisations which will issue new coats of arms. Because there is no recognition in law for heraldry, there is nothing against so doing. But it would be wrong to suggest that these coats of arms compare with those issued by the College of Arms, as there is no guarantee that there are no duplicates, nor that similar coats of arms will not be issued to the next person who pays his or her money. Occasionally those issuing these arms are not very familiar with the rules that govern heraldry from its inception, nor are they always aware of what is considered to be 'good' heraldry. Charges are not always well placed on the shield and may be in rather startling colours.

Most American cities and states have seals which are used for legal documents. These may be armorial – that of Maryland is of the Lords Baltimore and is *Quarterly first and fourth paly of six Or and Sable a bend counterchanged second and third quarterly Argent and Gules a cross botonny counterchanged.* The first and fourth sections are vertical stripes of gold and black, with a diagonal stripe of the same colours but counterchanged, that is, where the stripe on the shield is gold that on the diagonal stripe will be black, which

*Far right and right.
The magnificent
pavilions surroun-
ding the Royal Coat
of Arms above a
delicatessen shop in
The Hague, The
Netherlands.*

*These are similar
to Royal Warrants
in the UK, and have
been retained by
the shopkeeper des-
pite the change of
use of the shop.*

*Right.
The coat of arms of
Amsterdam, above
a beautiful classic
building along a
canal.*

*Far right.
The same devices
on the coat of arms
– saltires – ingen-
iously used as the
decorative bases to
street lights.*

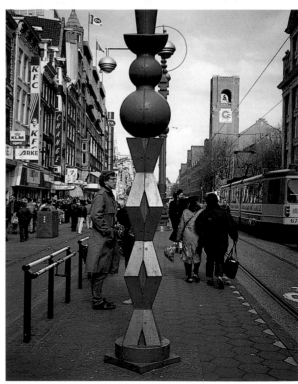

286

is for Calvert, Lord Baltimore. The second and third sections are silver and red with a cross botonny, and again counter-changed, so that where the field is red that section of the cross will be silver. This is for Crosland, the family of the heiress who married the first Lord Baltimore. Others cities and states may have shield shapes, but the charges and colours do not necessarily comply with heraldic rules.

Canada

Because Canada is part of the Commonwealth matters per-taining to heraldry were dealt with by the College of Arms in London; kings of arms had as much jurisdiction over Commonwealth countries as they had in England. How-ever Canada now has a separate heraldic authority, granted by Queen Elizabeth II in 1988. The Chief Herald of Canada maintains the traditions of the College of Arms by gran-ting new armorial bearings to citizens of Canada and to institutions and businesses, following the established rules of heraldry.

Europe

Heraldry was a movement which swept though Europe in mediæval times, when the Roman Catholic church united Christian countries in the Crusades against the Moors. The meeting of soldiers from different nationalities in their quest to free the Holy Land from the infidel helped to promote the use and development of heraldic symbols and devices on armour. Once back in their own countries the traditions of using heraldry often varied in subtle ways. Charges on the shields differed; in England there were more smaller charges and, perhaps because of the climate, furs were used. In The Netherlands, the shields usually featured only one bold charge. The devices on shields in German heraldry were often rep-eated in the choice of design for the helm. In France there are no crests at all.

The Netherlands

Heraldry in the Netherlands is distinctive because of its bold-ness and simplicity. There is usually only one charge on the shield, with one helm and one crest; there are few marshalled or quartered arms. There is also much evidence of heraldry on buildings, street furniture and in public places. There are no laws which govern the issuing of arms, nor is there any register, similar to the College of Arms, and anyone in the Netherlands can design his or her own arms and adopt them.

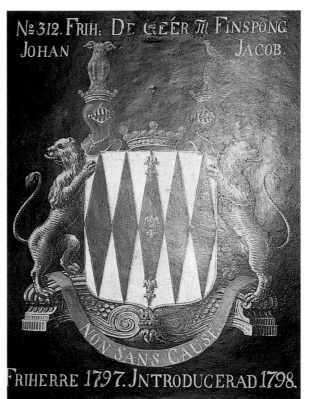

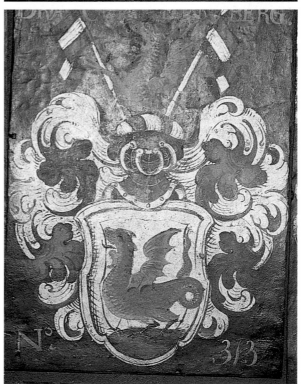

Above and below. Armorial plaques in the Riddarhuset (the 'House of the Nobility') where more than 2,000 coats are arms are shown, Stockholm, in Sweden.

287

The coat of arms for Madrid in Spain is a bear and a mulberry tree. (Both used to be common in the area.) This device is used repeatedly in the city on litter bins, drain covers, parking signs and so on.

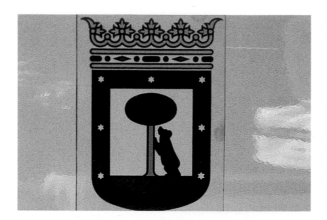

However, there is a governing body for the arms of the nobility. The Supreme Court of the Nobility is answerable to the Queen of the Netherlands. It regulates titles, public arms, badges and emblems for the armed forces, flags and similar matters.

Sweden

The Riddarhuset in the old city of Stockholm is a beautifully designed, yet understated, seventeenth-century building in Dutch Baroque Style. As in many buildings of this period the main rooms are on the first floor. Here there is a magnificent chamber, a great hall, built as a meeting place for the members of the Swedish nobility. The walls are covered with two thousand small copper panels, a little larger than the size of a piece of photocopying paper, on which are painted coats of arms. For anyone interested in heraldry it is a breathtaking sight.

Although originally there were no titles, these were introduced between 1560–68 during the reign of King Eric XIV. Those of count and baron are indicated on the coats of arms by the coronets and the numbers of helms and crests.

These were stopped by law in 1902, and the use of personal arms or similar denotions of rank have been discouraged, apart from for those who receive Sweden's most important order – the Order of the Seraphim.

It is not only in Stockholm, the capital of Sweden, that there are examples of heraldry. Arms for administrative areas throughout the country, companies and the church are still in evidence and indeed encouraged.

Spain

It is only in the twentieth century that heraldry in Spain has been brought into some semblance of order. Before this heralds and kings of arms had little power and acted very much on their own initiative, as there was no similar body to the College of Arms. Perhaps it was this lack of regulation that led to certain anomalies, such as the juxtaposition of heraldic metals, gold and silver, which do not occur in other heraldic systems. Nowadays this is all controlled by law and ministerial edict.

Spanish shields, and indeed those of Portugal, too, are wide. This may be because it has become the practice for a husband to place on a broad border elements from his wife's coat of arms. Occasionally the whole coat of arms appears

Far left.
The coat of arms
outside a church
building in Gaeta,
Italy. Note the
stylised hillocks, or
coupeaux, at the
base.

Left.
Heraldic devices on
the wall of the town
hall in Padua, Italy.

on this border in the form of seven or eight tiny shields. Many shields are quartered as the arms of a wife's family appear on the shield whether or not she is an heraldic heiress. Usually there are no crests on a Spanish coat of arms, instead a plume of ostrich feathers is attached to the top of the helm.

Italy

Unusually shaped shields are a distinctive feature of Italian heraldry. They may be almond-shaped, but are more often horse head-shaped. It is thought that the shields became this shape simply because they were placed over the front of a horse's head at a tournament.

Italy has had a very turbulent history, with invasions from other European countries and wars between the various sovereign states. Heraldry was used an an outward display of loyalty, and the chief, or upper part of the shield, often shows allegiance to one particular country or to the Holy Roman Empire.

Interestingly, the designs on a number of shields show stylised hillocks or coupeaux, rising from the bottom or base of the shield, usually in groups, perhaps three or six.

As well as this Italian heraldry is closely connected with the church, many families having close links with the clergy. In earlier times the Pope would have awarded arms and titles, and this is reflected in the crossed keys or papal tiara which appear on many shields.

As a republic, Italy does not now recognise former titles or honours of rank, which includes heraldry, although members of the nobility still maintain some old traditions.

Poland

Polish heraldry is unlike that of any other European country in that the same design on a shield, with no marks of difference, is used by a number of different noble families, not necessarily with the same surname.

A horseshoe, enclosed by a cross, which is part of the coat of arms of Sir Conrad Swan, previous Garter Principal King of Arms, is used by nearly six hundred families. This developed from a system of clans where the link between families was an area of land or loyalty to a particular individual. Indeed, some families have more than one shield where they have married into a family or where they have shown obvious allegiance to those of another clan

Shield designs are incorporated into license plates in Austria. They show the area in which the car had been registered.

with different shields. Rather than marshalling the arms, the family shows two shields.

Another characteristic of the designs on the shields is their simplicity. There are very few divisions of the field or ordinaries. The one or two charges originated from the straight lines and curves of runes (see page 61), which pre-dated heraldry. These were transferred on to shields and sometimes gradually changed to a cross, arrows, a crescent or a horseshoe.

Austria

Austrian heraldry is very visible as it is prominently displayed on all car registration plates. The shield indicates the area in

which the car has been registered and these make a lively and colourful addition to a plate which is usually dull and uninteresting.

Austrian heraldry is part of the Teutonic tradition. The most obvious feature is that the crests almost always repeat what is on the shield, usually both the charge and the tincture. This can be very striking when shields and crests are depicted on a roll of arms.

Another feature of heraldry in this area of Europe was that as individual shield designs were marshalled, or combined, on one shield, so too were the crests incorporated into the design. It is very rare in English heraldry for there to be more than one crest in a coat of arms design, but in Teutonic designs there may be a number of crests. As well as this the crest and the mantling are often combined so that they almost look as one.

Modern heraldry in Vienna.

Reference

This section brings together a mass of information relating to the practical aspects of calligraphy, illumination and heraldry. See also the Glossary *on page 313 for definitions of technical terms.*

Paper

There is a variety of writing and painting surfaces which can be used in calligraphy, illumination and heraldry. Paper is the most familiar and the most versatile.

Paper manufacture

Paper is made from cellulose. Cheaper papers, including newsprint, are made from wood pulp alone. The acidic content in paper made from wood pulp is high, and the paper discolours quite quickly; a newspaper left in the sun for a week, for example, will soon become yellow and brittle. Trees grown for producing paper are felled, cut into lengths, then ground in huge machines to make wood pulp. Better-quality papers are made from mixed wood pulp and rag fibres, usually cotton, or from rag alone. The higher the proportion of rag, the better the quality of paper. Some papers of this type are **acid-free**, sometimes called **archival,** which means that not only will they keep their colour and not deteriorate, but also they will not cause the ink or paint to change colour because of the acid content. Often the acidic content of paper is included with information about the paper. Paper which is neutral has a pH of 7, acidic papers will have a lower pH figure and alkaline a higher pH figure.

The making process for both hand-made and manufactured papers usually includes the addition of bleaches – to whiten the paper and take away any natural colour so that dyes can be added if necessary; fillers – so that the surface is smooth and regular; and size – without this any ink would bleed over the surface of the paper. Unsized paper is blotting paper.

The pulp for manufactured paper, once it has been mixed in vats, is allowed to fall on to a conveyor belt. This gradually shakes the paper fibres so that most of them are in the same direction. Any markings, such as a watermark, are pressed into the paper at this point.

A series of rollers and presses dries the paper, gives it the required finish and cuts it into sheets or rolls.

Hand-made papers use the same raw material of fibres, dyes and size (usually), but the paper maker produces individual sheets of paper with a mould and deckle. The mould is a wooden frame with the centre part consisting of a mesh of wires. The deckle, similar to a picture frame, fits snugly on to the mould. It is the deckle which gives hand-made paper an uneven, or deckle-edge as small amounts of paper fibres seep out between the mould and deckle. Both mould and deckle are dipped into a vat of pulp by the *vatman.* As the mould and deckle are taken out of the vat with the pulp fibres lying on the surface they are tipped one way and then the other. This ensures an even distribution of pulp over the mould. It also means that the fibres are not in any particular direction.

The mould and deckle, once drained a little, are passed to the *couchman* who allows the sheet of wet paper to fall on to a woollen cloth, which is usually felt. The routine between the vatman and couchman, and the skill they have in doing this, is most impressive. When about 150 sheets, or six quires, are in a pile, they are put into a large press which squeezes out the water.

The damp paper is peeled from the felt by the *layman,* and then hung up to dry by the *quireboy.* The felts are re-used.

Paper finishes

The mesh used to produce papers is made from wire. This thin wire is strung across the mould in one direction, and then slightly thicker wires, called chains, strung at intervals in the opposite direction, form a reinforcement which makes the mesh strong. These thicker wires produce a pattern on the paper, and the paper itself is called **laid,** because the laid lines are visible. In the eighteenth century a finer, yet still strong, mesh was developed, with no need for thicker wires. This produced a paper with a much smoother surface, called **wove.**

Both laid and wove papers are manufactured or hand-made today. Some good-quality letter-writing paper shows laid lines. These are nowadays pressed into the paper during the manufacturing process, and are not as a result of laid wires.

The smoothness of the paper surface is produced by pressing between rollers or leaving the paper as it is. When hand-made paper is allowed to dry naturally, the surface will still have a distinct imprint of the woollen cloth or felt between which it is squeezed at that first pressing to remove excess water. This paper has a rough texture, and is called **Rough.** It is not the best paper for beginners to use for lettering, as it takes a little while to adjust to the textured and uneven surface. However, it does produce interesting and varied letter-forms, and it is certainly worth trying rough paper when you feel more comfortable with the pen. Or use a broad-edge brush to write on it, or a very fine nib.

If the paper has been passed through rollers which have not been heated, the rougher parts of the surface are pressed down, and this paper is called **Not** or **Cold Press**. It is called Not because it has not been passed through heated rollers. This paper has a more forgiving texture and it is possible to create letter-forms which have a sharper edge than those on rough papers.

Paper which is passed though heated rollers has a very smooth surface, suitable for most types of writing, although it should be pointed out that not all these papers are suitable for calligraphy, heraldic painting and illumination, as they may be a little greasy or lack tooth, providing little resistnce to the pen. This paper is called **Hot Pressed** or **HP** paper, because it has been pressed through hot rollers. The paper used in this book and most letter-writing paper is hot pressed.

Grain direction

Because of the process of manufacture, the fibres in papers which are not hand-made tend to fall in a similar direction. (The fibres in hand-made paper will be in no particular direction.) This direction of fibres will make no difference if you are using a whole sheet of paper. If, however, you wish to tear or fold the paper, then grain direction does make a difference, and grain direction is crucial if you are planning to make a book.

Most people are aware of grain direction without realising it. If you want to tear a coupon or an article from a newspaper one way tears very easily and almost straight, and the other is very difficult to tear and the result is a ragged and uneven edge. The easier side is being torn with the grain direction, along the direction of the long fibres. The more difficult and uneven side is against the grain direction, and you are having to break the long fibres or pull them apart.

Tearing paper is one way of determining grain direction, but you may wish to preserve your whole sheet of paper.

There are other ways of finding out the direction of the grain of paper. With thicker papers it is often possible to tell by the feel of the fold. Gently bend the whole sheet over without actually making a crease. Then bend the whole sheet over at right angles to the first direction. The sheet of paper will bend more easily and may even stay in the same position when it is bent in the direction of the grain. It will resist the folding and spring back up again when folded against the grain direction. Mark the grain direction on the paper with a pencil arrow.

It is easier to tell grain direction with thinner papers by using only a corner. Take a piece of one side of the corner of the paper between the thumb and first two fingers of both hands. If the paper is large enough place your hands about 12 cm (5 in) apart. Gently bend the paper, feeling the resistance between your fingers. Turn the paper so that your hands are about the same distance apart along an edge at right angles to the first. Bend again and feel the resistance. There will be less resistance along the grain direction. Again mark with a pencil arrow.

For cheaper papers, such as photocopying paper, or thin papers, you can moisten a corner of the paper. Use a sponge and lightly wet a strip about 6 cm (2·5 in) from the corner in both directions, and about 2–3 cm (1 in) wide. Do not add too much water. Quite quickly the paper will begin to curl, and may even go a little wavy. The curl and the waves will be along the grain direction. Mark the grain direction as before.

Once you have determined the grain direction do mark it on any additional sheets of paper of the same type that you have. This will save you doing it each time.

If you are unsure of how to determine grain direction, then experiment with cheap papers. Moisten and bend the sheet of paper so that you know what you are looking for. Photocopying paper is particularly good for this. The grain direction is not always the same with different makes of paper.

Paper weight

In the past the weight of paper related to the size of the sheet, so unless you knew the individual sizes of papers, which had a variety of names ranging from Colombier (34·5 × 23·5

inches), Elephant (27 × 20 inches) or Hand (16 × 22 inches), you would have little idea of the weight of individual sheets of paper. This was further complicated by half, large, small, double and quad – so a sheet of Double Colombier would be 79 × 47 inches, and a sheet of Half Hand 8 × 11 inches, for example. These sizes of paper were sold according to their weight for 500 sheets, or a ream. So 500 sheets of Double Elephant would be a certain weight measured in pounds (lb), but that for 500 sheets of the same thickness of paper for ordinary Elephant would be less, and again 500 sheets of the same thickness of Half Elephant would be less again. All this was very confusing to everyone apart from those whose business it was to deal in paper.

The weight of paper has now been standardised in most countries; it is now related to a set measurement, which is a square meter of the sheet of paper. Paper weight is measured as **gsm,** or **gm²,** that is grams per square meter. This means that sheets of the same paper, no matter what size they are cut into, are known by the same weight, and different papers relate to one another by weight.

Photocopying paper is usually about 70–80 gsm, slightly heavier weight photocopying paper is 100 gsm, which is a similar weight to letter-writing paper. This is perhaps a little lightweight for calligraphers to use. For best pieces a paper which is about 150 gsm is a good start. Unframed certificates and panels of lettering may require an even heavier weight, and papers of about 350 gsm are almost card.

Choosing papers for lettering

When beginning lettering or painting, expensive hand-made paper is not necessary. Because you will be practising, and filling many sheets with your letters or trial paintings, it is better to choose the cheapest suitable paper. However, later on you will want to choose better quality papers when writing out poems or cards and pieces to give away or frame for yourself.

Papers for starting out

Most **photocopying paper** is perfectly serviceable, and a ream, or 500 sheets of larger-size sheets will last for a long time. Turn the paper so that it is longer sideways, or landscape, so that you have fewer lines to draw. It is recommended that you try out one sheet of paper before investing in a whole packet. A few papers like this do not have a suitable finish for calligraphy pens and inks, and the resulting letters are not sharp, and may even appear feathered.

Pads of **layout paper** are also good for beginners, although more expensive than photocopying paper. They are available in a variety of sizes and it is recommended that you buy a larger pad, (at least A3 size, and if possible A2). There will be times when you need a large sheet for laying out a panel, working out a complicated piece, or practising some really large letters, and sticking two pieces together is not really suitable. You can always slit the larger sheets in half if they do not fit your board or if you are happier dealing with smaller sheets.

Paper used for **computer printers** has a good 'tooth' which usually works well with a calligraphy dip pen. Sometimes there are lines already drawn on the paper but they are rarely at exactly the right distance apart to use as guidelines.

Choosing paper for best pieces

Soon you will want papers, perhaps in a range of colours, textures and weights, on which to use your newly acquired calligraphic, painting and illuminating skills. The range of papers available in a good paper store is vast and can be overwhelming. It may be helpful to ask yourself some questions – not necessarily in this order – before you buy:

1 *What colour do I want?*
Formal pieces tend to be written or painted on white, creamy-white or cream smooth, or HP, paper. However, you may prefer to use a pastel colour, or even a strong colour or two or more colours for the piece you have in mind. A creamy white will show off heraldry and illumination to good effect, but a coloured background may be just as appropriate for your needs.

2 *What should be the texture?*
Hot pressed, or HP, paper gives the smoothest texture for writing and painting and is certainly preferred for most gilding. You may, though, be planning to use a Not or Rough surface. Some papers are made in all three surfaces. If you have the time, Not and Rough papers can be smoothed to a suitable writing surface by rubbing with a smooth stone or burnisher in the areas where you plan to have finer writing.

Hand-made papers are available from specialist suppliers in a variety of textures, sometimes incorporating flowers, straw, wool fibres and other interesting materials. You could also use strong tissue (with care), or cheap brown wrapping paper for some projects.

3 *What weight paper do I require?*
Good-quality papers are often made in two or more weights, the heavier weight being more expensive. Lighter-weight papers, say about 150 gsm, are suitable for most projects, especially if they are to be framed or bound in a book so there is less chance of any damage to the sheets. Heavier-weight paper is, though, easier to handle, as it is less likely to crease or tear, but it is more expensive. It is usually better to choose a heavier-weight paper for painting and illuminating, because these stand up to the process better,

Making Paper (photographs taken at Wookey Hole Paper Mill in Somerset).

1 *The vatman dips the mould and deckle into the pulp.*

2 *The couchman tips the sheet of paper on to a large piece of felt. Layers of paper and felt make a pile.*

3 *This is then placed under a very strong press which gradually squeezes out all the water.*

4 *The drying loft where the paper is allowed to dry before packing and storage.*

If you are putting a wash on the paper before or after you write, then paper which is about 350 gsm or more may not always need stretching (see page 298).

4 *How large a piece of paper do I need?*
For most pieces that you write a whole sheet will be more than sufficient. If it is not too expensive do buy paper preferably five or ten sheets at a time, or at least two or three sheets. You will need some spare paper to try out the pen or brush, to make sure that the writing and painting settles well and the ink does not feather out. The paper may need treating with pounce or gum sandarac as well (see page 297). If the piece goes wrong, or if it is liked and you are asked to repeat it, you will always have some spare paper to hand. The pressure on the scribe or artist when there is only one sheet of paper available is great indeed, and almost guarantees a mistake. In addition to this, batches of the same paper, in a similar way to wall paper rolls, vary in colour and texture. You may start a project such as a book and find that you have insufficient paper to finish. The new sheets of paper may not be exactly the same as the first.

There will be some pieces which, because of their shape or size, are larger than normal single sheets of paper. Certain papers can be bought as rolls. These are expensive because you are buying perhaps 30 meters of paper. It is economical in the end though, as you can always cut smaller pieces from the roll, and if you want to write out a really long piece, you have the paper available.

If you do use paper from a roll, cut it the day before using and allow time for the curl to relax a little. Leaving it in a slightly damp room for a few hours will accelerate this, but do give the paper time to dry out, too. You may have problems if you write or paint on damp paper.

5 *Does the grain direction matter?*
If you are using the whole sheet of paper, or simply cutting a piece from the sheet, then grain direction is of little importance.

If the paper is to be torn or folded into folios for a book or pamphlet, then grain direction is an important consideration. The grain direction on some sheets of paper will mean that you can get two folios, or folds of paper, from one sheet. On others, you will be able to cut only one folio from each sheet and have to waste the rest, or use it for much smaller pieces.

6 *How much am I willing to spend?*
It is not necessary to buy expensive hand-made sheets of paper for calligraphy. Depending on your intention you can use the cheapest of papers for calligraphy and painting. People have written letters on paper kitchen towel with a brush, and on newspaper and wrapping paper, although these may not suit the project you had in mind and you may prefer a

better quality. There are some inexpensive manufactured papers which provide a good surface for lettering, painting and illuminating – and bear in mind that not all expensive papers are suitable for pen and brush.

7 *And then is the paper suitable for calligraphy, heraldry or illumination?*
This will be your greatest problem. The days of paper made specially for just writing or painting have long since gone. Nowadays most papers are multi-purpose and not all react well to the pen or brush.

Paper for calligraphy and painting should be strong, well sized and provide a tooth for the pen. Some of the worst papers to use are those with such a smooth, shiny surface that the pen skids around with little control, or where the paper is insufficiently sized and so the ink or paint feathers or it is impossible to write letters with fine, thin strokes. Paper to avoid is fake-looking 'parchment' paper, as it is very difficult to get good, crisp letter-forms or smooth, flat paint on this.

So how do you know if a paper is suitable for calligraphy and other skills, apart from trial and error? There are a few guidelines which may help. First, hold a sheet of paper between your thumb and first finger and give it a couple of brisk shakes. The paper will rattle; sheets which are well bonded and strong will give a higher relative tone, although thicker paper gives a deeper rattle than thinner paper. Now look along the surface of the paper to see the texture. Some HP papers have a number of protruding paper fibres which could catch in the sharp nib of a pen and drag the ink or cause the paint to lie flat. Feel the surface too, for the finish.

It is possible to test paper for how well it is sized, but you will probably have to buy the sheet of paper first. Let one drop of water fall on to the surface and note how long it takes and how well it is absorbed. The water will stay longer on the surface of well-sized paper.

A good guide to paper is to ask other calligraphers and artists what they use, and also to note in lettering and similar exhibitions and their catalogues what paper was used for various pieces. After a while you will start to build up your own paper stock, with personal preferences. Some letterers and artists prefer a hard-surfaced paper, others a softer and more textured surface. The papers shown on here are all ones which are suitable, although those with a Not or Rough surface will not give smooth edges to your letters.

Handling paper

If possible, it is best to store paper flat in a chest which has a series of drawers. The room should be neither too hot nor cold, nor should it be damp. Heat will make the sheets of paper brittle; damp encourages the growth of moulds and

Types of paper suitable for calligraphy, illumination and heraldry.

At the top are the cheaper and easy to obtain papers such as layout paper and photocopying paper – these are suitable for practising, roughs and trying out ideas.

Below that are cheap but heavier-weight papers which are suitable for some finished pieces. Then, still white, off white or cream in colour are more expensive papers for best pieces. These are more robust and of a better finish and so it is easier to make alterations and erasings.

Hand-made paper often has a wavy edge due to it being made as a single sheet on a mould. Some hand-made papers from India and the far East incorporate fibres, water algæ, fragments of tea and even rice straw.

Darker shades of paper can be used to quite dramatic effect, but it is not so easy to erase lines or to make alterations without these being obvious.

Standardised metric paper sizes for Europe and some other parts of the world. Measurements in mm.

In the USA. imperial sizes are used.

coldness also affect the sheets of paper. Flat sheets will be ready for you to use at any time. If short of space many resourceful artists have stored paper between boards under the bed. However, if this becomes your chosen storage, do not forget that the paper is there!

Shortage of space – sheets of paper can often be a meter long or more – may mean that you have to store paper as rolls. Roll the paper as loosely as you can, perhaps around a wide, 12 cm (4 in) plastic drainpipe. Cover the sheets with some scrap paper held together with strips of masking tape, to keep them clean. All paper sheets have a natural roll, which is much looser than most people think. Do not roll your valuable sheets of paper tightly round to push them into a narrow cardboard tube. It is better to simply roll them around themselves with no support. Keep the rolls somewhere where they, and the edges in particular, will not be damaged, perhaps on top of a wardrobe. If they stand on the floor then they may be knocked and pushed against by mistake. Again the conditions should be dry and not too warm.

Pieces cut from a roll will require a few hours to relax so that they can be flattened for use. To aid this process, it helps to roll them carefully, against the natural roll, around a wide cardboard tube or length of drainpipe. Use a sheet of scrap paper on the outside of the piece of best paper to help the rolling. A damp environment will also speed up the process. Avoid at all costs making a tight roll of the paper against its natural roll, as the first 10 cm (4 in) or so will probably get very creased, and therefore wasted.

Get into the habit of handling sheets of paper with care. Always have clean hands; dirt as well as grease will affect the paper surface. Pull out the storage drawer as far as it will go to remove a sheet of paper. Hold each sheet from both edges in a very loose fold, and move around a room carefully, avoiding doors and walls. There should be nothing on your work surface when you place paper flat which may crease or damage the sheet.

Before you use it examine each side of the paper carefully. Paper has two sides, and that which has rested on the woollen felt usually has a very slight impression of it, even if it has been highly pressed. Try both sides; you may find the side with a slight texture the one you prefer because it has a better tooth.

Folding paper

If you are cutting a piece from a sheet of paper, measure

carefully and use the edges as a guide for straight lines.

To fold paper, note the grain direction first so that the fold goes along the grain, and then line up the outer edges of the paper. Use a book-binder's bone folder or a clean plastic ruler and press the fold together starting at the centre. Then run the bone folder or ruler out from the centre towards one and then the other edge. This will give the minimum of creasing, although there still may be a slight indentation at the centre of the fold.

Problems with paper

A soft eraser, or traditionally, white bread crumbs, will remove most dirty marks from paper, but it is difficult to remove grease. Occasionally it will lift on to a piece of just damp blotting paper placed over the mark and then pressed gently with a warm iron, but it is better if the grease is not there in the first place.

Small creases can be removed in a similar way. Place the sheet of paper between damp blotting paper and press lightly with a warm iron. When the paper surface has actually cracked, though, this will usually still be seen.

Sometimes the whole surface of the paper is greasy. You may not have chosen to use this particular paper, but it could be a commission, such as writing names in a Book of Remembrance. Gouache often reacts better with these surfaces than ink, so do try this in an unobtrusive place such as a corner of the back page.

Pounce, a mixture of ground pumice and cuttlefish bone (which can be picked up from the beach or is available from pet shops), will also remove grease. If it is difficult to buy pounce then you can buy the separate elements, grind them singly in a pestle and mortar until they are a fine powder, and then mix them together in the proportion of 2 parts pumice powder and 1 part ground cuttlefish bone. This can be stored in a screw-top jar and used again and again. Powdered pumice can be used on its own (and in fact most 'pounce' sold in shops is now simply pumice), but the cuttlefish does give an extra edge. To make powder from cuttlefish, first wrap it in layers of newspaper, then smash it with a hammer on a hard surface. Do this preferably outside. The resulting small lumps and dust can then be ground in a pestle and mortar.

Shake some pumice powder on to the paper surface. Using another scrap of paper or a cotton wool ball, gently rub the powder over the surface where you are to write. Fold a sheet of scrap photocopying paper in half, and then brush off the excess powder on to this, making sure that as much of the pounce is removed as possible. The powder can now be tipped easily back into the jar from the folded paper.

If the ink spreads on the surface of the paper, then use **gum sandarac.** These yellowish lumps of resin must be ground to a powder in a pestle and mortar before use. When you have a fine powder, tip it into another screw top jar, where it will keep for many years.

You can shake powder on to the paper surface and rub it in as for pounce. Or you can make a little bag of the powder using a 10 cm (4 in) square of finely woven cotton, such as a handkerchief or piece of sheeting. Tip some powder into the middle of this square and tie up the edges with a length of string. The gum sandarac can now be dabbed over the paper where you are to write. The sandarac acts like a resist, making your strokes sharp and fine.

Note: some people are allergic to gum sandarac, so you are advised to wear a mask when using this powder, and possibly disposable gloves.

Removing mistakes

Good-quality paper will allow you to remove errors, and for this reason alone it is worth using paper which is sold as separate sheets rather than in a pad of less good quality paper from stationers. It takes time to remove a mistake, and you will have to judge for yourself whether it is worth doing so or starting the piece again.

Calligraphy requires such intense concentration, and while writing you will be thinking about angle of pen, letter-shape, stroke sequence, rhythm, consistency and so on, that simple words can be mis-spelt, or letters omitted. Be assured that it is very easy to do, and most scribes, no matter how experienced, do it.

If possible, start to remove the mistake before the ink has dried. You will need a jar of clean water, a clean, fine paintbrush, clean white paper kitchen towels or tissues and an ink eraser. Dip the paint brush in the water and paint over the letters which are to be removed. Dab the tissue or paper kitchen towel over the letters each time to soak up the water and dilute paint or ink. Gradually less and less colour will come out of the paper, and eventually the water soaking up into the tissue or kitchen towel will be clear.

Allow the paper to dry. It is best to let it dry naturally, but this may take a couple of hours. In emergencies I have dried the paper with a hair dryer, but this may affect the surface texture a little.

Now rub over the area to remove the remaining paint with an ink eraser. Be patient while you are doing this. It is far better to rub slowly and gently than quickly and fiercely, when the result may be a hole in the paper. The best ink erasers to use are those which are shaped like a pencil. Remove the rubbings with a soft brush, rather than your hand which may smudge the rest of your writing.

When all traces of the mistake have been removed, the surface of the paper should be pushed back down, as the eraser will have lifted some of the fibres. Use the back of

Use gum sandarac in a little pouch made from a square of finely woven material. Gather the edges together and then wind a length of string around to tie to ends to secure. Powdered gum sandarac is particularly useful if you want to write on a wash as it helps to prevent the ink or paint from feathering into the wash. When the wash is completely dry, dab over a little gum sandarac only where you are to write. Brush this off so that there is no powder visible on the surface.

your finger-nail, a book-binder's bone folder or an agate burnisher to do this. Place a piece of thin paper, such as typewriting copy paper or photocopying paper over the area, and gently rub over with the burnisher or similar tool. If you press down the fibres without the lining paper then the paper may be polished to a shine, which draws attention to the area of error.

Paper which has been tub or vat sized has size throughout, and you should be able to write on the corrected area without problem.

Surface-sized paper is another matter, and it is best to find out the sizing when you buy the paper, choosing tub or vat sized paper if you can. A good paper seller will know this, or you may have to contact the paper manufacturers. Once the surface size has been removed to correct an error you will have to replace the size. To coat the surface of the paper for writing over a correction, use a very dilute solution of vellum size or gelatin in the proportions of one drop of vellum size (see page 305) or gelatin solution to at least ten drops of water. Paint this carefully over the area and allow to dry. Do this on a scrap of the same paper, too, to test and make sure that it is properly sized. Or you can use dilute PVA or cellulose paste in the same way. You do not want to waste all your efforts is erasing mistakes completely with the result being lettering with feather edges.

Some scribes remove mistakes by making a shallow scoop

in the surface of the paper with a very sharp knife such as a scalpel. This takes some experience to perfect and causes the same problems with surface-sized paper. Use a very sharp knife with a curved blade and make the shallowest scoop that you can which removes the error. You may need to burnish the paper afterwards to flatten the fibres. If you do, place a thin piece of paper between the burnisher and the best paper to avoid a shiny surface as before.

Stretching paper

Heavier-weight paper, such as that over about 350 gsm, does not always need to be stretched when laying a wash. Nor should any paper which you are using simply for writing. However, if you wish to put a wash on the paper which you are to write over, or put a wash over letters written with a resist, and the paper is not heavier-weight, then to avoid the paper cockling it is better to stretch it.

Stretching paper is not difficult. You will need:
- *a piece of paper which is at least 3 cm (1 in) larger all round then the intended finished size*
- *a stout wooden board which is at least 3–4 cm (1·5 in) larger than your paper*
- *four cut lengths of brown paper gummed tape (Butterfly tape) for each side*
- *a sink or bath with a little water in it, or a sponge and bowl of water to moisten the paper*

What to do

Cut four lengths of brown paper gummed tape for the four sides of your paper. This tape is the best for paper-stretching because it holds firmly when the paper is wet. Ordinary cellulose and similar tapes are of no use when wet. If the paper is rectangular, place the lengths of sticky tape for the top and bottom at the top of the wooden board, and those for the sides to one side.

I have tried stretching paper with masking tape, and as long as the paper is not too wet, this does hold satisfactorily on most occasions.

Dampen the paper. This can be done by totally immersing the sheet in either a clean sink or bath. Push it down under the water so that top surface and underneath sides are wet, and then remove it. Do not allow it to become sodden and too floppy. You can also moisten both sides with a sponge and water.

Place the paper on a wooden board. Wood will hold the gummed tape in place and not allow it to move. Formica and similar surfaces are too smooth and slippery.

Moisten one length of gummed tape and use it to stick the paper to the board. Repeat this for the opposite side, but before attaching it to the boards lift the opposite side of paper, pull it

Types of animal skin to use for writing, illuminating and painting. From the left – slunk vellum, sheepskin parchment, goatskin manuscript parchment, goatskin classic parchment, manuscript vellum, classic vellum, natural vellum and Kelmscott vellum. Slunk vellum and sheepskin parchment are more transluscent than some skins; this can be seen by the fact that the paintbrush is partly visible beneath the two skins on the left.

very gently, so that there is a slight tension. It should not be pulled hard or the paper may actually tear when drying, or the gummed paper strips may not hold securely. Replace it on the board and attach it with the length of moistened tape. Stick the other two sides down to the board with moistened tape.

Allow the paper to dry. Leave it on the board and apply any wash, or resist and then the wash. Only when you have completely finished applying washes and allowed them to dry should the paper be cut away from the board.

Papyrus

The word paper comes from papyrus which was manufactured in Egypt for thousands of years. It was the main writing material throughout the ancient world and it was only when supplies of papyrus became scarce that another source for writing was developed.

Papyrus is made from the Paper Reed or Paper Rush *(Cyperus Papyrus* or *Papyrus Antiquorum)* which used to grow wild in the River Nile. Long stems of the reed were harvested, trimmed into shorter lengths and the outer green coating stripped away. This left a triangular inner white stem which was cut into flat strips. A series of strips was laid down flat just touching one another on a level surface. Then another series of strips was laid down at right angles on top with a third layer, again at right angles on top of that. The strips were made

into a sheet by hitting or pounding with a heavy stone. The stone broke down some of the cell structure, releasing a liquid which acted like a glue, attaching the strips to one another. Occasionally the papyrus strips were soaked to increase the adherence. The durability of papyrus is evident from the number of pieces dating from the ancient Egyptian period which are displayed in museums today.

Papyrus is still manufactured in Egypt, although the papyrus reed is no longer harvested from wild plants along the Nile. Sheets of light brown coloured papyrus can be purchased from specialist suppliers. It is interesting to note that there are references by ancient writers to papyrus being of a creamy-white colour, yet the sheets available to us now are nowhere near this shade.

Pens and brushes can be used on papyrus with no additional preparation, although the uneven texture of the surface may mean that a brush is easier to use, as it glides over and does not catch in the lumps and bumps. Use an ink eraser to remove any errors, although this can take some time.

Vellum and other animal skins

Vellum and parchment were the preferred material when papyrus became scarce. Animal skins in the form of leather had been used for some time, but writing on leather and writing on vellum are very different.

Vellum is calfskin prepared so that the grease has been removed, and the resulting surface is usually a joy to use. As well as this, mistakes can be erased from vellum with almost no trace – which is invaluable for a scribe! Vellum is available in different qualities.

That used by most scribes today is *manuscript calfskin vellum.* This has been prepared for writing on both sides by the manufacturer, although it would normally require some additional preparation before use.

Classic vellum has more natural colour as the skin has not been bleached so much and you can often obtain beautifully coloured skins which add greatly to certain pieces of writing. It is usually cream coloured. Classic vellum is prepared only on the hairside and so is suitable for writing on this side and not the flesh side.

Mediæval books were sometimes written on vellum so thin and fine that it was almost transparent. Skins from still-born or new-born calves were traditionally thought to have produced *slunk vellum*. These skins were small and it is unlikely that so many calves died at such an early age. It is more likely is that the vellum skin was split, or the skin shaved to a fine degree. Although prepared on both sides for writing, slunk vellum has a slightly soft surface without much tooth. Exciting use can be made of its almost transparent qualities by colouring on the reverse though it would not be used for most writing projects on vellum.

Bookbinders use vellum for limp vellum binding and covering boards. **Bookbinding** or *natural vellum*, or natural grained (or veiny) calf vellum skins are subtly coloured in creams, browns and greens. They, too, are prepared on one side only and so only the hairside can be used.

Kelmscott vellum is prepared specifically for printing, and was developed initially by William Morris, the Victorian artist and craftsman for his Kelmscott Press. The calfskin is filled to produce a very smooth, almost silky finish. It is too slippery for the pen, but very good for miniature painting.

Parchment is sheep skin which is usually split. It is quite thin and can be a little transparent. Parchment is creamy white, although can occasionally be grey. It has a greasy surface, does not have much tooth even after preparation, mistakes cannot be erased easily, and most scribes would choose not to use it.

Goatskin is available as a finished skin for writing either as white or naturally coloured. It is usually finished on the hair side only, and has a rather dimpled texture which may take a little while to get used to.

Vellum manufacture

A skin of vellum is very much more expensive than a sheet of hand-made paper, but the preparation of each individual skin is lengthy, time-consuming and skilled. Skins are pre-pared by being soaked in vats containing a lime and water solution for from three to ten days to remove the dirt and hair. The skins are stirred in these vats several times each day.

When judged to be the right time the skins are removed and placed, so that the hair side is on the outside, over a large piece of wood. Using a special curved knife with handles either side, most of the hair and some of the outer film of the skin is scraped away. The inner side is scraped in a similar way.

Then the skin must be soaked for a couple of days in water to remove any trace of lime. Once out of the water the skin is again treated. It is stretched out within a wooden frame. Small smooth stones (or, more likely nowadays, screwed up pieces of newspaper!) are pushed from the back of the skin around the edges to form a knob around which a cord is wound. The other end of the cord is pushed through a slot in a wooden peg, attached to the frame, which can be turned and tightened. This continues all around the skin at intervals of about 10–15 cm (4–5 in). As the skin is worked on the pegs are constantly turned and hammered tightly so that the skin is always held tautly.

More water and possibly bleach is added as both sides of the skin are shaved again with the curved knife. The skin is then allowed to dry, still held in its frame.

Another session of scraping continues the process, this time with the skin not so wet and very taut. The shavings are dry and almost fluffy. The shaving is stopped only when the skin is of the required thickness. The skins are then allowed to dry in a controlled atmosphere whilst still on their frames. Finally they are cut from the frames, rolled up and stored ready for use.

Hair and flesh side

Some skins of vellum are prepared on the hair side only, others are prepared so that both sides can be used. Given the choice, the hair side is the preferred writing surface.

The hair side has more colour, it is more marked, may have a slight texture and there may even be little hair follicles still visible. The flesh side is whiter, waxy and smoother, almost silky to the touch, and *looks* like the side to be used. To determine on which side to write look at the vellum and feel the surface. Note the whiter, smoother and waxier side and then turn over and use the other side!

Preparing vellum for use

Writing on a properly prepared skin of vellum is wonderful. Writing on a piece of vellum which has not been prepared is often like writing on a skating rink! The nap of the skin needs to be raised so that it has the appearance of fine suede

or velvet, and the grease has to be removed. The skin must also be made flat, as vellum is usually stored and sent out in rolls.

Unrolling the skin
It is best to unroll the skins and flatten them as soon as they are received if you can. They then have longer to relax and lose their curl. Store these skins of vellum between two pieces of large, clean acid-free paper. Place a large board on top and then some weights on that – a packet of paper or large books will do. However, skins can be large and you may not have the surface area available, in which case storage in rolls may be your only alternative.

The skins are usually sent wound around a cardboard tube which is about 6–7 cm (2·5 in) in diameter. Remove the wrapping and wind the skin around a cardboard tube or plastic drain pipe which is at least 10–12 cm (4–5 in) in diameter. Wrap a piece of acid-free scrap paper around the vellum for protection. Store this in a place which is not too cold, hot or damp, any of which conditions will adversely affect the vellum.

The day before you want to use the skin try to remove as much of the curl as possible. Do this by rolling it in the opposite way around a wide cardboard tube or drainpipe of previous dimensions. Also use a wide piece of scrap paper and three or four strips of masking tape to help you.

Place one end of the skin against the tube and place the scrap paper tightly against the outer side of the skin. Gradually wind the paper around the tube which will also wind the skin inside around. When you have wound the whole skin attach the scrap paper to itself with a few strips of masking tape.

Leave the skin for a few hours, or preferably overnight. If you have a damp cool place then this will accelerate the process in relaxing the skin, although it should be removed from there a few hours before you are to prepare it for writing.

Removing grease
If the skin has recently been produced by the manufacturer then there may not be much surface grease, but if it has been stored for any length of time then the grease from within the skin will have come to the surface and must be removed otherwise the ink and paint will not adhere to the skin.

The grease is best removed by **pounce** which is a mixture of powdered pumice and cuttlefish bone. This is available from specialist suppliers, but if you cannot obtain this greyish gritty powder, then you can easily make your own by grinding separately pumice and a cuttlefish bone (see page 297). Mix them together in the proportion of two parts of ground pumice powder to one part of ground cuttlefish bone. Store this powder in a screw-top jar and it will last for a long time.

Simply shake some powder on to the surface of the vellum. Use a cotton wool ball, another small piece of vellum or even your fingers, and go over the whole piece of vellum in a circular motion working from one corner at the top to the other and then gradually down the skin.

Fold a piece of ordinary photocopying paper, or, for a large piece of vellum, a larger piece, in half and gently tilt the vellum over this. Tap the skin and most of the pounce will fall on to the paper. With a soft brush remove the remaining excess powder. It is now easy to tip the excess pounce back into the storage jar for reuse. Any pounce left on the vellum will collect in your pen and cause you problems, so check to see that there are no areas of pounce powder remaining on the surface.

Although you may not be using the reverse of the vellum, the flesh side, it is best to remove the grease with pounce from this side, too.

If you are to write on the vellum then the nap must also be raised. If painting then it is necessary only to remove the grease.

Raising the nap
The scraping of a skin of vellum as it is prepared produces a slightly textured writing surface. A completely smooth writing surface is not ideal, as there is then no tooth which acts as a slight resistance to the pen and aids in the control for better letter formation. With a good tooth the pen does not slide all over the surface.

In the past scribes would have raised the nap by scraping the surface of vellum with a very sharp knife. It is easier and quicker to carry out this process using abrasive paper or wet and dry paper. I used to use two grades – a fine and even finer. Now I usually use grade 330 only. Start with paper at grade 320–400. Wrap a piece around a cork sandpaper block and work carefully and methodically all over the skin.

Avoid working on one place only as the heat generated may cockle the skin. Take care also when moving from one place to another as too swift and violent a movement may make a crease, which will be almost impossible to remove. This sanding process creates a degree of dust, so it is best to do this outside or in a room with good ventilation. When the whole piece has been sanded with that grade, you may like to change to grade 600 and repeat the process. The very smooth, sometimes shiny, surface of the vellum will change to one which resembles very fine suede or velvet. It will still be a smooth texture, but writing on the prepared surface will be unlike any paper. The positive reaction of the pen nib with the vellum is perhaps one of the reasons why scribes have chosen to write on skin over so many hundreds of years.

For other skins and the flesh side of vellum then less preparation is usually required, but the surface is then less suitable for writing. Experiment on a small off-cut of the skin, and use the method of preparation which seems appropriate – less use of the abrasive paper, more pounce, or what-ever your tests suggest.

Gum sandarac
Although it is possible to write straightaway it is advisable

Animal skins vary in thickness. Select an appropriate area of skin for your purpose.

Stretching vellum

1 *Using a pencil and set-square mark the dimensions of the finished piece on the* **front** *of the vellum and cut away the corners.*

2 *Place the vellum face downwards on a clean, protected surface and dampen the back. Allow to stand for 10 minutes until the skin is limp and relaxed.*

3 *Meanwhile paste the good-quality heavier-weight paper on the front of the wooden support board using dabs of glue.*

4 *Place the board face downwards on the vellum. Use PVA to paste the sides on to the board. With a knife and sharp edge make a diagonal cut at the corners which allows you to remove triangular waste pieces of vellum.*

5 *You should have a neatly covered board when this is done for all four corners.*

6 *Paste the lighter-weight paper over the back of the vellum and board to make a neat finish.*

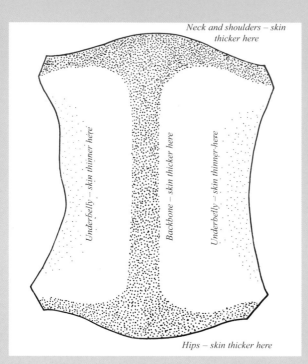

Neck and shoulders – skin thicker here

Underbelly – skin thinner here

Backbone – skin thicker here

Underbelly – skin thinner here

Hips – skin thicker here

to rub over those areas where you are to write with powdered gum sandarac. This acts as a resist and very slightly shrinks the ink making hairlines, flicks and ticks very fine indeed.

Gum sandarac is usually sold as yellow powdery lumps of resin which must be ground to a powder before use. See page 297. *(Note: some people are allergic to this powder so wear protective gloves and a mask if necessary.)*

Dab the powderd sandarac over where you are to write.

Avoid being too heavy handed with gum sandarac. Dabbing it on, or smoothing it backwards and forwards once over the appropriate areas, is all you need. Too much will result in your letters having a gap down the centre, as the powder resists the ink.

Use a soft-headed brush to remove any excess gum sandarac. The powder which has collected within the grain and fibres of the vellum will do the job sufficiently.

Selecting the best vellum

It is clearly better if you can visit a parchment and vellum works to select your own skins. Very often there are imperfect skins and the defect may be in a place which will be cut off

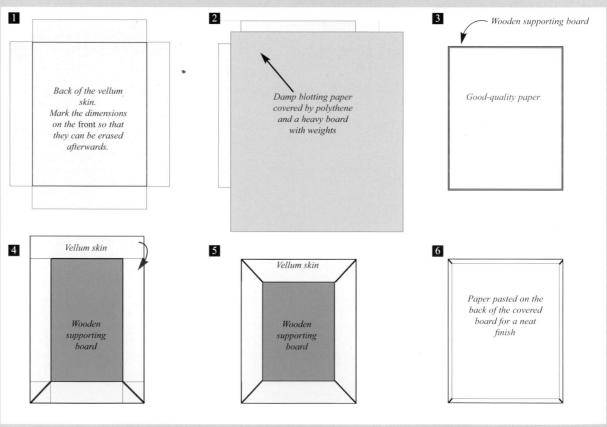

1 *Back of the vellum skin.*
Mark the dimensions on the **front** *so that they can be erased afterwards.*

2 *Damp blotting paper covered by polythene and a heavy board with weights*

3 Wooden supporting board

Good-quality paper

4 *Vellum skin*

Wooden supporting board

5 *Vellum skin*

Wooden supporting board

6 *Paper pasted on the back of the covered board for a neat finish*

or on the back of a stretched skin and so will not show. These skins are cheaper.

Buying a very slightly larger skin than one you require for a particular piece may mean that you can get two panels from one skin, which again is cheaper. The markings on skins also can be selected for the project you have in mind. However, vellum manufacturers are not to be found in every town and city and a visit may not be possible. My own experience is that, because it is an industry which prides itself on producing goods fit for the purpose, and has a long tradition of quality, the skins I have received have always been very good. And if you want a skin which is a little unusual, these requests are normally accommodated without problem.

The thickness of an individual skin varies. Some areas, such as that over the backbone, shoulders and haunches are much thicker than that under the animal. Cutting a section of vellum which extends from the backbone to under the belly for one panel will give an uneven piece which will not be easy to stretch because of this. If there is the choice, it is better to cut a piece where the sides are about equal in thickness.

As there is no grain direction, book pages can be cut from almost any part of the skin, but again consider the thickness. A small book will be very bulky if the thicker part of the skin is placed at the fold of the folios. Place the pages of these books avoiding any thicker parts. For large books you will have little choice, and here the thickness at the fold will be a problem for the bookbinder. The weight of the larger page however will help the individual pages to lie flat when the book is opened, and a heavy-weight binding, perhaps between two hardwood covers, will help to keep the book closed.

Vellum stretching

Small pieces of vellum, less than about 10–15 cm (4–5 in), can be used unstretched, especially if they are to be framed fairly soon after finishing the work. Larger pieces of vellum should be stretched over a wooden board if you want the skin to lie flat. Being a natural material of variable thickness, vellum reacts to the atmosphere. Heat and damp will cause it to cockle and buckle.

The width of the board over which the vellum is to be stretched depends on the size of the finished piece. Smaller pieces, less than about 30 cm (1 foot), with vellum which is not too thick, can be stretched over boards which are between 0·5–0·75 cm (0·25 in) thick, larger panels may require a board of 2 cm (0·75 in) in thickness. Vellum is a tough material, and it is strong enough to warp a wooden board if of insufficient thickness. Err on the side of thicker rather than thinner board for this reason. I have been experimenting with various types of fibre boards, but I find that a board made of layers of ply is the most robust.

Making vellum.

1 *The skins are first soaked in vats of lime to remove the hair and dirt.*

2 *Individual skins are then pulled out on stretchers and held in place by thongs attached to wooden pegs. These are turned so that the skins are always held under tension.*

Wim Visscher of Cowleys Parchment works in Milton Keynes in England works over the skin with a parchmenter's lunar knife.

3 *The skins are allowed to dry in a controlled atmosphere.*

4 *Finally they are cut from their frames, rolled and stored, ready to be sent out for use.*

(Photographs taken at William Cowley Parchment Works, Milton Keynes, UK, and reproduced by kind permission.)

303

In my experience it is better to stretch vellum before you use it, especially if there is to be raised gilding on gesso on the piece as the relaxation of the skin may disturb the attachment of the gesso and gold on the surface of the vellum. However, it is impossible to work on very large pieces which have been stretched over a board, and in this instance the stretching must be done later.

Stretching vellum takes less than an hour, plus drying time, but is not difficult to do if you allow the skin to relax properly. It only becomes a problem if you try to hasten the process.

You will need:
- *a piece of vellum which is the size of your finished piece, as well as an allowance on each of the four sides for the width of the board and at least 3 cm (1·25 in) for turning over*
- *a piece of clean plywood which is the size of your finished piece, with the edges sanded to a slight bevel*
- *a piece of good-quality white paper, hand-made if possible, about 250–280 gsm in weight, about 1–2 mm (0·05 in) smaller than the finished piece on each side,* **or** *a piece of acid-free heavy-weight white blotting paper of similar size*
- *another piece of white paper, of reasonable quality, about 150 gsm, about 5 mm (0·25 in) smaller than the finished piece on each side*
- *two sheets of white blotting paper, preferably acid-free, large enough to cover the vellum*
- *a large piece or pieces of clean polythene (such as that used for freezer bags) to cover the piece of vellum*
- *sponge and clean water*
- *wooden board larger than the piece of vellum*
- *large heavy books or weights*
- *acid-free (archival quality) PVA*
- *a clean home-decorating brush*
- *bookbinder's bone folder*
- *pencil, sharp knife and metal ruler or set-square*

What to do
A skin of vellum is stiff and unwieldy. To wrap it around the wooden board it needs to be relaxed.

Mark with a pencil and ruler or set-square the dimensions of the final piece on the **front** (hair side) of the vellum. You can erase these lines when the vellum is dry. If you mark on the flesh side this will be wrapped around the board and may show through. Place the vellum with the hairside face down on a clean sheet of paper which is itself on a flat clean surface. Slip a cutting mat under the vellum and cut away each corner with a or a metal ruler and sharp knife.

Lay the pieces of white blotting paper over the vellum and dampen them with the sponge and water. Work quickly because you do not want one area to dry before another has been wetted. The blotting paper should be wet, but not completely soaking with water. On top of the blotting paper lay the sheet or sheets of polythene. These keep the water down into the blotting paper and so into the vellum. Lay a smooth wooden board or cutting mat on top of the polythene and then add weights or some heavy books.

Allow the water about five to ten minutes to soak into the vellum, checking it at intervals. The whole skin of vellum should be relaxed, that is limp, with its stiffness gone and more pliable. It should not be completely soaked through with water such that large areas are transparent. Some thicker areas of vellum may require a little additional water dabbed on to the blotting paper.

Meanwhile attach the sheet of good-quality heavier-weight paper to the wood with a few tiny dabs of paper glue or PVA. This paper does not stretch to the very edge of the wood. When the dampness from the vellum seeps through into the paper, the paper may well stretch. The few millimetres which have been left all round this paper allow for this stretching. If the paper goes to the very edge of the wood, or if the paper is wrapped around the piece of wood, there is not space for the paper to stretch, and it may wrinkle under the vellum, causing an uneven surface.

When the vellum is relaxed and there are no stiff areas remove the weights, board, polythene and blotting paper. All can be re-used when you stretch vellum again so store them carefully when dry.

Place the wooden backing board with the attached sheet of paper face downwards on the vellum. The paper should be touching the back of the skin of vellum. Relaxing the skin may have slightly distorted the corners you cut earlier, but this does not matter. With a home decorating brush, or special paste brush if you have one, brush PVA on the cut edges of the board and on all the vellum you can see.

Now pull up one side of the vellum and press it on to the back of the wooden board. Use a book binder's bone folder to ensure that the vellum is tight against the sides of the board and press the vellum hard on to the back of the board. Repeat this with the opposite side, pulling quite firmly so that there is a slight tension in the skin. This is not a tugging motion – you do not want there to be too much of a pull within the vellum, as it is so strong that it can warp the board.

The third and fourth sides should be pulled over as for the first side, using the bone folder to ensure a close and tight fit. Press the vellum down hard on the back of the board.

With a set-square or metal straight ruler and a sharp knife, make a diagonal cut from one of the corners of the board to the junction where the two edges of vellum overlap. Lift the pieces of vellum and remove the waste triangular pieces which have been cut. The vellum at this corner will now have a neat edge and sit flat. Repeat this for the three remaining corners. This should be done with a degree of speed before the PVA dries.

Paste all over the second piece of paper with PVA and stick it to the back of the board, over the vellum. Place a sheet of scrap paper over this and rub over with the bone folder, or rub it directly over the paper.

The whole panel should now be left in a cool dry place for the moisture in the vellum to evaporate. As it does so, the vellum will become taut over the board. The underlying paper will provide a soft cushion on which to write, and its light colour will enhance that of the vellum.

The surface of the vellum for painting or writing can be prepared when it has dried completely.

What to do if it does not work
Usually the vellum will sit tightly and well around the board using this method of stretching.

Problems may occur if the vellum has not been relaxed sufficiently. The thickness of one skin of vellum varies, and if you did not choose to cut the piece carefully, or if you had no choice, a thicker part on one side may not lie flat around the board and so mean that the stretching was unsuccessful. Here the best approach is to start again. PVA can be removed with water. Relax the vellum once more, paying particular attention to the thicker part of the vellum, adding additional water to the blotting paper at this section, and try again.

You may prefer to repeat the stretching process if there is a large area which seems to bubble up away from the board. This may because the vellum is a little thinner here and the dampness had almost overstretched it. Do make sure first though that the vellum is completely dry; this area may be raised because it simply has not yet dried out – leave it for twenty-four hours in a warm room, or somewhere where it is not damp. If it does not go down, then re-stretching may work, but do not add any additional water to the blotting paper covering this area.

Alternatively, you may wish to try a rather drastic method which does sometimes work in emergencies. Put a piece of blotting paper over this area of vellum, and rub a cool- to warm-iron over the blotting paper, keeping it moving constantly. Try also making the blotting paper very slightly damp. This sometimes changes the texture of the vellum, but is worth trying if time is limited.

Vellum size

Vellum size can be used in gesso recipes to increase the stickiness, and for other purposes. It is easy to make and uses up scraps of vellum. Place a handful of snippets of vellum in a pan and just cover with water. Boil until the water has been reduced by half and then strain the liquid into a clean container. Leave until the jelly has turned to liquid (about a couple of weeks). Store the closed jar in a refrigerator where it will keep for some time.

Fabric

Extend your repertoire of surfaces for writing by using fabric. You can write with an automatic pen and designer's gouache on unbleached calico or finely woven fabric such as cotton sheeting, but it is best to use a brush on finer fabrics such as silk chiffon.

Decide first whether your fabric will need washing when you have finished. This will determine whether you use waterproof or other paints.

There are special fabric paints available but do experiment with these first, or ask colleagues who may have used specific brands. Although all these paints may be suitable for fabrics, not all are suitable for *lettering* on fabric, and may give an uneven or patchy finish, or be rather sticky without a great deal of flow, or have too much flow and result in letters which are not sharp and crisp.

Perhaps it is best to stick to designer's gouache for materials that will not be washed, and acrylics for those that will. Acrylic paint can be diluted with a medium which produces matte or gloss lettering and is then a good consistency for use with a pen, but when dry the paint is waterproof and so the fabric can be washed.

If you are using a brush then choose acrylics which are sold in small jars as these are more liquid and flow better from a brush.

Lettering on fabric opens up a whole area for experimentation. You can letter your own wall hangings, letter the fabric for curtains and window blinds, for deck chairs and garden chairs, for cushion covers and what you will.

Brushes

Brushes can be used for different types of lettering. Brushes which have a chisel edge can be used to create letters which have thicks and thins similar to pen-made letters. Pointed brushes can be twisted and manipulated to make interesting letters, and very fine brushes can be used to paint letter-shapes on paper and other surfaces.

Sizes of brushes

The sizes of brushes are indicated by a number. The bigger the number, the larger the brush will be. For larger strokes brushes may be 9 or 10. For very fine work in heraldry, miniature painting or illumination, you should use a fine brush which may be 00 or even 000.

Types of brushes.

*From the left:
a large wash brush,
one-stroke brushes,
pointed brushes, or
rounds, used for
fine detailed work,
and Chinese
brushes which can
be used both for
some washes and
for finer strokes.*

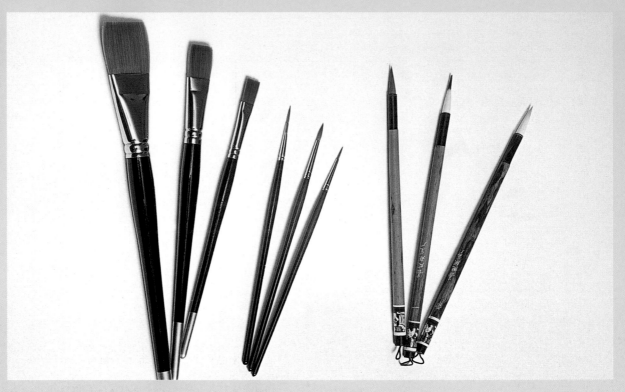

Types of brushes

Brushes have different shaped tips and are made of a variety of materials. (See page 305). For anything but the finest work, nylon brushes or those made of cheaper materials are perfectly adequate.

For fine work, it is best to choose brushes which are made of the best materials. You will be paying for hairs which have been hand selected and put together carefully. Best brushes are made from sable, and the best quality sable is Kolinsky sable (also known as Siberian mink or red Tartar marten) made from the tail of the male winter coat. Because the brushes you use for this fine work are so small, the cost of an individual brush is not prohibitively expensive. The advantage when you work is that the spring in the brush will help your fine painting. For the finest hairlines and making detailed patterns on your work dip the brush into paint which is the consistency of thin, runny cream, wipe most of the paint from the brush on to a paper kitchen towel and use the brush almost vertically so that just the tip touches the surface.

In an art shop you will probably be amazed by the selection of brushes available. The shapes are very varied. For a wash you should use a flat brush which is quite wide – about 2·5 cm (1 in) – so that the colour is put on the paper evenly. These brushes are usually called flats.

You may also choose Chinese brushes for different sorts of lettering; most come to a point. Chinese brushes are made also from a variety of materials, some quite soft and others more bristly.

Brushes for fine work should be shaped so that they come to a point; these are called rounds.

Brushes which are similar to the broad-edge shape of a pen are called one-stroke or single-stroke. These are useful for large-sized lettering such as on posters. These brushes are also suitable for lettering on fabric, and will make letter-shapes which have thicks and thins.

Choosing a fine brush

Before you buy a fine brush, slightly wet the tip (most good shops will have a jar of water nearby for you to use) and roll it to a point between your finger and thumb. Hold the brush up to the light and check that it comes to a good sharp point and that there are no stray hairs sticking out. If there are, choose another brush. These hairs will spoil your work, and even if they are cut off or pulled out, the quality of such small brushes is never the same.

Ask to see other brushes if there are none of good enough quality on display. Brushes are usually supplied in boxes, and these will not have been handled so much for the hairs to have become broken or damaged. Remember that the better quality the brush the better quality will be your work.

Good-quality brushes are often sold with a narrow plastic protective sleeve. You should take great care when replacing this over the hairs of the brush. If you lose this protective sleeve then it is easy to cut a plastic drinking straw into suitable lengths as replacements. Many artists do not use these sleeves because they can break off the hairs as they are slid over the ferrule. Store your brushes upright in a jar rather than flat on a surface or in a case. This way there is less likelihood of damage. Also take care when placing a brush in the jar that you do not damage the hairs of others.

Taking care of your brush

You should look after your brush whether it is cheap or expensive so that it will last. Never stir paint vigorously with a good-quality brush, nor leave it standing in a jar of water; this will bend the hairs possibly permanently.

During use, wash the brush frequently in a jar of clean tap water, and dry gently by rolling the hairs between your finger and thumb through a clean tissue or piece of paper kitchen roll. Then roll it again without the paper kitchen towel to regain its good point.

When you have finished using the brush, wash again in clean water and dry in the same way on a tissue or kitchen roll, paying particular attention to where the hairs meet the metal ferrule. Look at the tissue and see if there is any colour from the paint on it. If there is, wash again and repeat the process until no more colour comes from the brush.

Colour

Most people are already aware of the three primary colours – red, blue and yellow – and that mixes of two of these three colours lead to the secondary colours of green, purple/violet and orange, made by mixing two of the primary colours together.

Looking at the various types of reds, blues and yellows, though, which ones do you start with to get the secondary colour you want? And why, when you mix this blue with that yellow do you get a dirty sludgy green and not the bright spring green that you want? The reason for this is that paint manufactures do not produce pure primary colours. Reds are a mix of red pigment and perhaps a bit of blue to make them slightly more purple. Blues may be a mix of blue pigment and a bit of yellow to make them slightly more turquoise. Mixing this red and this blue to make a pure purple means that you will actually be combining red, blue as well as yellow: result – a dull purplish brown!

Look carefully at the tubes of colours in an art shop. Some reds are more orangey and others more violet. Alizarin crimson and madder red, for example are quite bluey reds,

whilst cadmium red and vermilion are more orangey reds. Mixing either of these reds with yellow will give you totally different types of orange. Cadmium red or vermilion and an orangey yellow will give you a good orange. Alizarin or madder red and an orangey yellow will give you orangey-brown, because it has that bit of blue already mixed in it.

It is a good and useful exercise to spend an hour or so playing with the paint colours you may already have. Squeeze small amounts out and mix two of them together. If you do this on one sheet of paper and name the paints you mixed then this will act as a guide for you in the future.

If, though, colour is new to you, what tubes of paint should you buy? Is it necessary to have the whole set of hundreds of colours, or can you make do with fewer? The answer is, of course, that you can make do with far fewer tubes of colour than you may think. In fact a good white and black, plus six colours, are all you need. These are:

Jet black
Titanium white or permanent white
Cadmium red or vermilion – red tending towards *yellow*
Alizarin crimson or madder red – red tending towards *blue*
Ultramarine – blue tending towards *red*
Cerulean blue – blue tending towards *yellow*
Cadmium yellow – yellow tending towards *red*
Lemon yellow – yellow tending towards *blue*

The limited range of colours here consist of pairs of the primary colours – red, blue and yellow. For best results in making a clear mix of a secondary colour use only those colours which are linked by a tendency towards each other.

The colour wheel and colour mixing (see page 310)

Colours can be arranged around a circle or wheel – the primary colours of red, blue and yellow merging to make secondary colours of purple, green and orange. The new colour wheel now has six colours rather than the original three. The six colours consist of two reds, blues and yellows, each colour having a tendency to one of the other primaries.

Good secondary colours can be mixed from primaries which have a tendency to one another:
For a clear *violet* mix **alizarin crimson** and **ultramarine**
For a clear *green* mix **lemon yellow** and **cerulean**
For a clear *orange* mix **cadmium yellow** and **cadmium red**
Remember always to add dark colours to light ones, as you will require smaller amounts of dark paint for a mix, but a small amount of dark paint will need a lot of light paint to achieve the colour you want.

Duller secondaries can be made by mixing primaries which do not have a tendency to one another:

For a dull *violet* mix **alizarin crimson** and **cerulean** *or*
mix **cadmium red** and **cerulean** *or*
mix **cadmium red** and **ultramarine**
For a dull *green* mix **lemon yellow** and **ultramarine** *or*
mix **cadmium yellow** and **ultramarine** *or*
mix **cadmium yellow** and **cerulean**
For a dull *orange* mix **cadmium yellow** and **alizarin crimson** *or*
mix **lemon yellow** and **alizarin crimson** *or*
mix **lemon yellow** and **cadmium red**
Different **greys** and **browns** can be made by mixing varying quantities of the reds, yellows and blues:
either of the **yellows,** with **alizarin** and **ultramarine**
either of the **blues** with **cadmium red** and **cadmium yellow**
either of the **reds** with **lemon yellow** and **cerulean**
(The names may vary slightly with different brands.)

Try experimenting with these colours until you find ones that you like and suit your purpose. In fact it is well worth spending some time learning more about colours and how they mix by making your own colour chart.

It will become a permanent reference for you if you carefully measure the quantities of paint you use to mix. Squeeze a tiny amount of paint from the tube of the lighter colour paint and slice straight down with a knife or a wooden or plastic toothpick. This is so that you have a clean edge from which to measure. Now squeeze out another quantity of paint but this time along a ruler. Start by squeezing out about 5 mm (0·2 in). Again cut straight down with a knife or toothpick and replace the cap of the tube. Scrape all the paint from the ruler and put it into a palette. Repeat this operation with the darker colour, but only squeeze about 2 mm (0·1 in). Mix the colours together with sufficient water to make a smooth consistency – that of thin, runny cream. Paint a rectangle of colour, noting the colours used and the quantities. If you want to repeat this colour, then you know exactly how much of each colour of paint to use.

(If you are unsure of colours and mixing then the best book for reference is *Blue and Yellow Don't Make Green* by Michael Wilcox.)

Despite the fact that some modern colours may be a little gritty, greasy or grainy, buying a tube of paint is a big improvement on the process which mediæval scribes used. Paint had to be created first by grinding lumps of colour thoroughly in a pestle and mortar, or on a stone slab which, if the original colour material was not pure, or of a crystalline nature, would not produce a very fine powder. The resulting pigment was mixed with egg yolk to make egg tempera, and then diluted with water to use. (See page 184 for painting with egg tempera.)

If, though, you want to expand your list of paints to use, what paints are suitable and how do they work in a pen for calligraphy and in a brush for painting? Not all are good paints to warrant a place in your storage area.

The following list of paints should give you some guidance.

Reds

Alizarin Crimson, Madder Lake, Red Madder – this is usually quite well ground and a useful colour as it is a bluish-red which is one of the key mixing colours. It can be a little transparent.
Cadmium Red – is a deep, bright red with a yellow tinge, and is also one of the mixing colours to use. It is usually smoothly ground and works well with the brush and pen.
Carmine Red, Crimson Lake – this is a scarlet red which is not very light permanent and can eventually turn to brown.
English Red, Iron Oxide Red, Red Ochre, Indian Red, Venetian Red, Tuscan Red, Mars Red – are all warm or dark reds – some ranging almost to brown others almost maroon. These earth colours cover well and are finely ground. Most work well in the brush and pen.
Lead Red, Minium – this bright orangey-red was used in miniatures and gave its name to them (rather than the other way round!). It gives good coverage and has a fine texture although can turn brown when exposed to light.
Scarlet Vermilion – can be rather pink, but is usually well ground and flows through the pen and brush.
Vermilion, English Vermilion, Chinese Vermilion – is red mercuric sulphide which is the treasured red of mediæval manuscripts. Vermilion covers well but is affected by the light.

Blues

Cerulean Blue – this is a rather greenish blue. It can be a little greasy, and not give a very good cover. However it is one of the six key mixing colours.
Cobalt blue – almost a pure blue and not affected by sunlight. This is rather an expensive paint if you buy a good quality and it can be a little grainy. Mix a tiny amount of another colour with it to alleviate this problem.
Egyptian Blue, Blue Frit, Pompeian Blue – the blue of classical times. A good blue but perhaps better to use the two recommended mixing blues.
Indigo – a deep dense purple blue with great coverage and staining power. Well ground and works well with a pen and brush.
Manganese Blue – this can be a little coarse and grainy and other greeny-blue colours are preferred.
Phthalocyanine Blue (Thalo), Monastral Blue, Winsor Blue – are all vibrant deep greeny-blues which can be rather loud! They are well ground and work in calligraphy and

painting, although take care where they will be used because of their overpowering tendencies.

Prussian Blue, Berlin Blue, Paris Blue, Antwerp Blue, Chinese Blue – a deep blue with a tinge of green with good coverage. Only small amounts are required when mixing with other colours. It can be a little greasy although usually works well with a pen and brush.

Ultramarine, French Blue, Permanent Blue – one of the key six mixing colours although this is a hot colour with a slight tinge of red and is very dominant when used with other colours.

Yellows

Aureolin, Cobalt Yellow – these are pure yellows with a reasonable covering power. They are expensive, though, and are not a great advantage over the two recommended yellows.

Brilliant Yellow, Permanent Yellow Deep – are bright, slightly orange yellows, which are well ground and work well with a calligraphy pen and a brush.

Cadmium Yellow, Cadmium Yellow Lithopone – this yellow sometimes has a slight orangey tinge. It is one of the six mixing colours and is recommended.

Chrome Yellow – this bright sunshiney yellow is a cheerful colour to have, but it does tend to fade to brown in time.

Gamboge – is not very permanent and fades quickly in sunlight. Mixed with Prussian Blue it makes Hooker's Green.

Indian Yellow – is a rich deep yellow, almost orange in colour, and very finely ground. It is a good colour for the calligraphy and for painting.

Lemon Yellow, Barium Yellow – are yellows with a slight tinge of green. Lemon yellow can be a little transparent and does not cover well. Lemon Yellow is one of the six mixing colours.

Naples Yellow, Antimony Yellow, Jaune Brilliant – these are dull yellows, originally compounds of lead, are finely ground and have good coverage.

Whites

Bleedproof White – this is a dense white which gives good coverage. It can also be used to cover any mistakes if you are preparing work for photocopying or reproduction. It can be a little thick in texture and needs diluting.

Permanent White – this can be used on its own as a white as well as mixing with other colours.

Titanium or *Titan White* – are good strong whites to use both for mixing and on their own.

Zinc White or *Lead White* – (this does not usually contain lead nowadays) these paints separate too easily and float on the surface of the palette. It is also rather watery in texture,

and needs other paints to give it body.

Blacks

Carbon Black – this is a brownish-black which can be a little grainy. It does not write particularly well and does not always give good coverage.

Ivory Black – is a dense black, sometimes slightly blue-brown. It is quite smooth and works well in the pen and brush.

Jet Black, Velvet Black – is one of the best paints for painting and for writing, and is often better than many calligraphy inks. It is smooth and well ground and produces a very black cover.

Lamp black – is a good paint for using to make neutral greys. It does not mix particularly well.

Purples and Violets

Alizarin Violet – this colour is well ground and a clear purple lake but it is not very permanent and it is better to choose another colour.

Cobalt Violet Dark/Light – *dark* or *deep* is a blue-violet and *light* a reddish-purple. Both are well ground and suitable for calligraphy and painting.

Light Purple – this covers well and is smooth for writing and painting.

Lightproof Violet, Spectrum Violet – a blue violet which is finely ground and covers well, too.

Magenta is a rich red purple which mixes well with other colours and is good with a pen and brush.

Manganese Violet, Permanent Violet – a little insipid violet but which works well with a pen.

Purple Lake and *Light Purple* are bluer purples and also well ground.

Ultramarine Violet – a violet from ultramarine blue which is ground finely and is good for lettering and painting.

Greens

Cinnabar Green, Chrome Green, Moss Green, Olive Green – these are finely ground colours which work well with a pen. They are mixes of Prussian Blue and Chrome yellow which you may prefer to do yourself to save buying extra tubes of paint, or preferably, make your own from the six primary colours.

Cobalt Green, Rinmann's Green, Zinc Green – are greens with a slightly bluish tinge, none of which has great covering power.

Emerald Green, Schweinfurt Green, Paris Green, Permanent

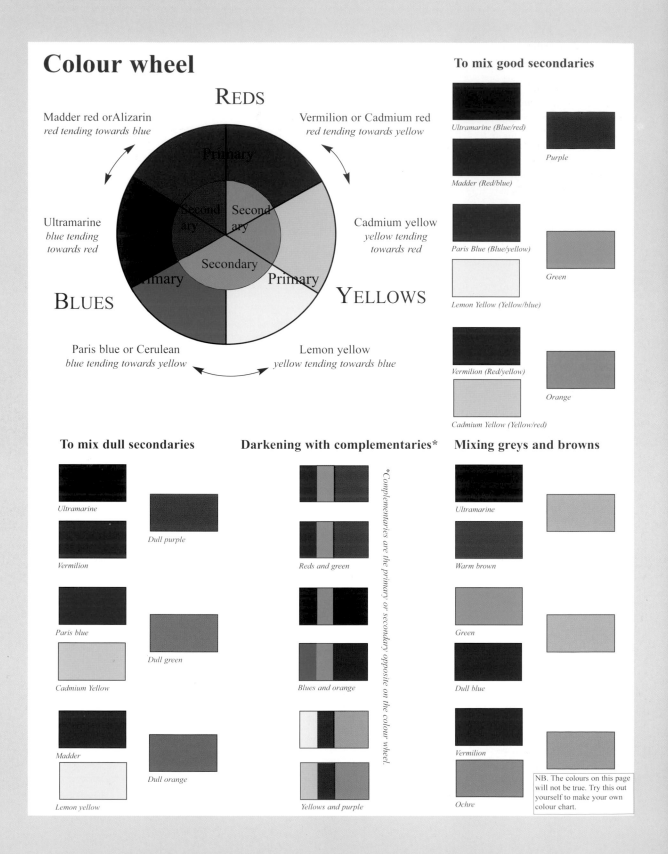

Colour wheel

REDS

Madder red orAlizarin
red tending towards blue

Vermilion or Cadmium red
red tending towards yellow

Primary

Second
ary

Second
ary

Ultramarine
*blue tending
towards red*

Cadmium yellow
*yellow tending
towards red*

Secondary

Primary

Primary

BLUES

YELLOWS

Paris blue or Cerulean
blue tending towards yellow

Lemon yellow
yellow tending towards blue

To mix good secondaries

Ultramarine (Blue/red)

Purple

Madder (Red/blue)

Paris Blue (Blue/yellow)

Green

Lemon Yellow (Yellow/blue)

Vermilion (Red/yellow)

Orange

Cadmium Yellow (Yellow/red)

To mix dull secondaries

Ultramarine

Dull purple

Vermilion

Paris blue

Dull green

Cadmium Yellow

Madder

Dull orange

Lemon yellow

Darkening with complementaries*

Reds and green

Blues and orange

Yellows and purple

Complementaries are the primary or secondary opposite on the colour wheel.

Mixing greys and browns

Ultramarine

Warm brown

Green

Dull blue

Vermilion

Ochre

NB. The colours on this page
will not be true. Try this out
yourself to make your own
colour chart.

Green Light (sometimes) – these can be rather gritty colours which are not exceptional and you would be better mixing your own.

Hooker's Green – this is a mixture of Prussian blue and Gamboge which produces a deep bluey-green. It is usually finely ground and works well with a pen, but you can easily mix your own.

Oxide of Chromium, Viridian Matte – these are very smoothly ground and work like a dream with a pen and a brush. They have good coverage and are quite lightfast. Unfortunately the colour, a mid-green, is not very exciting, so add a touch of indigo or yellow to it to zap it up.

Permanent Green – is a mixture of viridian with cadmium or zinc yellow. It is smoothly ground and works well with a pen and a brush.

Phthalocyanine Green (Thalo) – is a finely ground intense green.

Sap Green – this was originally made from the ripened berries of the blackthorn, Rhamnus; now it can be almost any colour green the manufacturers want. Although it is finely ground it is better to mix your own green.

Terre Verte, Green Earth – is a naturally occurring pigment, which ranges from a yellow-green to a pale greenish-grey. In tubes it is usually a neutral sage green, which has a low covering capacity. It is an unusual colour, but does have its attractions for the calligrapher and artist. My suggestion though is to mix your own.

Viridian, Guignet's Green – this is a cool, pure green, but can be rather grainy for use in calligraphy or painting.

Oranges

Cadmium Orange – this is a deep orange which has a good covering power and is well ground.

Orange Lake Light – can be mixed with scarlet vermilion to give a better orange-red for manuscript work. It is finely ground but a little startling on its own!

Browns

Burnt Sienna – this is burnt or roasted Raw Sienna which produces a warm, reddish brown. Burnt Sienna is a good colour to have because of its mixing qualities. Mixed with Ultramarine it forms a good warm grey.

Burnt Umber – is burnt or roasted Raw Umber which produces a warm brown with a slight yellowish tinge. The paint can be a little sticky and granular for writing or painting.

Caput Mortuum – is a bluish red iron oxide which works well with a pen and brush.

Raw Sienna – is a warm yellow with a tinge of orange but it can sometimes be a little sticky to use.

Raw Umber – contains manganese dioxide as well as iron oxide and in colour is a warm yellow-brown with a tinge of green. It works well with a pen.

Sepia – is a mixture of Burnt Sienna and Lampblack.

Vandyke Brown – is a sticky dark brown pigment which is produced from brown coal or lignite. It hardens quite quickly in the tube, and can be a little grainy. It is hardly worth having in your palette because of these properties.

Yellow Ochre, Mars Yellow – are yellows with a tinge of brown, are finely ground and have good coverage.

Greys

Mixing Greys, Neutral greys – manufactured greys which are generally rather dull. Mix your own from Burnt Sienna and Ultramarine.

Neutral Tint – is a watercolour made from a mixture of India ink, Phthalocyanine Blue and a little Alizarin Crimson. It has limited uses for calligraphy.

Payne's Grey – does not cover well and you would be better mixing your own from Ultramarine with a little black and Red Ochre to soften the colour.

Using manufactured paint

The coloured pigment in tubes is mixed with glues and gum to attach it to the paper; used properly, it cannot then be brushed off the paper with the hand. It is also mixed with fillers to give it bulk and softeners to prevent it from going hard in the tube too soon.

Artists may use large amounts of paint for their work; calligraphers, miniature and heraldic artists use only 5 mm (0·2 in) at a time squeezed from a tube. Tubes of gouache remain in a scribe's store for many years. Make sure, then, that, when buying, you choose a tube which is still pliable. Give each tube a slight squeeze to check that it has not started to harden before you buy.

The tops of some tubes of gouache are very difficult to turn as they are so narrow; other makes are manufactured with wider tops which even have a straight indentation so that a coin can be inserted for ease of use. The latter are not so readily available, however, and may need some searching out, but it is worth doing so.

To use gouache, squeeze the tube gently. There may be about 5 mm (0·2 in) of clear gum which has collected at the top of the tube and which seals the paint from the air. Wipe this away on an old rag or paper kitchen towel. Then squeeze about 5 mm (0·2 in) into a palette or white saucer. Add drops of water to the paint and mix with an old paint-brush until it is the consistency of thin, runny, cream. This can then be fed into a calligraphy dip-pen with the brush or used for painting.

Problems with paint

If the paint is not flowing particularly well then one drop of liquid ox gall can be added to the mix as a 'lubricant'. (Be warned that the smell of ox gall liquid is not at all pleasant!)

If the lettering is to go into a book, where there may be a problem of the paint transferring to the opposite page, then add a drop or two of liquid gum arabic. If you use too much however the mix will be too sticky to flow from a pen.

If the paint hardens in the tube over the years, do not throw it away. Cut the end of the tube straight across with scissors and extract the hard paint from there, as it will not squeeze through the top of the tube. Mix with water and try the paint before you use it. It may need gum arabic to make it adhere to the paper, or ox gall to encourage it to flow well.

Mixing paint

It is best to mix up as much paint as you think you will need for the job in hand. Excess paint can be retained in the palette until you want that particular shade again. It is probably better to add a drop of gum arabic to paint which has been left for some time. The sticky component of the paint will evaporate along with the water, and there may be insufficient to attach it to the paper.

See page 309 for mixing precise amounts of colour.

Laying a wash

Laying washes which are smooth requires a little practice and a bit of technique. Unless the paper is heavyweight, it will need to be stretched to prevent the paint collecting in pools and ruining your wash. See page 298.

Mix up the paint in a palette with water until it is at least as thin as the consistency of runny cream, or probably of a more watery nature. Use a wide brush such as a 3 cm (1·5 in) wash brush, or a clean home-decorating brush.

Prop the board on which the paper is stretched on a book or another board so that the top edge is about 3 cm (1 in) higher than the lower edge. Dip the brush into the paint, ensuring that it is well filled, and with a broad sweep take the brush from the top left hand edge to the right. Continue in horizontal strokes never allowing the previous band of paint to dry out, otherwise there will be an obvious line. Allow the paint to dry before cutting the paper from the board. To get a really smooth wash, it often helps to dampen the paper before applying colour.

Various special effects can be made to a wash. A resist, such as masking fluid, can be put on before the wash so that the paint does not adhere to those areas. The wax from a candle has the same effect but is more difficult to control. Other colours and clean water can be dropped into the wash while it is wet; this then bleeds into the surrounding base colour. Or colours and water can be added after the paint has dried for different effects. Salt in wet paint creates an interesting texture, so, too, does clingfilm or saranwarp when placed over the wet wash and slightly pulled together with the fingers. See page 119 for some of these effects.

Glossary

acrylic medium (cryla gloss, etc) an adhesive which dries clear and to which metal leaf will stick.

archival paper paper which is acid-free and so will last longer without affecting the colour of painting or writing.

arch the curved part of the letter as it joins the downstroke.

arms parlant (also *canting arms*) a design in heraldry which makes a word play on the person's name.

ascender the stem of the letter which extends above the x-height as on letters **b, h, k** and **l**.

automatic pen type of pen which has a wide tip and a large reservoir for writing big letters.

bâtarde style of writing used mainly in books developed in Burgundy, France in the fifteenth century.

blazon word description of a person's coat of arms.

body height the x-height (see *x-height*).

bone folder often used by bookbinders to assist in folding and scoring paper; made of bone and blade-like, it may have a point at one end and a curve at the other or two curved ends.

bookbinder's corner way of making a cover for a book which ensures that the corner is neat and totally covered by paper or fabric.

bowl the round or oval curved part of a letter.

breathing tube a device made from paper, a drinking straw or hollowed out bamboo to focus moist air on a particular spot for gilding.

burnisher polished metal or stone which is used to help gold attach to an adhesive and then to make it shine.

cadency symbols which are placed on a shield to denote a man's (or his predecessors) rank in the family.

canting arms see *arms parlant*.

cap of estate/dignity/justice/maintenance a velvet hat usually red and lined with ermine which can be used in place of a wreath on top of the helm in heraldry.

carpenter's pencil pencil with a rectangular lead which can be shaped to an appropriate tip for making letters with thicks and thins.

charges devices and designs on a shield and/or used as part of a coat of arms.

chrysography writing in gold.

coat of arms a full grant of arms which includes the shield, helmet, mantling and wreath as well as the crest, although originally it meant just the shield.

coit pen similar in form to an *automatic pen* but with a central rippled reservoir.

cold press paper see *not*.

compartment the base of a grant of arms on which supporters rest if used.

concertina books also zig-zag books; books made from a long strip of paper folded to resemble a concertina or zig zag.

crest the part of a coat of arms which sits on the wreath above the helm.

cross bar the horizontal stroke on a letter such as **t** or **f**.

crystal parchment (also *glassine)*; paper with a resistant (non-stick) surface which is used in gilding and bookbinding.

cure (feathers) using heat or time to make the barrels of feathers go hard enough to be used as quills.

deckle edge slightly rough or uneven edge of paper made by small amounts of the paper pulp seeping out between the mould and deckle when the paper sheet is made.

devisal of arms a design and record of arms made by the College of Arms for towns, institutions and corporate bodies in the USA and South Africa.

descender the stem of the letter which extends below the x-height as on letters **p**, **q** and **y**.

dexter the right-hand side on a shield, grant of arms, etc. Because the shield is always considered to be held by the bearer, the dexter is the left-hand side when viewed.

diapering patterns on a shield, mantling, etc, which do not detract from the main tincture.

difference a charge added to a coat of arms to show cadency. (See *cadency.*)

dividers technical drawing implements which have a point at the end of each arm, used for marking the position of lines.

Dutch metal gold coloured metal foil.

Dutching tool a narrow pointed metal implement, attached to a wooden handle, for conducting heat along the barrel of a feather to cure it to make a quill.

egg tempera the addition of egg yolk to pure powdered pigment to make paint.

embossing pushing paper though a hole in a cut-out stencil so that the paper becomes raised from the rest of the surface.

endpapers the first and last fold of papers in a book which attach the pages of the book to its cover.

fishtail serifs the beginnings or ends of letters where the stroke divides like the tail on a fish.

flourishes strokes added to letters, often ascenders and descenders, but also to cross bars, to extend them in a decorative way.

gall (oak) hard, round secretion from an oak tree which is used in making oak gall ink.

gesso compound made from plaster of Paris (mainly) and glues which can be applied to a surface to form a base on which layers of leaf gold can be attached.

glassine see *crystal parchment*.

gouache paint, a little like watercolour, but opaque; used often by scribes as it does not show lines or repeated strokes when mixed to the appropriate consistency.

grain direction the direction in which manufactured paper folds most easily; essential when bookbinding.

grant of arms the granting of armorial bearings.

guard sheet a piece of paper covering of the lower part of a calligrapher's board behind which the best paper slips while in use, thus preventing it from becoming dirty.

guidelines lines usually drawn in pencil or with a hard point to indicate where letters and words should go.

gum sandarac lumps of gum which can be ground into a powder and applied to paper or skin to improve the surface for writing.

hatchment a diamond-shaped panel, usually found in churches, often as an indication of a person's death.

helm or **helmet** part of the coat of arms; the type of helm often indicates the rank of the bearer.

hierarchy of scripts the use of different styles of writing to indicate the importance of the words in the text.

hot press paper (HP) paper made with a smooth surface.

interlinear spacing spacing between lines which is usually sufficient to prevent ascenders and descenders from clashing.

laid paper paper which shows the laid lines.

letter families groups of letters where similar strokes are used in their construction.

majuscule capital or upper case letter.

mantling a protective covering of material at the sides and back of a helm in heraldry.

manuscript books books made, and also usually written, by hand.

marshalling putting together the various combinations of armorial designs in one coat of arms to show office, inheritance or marriage.

miniature small painting, sometimes illuminated, in a manuscript book.

minuscule small or lower case letter.

not paper paper which has been passed through cold rollers, not heated rollers, the resulting surface being between hot press and rough.

oak gall ink ink made from oak galls

papyrus writing or painting surface made from strips of a water-loving plant hammered together.

parchment sheep- or goat-skin prepared by bleaching and scraping to a smooth surface for writing or painting.

paste papers applying paint mixed with paste to paper to make different backgrounds for calligraphy.

paste-up lettering or painting prepared for printing or photocopying where the best examples are attached to a backing surface.

Petra Sancta shading style of hatched lines devised in the 17th century to denote the armorial tinctures in heraldry.

pounce powdered pumice and cuttlefish used to remove grease in paper and improve the surface for writing.

prescissus terminals ends of letters which are straight across as though they have been cut.

PVA white adhesive which dries clear.

quill pen made from a hardened feather.

reservoir an attachment to a pen nib to hold ink.

rough paper paper which is allowed to dry naturally after being made, ie not passed through any rollers; the resulting surface is rough!

ruling pen a pen made from two pieces of metal, or one piece folded over, where either a central screw or the position and angle of the pen give strokes of varying widths.

schlag gold coloured metal leaf (Dutch metal).

serif the stroke at the beginning and end of a letter, sometimes made as part of the initial stroke.

sheepskin parchment writing or painting surface made from a sheep's skin

shield the flat area of a coat of arms where the design is displayed.

sinister the left-hand side on a shield, grant of arms, etc. Because the shield is always considered to be held by the bearer, the sinister is the right-hand side when viewed.

star book a book made from a long strip of paper, folded and glued so that from above it looks like a star.

tinctures colours, metals and furs used in heraldry.

tricking a description of a shied using abbreviations for the tinctures and charges.

vellum calfskin which has been treated, usually with lime and by scraping, to provide a suitable writing and painting surface.

weight of paper the weight of paper related to its area. In most countries this is referred to as its weight in grammes per square metre, or gsm or gm^2.

wove paper paper which has a smooth surface and does not show any laid lines.

x-height the height of a small letter x of the alphabet under consideration. This changes according to the width of the nib being used.

zig zag books see **concertina books.**

Suggested Books for Further Reading

J. J. G. Alexander, *Medieval Illuminators and Their Methods of Work,* 1992

Janet Backhouse, *The Illuminated Page*, 1997

Peter J. Begent and Hubert Chesshyre, *The Most Noble Order of the Garter, 650 years,* 1999

Bernhard Bischoff, *Latin Palæography,* English edn, 1989

Leonard Boyle, *Medieval Latin Palæography: a Bibliographical Introduction*, 1984

J. P. Brooke-Little, *Boutell's Heraldry,* 1983

Michelle P. Brown, *A Guide to Western Historical Scripts from Antiquity to 1600,* 1993

Michelle P. Brown, *Understanding Illuminated Manuscripts, a Guide to Technical Terms*, 1994

Michelle P. Brown, *The British Library Guide to Writing and Scripts,* 1998

Michelle P Brown and Patricia Lovett, *The Historical Source Book for Scribes,* 1999

Ann Camp, *Pen Lettering*, 1984

Hubert Chesshyre and Adrian Ailes, *Heralds of Today,* 1986 *(new edition in preparation)*

Heather Child, *Calligraphy Today,* 1988

Heather Child (Editor), *The Calligrapher's Handbook,* 1985

Christopher de Hamel, *A History of Illuminated Manuscripts,* 1986, reprinted 1994

Christopher de Hamel, *Scribes and Illuminators,* 1992

R. O. Dennys, *Heraldry and the Heralds,* 1982

Stephen Friar (ed), *A New Dictionary of Heraldry,* 1987

Michael Gullick, *Calligraphy*, 1995

Peter Gwynne-Jones, *The Art of Heraldry,* 1998

Susanne Haines, *The Calligrapher's Project Book*, 1987

David Harris, *The Art of Calligraphy,* 1995

Michael Harvey, *Creative Lettering Today,* 1995

Donald Jackson, *The Story of Writing,* 1981

Edward Johnston, *Writing, Illuminating and Lettering*, 1906; reptd, 1977

Stan Knight, *Historical Scripts*, 1984, 1998

London Survey Committee, *The College of Arms,* 1963

Patricia Lovett, *Teach Yourself Calligraphy,* 1993

Patricia Lovett, *Tools and Materials for Calligraphy, Illumination and Miniature Painting,* 1996

Otto Pächt, *Book Illumination in the Middle Ages,* 1986

Charles Pearce, *The Little Manual of Calligraphy,* 1982

Sir Anthony Wagner, *Heralds of England,* 1967

A. R. Wagner, *A Herald's World,* 1988

James Wardrop, *The Script of Humanism,* 1963

Michael Wilcox, *Blue and Yellow Don't' Make Green,* 1989

Thomas Woodcock and John Martin Robinson, *The Oxford Guide to Heraldry,* 1988

Index

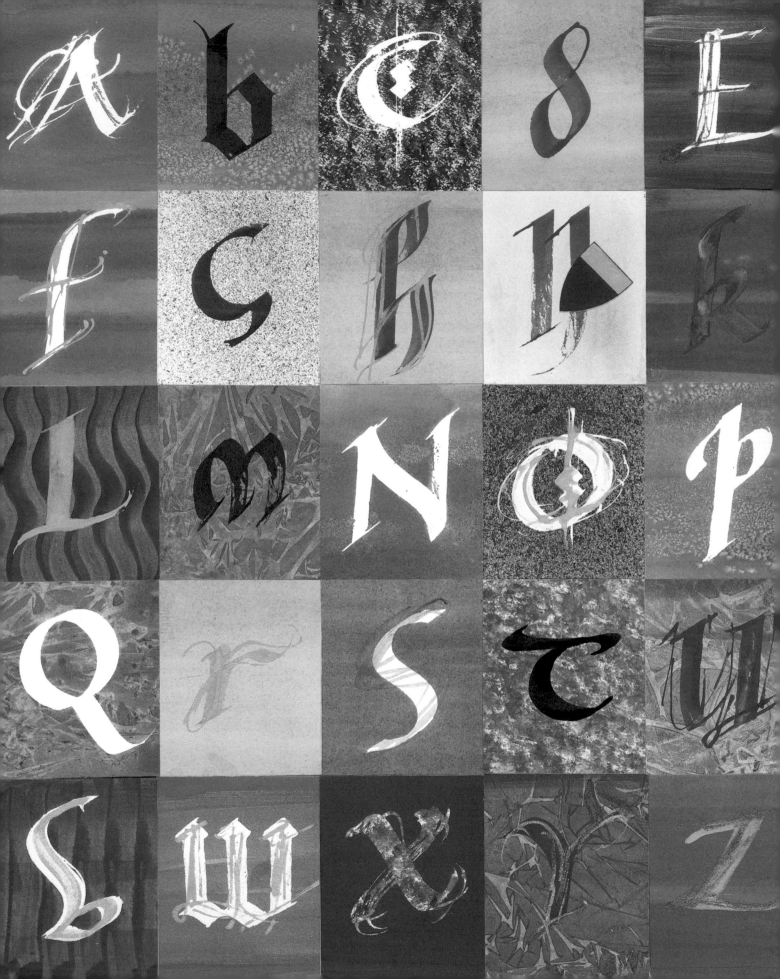